Apple Aperture 2

The Digital Workflow Series from Focal Press

The digital workflow series offers clear, highly-illustrated, in-depth, practical guides to each part of the digital workflow process. They help photographers and digital image makers to work faster, work smarter and create great images. The focus is on what the working photographer and digital image maker actually need to know to get the job done.

This series is answering readers' calls to create books that offer clear, no-nonsense advice, with lots of explanatory images, but don't stint on explaining *why* a certain approach is suggested. The authors in this series – all professional photographers and image makers – look at the context in which you are working, whether you are a wedding photographer shooting 1000s of jpegs a week or a fine artist working on a single Raw file.

The huge explosion in the amount of tools available to photographers and digital image makers – as new cameras and software arrives on the market – has made choosing and using equipment an exciting, but risk-filled venture. The Digital Workflow series helps you find a path through digital workflow, tailored just for you.

Series Editor: Richard Earney

Richard Earney is an award-winning Graphic Designer for Print and Web Design and Coding. He is a beta tester for Adobe Photoshop Lightroom and Photoshop, and is an expert on digital workflow. He has been a keen photographer for over 30 years and is a Licentiate of the Royal Photographic Society. He can be found at http://www.method-photo.co.uk

Other titles in the series

Canon DSLR: The Ultimate Photographer's Guide
Mac OSX for Photographers
Nikon DSLR: The Ultimate Photographer's Guide

Apple Aperture 2

A Workflow Guide for Digital Photographers

Ken McMahon
Nik Rawlinson

ELSEVIER

Amsterdam • Boston • Heidelberg • London • New York
Oxford • Paris • San Diego • San Francisco • Singapore
Sydney • Tokyo

Focal Press is an imprint of Elsevier

This book is dedicated to Rich from Nik

Focal Press is an imprint of Elsevier
Linacre House, Jordan Hill, Oxford OX2 8DP, UK
30 Corporate Drive, Suite 400, Burlington, MA 01803, USA

First published 2009

British Library Cataloguing in Publication Data
McMahon, Ken
 Apple Aperture 2 : a workflow guide for digital
 photographers. (Digital workflow)
 1. Aperture (Computer file) 2. Photography – Digital
 techniques
 I. Title II. Rawlinson, Nik
 775

Library of Congress Control Number: 2008934963

ISBN: 978-0-240-52039-1

For information on all Focal Press publications
visit our website at www.focalpress.com

Printed and bound in Canada
09 10 11 12 12 11 10 9 8 7 6 5 4 3 2 1

CONTENTS

CONTENTS

CONTENTS

CONTENTS

CONTENTS

Raw Files

Introduction

One of Aperture's biggest assets is that it gives you the ability to work with Raw images without converting them to other formats. At the end of this process, if you want to use the output images in other applications, on the Web, or in commercially printed publications for example, Aperture's Raw decoder can convert the Raw files into TIFF, JPEG and other image file formats.

You can, of course, use Aperture in a non-Raw workflow to organize and edit TIFF or JPEG files from your camera, but you'd be missing out on the opportunity to obtain the highest quality images that your camera is capable of producing with Aperture's help.

Aperture's Raw decoder is designed to help you squeeze the last ounce of quality from your digital images, from the Raw Fine Tuning controls that allow you to influence the way Aperture's decoder interprets the data in your camera Raw files to the tonal adjustments that allow you to recover apparently lost highlight and shadow detail. Aperture's tools are designed primarily to work with camera Raw files.

Knowing what camera Raw files are, how they differ from RGB file formats like TIFF, JPEG and PSD, and how camera Raw data are produced and stored will influence every aspect of your digital imaging

Fig. 1.1 The Raw Fine Tuning brick on Aperture's Adjustments Inspector.

workflow, from your choice of exposure to how and when you apply sharpening to your images.

In this chapter we begin by taking a look at what camera Raw is and what are the advantages and disadvantages of adopting a Raw digital imaging workflow. If you're not currently shooting Raw, and aren't sure if this is for you, this information may help you come to a decision.

Following that, we take a fairly technical look at how imaging sensors record the data in a scene and how that information is stored in a camera Raw file. It's not essential to know this, but it will help you make shooting and editing decisions that produce the final image of best possible quality.

The second half of the chapter deals specifically with the Adjustment controls found in the Raw Fine Tuning brick of Aperture's Adjustments Inspector (Fig. 1.1). These are available only when working with camera Raw files and determine how Aperture's Raw decoder interprets Raw data to produce an RGB image ready for further editing. If you're new to Aperture, you might want to fast forward to Chapter 2 to familiarize yourself with the workspace and how Aperture works with images and Versions before returning to this section.

The chapter ends with an explanation of Adobe's DNG Raw format and the advantages it offers in an Aperture-based Raw workflow.

What is Camera Raw?

The first thing to understand about camera Raw is that it is not one file format, but many. Camera Raw formats are proprietary, developed by camera manufacturers to best handle the data produced by individual models. Hence, the Raw file format produced by Canon's EOS 5D will differ from that produced by the Nikon D3 and even from other Canon dSLRs.

Though there are some important differences, Raw is just another file format like JPEG or TIFF. The major difference is that Raw files contain unprocessed data from the camera sensor. Before Raw data can be viewed as an RGB image, they have to undergo a number of processes. If you shoot in an RGB format, such as TIFF or JPEG, this processing is done in the camera. If you shoot Raw, the same is done by Raw decoder software like that used in Aperture.

Raw Support

The proprietary nature of camera Raw formats has a number of important implications for the photographer whose livelihood may depend on the integrity of and future access to a Library of images.

In practical terms, your ability to view and manipulate Raw files from your camera depends upon the availability of software which is able to read those files. Camera manufacturers usually supply a software utility for this purpose and, as well as MacOs 10.5 Leopard and Aperture, an increasing number of applications developed by third party vendors now support a wide range of proprietary Raw formats. Apple maintains a list of Camera Raw formats supported by Aperture 2 on its website at http://www. apple.com/aperture/specs/raw.html (Fig. 1.2).

Raw file formats tend to adapt and change to keep pace with hardware development. Thus, when a camera manufacturer

Fig. 1.2 You will find a list of all the Raw formats supported by Aperture at http://www.apple.com/aperture/specs/raw.html.

releases a new model it's possible that the Raw file format will differ in some respect or other from the one used in previous models.

The practical consequences of this are two-fold. First, it means that if you buy a newly released camera model and shoot Raw with it, you may not be able to import those files to Aperture, or any other third party application until they are able to provide support for it. Given the proprietary nature of Raw formats, this process can take time. In the meantime, you may be forced to rely on the manufacturer's software to read and convert Raw files into a format that your software can handle.

A second, more long-term issue concerns image archiving. Given the pace of change of digital hardware, it's not unlikely that in the course of, say, the next decade, you'll own and use a variety of cameras, each with its own flavor of camera Raw file format. At the end of this period and for the foreseeable future beyond, it would be reassuring to know that you could rely on the availability of software to allow you to open and manipulate those images the way you do today.

Regrettably, if past history is anything to go by, this is by no means a certainty. Camera manufacturers, software companies, hardware platforms and operating systems come and go. Even assuming they are still around for 20 years, how likely is it that they would be willing to support a format for a camera that nobody has used for decades?

There are, however, ways in which you can future-proof your images from this risk. Simply by importing your photos to Aperture you are providing one means of defense. It's fair to assume that Aperture's Library and Vault backup files will continue to be readable by future Versions of the program. Another means of ensuring future readability of your Raw files is to convert them to Adobe's published 'digital negative' DNG format. This option is discussed in greater detail later in this chapter.

The Pros and Cons of a Raw Workflow

More and more professional photographers are realizing the benefits of shooting Raw as opposed to TIFF or JPEG. The fact that many dSLRs now provide the option of saving both types of file from a single shot gives you the option of producing a 'just in case' Raw file. It may be that your usual workflow involves

Fig. 1.3 Support for new camera Raw formats is provided in the MacOs operating system. Owners of newer digital cameras like the Canon EOS-1DS Mark III, which was launched in August 2007, had to wait for the MacOs 10.5.2 update in February 2008 before they could work with Raw files from the camera in Aperture. Baseline DNG support in Aperture 2 provides a stop-gap solution for this kind of issue in the future.

very little image processing, subjects aren't problematic from an exposure point of view, and that 8-bit JPEGs provide good-quality images.

In such situations you might think of Raw files as an insurance policy to fall back on should the lighting turn out to be problematic, or the White Balance off. You can correct RGB files in these circumstances, but Raw files will provide you with more options and generate a better quality end result.

There is, of course, a downside to shooting Raw. The files are bigger than JPEGs, they take longer to write and, if you're not using Aperture, you may have to introduce at least one extra processing stage to your workflow. On balance though, we'd argue that advantages heavily outweigh the disadvantages.

Fig. 1.4 These three files are all from the same image shot in Raw with JPEG mode on a Canon EOS 20D. The Raw file comes in at 8 Mb with the JPEG occupying only 1.2MB. The third file was produced from the .CR2 file using Adobe DNG converter with lossless compression selected.

If you're still undecided, the following might convince you in one way or the other (Fig. 1.4).

Benefits

Overall Quality

In a well-exposed image with a full range of tones that do not require processing, the differences between, say, a TIFF file produced from your camera and one produced using Aperture's Raw converter would probably be marginal. This is probably the only situation in which there is little advantage to be gained from shooting Raw, but probably not one that occurs all that regularly for most photographers.

Bit Depth

Camera Raw files use the full number of bits (usually 12) available in the image data. If you shoot JPEGs, this is downsampled to 8 and the camera, not you, makes the decision about how effectively it uses those bits to represent the tonal levels in the image. For some images this can result in the irretrievable loss of highlight and/or shadow detail.

No Compression

Camera Raw files are not usually compressed, if they are, a lossless algorithm is employed. JPEG compression, even at the highest quality settings, removes a lot of data from your images which can severely limit what your are able to achieve in post-processing.

Increased Latitude

Latitude describes the exposure characteristics of film emulsions or digital sensors in terms of their ability to cope with a range of light

levels. When the range of light levels (called the dynamic range) in a subject is within that capable of being recorded by the film or sensor, latitude provides an indication of the degree to which the image can be over- or underexposed while still producing acceptable results (i.e. image detail in the highlights and shadows).

In a Raw workflow, your images have greater latitude than if you're working with RGB files. By using Aperture's Exposure, Levels, and Highlight and Shadow tools, you can ensure that the critical tonal regions receive the maximum number of bits. In practise, this means you can pull detail from apparently blown highlights and, to a lesser degree, rescue shadow detail and produce a robust image capable of withstanding further pixel manipulation.

Future Improvements

Currently Aperture's Raw converter does an excellent job of producing high quality RGB files from camera Raw data, even in relatively inexperienced hands. Future releases will doubtless improve on this, thereby making it possible for you to revisit your archived Library and produce even better images for your 2050 retrospective.

Disadvantages

More to Do

In many digital imaging workflows, Raw images introduce an extra processing stage as they must be converted to RGB files before they can be used, for example, printed, added to a Web page, or undergo further editing. Because Aperture treats all files as Master images, and stores Versions and their edits and adjustments internally, there is, in fact, little difference between working with Raw files and JPEGs or TIFFs.

Bigger Files

Raw files are bigger than JPEGs and this has consequences all the way down the line. It takes longer to write Raw files to a data card in the camera with the obvious consequences for action photography. Raw files will take up more hard disk space and, because of the necessity to generate an RGB TIFF if you want to edit the image in Photoshop, it's necessary to produce duplicates. On the upside, because Aperture handles all adjustments to the original Raw Master on the fly, there's no need to keep several edited Versions of images.

Proprietary, Closed Formats

As we've seen, Raw is not one format but encompasses many different proprietary file formats. This carries a risk in terms of the availability of future support for existing camera Raw formats.

From Raw to RGB

Raw files contain information about brightness values recorded by each photosite on the camera sensor. These data are analyzed and referenced according to its position on a grid to determine the color value of each image pixel (see 'How sensor data is captured and stored' on page 12).

This process, called demosaicing, determines the color of pixels in the data matrix depending on their position and the color of neighboring pixels. The resultant image is then color calibrated according to the camera's White Balance settings, saturation is determined, and the image may be sharpened. Finally, the image color space is assigned and, if you are shooting JPEGs, the file is compressed.

Some of what happens during this process is determined by your camera settings. Most dSLRs provide 'parameter' sets which apply manufacturer- or user-defined presets for all of these settings (Fig. 1.5).

By setting your camera to shoot in Raw mode, you are effectively bypassing this in-camera processing of the sensor data. This means that before you can view the files, you have to process the data yourself and this is where the huge advantage of working with Raw files becomes clear.

When Raw image data is processed in the camera to produce a JPEG or a TIFF file, decisions are made about how the data are interpreted – some of the data are even discarded. The camera's processing algorithms are designed to produce the best result under all possible conditions, but your camera can't tell if the image it is processing is correctly exposed, if the scene before it contains a full range of tones, or whether the shadow detail is more important to you than the highlights. By delaying processing of the Raw file until you've seen the image, you can decide for yourself how best to interpret the data to produce a robust RGB file.

You can, of course, manipulate tones and colors and make other changes to an 8-bit TIFF or JPEG file processed by your camera, but these edits are destructive. Even minor Levels adjustments in

Fig. 1.5 dSLR parameter settings provide in-camera control over some aspects of Raw processing.

Photoshop can produce tonal discontinuities and exaggerate noise. Such changes applied to Raw files don't always carry the same penalties because you are not only working with much more of the image data to begin with but also interpreting this to produce a clean RGB file (Fig. 1.6).

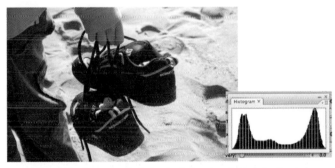

Fig. 1.6 Both of these images have had a Levels adjustment applied to darken the shadows and increase image contrast. Both images are from the same original camera Raw file. For the top image, the Camera Raw Master was Levels adjusted in Aperture and the image was opened in Photoshop as a 16-bit PSD. Despite the Levels adjustment, the Photoshop Histogram is smooth and shows no discontinuities. The bottom image was opened unadjusted in Photoshop, also as a 16-bit PSD, then downsampled to 8 bits per channel using Image > Mode > 8 Bits/Channel. It was then given a similar Levels adjustment to the top image in Photoshop. Because there is less information in this image, the adjustment has produced discontinuities in the Histogram. In severe cases these will appear as posterization or banding. Raw files are much more robust and able to tolerate much greater tonal manipulation than 8-bit RGB files. Whereas the top image still has sufficient information to undergo further editing, further adjustments to the bottom file will likely result in visible posterization, noise and other artifacts.

How Sensor Data is Captured and Stored

A sensor consists of a grid, or 'array' of individual photodiode receptors which convert the light that falls on them into an electrical voltage. The voltage varies in direct proportion to the amount of light and is converted into a number by an analog to digital converter.

Image sensors don't detect or measure color, but only light, or 'luminance', which is represented digitally as a grayscale value. The color information is provided by a 'color filter array' consisting of red, green, and blue cells placed over the sensor.

As we know from the trichromatic theory of color reproduction, all colors can be composed of the three primaries red, green, and blue. Although each pixel in the sensor array measures only one primary color, the 'missing' two components for each pixel are interpolated by analysis of neighboring pixel values in a process known as demosaicing.

It is this grayscale data, along with some metadata, that is stored in the camera Raw file. Among other things, the metadata include the camera's White Balance setting, the ISO setting, and other exposure and metering values, but, if you are shooting Raw, this information is simply recorded, and is not applied to the data to create an RGB image.

In-Camera Processing and the Aperture Alternatives

By taking a look at how captured sensor data are processed to produce an RGB image file, you can better understand how to use Aperture's adjustment controls to extract the utmost quality from your Raw files.

Demosaicing and Color Space Conversion

As we've seen, camera sensors produce only luminance information that is initially recorded as grayscale values. By making use of a colored grid, or color filter array placed over the sensor, the correct color value for each image pixel can be determined by a process called demosaicing.

The most common type of array in use is the Bayer pattern, which alternates lines of red/green and blue/green cells – there are twice as many green cells as red or blue because

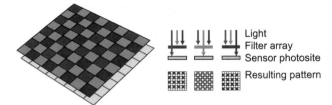

Color filter array sensor

Fig. 1.7 A color filter array placed over the camera's image sensor filters light to transmit only red, green or blue at specific sensor locations. By analysing the luminance values of a single sensor location and its neighbors the color of individual pixels is determined. This process is known as demosaicing.

the human eye is more sensitive to that portion of the visible spectrum. To determine the correct value for a given pixel, the demosaicing algorithm assesses the value of both that pixel and its neighbors (Fig. 1.7).

This is one process that Aperture doesn't give you much control over. It happens automatically using profiles which tell Aperture about the color characteristics (e.g. the type of filter array used) of the camera used to create the Raw file.

You do, however, have the option to influence the result using controls in the Raw Fine Tuning brick of Aperture's Adjustment Inspector. If you are using the Version 2.0 decoder, these include Boost, Hue Boost, Sharpening, Moiré, and Auto Noise Compensation. See Raw Fine Tuning in Aperture for more details on using these adjustments.

In their default positions, all of these are set to produce optimal results for the given camera profile; you may, however, be able to achieve better results through experimentation on individual images. If you find something that works well, you can save it as a preset by selecting Save as Preset from the action menu.

Tonal Mapping

If you want to produce the best possible quality images from your Raw files, understanding how digital cameras record tonal data and how to safely manipulate that data will underpin virtually every adjustment you make to a digital photo from here on.

The human eye doesn't see light in a linear fashion. That is to say, if twice as much light enters your eye it doesn't appear twice as

bright. It's this non-linearity of response that enables us to see so well in such a wide range of conditions – from a dimly lit room to bright sunshine. One other thing that's important to know about the human eye is that it is much more sensitive to shadow detail than it is to highlights. You can differentiate more tones in a dark scene than you can in a light one (Figs 1.8 and 1.9).

Film responds to light in a similar non-linear fashion and if you plot a curve of this response with input along the x-axis and output on the y-axis you get a gamma curve which describes it (Fig. 1.10). Although film stock characteristics vary, the general appearance of a film gamma curve is S-shaped like that in Fig. 1.11.

Unlike our eyes and photochemical emulsions, digital sensors have a linear response with a gamma of 1. Their gamma curve is a 45 degree straight diagonal line.

Most digital cameras use 12 bits per pixel to record tonal information in a Raw image file. Those bits are allocated across the range of tones that the sensor is capable of recording from the darkest black to the lightest white providing 4096 (2^{12}) discrete levels. Assuming your camera is capable of recording a dynamic range of six stops, which is typical for a modern dSLR, you might expect that one sixth of the available bits is allocated to each stop so that the darkest and the brightest levels contain equal numbers of data. This is not the case.

Fig. 1.8 The way digital camera sensors record light.

Fig. 1.9 The way the human eye perceives light.

Fig. 1.10 Linear gamma curve.

Fig. 1.11 Gamma curve for a typical film emulsion.

In fact, half of the levels, 2048, are used to record the brightest stop, leaving 2048 for the remaining five stops. Half of these (1024) are devoted to the next stop, half of the remainder (512) to the next, and so on down to the darkest stop which gets 64 levels (Fig. 1.12).

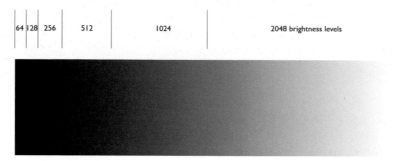

| 64 | 128 | 256 | 512 | 1024 | 2048 brightness levels |

Fig. 1.12 This diagram shows how data are allocated to represent the brightness levels in a 12-bit image. Half of all the image data are used to represent the brightest stop. Half of the remainder are allocated to the next stop and so on. While the brightest stop gets 2048 brightness levels, the darkest gets only 64. This has significant implications both for exposure settings when shooting and for tonal adjustments of shadow detail in Raw images.

Do you see the problem? The shadow details, to which our eyes are most sensitive, are recorded using the least number of data and therefore the fewest grayscale levels. This has important consequences for how you shoot Raw images, how you convert them to RGB files, and how you make tonal and color adjustments.

As we have seen, adjustments to Raw images do not carry the same consequences for data loss and image degradation as with RGB image files. That does not mean your changes will not affect image quality. There would not be any point in working with Raw files if you could not achieve quality improvements, though you could also make things worse if you are not careful.

Clearly, if the shadow regions of an image are recorded using relatively few levels, manipulation of those levels is likely to cause problems. Any adjustment that stretches the Histogram to the right, moving data from the shadows to the midtones, e.g. Levels, or Highlights and Shadows, carries the risk of introducing image artifacts such as posterization or noise.

You are only likely to need to make such adjustments with images that are underexposed, where the Histogram is bunched up on the left. So it clearly pays to avoid underexposure. The generally accepted rule when shooting Raw is to set your exposure so that the highlights are close to blowing out without actually doing so. In doing this, you ensure that tonal detail is recorded using all of the available bits.

Let's suppose you shoot a subject and subsequently discover the Histogram is bunched on the left with no pixels visible on the right hand side, in the area normally occupied by the brightest stop of image detail (Fig. 1.13). By doing so, you would have effectively sacrificed half of your camera's capacity to record tonal detail before you have even started processing the image. This is not a good start.

When you come to making image Adjustments in Chapter 5, you will discover that the Histogram is your best guide when determining what controls to adjust and how far to go with them. Likewise, when you are shooting Raw, the camera Histogram is your best guide to determining whether your exposure settings are providing you with the most data-rich image it is possible to obtain and the one which provides the best opportunity for processing into a high quality RGB file.

It can often be difficult to determine from a camera Histogram at exactly what point image highlights are blown beyond recovery. For one thing, the displayed Histogram is adjusted to a non-linear gamma and so it does not tell you the whole story and can exaggerate highlight clipping. For another, Aperture is quite good at recovering lost highlight detail; so a small amount of clipping at the right side of the Histogram is not necessarily the end of the world and, in any case, is preferable to losing shadow detail from the other end (Fig. 1.14).

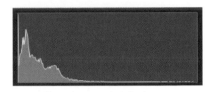

Fig. 1.13 If your Histograms look like this, you are wasting most of your camera's ability to record tonal information.

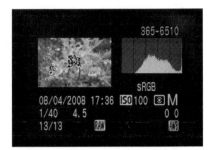

Fig. 1.14 Camera Histograms show the data for a gamma-adjusted image and can exaggerate highlight clipping which, in any case, can easily be recovered in Aperture. A small degree of highlight clipping is infinitely preferable to underexposure.

White Balance

The White Balance setting on a digital camera makes a qualitative assessment of the lighting conditions in the scene being photographed and interprets the data so that white areas in the scene appear white in the image and other colors are accurately reproduced.

You can tell the camera about the ambient lighting conditions by using a White Balance preset, such as 'Daylight' or 'Tungsten' or by setting a specific color temperature. By using the automatic White Balance setting you can let the camera determine the color temperature of the ambient light, or you can set the White Balance more accurately by using a custom White Balance setting and taking a reading from a neutral surface, such as a white wall, or neutral gray card, in the scene you are about to photograph.

Fig. 1.15 The image on the left has been shot with the camera White Balance incorrectly set for artificial light. Using Aperture's White Balance Adjustment you can correct for this by indicating the approximate color temperature of the lighting conditions in the scene (or simply judging the result visually). Because the White Balance Adjustment occurs prior to conversion of the raw data, it's exactly the same as if you'd set the correct White Balance on the camera. This is not the case with RGB files, which will suffer a loss in image quality as a result of such a color correction.

If you are not shooting Raw it is important to get the White Balance right, because inaccuracies will need to be corrected and such corrections to pixel values are destructive and result in a loss, albeit marginal, in image quality.

When shooting Raw White Balance is less of an issue; in fact, it's not an issue at all because, as the Raw image data hasn't been colorimetrically interpreted, the White Balance has not yet been determined, and you can do that in Aperture.

In practice, this makes the Camera's White Balance setting more or less irrelevant. You can adopt whichever of the above mentioned White Balance methods you favor, sure in the knowledge that, if a problem arises, it can easily be dealt with. Aperture will use the camera's White Balance setting to make the initial conversion so that the image can be displayed and this is what will appear in the White Balance section on the Adjustments Inspector.

It's important to understand that this White Balance is not 'fixed' as it is for RGB files. The white balance information from the file metadata is applied to the Raw image to produce what you see

on the screen. You can drag the slider to set any White Balance you want and this is effectively the same as setting the White Balance in the camera.

Noise Reduction and Sharpening

Noise reduction in the camera is a proprietary process developed by the camera manufacturer to reduce image noise. Light falling on a camera sensor produces an electrical charge which is amplified before being converted to a number by an analog to digital (A/D) converter.

Analog systems such as this are subject to noise – a component of the signal that is generated by the circuitry and which, if you like, pollutes the pure signal. Noise in digital images is often compared to film grain and, just as faster films exhibit more graininess, digital images shot at higher ISO rating display more noise (largely as a consequence of analog signal amplification resulting in a lower signal to noise (s/n) ratio). Visible noise can also be generated by long exposure settings.

Camera manufacturers implement noise reduction algorithms to deal with the noise characteristics of sensors at given ISO settings. Aperture's Auto Noise Compensation is an on or off control that performs a similar function and also removes so-called hot and cold image pixels caused by camera sensor faults (Fig. 1.16).

Additionally, the Noise Reduction adjustment can be applied in varying degrees depending on the amount of correction required. See Chapter 5 for more details on how to use the same.

The demosaicing process produces slightly soft images, and noise reduction tends to exaggerate this softness. In camera, sharpening is usually subsequently applied to redress the balance and produce images with acceptably well-defined edges. Aperture's Raw fine tuning provides a Sharpening adjustment with two settings – Sharpening (Intensity in the 1.1 decoder) and Edges.

Most digital sharpening tools work by enhancing contrast in edge detail and this tool is no exception. The Sharpening control determines how much the edge contrast is increased and the Radius slider defines the edge boundary – it tells Aperture how far to look on either side of a given pixel to detect a change in contrast.

Fig. 1.16 Section from an 800 ISO image with (top) no noise reduction (Auto Noise Compensation turned off, (middle) Auto Noise Compensation turned on and (bottom) Auto Noise Compensation and Noise Reduction.

Raw Fine Tuning in Aperture

Raw Fine Tuning

The Raw Fine Tuning brick at the top of Aperture's Adjustments heads-up display (HUD) provides some user control over how images are decoded to find out the ones that can be used to adjust the appearance of decoded images to a degree.

Which Decoder?

The Decoder Version pop-up menu provides four options – 1.0, 1.1, 2.0 DNG and 2.0. In most circumstances, 2.0 is the default decoder; it is the most recent Version and will usually produce the best results. For all new images imported into Aperture 2.1 you should use the 2.0 decoder.

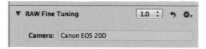

Fig. 1.17 Raw Fine Tuning controls for Decoder 1.0.

The 1.0 and 1.1 decoders are legacy Versions from Aperture 1.0 and 1.1 respectively. They are included to maintain consistency for images originally decoded with them in earlier Versions of Aperture. Images originally decoded in, for example, Aperture 1.1 with the 1.1 decoder will continue to be decoded with the 1.1 decoder when you display them in Aperture 2.1 and will look exactly the same as before.

Depending on your workflow and the final output destination for your images, you may want to continue with the legacy decoders for older images. If consistency is not an issue you will be able to produce better quality results by switching to the more recent 2.0 decoder. This is particularly the case for images using the 1.0 decoder.

Fig. 1.18 Raw Fine Tuning controls for Decoder 1.1.

To change the decoder Version used for individual images, simply select the new Version from the pop-up menu. The Version 1.0 decoder has no adjustment sliders – all the decoding parameters are set automatically. The Version 1.1 decoder has a Boost slider, which controls contrast, sharpening controls, a Chroma Blur adjustment, which helps reduce the effects of chromatic aberration and optional Auto Noise Compensation (Figs 1.17 and 1.18).

The Version 2.0 Decoder

The Version 2.0 decoder adds a Hue Boost slider under the Boost slider (Fig. 1.19). This is used to maintain the hue values in an image as the contrast is increased. Higher Hue Boost settings cause color in the image to shift more as the Boost slider is

Fig. 1.19 Raw Fine Tuning controls for Decoder 2.0.

increased. At lower Hue Boost settings, boost has less of an effect on color values in the image. In practise, high Hue Boost settings work well for images with saturated primary and secondary colors, like flowers. You can use lower Hue Boost settings to maintain natural skin tones in portraits.

The default for Boost and Hue Boost settings is 1.0 and 0.5 respectively. This does not mean that the same settings are applied to all images. 1.0 is the recommended amount of boost for the camera Raw format of the selected image. You can reduce this, but not increase it (Figs 1.20 and 1.21).

Reducing the Boost is often a good first step in recovering highlight detail in overexposed images or those with a high dynamic range. See Chapter 5 for more details on how to go about this.

Sharpening

Next on the Raw Fine Tuning brick are two sliders which control sharpening. The sharpening adjustments on the Raw Fine Tuning brick are designed specifically to compensate for softening of the image which occurs as a result of the demosaicing process.

Like the other Raw Fine Tuning adjustments, Sharpening is applied on the basis of the camera model characteristics – different

Fig. 1.20 The Version on the left has the default Boost adjustment of 1.0; on the right this has been reduced to 0.5. For most images the Default Boost setting produces excellent results.

Fig. 1.21 Both of these Versions have a Boost setting of 1.0. The Version on the left has a Hue Boost setting of 0; the one on the right has a Hue Boost setting of 1. The difference is marginal, but most noticeable in the yellows and greens.

sharpening parameters will be applied, for example, to images from a Nikon D3, than to those from a Canon EOS-1DS Mark III.

The sharpening slider controls the amount, or intensity, of sharpening and the Edges slider defines the largest group of pixels which, for sharpening purposes, constitute an edge. As you drag the Edge slider to the right, more of the image is sharpened.

Sharpening has a very minimal impact on the image compared with Aperture's Edge Sharpen adjustment. See Fig. 5.29 in Chapter 5 for a comparison of an image with the default sharpening settings applied and that with no sharpening. You will also find a more detailed discussion of sharpening in general.

Given that it has such a marginal effect, you might be tempted to turn Sharpening off altogether. In our view this is not a good idea. For most images, the best option is to leave Sharpening on it default setting and use Edge Sharpen later in your workflow to sharpen images in preparation for output.

Moiré and Chromatic Aberration

The Moiré adjustment and its associated Radius slider are used to reduce the effects of Moiré interference patterns and fringing caused by chromatic aberration in lenses.

Moiré patterns will be familiar to anyone who has experience of commercial printing, where they commonly occur as a result of interference between fine image detail and halftone reproduction screens. In cameras they are similarly brought on by interference between the color array and repeating fine image detail.

Chromatic aberration is a lens fault where light of different wavelengths is focused in different planes. It results in a colored fringe, usually purple, around backlit objects. In good-quality lenses, chromatic aberration is rarely present, but it is difficult to eliminate in ultra-wide-angle lenses and can often be seen in images from digital compacts.

To reduce Moiré or fringing, drag both sliders to the extreme right to apply the maximum amount of Moiré at the largest radius setting – 1.00 and 25 respectively. Reduce the Moiré until the effect starts to reappear, then increase it just enough to eliminate it. Finally do the same with the Radius slider, reducing it until the Moiré pattern starts to reappear in areas of the image and adjusting back up to the minimum setting required to eliminate the effect.

Changing Decoder Settings for Multiple Images

Using the Decoder Version pop-up menu to update individual images to the version 2 decoder is fine if you're happy to update images on an ad hoc basis when you are working with them. If you want to update all of the images in your Aperture Library to the Version 2.0 decoder, or even a single Project, there's a better way to do it.

Select the images in the Browser, or select a Project or Album in the Projects Inspector and choose Migrate images from the File menu. You can also migrate books, Web galleries, Web journals, Web pages, Light Tables, and Smart Albums. Select the Library to migrate all of the images in your Library, but be aware that for large Libraries this could take some time.

The dialog box provides a number of 'upgrade' options. If you click the first radio button – 'Upgrade existing RAW images' (the default setting) existing Masters and Versions will be switched to the Version 2.0 decoder (Fig. 1.22). If you want to keep the

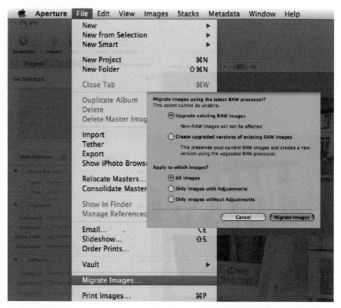

Fig. 1.22 Migrate Images produced using earlier Versions of Aperture's Raw decoder by selecting File > Migrate Images. In the Migrate Images dialog box you can elect to 'Upgrade existing Raw Images' or keep the old ones and create new Versions using the Version 2.0 decoder. Non-Raw images and those that already use the Version 2.0 decoder remain unaffected.

existing images in their present legacy-decoded state and produce new Versions using the 2.0 decoder check the 'Create upgraded Versions of existing Raw images' radio button.

Use the three radio buttons in the lower half of the dialog box to choose to upgrade all images, only images with adjustments, or only images without adjustments. Once images have been upgraded to the Version 2.0 decoder, you can not migrate them back, or undo the process, but you can individually change them back to earlier Decoder Versions using the Decoder Version pop-up menu on the Adjustments Inspector.

Non-Raw images are ignored by the migration process, as are those Raw files that already use the Version 2.0 decoder.

DNG

If your camera Raw format is not supported by Aperture, one way around the issue is to convert the Raw files to Adobe DNG format. DNG is a Raw format published by Adobe in the hope of

creating a single industry standard and open Raw format as an alternative to the multitude of proprietary Raw formats currently in existence.

One advantage of this for developers of software that works with camera Raw files is that it would not be necessary to add support for new formats each time a new camera model is released. And owners of those new cameras would not have to wait for their image management and editing applications to add support; so they can start using them with images from their new hardware.

Although some camera manufacturers, such as Hasselblad, Leica, Ricoh and Samsung, produce models which can write Raw files in DNG format, most manufacturers continue to use proprietary camera Raw formats. But you do not need a camera that writes DNG files to be able to use it in your Raw workflow. Adobe's DNG converter application converts files from a wide range of camera Raw formats into DNG.

Even if Aperture supports Raw format files from your camera, there are advantages to converting your Raw files to DNG. We have already talked about the risks of archiving images in a proprietary unpublished format and the problems inherent in adding software support for new formats as they become available. As well as standardizing on a single format for all of the images you produce in the future, regardless of hardware developments, DNG can help you work with images for which Aperture does not currently provide support.

Because DNG files can contain embedded IPTC (International Press Telecommunications Council) metadata, they can also provide a vehicle for migrating images that have had metadata added in other applications to Aperture. See Chapter 7 for more details on how to migrate images from Adobe Bridge to Aperture using DNG Converter.

Along with the decoder versions already mentioned, there is a fourth option on the Decoder Version pop-up menu – 2.0 DNG. You might not see this option unless a DNG file is selected in the Browser. The 2.0 DNG decoder is used to decode images which have been converted to the DNG format whose original camera Raw format is not supported by Aperture.

Apple calls this Baseline DNG. In the absence of information about the camera characteristics, Aperture decodes the Raw

images using a generic camera profile. One drawback of this is that the conversion may not yield results as good as those for natively supported Raw formats. Another is that, in the absence of information about the sensor and its noise characteristics at different ISO settings, Auto Noise Compensation is not available with the 2.0 DNG decoder. And Baseline DNG does not support cameras with a Foveon X3 sensor, such as one of the Sigma SD dSLR range. Nonetheless, being able to work in Aperture with images from new cameras and those that are not natively supported is a huge advantage.

Using DNG Converter

DNG converter is a free download available from www.adobe.com/products/dng/. All the conversion options are provided from a single panel divided into four numbered sections. The first two of these are used to select the images you want to convert and specify a destination folder and file naming options.

Specify a separate location for the converted DNG files (Fig. 1.23). Depending on your archival requirements you may want to archive the original Raw files to a removable or separate disk.

Panel 3 provides file renaming options. In most cases, the default settings, which keep the original filenames and append a .dng suffix, are fine. If required, you can always rename the files on import to Aperture.

Panel 4 displays the conversion preferences which determine the kind of DNG file produced. Click the Change Preferences button to open the Preferences dialog box. The JPEG Preview pop-up menu sets the size of the JPEG preview. If you checked the 'Use embedded JPEG from camera when possible' box in the Preview pane of the Aperture preferences window, this is the preview that Aperture would use. Otherwise, or if you choose none, Aperture will create its own preview.

Image Conversion method provides two options, Preserve Raw Image and Convert to Linear Image. Preserve Raw image maintains the Raw data in its mosaiced format. This is the conversion method you should use for images that you intend to import to Aperture both for cameras whose native formats are supported and for those that are not and for which you plan you take advantage of baseline DNG support using the 2.0 DNG converter (Fig. 1.24).

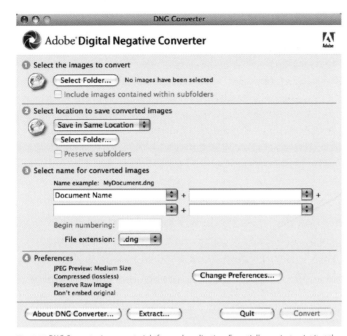

Fig. 1.23 DNG Converter is a very straightforward application. Essentially you just point it at the Raw files you want to convert, tell it where to store the converted DNG files and click Convert.

Fig. 1.24 Set conversion options in the DNG Converter Preferences window. For most purposes you would want the Preserve Raw image conversion method which maintains the Raw data in their original format and does not perform a demosaic operation. You can choose to embed the original Raw image for archival purposes, but the conversion will take longer and DNG file sizes will be correspondingly larger.

Convert to Linear Image demosaics the image data. Despite the information which is displayed when you select this option, i.e. 'This can be useful if a camera's particular mosaic pattern is not supported by your DNG reader,' it is not supported by Aperture.

Finally, DNG converter provides the option of embedding the original Raw image file in the DNG file you are about to create. This is an archival option which provides for the extraction and retrieval of the original Raw file should you require it. It is, if you like, a 'belt and braces' option. The only drawback is that it increases the size of the DNG file considerably. Though it does not provide the convenience of co-location, a more workable option might be to archive your Raw originals separately. Embedded Raw files can be extracted from DNGs using the Extract button.

How Aperture Works

The Aperture Workspace

Aperture is part of Apple's 'Pro' application lineup, where it sits beside Final Cut Studio, Logic and Shake. As such, it sports the distinctive dark interface that Apple uses for these products, and works best on high resolution displays as it adopts a smaller on-screen font and a range of complex panels and palettes. It's even better when spread across two screens, where the management and editing workspaces will be separated out from each other and your pictures will have room to breathe (Fig. 2.1).

The interface is split into resizable areas dedicated to specific tasks, such as Project management, image editing, photo browsing and viewing at larger sizes. Each one is contained within the Aperture application interface rather than spun off as a separate panel as things are in Photoshop. This follows the methods used in Final Cut Studio, iTunes and iPhoto. There are exceptions, however, in the form of head-up displays (HUDs) and the innovative full-screen mode. When running in full-screen, Aperture hides its rigid gray interface and instead adopts a black background to better show off your photos, and strips at the top and bottom of the display showing, respectively, tools and thumbnails. The HUDs, meanwhile, are semi-transparent dialog that overlay the main interface and allow you to perform a range of tasks which

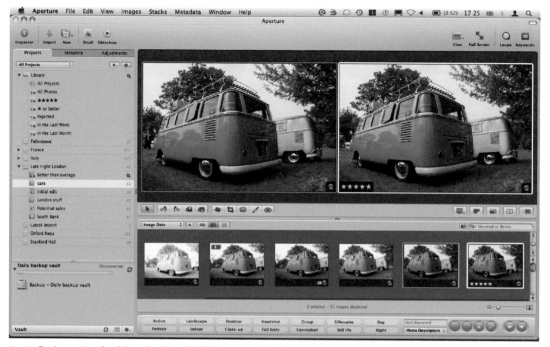

Fig. 2.1 The Aperture interface follows the design of Apple's Pro apps, with a dark background, smaller font, and distinctive panels inside a unified interface. The main working area is the large Viewer, below which is the Browser, used for selecting images. To the left is the Inspector, used for organizing and adjusting.

includes assigning keywords and editing colors and exposure. They can be used in regular and full-screen modes.

In its regular layout, Aperture's three most obvious palettes are the Projects panel, the Viewer and the Browser. By default, these sit to the left, top and bottom of the display respectively. The Adjustments and Metadata panels sit behind the Projects panel and you can switch between them either by clicking the tabs at the top of the pane or by tapping **W** to cycle through all three.

Supplementary to these are the Toolbar and Control Bar. The Toolbar sits at the very top of the screen, just below the OS X menu bar, and handles image imports, creates books, galleries, slideshows and so on, emails your photos, invokes the Loupe and applies keywords to your files.

The Control Bar sits at the very bottom of the screen. It handles the way in which your images are displayed in the Viewer and – if

you've called up the relevant dialog – provides for an easy way to rate pictures, add keywords and skip through your Library.

Everyone will use Aperture in different ways, and while some will never step out of the regular interface layout, others will spend all of their time working in full-screen. In this mode, it is particularly beneficial to have a good working knowledge of Aperture's keyboard shortcuts as it will allow you to work without constantly showing the hidden Toolbars and menus that sit at the top and bottom of the screen.

In this chapter, we will examine each element of the Aperture interface in detail, walk you through the various options open to power users, and explain how to use each to best effect. We'll also point out the essential keyboard shortcuts wherever they apply.

First, though, we'll take you through how Aperture stores your images. A thorough understanding of its filing system goes a long way to understand how it applies edits and adjustments to your files.

How Aperture Stores Your Images

Aperture stores all of your images in its Library. Under the hood, this is a complex collection of folders, sub-folders, packaged files and original images, accompanied by thumbnails, previews and metadata files describing how they should be organized and what changes you have made to them.

At a system level – on your hard drive – your images are organized in a complex series of embedded folders hidden inside a package in your Pictures folder called Aperture Library. Double-clicking this will open Aperture, but right-clicking and selecting Show Package Contents will open it up for inspection. While there is no harm in taking a look at what it contains, you should resist the temptation to fiddle with its contents, as doing so could cause irreparable damage to your Photo Library, and you risk losing some or all of your images.

Within this package, you'll see two folders – Built-in Smart Albums and Aperture.aplib – which control how Aperture organizes your files, along with a series of folders whose names match the Projects in your Aperture Project pane. These are the roots of an extensive folder tree that contains a directory for every sub-folder in your Library, and at the furthest ends of each branch, your

Fig. 2.2 Any images you import into Aperture directly are stored in its Library, a packaged folder than can be explored through the Finder. Never tamper with the contents or you could irreparably damage your collection.

original Raw images, plus thumbnails and previews in JPEG format, which were created when you imported your pictures (Fig. 2.2).

Why does Aperture put each photo into a folder of its own? Because every time you make an adjustment, it leaves the original untouched and simply makes a note of the changes in the form of text-based XML files that sit alongside it and are applied every time you switch between Versions.

By gathering everything together in one place, it keeps your drive tidy and unfragmented. This also means that it can use plain-English filenames, which makes identifying which file relates to which version easier as you always know that Version-2. apversion will be the second revision of the original photo from which the folder took its name, Version-3.apversion will be the third, and so on. Clustering all of these images together would have made it impossible to create such an easily navigable file structure, and would have necessitated greatly extended filenames to differentiate second versions of each file which would be impossible to separate for anyone manually trawling the directories as we do now.

Fortunately, all of this is hidden inside Aperture itself, which makes a thorough understanding of the Library's underlying directory structure unnecessary. All images are organized in the Projects panel and selected in the Browser, which presents lists or thumbnails of files below the main editing window, the Viewer (Fig. 2.3).

The precise sub-divisions of your images are up to you. If you want, you can have a single large Project containing everything you've ever imported, although this would be barely any easier to navigate than the on-disk file structure. Instead, you should use Projects to split your photos by assignment or subject – say France, Jill's Wedding and so on – with Albums inside each one to further categorize the contents – such as Lyon, Paris, Marseilles, and Dress, Cake, Ceremony in the examples above. Supplementary to these are Light Tables, used to help sort and filter your images; Web galleries, pages and Journals used to publish them online; and Books.

Above your Projects panel are Aperture's 'Smart' folders, which are split off from the Projects by any Web galleries that you might have created (see p. 316). These are automatically populated when you import images into Projects elsewhere in the application, and then start to rate them, and you can add your own Smart folders to further automate your photo management. With the pre-defined Smart folders, you have an immediate access to the very best images across all categories by clicking on the automatically maintained five-star group in the Library. This will help when it comes to maintaining a portfolio of your best work.

The 'All Projects' Album at the very top of the Library section shows thumbnail views of every Project you have created in the application. Rolling your mouse across them from left to right or right to left flicks through all the images they contain, allowing you to quickly preview their contents, thereby helping you distinguish between similarly named Projects (Italy 2008 and Italy 2009, for example).

We'll explore these subdivisions in greater detail in the pages that follow.

Digital Masters and Versions

Every photo you import into Aperture is a Digital Master. Regardless of the format, it is considered sacred within the application and will never be touched by any of the editing tools at your disposal. Even cropped images still exist in their original format in the directory structure we described above; so that should you suffer a serious drive corruption after which Aperture can no longer open your Library itself, you can still go back and manually copy the images yourself. This assumes, of course, that

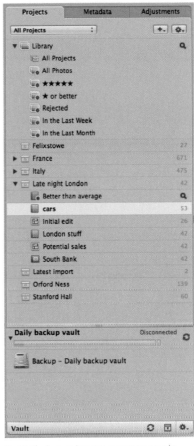

Fig. 2.3 The Projects Inspector organizes not only Projects, but also folders, Albums, Smart Albums and the products you make with your images, such as Web pages, Galleries, Journals and Books.

Fig. 2.4 Whenever you make an adjustment to a Digital Master, Aperture creates a new Version. This sports a numeric badge, which shows how many Versions of the picture exist in your Library.

the drive hasn't failed, in which case you may need to employ the services of expensive data recovery specialists.

When you use the Adjustments panel to edit an image for the first time, Aperture creates what it calls a Version. It will then show a small numeric icon in the corner of the original showing how many Versions (including the Master) it now holds in its Library. Digital Masters and their Versions are organized into Stacks, which can be expanded and contracted by clicking on an icon, called the Stack button. A detailed section on Stacks starts on p. 55 (Fig. 2.4).

The Browser – the strip running along the bottom of the screen – shows your imported images as either a series of thumbnails (in grid or film strip view) or a detailed list of files, similar to the Finder in Mac OS X. When shown as thumbnails, they are displayed as icons at the size you specify using the slider at the bottom of the Aperture interface, and each Stack is outlined using a thick gray border. In the list view, Versions are organized within a folder that takes the name of the original image. It doesn't look like a folder as it also sports the Digital Master's shooting metadata, but a disclosure triangle in the margin betrays its true purpose, and, in this respect, it works just like folders in the Finder.

If you have already made some edits to a photo and want to make another copy to be able to try an alternative set of adjustments, you have two options. ⎇ *V* will copy the currently selected Version and all of its adjustments to a new Version in the Stack, allowing you to pick up further adjustments from the point you have already reached without doing further edits to what could already be a perfectly tweaked Version. ⎇ *G*, meanwhile, creates a fresh copy of the original, untouched image, allowing you to start making adjustments from scratch giving you two distinct Versions that you can then go on to compare side by side. Whichever you choose, the resulting copy will be added to the current Stack.

Versions can be treated in exactly the same way as Masters; you can print, copy, duplicate and export them. They can be rated separately from the original, you can have as many subsequent editions as you like, and you can use any one of them, or indeed several editions of the same Master, in a single Book, Gallery, Light Table, Web page or Journal.

Projects Inspector

The Projects Inspector is where you will do most of your organization. It shows top-level folders, Projects and the products you're making with your images, such as Light Tables, Galleries and Books. It doesn't show individual images as these are organized through the Browser, which sits below or to one side of the Viewer.

The Projects Inspector is pre-filled with smart folders that organize your images by rating or date, to which you can add your own Projects, Albums, Smart Albums, Books, Light Tables, Web galleries, Web journals and Web pages.

Adding too many items to the Inspector can lead to an oversized and unwieldy list in which the contents scroll beyond the bottom of the screen. This is where the All Projects drop-down comes into play. Located immediately above the pre-determined Smart Albums, it lets you display all your Projects, Albums, and so on (the default), or strip down the listing to just your favorite entries, or those you would have used recently. This latter option is particularly handy if you have a single assignment on the go to which you'll be returning frequently without using any of your other resources.

The combined Projects, Metadata and Adjustments panel can be quickly hidden and revealed by clicking the Inspector button on the main toolbar or using the keyboard shortcut '**L**'. This is particularly useful when working on a small screen, such as a 13-inch MacBook. In this instance, the same collection of Inspector panels can be used through an HUD, called up by tapping '**H**' with an image selected (Fig. 2.5).

Browser

The Browser is the panel through which you organize your photos and files. It works in tandem with the Projects panel, and shows the images displayed inside each Project, Web Album, folder, and so on (Fig. 2.6).

It can display your images in two ways: either as thumbnails organized in a grid formation (**ctrl** **G**), or as a list of files (**ctrl** **L**) accompanied by supplementary metadata showing key attributes including aperture, shutter speed, creation data and focal length. You can sort any of these attributes by clicking the header above each column. Clicking a selected column header

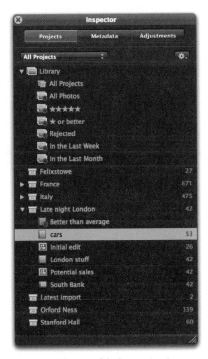

Fig. 2.5 Many elements of the Aperture interface are duplicated in the form of HUDs, including the Inspector, containing the Projects, Metadata and Adjustments panels.

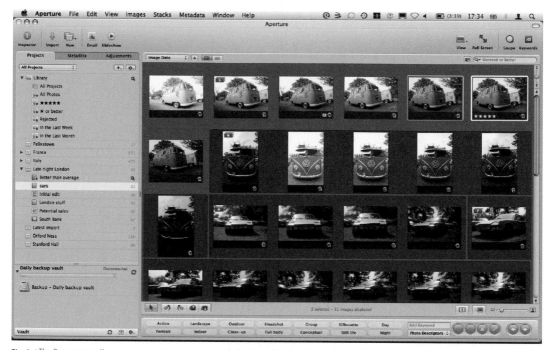

Fig. 2.6 The Browser usually appears as a strip running across the bottom of the interface, below the Viewer. However, it can also be maximized to occupy the majority of the screen for those occasions when organization and management are more important than adjustments and editing.

for a second time reverses the sorting order. So, clicking the ISO column once will sort your images in order of increasing sensitivity – say, from 100 ISO to 1600 ISO – while tapping it for a second time would sort it in order of decreasing sensitivity. Depending how you use this feature, it could let you quickly identify underexposed or grainy images, depending on which end of the scale is uppermost.

These sorting tools are replicated immediately above the Browser in a sorting criteria drop-down and a Sorting Order button (sporting a triangle icon). This is of less use in the list view than it is when your images are organized as a grid where you won't have access to the column headers.

Dragging the slider at the bottom of the screen adjusts the size of the thumbnails displayed in any Browser view allowing you to get the best of both worlds by selecting the list view and maximizing the thumbnails. The results won't be as large as they are in the grid view, but they are perfectly serviceable.

Fig. 2.7 The Toolbar runs across the top of the Aperture interface, just as it does in most applications, and is home to some of the application's most commonly used functions, including Project creation, and calling up the Loupe.

Toolbar

The Toolbar runs across the top of the Aperture interface, just as it does in Word, Excel, Finder windows in Mac OS X and in most mainstream applications. Its importance has been greatly reduced in Aperture 2; for while it was once used to open and close panels, rotate, crop and straighten images, fix red eye and apply selective patches to your work, it has benefited from a radical slimming down, and now focuses on core features (Fig. 2.7).

The first icon on the Toolbar – Inspector – hides and shows the combined Properties, Metadata and Adjustments panel on the left of the interface. The blue arrow to the right of this opens the Import tool to add photos to your Library. Technically, you could do the same by inserting a media card into an attached reader or connecting a camera (assuming you have Mac OS X set to treat Aperture as the default application for handling incoming photos), but by manually invoking the Import tool you could also add images from internal or external drives and network stores.

Controlling Image Imports

If you would rather not have Aperture pop up every time you insert a memory card, perhaps because you'd rather store your images in iPhoto or save them directly to a backed-up network drive, its auto appearance can be disabled in the operating system. It will then be up to you to manually invoke the Import command in whichever application you choose.

To disable Aperture's automatic appearance, or activate the same if iPhoto or another application appears each time you insert a card or connect a camera, open Aperture's Preferences (⌘ ,) and change the setting beside 'When camera is connected, open:' using the drop-down menu, selecting Aperture or 'No Application' as appropriate (Fig. 2.8).

Fig. 2.8 Control what happens when you plug in a camera or insert a card into a media reader by specifying whether Aperture, an alternative or no application at all should launch.

Fig. 2.9 The New menu is your first point of call when creating Projects to contain your images, or producing creative items, like Web pages or Books.

Import and New are grouped together using dotted dividers. There is good reason for this: they work hand in hand when adding photos to your Library. If you were to click Import when the top level of your Library was selected, Aperture would automatically generate a new Project – called Untitled Project – to hold them. This is efficient as it keeps everything tidy and saves you from having loose images floating around, yet at the same time it is also far from descriptive. You can still sort using metadata keywords attached to the files at the point of import, but it is useful to also have a list of appropriately named Projects and folders in view to which you can quickly jump (Fig. 2.9).

By using the New button menu, you can generate more appropriately named Projects before importing, saving you the headache of having to retrospectively rename them.

This same menu is also where you'd turn to create Albums, Smart Albums, Books, Light Tables, Web galleries, Web journals and Web pages. The relative importance of the Projects, Albums and Smart Albums is clear from the fact that they have keyboard equivalents (⌘ N, ⌘ L and Shift ⌘ L respectively), whereas the others do not. Why? Because they are used for organizing your images and so relate to everything you do. The others are creation actions, and so will apply only to a selection of images. As ever, it's worth getting familiar with these shortcuts as they are excellent timesavers.

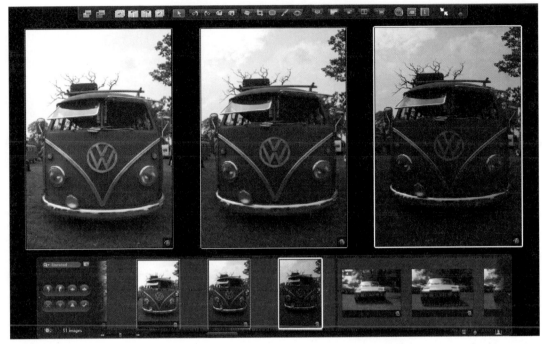

Fig. 2.10 Aperture's Full Screen mode lets you devote every available pixel to the task of editing your photos. The film strip at the bottom of the screen, and the Toolbar at the top can both be set to automatically slide off the screen as your mouse moves away from them.

Equally useful are the shortcuts that duplicate the Toolbar's View and Full Screen buttons. V cycles through the three options in the View menu switching between Browser only (your thumbnails or file list), Viewer only (the selected image) and a combination of the two. These views always appear within the Aperture interface with the menu, Inspectors and borders in place. To devote the whole of your screen to your images, tap '**F**' or click the Toolbar's Full Screen button. This fades away the Aperture interface and switches to a black background allowing you to focus all of your attention on the image in hand (Fig. 2.10).

The Loupe, the Toolbar's penultimate feature, is one of Aperture's most radical tools. It lets you examine an open image at up to 1600% magnification or, if you drag it over your thumbnails, view parts of them at higher zoom levels without fully opening them. More usefully, it will optionally display a crosshair at the center of its lens, detailing the individual color values of the center-most pixel (Figs 2.11 and 2.12).

Fig. 2.11 The Loupe lets you examine details in photos and thumbnails at up to 1600% magnification while maintaining an overall view on the rest of the screen.

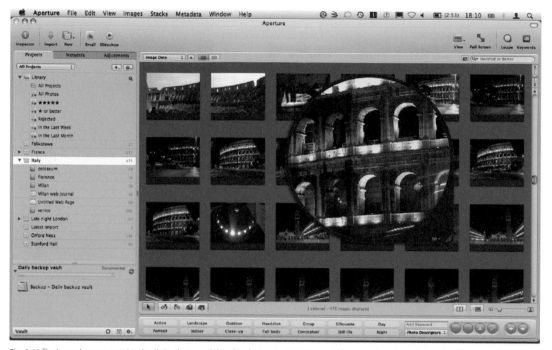

Fig. 2.12 The Loupe lets you examine details in photos and thumbnails at up to 1600% magnification while maintaining an overall view on the rest of the screen.

Dragging the Loupe around by its gray border is somewhat imprecise, so Apple has provided a second, more accurate way to position this tool. Click and hold in the center of its lens and you'll see that a thick white circle will shrink down to the mouse point. Drag this to its new position and let go to have the Loupe zoom the circle until it fills the tool's full frame.

The Loupe can sometimes be restrictive, showing less than you would want at any time. Tapping **Z** at any time therefore toggles the selected image between fitting in the viewer, and zooming to 100% magnification.

It's unlikely you'll fit the whole image on screen at this level, in which case you'll have to drag it around by moving the small red rectangle in the semi-opaque box that overlays the picture. This box indicates the visible portion within the whole image. If you prefer to mimic Photoshop's Drag tool, hold **Spacebar** while dragging on the image itself for more accurate positioning.

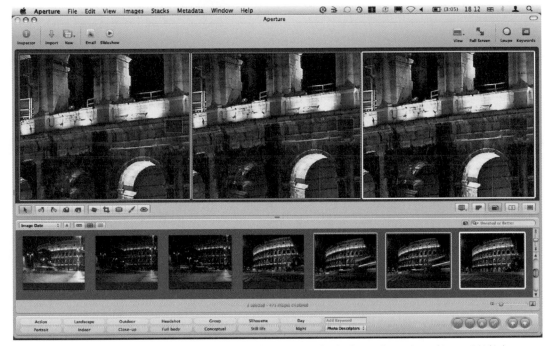

Fig. 2.13 Using the Zoom tool with several images opened side by side lets you compare fine details on each one when making your initial judgements.

The Zoom tool can be combined with other View modes. Tapping **Z** while in three-up view will, subject to your Mac being fitted with sufficient Ram to handle the images, show all three images at 100% zoom side by side, which is an excellent way to compare particular parts of different Versions of a Digital Master. Once zoomed, you can scroll the images simultaneously by holding **Shift** and the **Spacebar** and then dragging with the mouse (Fig. 2.13).

This leaves only the Keywords HUD – the right-most button on the toolbar. In its default state, this displays all the keywords in the system database that were added either when an image was imported, or when it was already in use. These keywords are persistent, and will remain in the database even if their associated images have since been removed. The Keywords HUD is the panel through which you can import and export keywords, organize them into logical folders, and apply them to thumbnails and images by dragging them from the palette onto the pictures themselves (Fig. 2.14).

Fig. 2.14 The Keywords HUD is the place to turn when you want to recycle tags you have already applied to one image and place them on another. From here you can also add new keywords and organize those already in your Library.

If you have been using Aperture since its first appearance, you may find the new slimmed-down Toolbar to be rather too svelte for your needs. Likewise, if there are a small handful of tasks that you perform on a regular basis that aren't represented in its default state then you may feel that the Toolbar is more form than function. In this case, you can customize it by right-clicking on any blank area of the Toolbar and choosing Customize Toolbar and then dragging optional elements onto the bar itself. To reset it after making changes, drag the default set back onto the bar and it will replace any additions you have made.

Control Bar and Keyword Controls

The Control Bar exists to help you organize your workspace more efficiently, and has just a few features that impact directly on your images. It's hidden by default, but revealed (and subsequently re-hidden) by tapping '*D*', which when combined with *Shift*, will also show and hide the Keywords tool allowing you to quickly add pre-defined keywords to your images to make searching more efficient. It sits at the bottom of the screen.

The Control Bar lets you manage your journey through the images in your current project and, like most of the other features in the application, can be bypassed once you've taken the time to learn some simple keyboard shortcuts.

It has been considerably slimmed down in Aperture 2; although the dedicated buttons for some of its former tasks may have disappeared, the keyboard shortcuts still languish within the application. Getting to know them can dramatically increase the speed at which you manage your Library.

Once you can work without reference to the Control Bar, your productivity will increase exponentially. It is fortunate that in all cases Apple has chosen logical keyboard shortcuts to represent each function performed by the different parts of the bar. If you are to learn the mouse-free operation of just one part of Aperture, make it this one.

Navigating Your Photos Using the Control Bar

The two simplest buttons on the Control Bar are the white forwards and backwards arrows. These move one step in either direction through the images in the currently selected Project, folder, Album or Smart Album, even if the Browser is hidden.

Combining these buttons with *Shift*, ⌥ and ⌘ lets you use them in a more intelligent way to view and compare several images at once. Here, switching from clicking the buttons to using the ⬅ and ➡ cursor keys on your keyboard pays dividends.

Shift ➡ and *Shift* ⬅ keeps the current image selected and adds the next or previous picture to the selection, displaying them side by side in the Viewer. Making further movements in either direction adds further images to the collection shown in the Viewer. Displaying several images side by side in this way lets you make adjustments to any one of them while comparing it with others in the collection, thereby easing the task of matching colors, brightness and simulated exposure across multiple related images.

The image in any selection of this sort to which Aperture will apply any adjustments you make has a thick white border. Letting go of the *Shift* key and using the arrow keys to move back and forth through the selection will move this border, and thus change the image to which the adjustments will be applied.

However, some features apply across all selected images at once. Notable among them are changes to the metadata and star ratings. Using '➖' and '➖' to increase and decrease ratings while you have multiple images selected at one time in this way will apply the changes to every image in the selection. The changes are relative to their existing rating; so if you have three images, out of which one is an unrated one while the other two are rated 2 and 5 respectively, then tapping '➖' once will give one star to the unrated image and the two-star image would have its rating increased to three, but the five star image would see its rating unchanged as it was already rated the highest.

The inverse is also true. Tapping '➖' instead of '➖' would have decreased every image's existing rating by one star, so that the unrated star is rejected. It would then appear in the Rejected Smart Album at the top of the Projects pane.

You could compare your images in a similar way, which we'll explore later.

Rating and Sorting Images with the Control Bar

The rating and sorting controls are among the Control Bar's most complex tools. This is because Apple has managed to cram

an enormous number of features into each one using a series of combined modifiers. Fortunately, the system is logical and regular throughout each one, so if you'd rather learn how to perform the same tasks on the keyboard, rather than using the mouse, you need learn only four shortcuts along with their five modifiers.

Rating images should be your first task after they are imported. It helps you quickly sort the good from the average, and the average from the bad, and then concentrate your efforts on only the best material from any session.

Ratings run on a scale of one to five, and are applied using the numbers **1** to **5** on the keyboard. They can also be applied comparatively using the green and red Up and Down buttons on the Control Bar, which respectively increases and decreases a picture's rating from its current setting. The same can be achieved on the keyboard using either '**=**' or '**+**' to increase the rating and '**−**' to reduce it, while combining these with the **ctrl** key will increase or decrease the rating of the image by one point and then move on to the next image in the Browser or selected range.

Images can be rejected outright using the Control Bar's red cross, and given a five-star rating using the green tick or, on the keyboard, using **/** on the numeric keypad (if you have one) and **** on the keyboard respectively. Once rated, they appear in the appropriate Smart folder at the top of the Projects pane.

Rating is often done in a linear fashion, where we move backwards and forwards through the photos from our latest shoot and rate them in turn. As such, each is rated before you have seen what comes next, and so you can often find that the next picture is better than the one you have just rated. Combining **Shift** rather than **ctrl** with '**−**', '**+**' or '**=**' will apply a rating change to your current image and simultaneously remove the rating applied to the previous one, while holding **Shift** **ctrl** and using the relevant rating increment command will perform three tasks at once. First, it will clear the previous image rating; second, it will increment the rating of the current image either up or down; and third, it will move on to the next.

This is an effective, but slightly messy way to work. You should always be rating images from a shoot on the basis of how they

compare to the other images taken at the same time, and this is best done when comparing them side by side.

By tapping **Return** when viewing an image, you'll set it as the comparison reference item. It will shift to one side of the Viewer and take on a green border. You can now click or move through other photos in your Library using the arrow keys or mouse and see each one lined up against the reference shot. Using the standard ratings keys outlined above, you can then mark each image against the reference shot, but at the same time increase or decrease the reference shot rating by holding down the modifier ⌥, so while '+' would increase the rating of the currently selected image (outlined in white), '⌥ +' would increase that of the reference shot against which you are comparing everything (outlined in green). '⌥ −' and '−' on its own would perform their respective functions in the same way.

When you have finished comparing your images, ⌘ **Return** takes you back out of Compare mode. The most recently selected image will take center stage, and can then be used as a reference point for future comparison by immediately hitting **Return** again.

So, the modifiers you need to remember are **Shift**, **ctrl**, ⌥ and ⌘. Combine them with '+' and '−' to step through your ratings, and the / and \ slashes, and you have a total of 20 rating functions at your fingertips.

	Solo	With **ctrl**	With ⌥	With **Shift**	With **ctrl** **Shift**
+	Increase rating	Increase rating, move to next	Increase comparison image rating	Increase image rating, clear previous image rating	Increase image rating, clear previous image rating, move to next image
−	Decrease rating	Decrease rating, move to next	Decrease comparison image rating	Decrease image rating, clear previous image rating	Decrease image rating, clear previous image rating, move to next image
/	Reject image	Reject image, move to next	Reject comparison image	Reject image, clear previous image rating	Reject image, clear previous image rating, move to next image
****	Approve image	Approve image, move to next	Approve comparison image	Approve image, clear previous image rating	Approve image, clear previous image rating, move to next image

Selecting and Displaying Images Using the Viewer Toolbar

The Viewer Toolbar sits just below the main area for displaying your images. It is split equally between editing tools and viewing tools. The former, which sit at the left-hand end of the bar, lets you straighten, rotate and crop your images, and perform some of the simpler traditional 'editing' techniques, which in many cases are duplicated in the Adjustments Inspector. The latter, which sits at the right-hand end, controls how your images are displayed (Fig. 2.15).

The first of these buttons, showing a screen icon, controls how images selected in the Browser will be shown in the Viewer, allowing you to switch between single- and multi-image configurations. You will spend most of your time with this setting at Multi, which will display any number of images when selected in the Browser (or a single image if you have selected only one). This is limited by the resolution of your screen. On a MacBook, for example, with the Inspector, Browser and Viewer activated, Aperture will show around 12 images within the Viewer before lopping off those it can't fit. If you select a 13th, both this and the 12th will disappear to make room for 11 thumbnails and a note saying 'and 2 more...'. Carry on with this and the number will simply increase.

There are five possible viewing modes in this menu: Multi, Primary, Three Up, Compare and Stack. The shortcuts for each are easy to remember, either because they are 🔀 plus the second letter of each one (**U**, **R**, **H**, **O** and **T**), or because taken together they seem to spell out You Are Hot in text speak.

Each of these display modes helps you to compare a number of images side by side, thus filtering down the results of your latest shoot to just the best of the best (Fig. 2.16).

Multi: View one or more images on the screen at any time. This is the most common mode in which you will work. Adjustments will be applied to images one at a time, even if you have more than one image on display, with the image to which the adjustments will be made indicated by a thicker white border.

Fig. 2.15 The Viewer Toolbar performs some basic edits to your images, but is best used to organize the way in which they are displayed in the Viewer.

Primary: Lets you select several images to make changes, but displays only the primary one of the selection in the Viewer.

Three Up: The viewer will always show three images in a row – the selected image in the center and, on either side, the images that come before and after it. If you have selected the first image in a Project, folder or Album then you will see only that and the one that follows. If you have selected the last then you will see only that and the one that preceded it.

Compare: Press **Return** to select a reference image against which you want to compare other images in your Library, or press **⌥** **O** to enter the Compare view. As you scroll through the images in the Browser they will be lined up, in turn, beside the reference image so that you can rate them against each other. When you find the one you judge to be better than the reference image, hit **Return** again to make it the new reference image and then continue moving through the Library to complete your comparison. You can compare several images against the reference frame by holding **⌘** while clicking them in the Browser.

Stack: Aperture will automatically open all the images in a Stack, side by side. The pick image – the one you have set to act as the representative for the Stack, and which will be used in photo books – will be used as a reference image against which you will compare the other images in the Stack. This lets you pick the very best image in any Stack and promote it over all of the others so that it is used in the products you create in Aperture.

If you have two monitors connected to your system, or you are running an iMac or a notebook Mac, all of which have an integrated screen and to which you can connect a second display, then you can take advantage of the extra space this will offer by using both simultaneously within Aperture.

Each display can be set up separately, and you can specify from the same menu what each one should show. The options outlined above will always remain true for the primary display, but the secondary viewer gives you the options for Mirror, Alternate, Span, Blank, or Desktop.

Mirror: As when you are giving a presentation using a notebook and a projector, this displays a similar – although not quite identical – view on the primary and secondary displays. The primary display shows the usual Aperture interface, including

Fig. 2.16 The Viewing Modes menu lets you switch between five different ways of displaying your images on screen. Each has a particular purpose, determined by the task you want to accomplish.

any selected images, while those same selected images are shown on the secondary display.

Alternate: This option displays the current image on the secondary viewer allowing you to maximize your editing space while devoting the whole of your primary display to the Aperture application interface.

Span: Displays multiple images on both monitors, splitting the number of open images as evenly as possible. This is particularly useful when you are using the Compare view, as you can display both your reference and comparison images as large as possible on separate screens. If you decide to do this, it is important to ensure that both screens are properly color-managed so that the output of each is properly comparable.

Blank: Pick this option if you want to reduce distractions by displaying an empty black screen on the secondary display.

Desktop: Although this name suggests that you will only be able to view your Mac's desktop on the secondary screen with this option selected, it is misleading. It actually confines Aperture to just one monitor even if you're running in Full Screen mode, and lets you use the other monitor for alternative applications.

To the right of the View menu, you'll see a negative strip – the Show Master button (shortcut **M**). This switches back and forth between the Version you're working on and the Digital Master from which it was created, effectively removing all of your adjustments to give you a quick view of the original to see whether your work is having the effect you want.

Beside this, the Zoom button, which shows your image at 100%, is replicated by the shortcut **Z**. To its right, there are Primary Only, which has no shortcut, and Quick Preview (shortcut **P**).

Primary Only restricts the number of images you'll work on when you have selected several of them at once. By dragging a selection around several images in a Browser, or **⌘** or **Shift** clicking more than one, you can move several images into the Viewer at one time. In this way you can batch-develop them simultaneously by applying adjustments across the whole selection rather than just one at a time. However, while this is perfect for initial editing, where you may need to correct a color cast or exposure problem across a whole session of photos, it is no good for making individual tweaks that would fix problems in just one.

To save you from deselecting all of your chosen images, making the change to the one in question and then re-selecting, toggling Primary Only means your edits will apply only to the image in your selection sporting a thicker white border. This is known – as the name might suggest –the primary image.

You can change the primary image in a selected group by clicking it with the mouse – in either the Browser or the Viewer – or by moving the border selection around using the cursor keys (Fig. 2.17).

Once your change has been made you can go back to editing the primary photo as part of a group by switching off the toggle again.

Quick Preview (shortcut **P**) temporarily ignores the original files that make up your Digital Masters and Versions; instead it reads only the compressed JPEG previews stored beside each one in the Library package. These are of a lower quality, but

Fig. 2.17 When comparing images, the reference photo is always indicated by a green border. This will be pinned open and compared against a sequence of images from the Browser, each of which is bordered in white.

Fig. 2.18 When working in Quick Preview mode, Aperture applies a yellow border to your image, in both the Viewer and the Browser, and details the mode on the Viewer toolbar, to warn you that it is emulating your output device on screen.

they also take up less space on disk, and so load more quickly. This lets you skip through a large collection of images quickly, while displaying each of them in the Viewer rather than just the Browser. You can not make adjustments in this mode, and so Aperture displays a Quick Preview line below the image in the Viewer, and highlights its selection in the Browser with a yellow background. You can, however, make changes to the metadata (Fig. 2.18).

That is the last of the buttons that control the way Aperture displays and selects your images. You'll soon realize that these features will be among the most often used in the application, and so it pays to learn their shortcuts early on, to save you excessive mousing time.

Full-Screen and Dual-Screen Mode

Aperture comes into its own when given room to breathe. While it's happy running on a MacBook or MacBook Pro for quick-and-dirty photo selections on the road, you'll work faster and more productively with two screens, or at the very least a large wide display you can devote entirely to the application.

Switching to Full Screen mode removes most of the toolbars and control panels, and maximizes your image on screen. The Browser becomes a thumbnail-based strip running along the bottom of the display, which can be set to automatically hide using 'ctrl /'. If set to hide, it will reappear when you move the mouse to the bottom of the screen, at which point the image will shrink to remain fully visible.

Likewise, by default, the Toolbar at the top of the screen remains visible at all times, but can be set to Auto Hide by moving the slider on the furthest right of the bar – the toggle for 'Always show toolbar'.

Adjustments and Metadata Inspectors

The Adjustments and Metadata Inspectors sit behind the Projects panel. They differ slightly from the Projects panel in that while that pane focuses purely on management, the Adjustments and Metadata Inspectors make virtual changes to the files themselves, writing these to the Aperture Library so that they remain associated with each Digital Master. Obviously, you can't see any changes you make to the metadata, unless you're looking at them in the Inspector itself, but any changes you make here are used by the application to control how they are filed. They also form the basis of filtering decisions made by Smart Folders.

The Adjustments Inspector

The Adjustments Inspector can be displayed either within the unified Aperture interface, or as an HUD. It is split into sections that can be expanded and collapsed using disclosure triangles so that you can focus only on the edits you need to make. You'll notice that whenever you make an adjustment the check box beside that part of the Adjustments Inspector's name – say, Exposure, Levels or Enhance, for example – will be ticked. By clearing the box you can quickly remove the adjustment and so reset your image. You can also undo the adjustment, but leave that part of the panel active, by clicking the backward-curling Undo arrow to the right of its name (Fig. 2.19).

If you find yourself applying the same change several times across multiple Projects, it makes sense to save it as a preset. This way you can come back to it every time you need to use it, and be sure that you are always applying the adjustment at the same

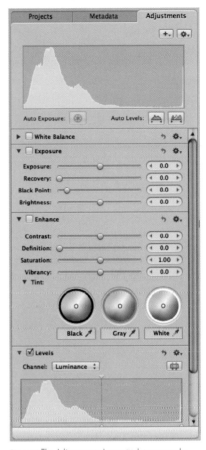

Fig. 2.19 The Adjustments Inspector lets you apply non-destructive edits to your photos. Each one is applied photo-wide, and can be removed by clearing the check box beside each section's name.

Fig. 2.20 If you find yourself applying the same adjustments to several images, you can save your settings as a preset to ensure that you make the same tweak every time you edit a photo taken under the same conditions.

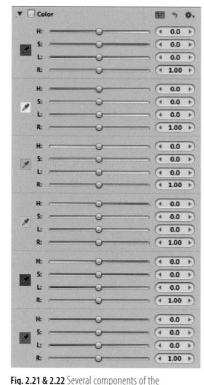

Fig. 2.21

Fig. 2.21 & 2.22 Several components of the Adjustments Inspector have standard and expanded views. A classic example is the color component, which caters for regular and advanced needs.

level. This would be particularly useful in a studio environment where you are unable to block out all of the available natural light. In a situation such as this, the color temperature will change over the course of the day – even with studio lighting in place – and you may want to create a series of presets to account for these changes throughout the course of the day. Each one would be given a plain English name, like morning light correction, afternoon light correction and evening light correction.

Presets are created by making your adjustment and then clicking on the cog on the right of the relevant section of the Adjustments Inspector and picking Save as Preset. You'll then be given an opportunity to name it, after which it will appear on the same menu under a Presets sub-heading (Fig. 2.20).

Some panes on the Adjustments Inspector have two levels of disclosure: fully closed, which is their default state, and an extended version that gives you access to a wider range of adjustments. The Color pane is a prime example. By default it gives you access to hue, saturation, luminance and range sliders with an eyedropper for sampling from the active image and buttons for the principal subtractive and additive colors (red, green, blue, cyan, magenta and yellow). However, clicking the Switch to Expanded View button to the left of the curled Undo arrow shows a far larger dialog giving you simultaneous access to the Hue, Saturation, Luminance and Range sliders for every principal tone side by side to save you from clicking back and forth between them (Figs 2.21 and 2.22).

The Adjustments panel is also where you'll crop, fix red eye and straighten your images. These panes, along with up to 19 others, are hidden by default, but can be added to the Adjustments panel through the menu on the '+' button just above the Levels pane. All of these panes are replicated in the HUD version of the Adjustments Inspector.

The Metadata Inspector

The Metadata Inspector displays everything Aperture knows about your images. This information is used to file and filter your assets, and also to assign rights and captions in the output. Some of it is generated automatically based on the attributes of the photo, other parts are written by your camera at the time of capture, and the remainder is input by yourself, either at the point of importing the pictures into your Library, or over time as you work with them.

As with other panels in Aperture, its views can be extensively customized allowing you to cycle through a large quantity of information in a relatively small area.

One of the most extensive Metadata views is that afforded by selecting 'All IPTC' (International Press Telecommunications Council) from the pop-up menu at the top of the pane. IPTC oversees standards for transferring information between photographers and publishers. However, this is overkill in most situations, and so it pays to selectively choose subsets of this information by cycling through other options in the pop-up.

The options available here – called views – can be streamlined by deleting those you don't use through Manage Views on the Shortcut menu. You can add your own views using the same menu.

Adding and Editing Views in the Metadata Panel

Each view needs a name which will appear in the pop-up menu that lets you switch between views shipped with the application. Your own views will appear at the bottom of the menu by default, but you can rearrange them through the Manage option on the Shortcut menu.

Once you have named your view, you can start adding attributes to be displayed whenever that view is selected by checking the boxes beside the various tag names at the bottom of the Metadata Inspector. These are split into various common sections defined by the keywords, Exif, IPTC, Other and Archive tags at the bottom of the dialog. Some, such as camera make, model, the year the picture was taken, and so on, will be pre-populated as shown in the Value column, so you can immediately see what changes will be made to the Metadata view of each image by checking those tags' boxes. This is a live view of the data in your system, which will change as you select another image (Fig. 2.23).

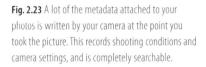

Fig. 2.23 A lot of the metadata attached to your photos is written by your camera at the point you took the picture. This records shooting conditions and camera settings, and is completely searchable.

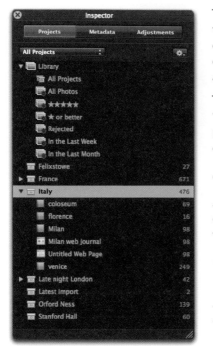

Fig. 2.24 The Projects Inspector is home to far more than just Projects, as it is also the place where you create and organize folders, Smart folders, Albums, Books, Light Tables, Web galleries, pages and Journals.

To remove a tag from the view, simply click the negative button to the right of its variable box in the view's main area. To finish editing the view, drag the divider between the view and the tags down to the bottom of the screen or use the shortcut '*ctrl* *I*', at which point the negative bars will disappear.

The same principle applies to editing existing views. Either tap '*ctrl* *I*' and pick the Edit option from the Shortcut menu or press one of the Tag Category buttons at the foot of the dialog to open the lists of available tags.

Organising Images

Aperture uses folders, Albums, Smart Albums and Projects for organizing your images, and it's not immediately clear how each works; the differences are subtle (Fig. 2.24).

Folders

Folders work in exactly the same way as they do in the Finder, and look like the Mac OS X equivalent. They are blue tabbed containers for the other files and collections in your Aperture Library. However, they can only contain Albums, Smart Albums, other folders and Projects; not images themselves. As such, think of them as handy dividers, or bookmarks that let you skip to a particular collection.

Their use is solely to keep related work together, and to allow you to collapse long lists of elements so that they take up less space in the Project panel. They are your only navigational tool – as opposed to search and indexing tool – so maximise their potential by using sub-folders inside main folders. For example, a Europe folder may contain Projects for Hungary, Spain and France; sub-folders for Paris, Lyon and Marseilles inside France; and further sub-folders for architecture, churches and people inside the Paris folder. You can now expand and contract each one, thus navigating through your folder structure without having the Project pane so long that it scrolls off the bottom of the screen.

Clicking on a folder will always show the contents of every element it contains, so if you couldn't remember whether you'd put Notre Dame cathedral in the Parisian architecture or churches folder, clicking on Paris would show you the contents of both, along with those pictures filed inside 'people'. Clicking France would show you all pictures filed under Paris, Lyon, or

Marseilles, regardless of how far down they were buried within any further sub-folders, while clicking on Europe would show all pictures from the three named countries, the cities within them and the folders, Albums, Smart Albums and Projects within.

Folders may look like dumb containers but – used wisely – are actually powerful filtering tools.

Projects

Projects are the first layer inside your folder, and they contain all of your images and the work you are doing on them. Such work could include Web galleries, Contact Sheets, Light Tables, or Books. The closest equivalent elsewhere on the Mac would be a directory in the Finder, which can lead to some confusion with folders in Aperture which, as we have seen, work in a very different way. Folders in Aperture are repositories for the products in which you use your photos, never your photos themselves.

Masters and Versions

Your Projects will contain two types of image, and neither is defined by the format in which it is shot. Known as *Digital Masters* and *Versions*, the latter is a copy of your original – the Digital Master – to which you have made some edits.

Regardless of the changes you make to the images in your Projects, Aperture will always preserve your originals. This allows you to experiment and refine your results to an infinite degree, safe in the knowledge that should you take things one step too far you can roll back to the original picture.

Digital Masters are effectively the negatives from which all successive images are developed. These derivative images are called Versions.

Stacks

You can have an unlimited number of Versions of any Digital Master, and by default they will be organized into Stacks. This is Aperture's way of keeping things tidy by piling up images so your workspace doesn't get too cluttered. In the Grid view they will be displayed side by side, but by switching to the List view you'll see that an icon of the original is shown, alongside which there is a

Fig. 2.25 Versions are organized into Stacks, helping you to relate derivative images to their originals. In the List view each Stack looks like a folder, accompanied by a disclosure triangle.

disclosure triangle. Clicking this shows the Digital Master and any Versions inside, with each Version given a number (Fig. 2.25).

Each Master or Version can be exported individually, and selecting more than one at a time lets you compare them side by side in the Viewer.

Images can also be stacked automatically on the basis of how quickly they were taken in succession. Anyone with a dSLR will know how easy it is to take several pictures in quick succession with a single press of the shutter. The chances are these are very similar editions of the same scene – perhaps dogs chasing a ball, athletes jumping hurdles or kids blowing out birthday candles – and the chances are you'll only want the one image out of ten that captures the moment you were after.

By organizing them into Stacks, Aperture lets you keep the whole sequence in one place, without having them fanned out across your workspace, thus saving screen space.

Workspace Layouts

Aperture is a great saver of screen space. However, it really flourishes when given room to breathe, and the ideal Aperture set-up is a dual-screen environment, where you can keep the main organizational guts of the application – the File Manager, Project Pane, Adjustment and Metadata panels – on a secondary screen off to one side, and have the image on which you are working maximized on the primary display directly in front of you.

Standard Workspace Layout

There are three primary interface layouts: Browser Only, Viewer Only and Browser & Viewer. Browser & Viewer is the default one and you can cycle through all three modes by tapping '**V**', or selecting them from the drop-down view menu on the Toolbar (Fig. 2.26).

Browser Only and Viewer Only Modes

Browser Only uses all of the space to the right of the Projects pane to browse images in any selected folders, Albums or Projects. It's primarily used for getting an overview of the images in use, and not for editing, because the images will usually be rendered too small for you to see what you're doing without using the Loupe or increasing the magnification, which negates the benefit of being able to see more files in one place.

Once you have identified the image with which you want to work, you should maximize the viewer to give your chosen image prominence as you make your adjustments.

Swapping and Rotating Workspaces

Workspaces can be turned through 90 degrees with '**Shift** **W**', and flipped with '**⌥** **W**'. Rotating them puts the Browser and Viewer windows side by side rather than above and below, while swapping them does exactly what the name suggests. The Project pane never moves in either of these operations, but a rotated layout of three columns rather than one column (the Projects pane) and two horizontal windows for the Viewer and Browser is better suited to single-screen use, as it allows portrait-oriented images more room to breathe (Figs 2.27 and 2.28).

Ratings and Keywords

The key to good management is an effective index. Attaching keywords to your images means you can easily search across all albums, Projects, books, Light Tables and Web galleries, and pull out every matching image. In extensive Libraries this can be a real timesaver, and when combined with ratings you can further refine your results to show only the best in each class.

Ratings can be applied or changed quickly by selecting an image in the Browser's grid or list and using the number keys **1** to **5**. Pressing **0** will remove any existing rating and **⌘** **9** will

Fig. 2.26 Aperture offers three view modes to suit your specific organizational and editing needs.

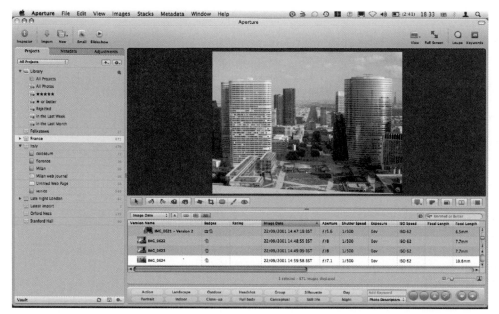

Fig. 2.27 The Aperture interface can be rotated and flipped to suit the most appropriate way of working, depending on the orientation of each selected image.

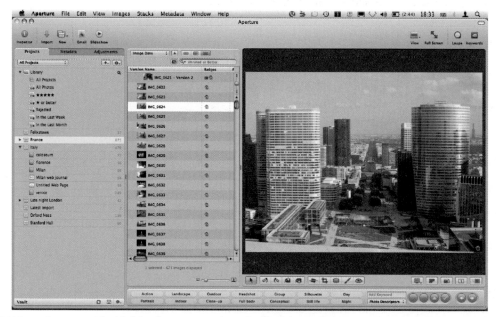

Fig. 2.28 Here we have swapped the default interface arrangement for a series of vertical panes that better suits the image on which we are working.

Fig. 2.29 Keywords can be applied by using keyboard shortcuts, but are also available through the Keywords toolbar at the foot of the Aperture interface.

reject an image. Ratings can also be applied in an abstract, rather than absolute, manner by increments. Tapping '⊞' increases an image's current rating (unless it already stands at 5), while ⌘ ⊟ takes it down by one point.

Keywords, too, can be applied using hotkeys on the keyboard. The Keyword Viewer (*Shift* *D*) sits at the bottom of the Aperture interface and is split into seven logical sections: people, photo descriptors, stock categories, snapshots, wedding (details), wedding (prep) and weddings. Each contains a set of buttons that apply associated keywords to the selected image. So people contains man, woman, couple, boy, for example, while wedding (prep) includes hair, flowers, makeup and decorations (Fig. 2.29).

You can add your own sections and buttons by selecting Edit buttons from the menu in the bottom right hand corner. This opens a panel with three panes: one for your button sets, one for their component buttons and one showing the keywords you have already applied to your images while importing them.

Start a new set by clicking the '+' below the first pane and give it a name. Here we're calling ours Europe. Next, drag corresponding entries from the Keywords Library, far right, into the Contents pane in the center. This adds each one to the new section you have just created. If you haven't imported any images yet, using one of the keywords you want, add a new one to the Library using the Add Keyword and Add Subordinate Keyword buttons. The former creates a top-level keyword, such as birthday, into which you'd add entries such as cake, candles, presents and games using the latter.

Once you have added as many keywords as you need to the Contents pane, OK out of the dialog and you'll find them present in the Keywords bar at the bottom of the screen. The first eight or fewer will have been assigned keyboard shortcuts, allowing you to tap ⌥ *1* to ⌥ *8* to apply them, and *Shift* ⌥ *1* to *Shift* ⌥ *8* to subsequently remove them. If you have more than nine, the remaining entries will lack a key combination, and must be applied by clicking their buttons on the Keywords Toolbar.

Adjustments and Filters

The adjustments panel is where you'll do the most of your work. It consists of collapsible panels that can be checked on and off to quickly roll back changes.

Apart from odd exceptions like red-eye removal, spot and patch, and retouch, Aperture works on a whole-picture basis. It relies on you to have shot a well-balanced image in the first place without excessively burnt-out or deeply shadowed areas that you'll need to recover later.

The Adjustments panel is split into sections, each of which is mirrored on the Adjustments HUD. Each one deals with a different kind of adjustment, and they can be shown and hidden by clicking the '+' button at the top of the Inspector and checking the ones you want. Beside this is the Preferences button (it looks like a cog), which changes the information displayed in the panel. This allows you to show and hide the value of the color over which your mouse is positioned, and hide or show the Histogram and auto-adjust options (Fig. 2.30).

From here you can also select your color value options (RGB, Lab, CMYK, HSB or HSL), the number of pixels it will take into account when assessing a value (blocks of 1×1, 3×3, 5×5 or 7×7), and what the Histogram should show (luminance by default, but optionally RGB, or just the individual red, green and blue channels).

Whenever you make a change in one of these sections, it is activated with a small tick appearing beside the section name. Unchecking this box removes the adjustment. In this way, it is best to think of edits made in Aperture like adjustment layers in Photoshop, although here their range is far wider, even covering such potentially destructive edits as crops and rotations.

Overlays

The various items of data associated with your images are, for the most part, hidden when the Adjustments and Filters or Metadata panels are closed. What is left is restricted to Star ratings and Version counts in the Browser, and just a rating in the Viewer, all of which overlays the images or thumbnails to which they refer.

There are times when you will want more detailed data, in which case you'll expand them with **Shift** **Y** and **Shift** **U** for the

Fig. 2.30 Features missing from the Adjustments inspector? Not a problem – tailor its look and feel to your specific needs.

Retouch	
Red Eye Correction	
Spot & Patch	
Devignette	
Straighten	
Crop	
Flip	
White Balance	
Exposure	
Enhance	
Levels	
Highlights & Shadows	^H
Color	^C
Monochrome Mixer	^M
Color Monochrome	
Sepia Tone	
Noise Reduction	^N
Sharpen	
Edge Sharpen	^S
Vignette	^V

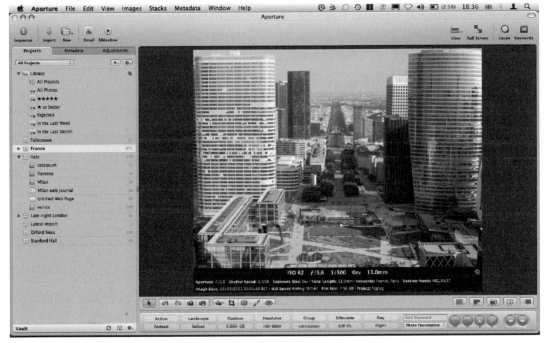

Fig. 2.31 Use shortcuts to temporarily expose more of the Metadata attached to your images within the Viewer itself.

data in the Viewer and Browser respectively. While expanding the Browser data means you lose the filename and can thus concentrate fully on your thumbnails, in the Viewer you end up with a broad survey of the shooting conditions for each image. This spans aperture, shutter speed and exposure compensation; actual- and 35 mm equivalent focal length, applied keywords, Version name, image date and rating. Combined, they allow you to close a lot of the HUDs on which this information is found.

That is where we're heading next (Fig. 2.31).

Head up Displays

As we have already explained, Aperture really gives your photos the opportunity to breathe. On a suitably equipped Mac, it is perfectly happy working across two monitors, devoting one to the organizational workspace, and the other to a Full-Screen view of your photos so that you can edit them with the best possible view.

However, even on a single-screen Mac, or a portable such as a MacBook, you can do much to maximize your working space while keeping every tool handy, thanks to its extensive use of Head up displays – or, in Apple parlance, HUDs.

These are floating, semi-opaque Versions of the key panels, allowing you to bring them into and out of view when required, and still see your work through them. They take their name from the displays projected onto cockpit windshields in fighter aircraft.

They are common across many Apple applications, and even break out of the professional application line-up; HUDs are also found in Pages, its consumer word processor, and iPhoto.

Some panels always work as HUDs, regardless of your view mode, while others appear in this form only when you're working in Full Screen. The keywords HUD (*Shift* **H**), for example, only ever appears as a floating panel, whatever your screen mode, because it duplicates features already found on the interface proper. By appearing in the applications in two incarnations, it is more accessible and can be shown even when the main keywords interface is closed or inaccessible. It presents a list of keywords already applied to images in your Library so that you can then apply them with a single click to whichever photo is selected at the moment. The first time you use it, you'll find that it already includes a range of pre-defined keywords relating to weddings, stock photography, and so on. You can add to these in exactly the same way as described on p. 139 using the Add Keyword and Add Subordinate Keyword buttons at the bottom of the HUD, and likewise delete existing entries using the Remove Keyword button to the right. This is explained in more detail in Chapter 4 (Fig. 2.32).

The Filter panel is also always shown as a HUD. It is invoked by clicking the button beside the search box at the top of the Browser panel, and appears as a pop-up that can be torn off and floated out on its own. This allows you to create Smart Albums, and gives you a live preview of the results as you define each query's search criteria.

The Inspector, containing the Projects, Metadata and Adjustments panels (shortcut **H**) exactly mirrors the panel shown in the regular interface.

Fig. 2.32 The Keywords HUD organizes keywords already applied to your images, and lets you remove or add new ones. Keywords can also be organized into sub-groups for better organization on the Keywords Toolbar.

Query HUD

With so much metadata at its disposal, Aperture makes short work of keeping your photos in order. It relies heavily on the data you input to do this as you feed it keywords, correct time zones on import, apply copyright information and assign bylines to your work. Then, once it sits inside Aperture, you organize it into Projects and folders, make adjustments, and build them into products for output. All of this is passive, but every action tells Aperture a little more about your assets, and adds to the extensive database of metadata it uses to keep things in order. By combining them with the data supplied by your camera about its settings and the shooting conditions it encountered, you'll soon have access to a comprehensive profile of every image on your system.

The Filter HUD gives you access to all of this data when performing complex searches of your Library. It uses your currently selected Project or folder as its starting point, so pick your initial location before showing it and then click the Filter button, on the right-hand side of the Browser toolbar, beside the Search box. To make system-wide search of all your images, select All Photos in the Projects Inspector as your starting point (Fig. 2.33).

The palette that pops up is notionally attached to the Toolbar, but can be torn off and repositioned anywhere on screen. It is a table of variable fields for rating, dates (calendar), keywords and import sessions, and lets you specify whether results should match some or all of your search criteria to qualify for inclusion

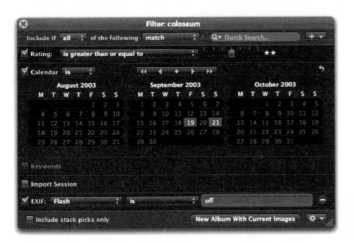

Fig. 2.33 The Query HUD lets you quickly sort your images thanks to its understanding of the metadata that already exists in your Library.

in the Smart folder it will create. None of these criteria can be removed, but they can be left undefined, and thus ignored, and you can add a further nine search criteria using the '+' pop-up at the top of the Filter interface, which includes a handy Other Metadata option giving you access with less common variables, such as aspect ratio, pixel size, and master pixel size. Used in combination, these various attributes should be enough to let you strip down your Library to a single image if you so desire.

To use any search variable in the Filter HUD, fill the check box beside its name and then use the pop-up menus and data grids that appear, to specify your requirements. Most of these dialogs are pre-populated with data from your Library allowing you to simply click further check boxes to narrow down the range of images it captures, as for several term variables you would be unlikely to remember the valid terms yourself. While you might remember some of the keywords you have used, for example, it is highly unlikely you would remember all of the import sessions you used to add assets to your Library.

Each section of the Filter HUD uses plain-English commands, so the calendar section gives you the option of trimming down to exact dates, regardless of what was taken on that day (if anything) or instead choosing that the date should not be one on which you took no photos, and also not be the dates selected in the calendar below.

You can select ranges by holding **Shift** when clicking the opposite extremes of a selection, and several disparate variables by using **⌘**. If you later want to deselect them, click again, and to deactivate a complete section, untick the selection's check box.

Aperture will maintain a live preview of the results of your Filter queries in the Browser window. Once these show what you were aiming for, it's time to either save or use the results using the buttons at the bottom of the HUD. The 'New Album with Current Images' button does just what its name suggests, but the Shortcut button beside it gives you access to Aperture's Light Table, book, and Web publishing features using the results as the source material.

Inspector HUD

The Inspector HUD works in exactly the same way as the Inspector pane in the main interface. It is hidden and revealed

using the keyboard shortcut **H**, or through the View menu, and is functionally identical to the regular Adjustments, Metadata and Projects Inspectors in the main interface.

Opening and closing sections in this HUD performs the same action – simultaneously – in the regular equivalent found in the main Aperture interface, as you can see if you keep both open at the same time. Collapsing and expanding panels, and moving sliders in the Adjustments pane will be mirrored, regardless of the Version of the Inspector in which you're working, and the same is true of the Projects pane. The only panel on which it doesn't work is Metadata, allowing you to show, say, General metadata in the Inspector, and Full ITPC in the HUD.

The real point of having a HUD that mirrors one built into the main interface, though, is that you can either close the primary interface, or switch it to something else, allowing you to display both the Metadata and Adjustments panels at once, for example, in the main Aperture interface and the HUD.

The only real difference between the two is the fact that you can't import images into the HUD based Library. Clicking the Toolbar's Import button when the Inspector is closed, or switched to the Adjustments or Metadata views, will return you to the main Projects pane and import the images there, even if it is already open in the HUD.

Lift and Stamp HUD

The Lift and Stamp HUD is like a sophisticated clipboard, along the same lines as that used in Word, Numbers or Photoshop. However, rather than holding plain text or parts of an image you're working on, it is used to transport data between different images to save you from applying them manually yourself. That data includes all metadata and adjustments applied to your image from the point it was imported into Aperture, including the keywords. Rotations are not lifted, for a very obvious reason: while most cameras will now record whether a photo was taken in portrait or landscape orientation and write this data to the image file, it's not a universal capability. As such, you may need to rotate some images in your Library but not others. If this rotation data was recorded when you lifted adjustments data from your images, and the data were then stamped onto a range of other images, you may find yourself having to spin some of them back.

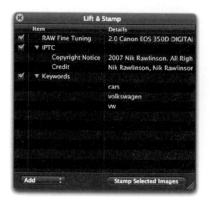

Fig. 2.34 The Lift and Stamp HUD acts as a sophisticated clipboard, used to transport metadata and adjustments from one image to another. Each field copied to it can be individually disabled, or deleted altogether.

The HUD is opened either by using the lift and stamp tools on the top of the Browser, or through its entry on the Window menu. We'd recommend leaving it closed until you start using the tools as it's otherwise redundant (Fig. 2.34).

To transfer data from one image to another using Lift and Stamp, either select your source image and press ⌘ *Shift* *C* or press the Lift button on the Viewer's Toolbar. It's fourth from the left and sports the icon of a luggage tag with an upwards-pointing arrow coming out of it. Alternatively, press *O* to select the Lift tool, rather than to directly lift the data. This will change the cursor to an upwards-pointing arrow; clicking with this on any image will copy the metadata and applied adjustments and drop them onto the Lift and Stamp HUD.

Each class of data is separated out, so that keywords sit apart from adjustments, and IPTC data are hived off in a section of their own. Each data set is stored in a collapsible section that is expanded using a disclosure triangle to show what it contains.

If you were then to apply these data to another image, they would be pasted in their entirety, which saves you a lot of time in performing the same edits or filing tasks on multiple photos one by one. However, there are many occasions when you will not want to drop the data wholesale. In these instances, you can temporarily disable them by unchecking the tick box beside each one. This will disable all of the data in that section, so if you have captured three adjustments in lifting the metadata from an image, unchecking the adjustments box means none of them will be applied to any other images when the data is stamped. You can be more selective about the range of data that is or is not stamped by instead expanding each data section using the disclosure triangles, and then clicking on each individual entry within, and pressing the ⟵ key to remove them. Note that none of these disabling and deletion measures has any effect on the original image from which the metadata were lifted. To remove the attributes from there you'll have to resort to the Adjustments and Metadata Inspectors.

Once you have filtered the lifted data down to just the attributes that you want to apply to other images in the Library, you will take one of two courses of action. If you lifted the data by pressing *O* to select the Lift tool and used the upwards-pointing arrow, you would notice that as soon as you copied the data the

arrow would flip to point downwards. Using this to click on any other image in your Library – even in a different Project – will apply the checked and active metadata displayed in the Lift and Stamp HUD (Fig. 2.35).

If you collected the metadata by clicking the Lift button or the **⌘** **Shift** **C** shortcut, select the image to which you'd like to apply the edited metadata and click the Stamp button (next to Lift), press the shortcut **Shift** **⌘** **V** to stamp immediately, or use **Shift** **O** to invoke the Stamp tool without stamping so that you can go on to stamp elsewhere. Once the tool is selected in this latter manner, it remains active, allowing you to apply the data to several disparate images in your Library. If all of the images to which you want to apply the data sit beside each other, you can select them by click-dragging across them or **Shift** clicking a selection range and then using the Stamp Selected Images button on the HUD.

The captured metadata will remain active in the HUD even when it has been closed, allowing you to go on and apply them to further images without your screen being cluttered up by a redundant panel you no longer need, but will reopen every time you use any of the shortcuts or buttons to capture new data.

Before closing it, then, take note of the pop-up menu in the lower left corner of the HUD that switches between Add and Replace. When set to Replace, any new data captured using the Lift tool will overwrite what already exist in the HUD. Set to Add, the new data will be appended to what you have already gathered.

Lift and Stamp is a deceptively powerful tool, which will greatly speed and simplify your workflow, whether in processing adjustments as a batch to meet particular requirements, or in updating an existing filing system to meet changing requirements.

Metadata Overlays

Technically, it's not an HUD, as you can't interact with it, but the metadata overlay for your images is well worth investigating – particularly if you often work in grid or film strip mode and so don't have access to all of the data shown in the Browser's list view. Toggle it on and off by tapping **T** and, when active, move your mouse over the thumbnails to see key metadata shown on a semi-transparent overlay. It also works with images shown in

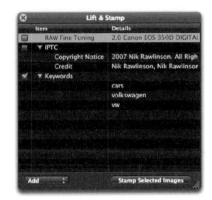

Fig. 2.35 Here, we have deselected the Raw fine tuning and IPTC sections of the lifted data so that they will not be applied to other images once they are stamped.

the Viewer, so is an easy way of differentiating between two very similar images when displayed side by side.

Using Aperture for the First Time

Aperture is built from the ground up for photographers, not computer technicians. As such, Apple has gone a long way to make it easy to understand and non-threatening. Even first-time users should be up and running in minutes, and will be pleasantly surprised by the amount of hand-holding on offer, making Aperture's workflow a more intuitive, productive one than that offered by Photoshop.

The Aperture Welcome screen offers five options for first-time users, the three most important of which go straight to importing photos into your newly created Library from either your camera or another location on your Mac's hard drive (Fig. 2.36).

Mac OS X's Unified Media Browser lets you use any photo managed by an Apple application – iPhoto or Aperture – in any compatible application, so you can view your Libraries in office tools like Keynote and Pages, or use them as desktop backgrounds or screen savers. By providing third-party developers with hooks into this system, Apple also allows these Libraries to appear in applications developed externally, such as RapidWeaver, so it's no surprise that Aperture and iPhoto can also happily exchange assets between themselves. As described elsewhere (see p. 286), this lets you use your photos to create

Fig. 2.36 The Aperture splash screen gives you an easy way in to the application's most common starting points. When you get more familiar with the program, however, it will probably be disabled.

products that are not available to each application, using iPhoto assets in Aperture to produce the more advanced Web pages not available in iPhoto, and Aperture assets in iPhoto to produce a calendar.

However, there remain good reasons not to import your iPhoto Library into Aperture including, not least, the fact that by maintaining a separate iPhoto Library you can use this for more personal projects, and save cluttering up your Aperture Library with family photos.

The remaining choices are a series of tutorials, leaping straight into Aperture, or importing photos from a memory card, which we'll come to in a moment. In the meantime, though, you should decide whether you want this splash screen to appear every time you start Aperture, and uncheck the box in the lower left corner if not, and also be prepared to decide whether Aperture should fire up every time you insert a memory card or attach your camera to your system. All of these options are reversible, so your choice here is not necessarily definitive. To bring back the splash screen at a later data, open Aperture Preferences (⌘ ,) and pick Reset All Warnings from the General Tab. To change what should happen whenever you insert a card or attach your camera, pick an option from the pop-up beside 'When a camera is connected, open' on the same tab.

We have covered importing your photos extensively elsewhere (p. 77), and hence will not repeat that here, but you should bear in mind that as you are starting from scratch with a brand new Aperture Library, you are in an enviable position. Here you can lay the foundations for a well-thought out filing system designed from day one to make your assets as easy to find and use as is possible. As such, you should pay particular attention to the metadata fields at the foot of the right-hand column in the Import dialog, accurately adjust the time offset if you were shooting in a different time zone but hadn't reset your camera's clock, and choose an appropriate folder structure. By default, Aperture will import your images into a new, untitled Project that you can rename later, but if you'd rather pre-empt this, then create a new Project immediately using the Toolbar's 'New' drop-down, and the focus of the import dialog will shift, as indicated by the output arrow, which will skip down to the new Project.

Bear in mind at this point that there is no obligation to import all of the images in a folder, camera or memory card; use Mac OS X's usual selection tools – *Shift* clicking to select a range or ⌘ clicking to select non-contiguous images – to specify the ones that should be imported.

Aperture will go about importing your images. The speed at which it can do this depends on the speed of your system, the speed of your interface (USB 1 or USB 2 makes a big difference) and the number of other applications you have running at the same time. Aperture isn't just copying your images from the memory media to your hard drive: assuming your camera isn't shooting simultaneous JPEG and Raw files, and you have not set it to use these as preview sources, it is also building a series of JPEG previews in the background, which will let you view your work more quickly.

If you want to track its progress you can do so through the Activity Monitor (Window > Show Activity), which displays the progress of every function the software conducts.

Customizing Aperture

Now that you have imported your first batch of photos, it's time to start thinking about how Aperture works, and whether this is right for you. The application is designed to be used by both the mouse and keyboard simultaneously, and you will benefit greatly if you take the time to learn at least those shortcuts that you'll use most often. However, these can be confusing if they are different to those used by any of your other most commonly used applications.

In this instance, you may want to tailor which keys are used and what they do. This is done through the Aperture > Commands > Customize… menu option, which opens an on-screen representation of the keyboard, with the various functions highlighted. Click through the various keys on the keyboard to see what they do in the Key Detail pane below right, and use the Command List pane below left to drill down on the key combination subsets and the modifier keys at the top of the interface to see how each function changes when combined with ⌘, *Shift*, ⌥, and *ctrl* (Fig. 2.37).

Aperture is rightly protective of the default set of key combinations, which are the ones used throughout this book.

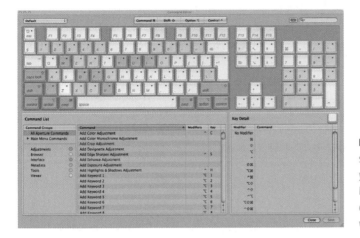

Fig. 2.37 Use the keyboard customization features to specify combinations that more closely match the way you are used to working in other applications on your Mac. Aperture will be careful not to let you overwrite core combinations used by the operating system, and warn you if you are going to overwrite any of its own.

As such, it won't let you define your own without first creating a complete copy of the originals. Use the pop-up menu at the top of the Command Editor dialog to duplicate the existing set, giving it a name of your own, and then set about defining your own key combinations (Fig. 2.38).

Do this by picking the option to which you want to assign a shortcut from the Command List on the left of the dialog and then press the key combination you want to use. Start with the shortcut keys ⌘, *Shift*, ⌥, *ctrl* and watch the on-screen keyboard as you press them, as a spot that appears on some of them will show that the key is already in use for another shortcut. If you ignore this, you'll see a warning, either forbidding you from using it if it's assigned to a system command, such as ⌘ W for closing windows and ⌘ , for opening Preferences, or overwriting it if it's only used by Aperture, such as ⌥ E for sending an image by email.

Exporting Shortcut Presets

Once you have set up your preferred shortcuts, you can export the settings for use on other Aperture installations. This is useful if you have installed the application on more than one Mac – perhaps because you have both a notebook installed for use in the field and a desktop edition for editing in the studio, you use it in two applications, or you want to roll out a standardized, tweaked edition of the application across several Macs in a creative environment.

Fig. 2.38 Before you can specify your own keyboard shortcuts, you must make a duplicate set of the default combination, to save you from destroying what is already in place.

Click the pop-up menu and pick Export from the options. Give your presets a name and pick a location, and Aperture will save a binary presets file with the extension .apcommands. To import this on a different Mac, pick Aperture > Commands > Import.

You can then switch between your installed customization and the defaults by choosing from your local menu in the Aperture > Commands > Default flyout, or your imported settings from the bottom of the menu.

Managing Color

Photos, in whatever medium, are merely representations of light and color in a scene. To get the most out of Aperture, therefore, it is critical that you set it up to best reproduce these tones on screen, and when outputting your work.

Mac OS X manages color using ColorSync, an operating system level function that translates the colors captured and displayed by components of your set-up – including cameras, monitors, and printers – so that they can be universally understood. This is important because not all devices can display the same range of colors, and so a certain amount of interpretation has to take part to simulate some tones on those devices with a narrower color gamut. Further, what one printer thinks is pure red may vary widely from another, and still more dramatically from the pure red of a pixel on your display, or a photosite sensor in your camera.

Without color management, you could have no confidence that the adjustments made to your images in Aperture would be accurately represented in a photo book, on a Web page, or in the output from your home or office inkjet printer.

Every device attached to your Mac should therefore include a color profile, which defines the range of colors it can handle. You can see the installed profiles by opening Applications > Utilities > ColorSync Utility. Clicking through them will display their relative abilities, which will vary widely. Contrast the abilities of your display, found by expanding the Computer and Displays sections using the disclosure triangles, with that of your printer, found in the Other section – again hidden by a disclosure triangle. If you are using a consumer Mac with an integrated display, such as a MacBook, you may be surprised at how many more colors your printer can handle, even if it's a consumer inkjet. In the grab (Fig. 2.39), we have held the gamut

of our printer for comparison by clicking the downward-pointing arrow in its profile graph and picking Hold for Comparison, and then clicking back to the profile for our screen (Color LCD under Displays). The display's profile is the colored graph which, as you'll see, is far narrower than the ghosted white profile representing the gamut available to our printer, shown behind it. This means that our printer can reproduce a wider range of tones right across the spectrum than our screen, and so rather than using pure tones our screen will have to work hard to interpolate a wide variety of colors so that it can approximate – as closely as possible – the results you will see when you come to print.

ColorSync handles this approximation by using a device-independent profile as a conduit for this color information in the same way that native English and Italian speakers may use German as a lingua franca if neither understands the other's native tongue.

These generic profiles span the usual range of Lab, CMYK and RGB colorspaces, and can be examined in the System section of ColorSync Utility, and Mac OS X needs to be told how these generic profiles differ from those of your output devices. As such, investing in an inexpensive calibration tool such as Pantone's Huey, which includes a sensor to affix to your display during the calibration process, should be considered a minimal first step. More expensive and extensive alternatives are also available.

Fig. 2.39 ColorSync Utility manages color translation between various applications and hardware devices attached to your Mac. Here, we are comparing the relative color gamuts of a screen and a printer.

Regardless of the price of the tool you choose, the process of calibrating your monitor is very similar in all instances. The bundled software will display a range of pure colors on your screen, and you position the optical sensor over them. This samples the colors produced and compares what it sees with what it knows the software to be producing using any variations it detects to build a profile that will be used to correct the display.

However, monitors change over time, and their performance can be affected by age, temperature and a range of other environmental factors. As such, while performing a one-off calibration when you first start using Aperture pays dividends, frequent re-testing is required if you want to rely on your display long-term.

Setting Your Preferences

You should now work your way through Aperture's Preferences dialog, setting up the application to work however is best for you. In its default state, it is configured in the way that Apple considers to be most beneficial to the greatest number of users, after extensive focus group testing. However, it won't suit all tastes. Many users will find that a black background in the Browser lets them focus more clearly on their work; the same goes for the Viewer.

Both of these run on a scale from black to white set using sliders on the Preferences Appearances tab, where you can also specify whether adjusted images should sport identifying icons and Stack Count badges (Fig. 2.40).

Fig. 2.40 Use the appearance tab in Aperture's Preferences to specify the background color of the Viewer and Browser. Many users will find they have fewer distractions and are better able to concentrate on their images when these are both set to black.

The Export and Metadata tabs are best left as they are for the time being, as these can be adjusted as and when needed using other parts of the application at the times when you are exporting your files, or changing the displayed data relating to your images. Setting them now would be to second-guess your future needs. Making the changes as and when they crop up means you should be able to make more accurate, relevant choices.

The Web Gallery tab, which we cover in detail on p. 312, is only accessible if you have an active Internet connection, and will only show useful data if you are signed up for Apple's £59 a year MobileMe service. If you are, then it's worth changing the gallery publishing setting to hourly, daily or weekly, so that the changes you make to published Galleries will automatically be reflected on your site without you having to manually republish them yourself. From here you can also stop publishing selected Galleries and upgrade your MobileMe Web space.

The last remaining tab – Previews – controls how Aperture goes about generating JPEG equivalents of your images inside its Library package. These speed up Aperture's operation by giving it less demanding files to open when scrolling through your Library in the Browser. You should only uncheck the box for creating these at the time of creating new Projects if you have a very good reason, as doing it then – when the images are imported into the system – is passive, and takes place in the background.

By now Aperture is ready for daily use. Over time you will continue to hone it to meet your own specific needs, as you can never know from day one precisely how you will use it. You can now import the remainder of your images into its Library ready for use in future creative Projects.

Managing Your Images

Adding Images to Your Library

There are two primary ways to get your images into Aperture – either directly from your camera or memory card, or from an attached drive or folder on your Mac. We will cover cameras and memory cards here, and move on to internal and external drives in the following section.

Whatever your source, photos are always added to the Aperture Library using the Import dialog. This may appear automatically when you connect your camera – if you have Mac OS X set to do that – but if not, it can be activated using the Import button on the Toolbar.

The setting that controls whether or not it appears every time your Mac detects that a camera or card has been connected is found in Preferences (⌘ ,) or through Image Capture, the utility that manages cameras and scanners at the system level. This is found in the Applications folder (Figs 3.1 and 3.2).

The Import dialog is split into three key sections, and links your source media, which appears at the top of the Projects pane, with the Projects themselves, showing the flow of your images from your external sources into your established Library.

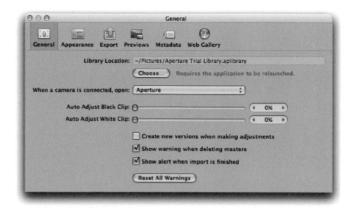

Fig. 3.1 Use Aperture's Preferences dialog to specify what should happen when a camera is connected to your computer. Select Aperture in the pop-up beside 'When a camera is connected, open:' to automatically launch the Import dialog.

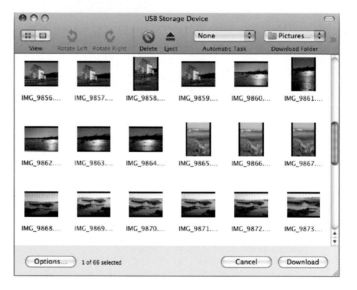

Fig. 3.2 Image capture gives you great control over how your images are imported and where they are stored. It also works with local and network-connected scanners.

You can move either end of this workflow by clicking in the appropriate pane of the Inspector at the new origin or destination point. To switch from a memory card or camera to your internal hard drive, for example, simply click the drive. To change the Project into which your photos will be imported, click on an alternative, or create a new one using the New button on the Toolbar (Fig. 3.3).

Importing from Your Camera

Cameras organize their images into folders, usually defined by the number of photos they have captured since they were

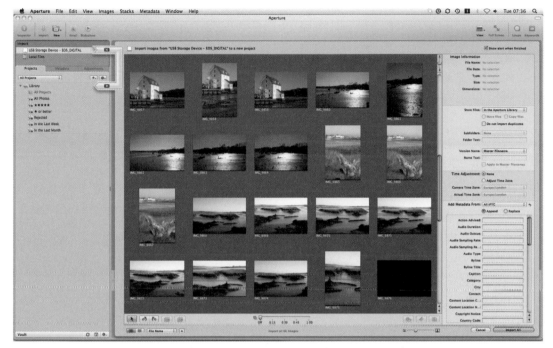

Fig. 3.3 The Import dialog is split into three logical sections – the Projects pane, which defines the destination of your images, the Preview of the images themselves in the central thumbnail area and the Metadata box to the right that lets you assign data and tags to your photos before they appear in the Library.

new. Each folder is usually restricted to holding just 100 images and so a day-long shoot can often end up split across several folders. Even if you have taken less than 100 images, you can still sometimes find that they are split across more than one folder. This is because your camera may have taken, say, 3690 images in all time. If you then take a further 50, the first 10 will fall into one folder and the remaining 40 into another (Fig. 3.4).

Aperture's Import From Camera dialog ignores these artificial subdivisions and instead presents you with a single grouping of all of your photos. Aperture is compatible with almost all current digital cameras, so it is unlikely that you will be unable to access your photos in this way, and even if you have trouble now, the chances are that in time your camera will eventually become compatible, as it draws its Raw processing tools from the operating system.

Fig. 3.4 Digital cameras maintain a strict filing system, splitting up images into different folders depending on their sequence number. This number is counted from the time when the camera was first manufactured, with most models creating a new folder for every 100 images shot.

Raw format files are simply a dump of all of the data gathered by the sensor of your camera. These data have not been edited or refined in any way, and so although metadata such as your ISO setting, shutter speed and exposure compensation are also recorded, only physical attributes such as the length of time the shutter was open will have any affect on the image. This leaves you free to change the other settings once you get them into Aperture.

The simplest course of action when importing your pictures is to click the Import all Images button at the bottom of the interface, or the arrow pointing at the project into which you're importing your photos. Alternatively, you can select a range of images by dragging a marquee around several pictures in the Import dialog's Browser area, clicking one end of a range and **Shift** clicking the other, or holding **⌘** while clicking to pick several non-consecutive photos. You then use the same Import button to bring them into the Library, although by now it will indicate the number of images in the selection ready to be imported.

Although they are speedy fixes, neither of these actions should be considered your primary way of working, as they skip several key steps that will help to manage your assets later. The more work you do at the Import stage, the less you will have to do once your photos are inside your Library, and so the more time you will have for creative activities.

Sort Your Images Before Import

You may think that Aperture's Import dialog looks similar to the Browser, and it does. That's no mere coincidence. Although it

deals with images that don't yet exist in your Library, it still gives you access to many of the same sorting and organizing tools as the Browser does for those you have already imported.

At the bottom of the dialog is a facsimile of the Browser toolbar, allowing you to switch between grid and list views and sort by name, date or file size in either ascending or descending order. A slider lets you vary the size of each thumbnail, while on the line immediately above you can rotate your images and create Stacks based on the interval between each shot. That interval is measured in seconds, and specified by dragging a slider from 0 to 1 minute. By default this is set to 0, effectively disabling stacking and graying out the Stack Control buttons (Fig. 3.5).

Stacks can also be created manually, on any basis that you like, and are not restricted to time-based controls. Selecting several images – either consecutive or disparate – and tapping ⌘ K, or clicking the Stack button, which looks like a roll of sticky tape, will gather the selected images into a Stack. Stacks can be opened and closed using the buttons to the left of the time slider, dismantled by using the Unstack all Stacks button at the far right of the Toolbar, and split by choosing the point at which the split should occur and tapping ⌥ K or pressing the Split Stack button.

However, there are several things you can't do that you can in the Browser, the most obvious being renaming files in their source location. All renaming should be done at the point of import, using the Image Information dialog to the right of the Image thumbnails.

Fig. 3.5 Use the time-based slider at the bottom of the Import dialog to automatically stack your images. The Stacks are determined by the interval between each photo, on a scale of 1–60 seconds. Moving the slider to the extreme left – 0 – turns off automatic stacking.

Organizing Your Images Before Importing Them

The Image Information panel to the right of the import dialog is used to attach the first user-defined metadata to each photo added to your Library. This information is supplementary to the data written by your digital camera, such as Aperture size, shutter speed and shooting conditions, which are untouchable and uneditable.

You won't apply any changes to your images at this stage, but simply define a range of attributes that will be added to Aperture's extensive underlying database and help you organize,

sort and filter your assets once you start working with them inside the program system itself.

The first and most basic task is to decide where your images should be kept.

Choosing Where to Store Your Images

Whenever you import an image to the Library from another location on your Mac or network, you have the option of adding it to your local Aperture Library or leaving it in its original location. Your choice will largely depend on how the image is used. If you work alone, then there is no problem with moving it to your local drive, but users on a network should be careful here, as changing its location could make it unavailable to others on the network.

You can, however, change the location of your Aperture Library. By default it is stored on your local hard drive in the Pictures folder (~/Pictures/Aperture Library.aplibrary). To change this click Aperture > Preferences … and in the General section, click the Choose button and navigate to a new location. Note that if you do this, you'll then have to re-launch the application.

The option to move your files or leave them where they are is found in the Sidebar. Your options are In the Aperture Library, In their Current Location, Pictures, Desktop and Choose…. The latter option is the most flexible, allowing you to store your images in a stand-alone format anywhere on your hard drive, rather than in the complex directory structure inside the Aperture Library package. Pictures and Desktop speak for themselves, although we would strongly advise against storing photos on the desktop. This part of the Mac OS X interface is intended only as a transport area, or for hosting a very small number of frequently used files, folders or links to applications. For maximum system efficiency – and maximum personal productivity – it should remain as clutter-free as possible (Fig. 3.6).

Images stored anywhere other than in your Aperture Library are called Referenced images (as opposed to Managed images inside the Library), because the application has to look elsewhere to get the full resolution photos to work on. When importing images, but leaving them in their original location or saving them anywhere other than inside the application itself, Aperture merely creates references to and thumbnails of the originals, and

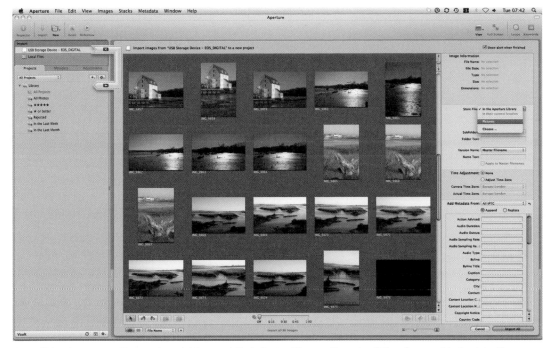

Fig. 3.6 Although most users will want to keep their images within the Aperture Library, and hence benefit from the access this gives to backing up using Vaults, you can also store them elsewhere on your hard drive. Photos stored in this way are known as 'referenced images'.

so it's imperative that the original is also available whenever you want to make edits.

You should also ensure that you have a suitable backup system in place to protect your referenced images, as they can't be stored in Vaults, Aperture's own internal backup spaces. As such, any serious system failure or a hardware fault that impacts on an external drive holding your referenced images will make them unavailable for use in Aperture. This is a serious issue, as they are used as the basis of Versions stored within your Library. As Versions don't actually exist in image format but are, rather, data files telling the application what changes to apply to a Digital Master in order to render each one, they would effectively be lost at the same time as your originals, leaving you with no assets at all. For more information on implementing an effective backup routine, see p. 96.

Even if you choose to store the images in your Aperture Library, or in another folder on your Mac, the originals remain exactly as

they are. Aperture will never delete them unless you specifically tell it to, with any originals simply copied – not moved – from one media or location to another.

Saving Referenced Images

Should you choose not to import your images into the Aperture Library but store them elsewhere on your system you will obviously need to specify where and how they should be filed. Even if you choose to place them in the Pictures folder, Apple doesn't expect you to drop them there loose, and so the import dialog lets you specify a directory structure to keep them separate from your other assets, and help you manually navigate through them using the Finder.

This is done using the drop-down Sub-folders menu, which gives you a range of logical options that, if applied to every subsequent import, will build a logical filing system that will be immediately obvious not only to you, as the owner of the photos, but also anyone else who wants to work with them in the future, even if they haven't been involved in taking or filing them themselves (Fig. 3.7).

By default the subdirectory used to store your images will be based on the name you give to the Project holding your imported photos, but the sub-folders drop-down gives you the option of defining a folder of your own based on, among other things, the current date or the date on which each image was created, or a custom name with an automatically incrementing filename. Picking None would drop them loose either onto the Desktop or into the Pictures folder (neither of which is recommended) while a flexible Edit ... option lets you build your own directory structure using a wide range of metadata drawn from the image.

This takes you to the folder naming presets dialog, which lets you construct a multi-level structure by dragging and dropping various metadata variables into an input box, which will then be replaced by live data from your images.

Creating Folder Naming Presets

The rules for creating presets for Folder names are similar to those for creating names, covered below, although the metadata at your disposal differ slightly. Notable through their inclusion

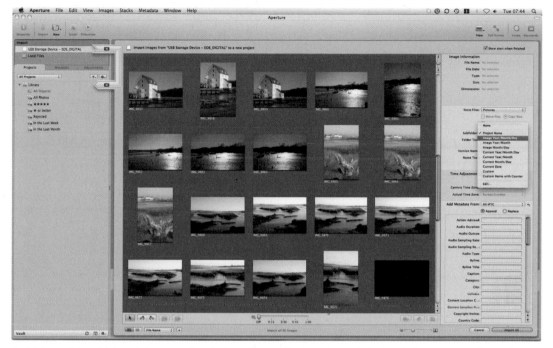

Fig. 3.7 Aperture's Import dialog includes a range of commonly used folder constructs for directing the location of referenced images. This selection can be expanded by defining your own presets.

are Folder names and Project names, which incorporate some of your manual filing measures into the resulting output and, perhaps most importantly, the forward slash. This cannot be used when specifying filenames.

It is used here as a separator for sub-folders. So, if you wanted to import (or later export) a batch of photos taken over the course of an extended journey through several countries, with each country batch stored in a separate Project, you might want to file them by both time and geographical location. Assuming that you are interested in telling a story in chronological order you might therefore create a nested folder structure by typing the words 'Asia Tour' into the Format bar and then dragging the relevant variables in to follow it (Fig. 3.8). You can type the forward slash rather than drag it in if you want to save time, but either way you'd end up with something along these lines:

Asia Tour / Image Year / Image Month / Image Day / Project Name / Sequence #

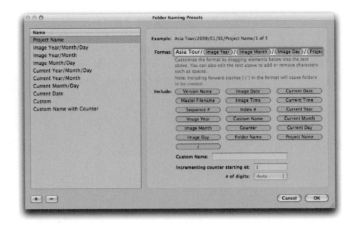

Fig. 3.8 Folder name presets can be built quickly and easily by dragging the various available tags from the Include section to the Format bar at the top of the dialog. You can also type into this bar, thus specifying set words that should appear in every folder name. In this example we have done that with the words 'Asia Tour'.

We have used the ISO standard reverse dating convention here, rather than European or North American for the very good reason that it is the most effective means of narrowing a large group of files sequentially. If we took one picture every day for a year and filed them using this structure we would end up with 365 files and 378 folders (one folder for the year, 12 for the months and 365 for the days). Reversing the order so that we had day/month/year would leave us with 761 folders and 365 files, adding a massive 1126 entries to the file system and greatly complicating the task of manually sorting through those files at a later date.

It works out to 31-day folders, inside 28 of which we would find February folders; folders for September, April, June and November in 30 of them; and folders for January, March, May, July, August, October and December in them all. Inside each month there would be a redundant folder given the number of the year – 2009, for example – and only then would we get to our files.

That's logical enough, but why put Project Name so far down the list? Because you would probably cross any international borders you need to negotiate during the course of a day rather than overnight, and so you could easily be in two or more countries in one single day. As each country is stored in a separate Project, putting Project Name in advance of the other elements in the chain would see duplicate date entries further down the nested folder structure, which will become confusing when you return to it in the future.

You could drag the unified Image Date element into the chain, particularly if your travels all took place in a single month, but by separating it out by year, month and then day you will be able to more quickly, isolated groups of images taken with a specified timeframe in the Mac OS X Finder. You would know that all of the images taken in May, for example, are found in sub-folders within a single folder and that opening that folder isolates them all. The alternative would be to select up to 31 individual folders to achieve the same thing if we had not separated them out.

Creating Filename Presets

Open the Naming Presets dialog and you'll see that Aperture ships with nine filename presets in place, but you can create an almost unlimited number of variations by dragging 16 different elements into the Format box. The elements include Version and Master filenames, current time and date, creation time and date, counters and index numbers and, perhaps most useful of all, the option to create a custom name.

The custom name must be set at the point of creating the preset, or else Aperture will interpret it as incomplete, and it will not be available for use in the Export dialog. However, you can go back and change it at any time if you find that your needs change at a later point.

The other variable that accepts user input at the point of creation is Counter. In this instance the input isn't compulsory, but it does let you specify an initial value and how many digits should be included in the Counter. Note that this digit length isn't a maximum beyond which the numbers will be capped (so no more than 999 for a three-digit length or 9999 for four) but the number of digits will be included in every filename. So pick 6 and even your first digit will be assigned 000001, along with any other variables you specify (Fig. 3.9).

You can split your filename into more manageable parts by inserting spaces and other special characters such as hyphens between the constituent parts. However, there are a number of reserved characters that cannot be used in filenames. The forward slash (/) is one, as this is used as a directory separator, and you'll not be able to enter it when creating your preset. However, you can enter a colon (:), although again this should be avoided as it is conventionally assigned to marking out drives

Fig. 3.9 The filename preset creation tool works in a similar way to the tool for defining folder name presets, but gives you access to fewer punctuation marks, and adds in sequential tools, such as Sequence number, which will specify the number of the image and where it appears in the overall collection, for example, 117 of 203.

by many operating systems. When the file is saved out, Aperture substitutes it for a forbidden forward slash.

Depending on the file type and which application is designated to open it, this could cause the file to self-replicate every time it is accessed. A PNG export including this character opened up in Preview, for example, will do just this, littering its folder, or the Desktop if that's where it is saved, with one duplicate edition for each opening. Another quirk permitted by Aperture, but which should be avoided, is the use of a full stop at the start of a preset filename. Do this and your exported file will never appear, as it is an indicator used to denote a hidden file. The export will take place, and the file will be saved exactly where you said it should, but you'll never see it without using FTP software, changing your system settings or rooting around with Terminal.

Completing the Import Workflow

The Import dialog defines a logical workflow for adding photos to your Library, and it is best to take a top-down approach to the Import panel, which brings us to time stamping and metadata, both of which are keys to effective file management within the application.

The modern photographer is no longer confined to a studio. Location assignments, reportage and international photo journalism have long called for a mobile freelance workforce, and who has time to be resetting their camera clock every time they arrive on site?

Using the Time Adjustment feature, you can have Aperture take care of this for you. Leave your camera set to your local time zone – or GMT (Greenwich Mean Time)/UTC (Coordinated Universal Time) for simplicity – and specify on each import the zone in which the photos were taken. Aperture understands the time relationships between key world cities, allowing you to select your camera time zone and assignment location geographically, rather than chronologically. Do this and it will make the necessary changes to the metadata of the imported Digital Masters without any further intervention on your part (Fig. 3.10).

By now you have reached the last step of importing your photos: adding metadata. This works on a batch basis, adding the same variables to all of the images you import in one session. You should therefore only specify data that applies to every image in your selection, and then further personalize them once they have been safely stored or referenced in your Library.

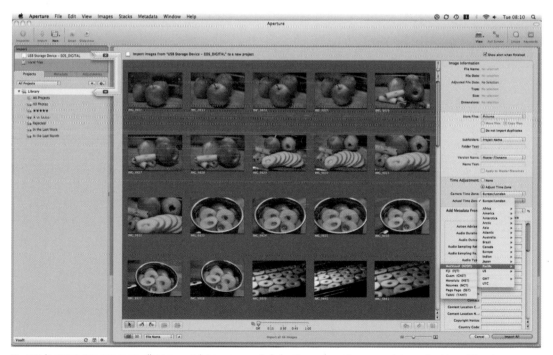

Fig. 3.10 Aperture is time zone aware, allowing you to leave your camera's clock set to your home time zone, and change the date and time stamps on your images at the point of import by picking the name of the country or city in which the images were taken from the Actual Time Zone drop-down menu.

Aperture ships with a range of pre-defined Metadata sets, which can be selected from the pop-up Metadata menu. The most important of these are the variations on the industry-standard IPTC (International Press Telecommunications Council) standard data set, which lets you assign rights, add captions and give instructions to picture editors who may want to use your work.

If none of the sets exactly meets your needs, you can create new sets by temporarily stepping out of the Import dialog.

Creating Metadata Presets

A lot of the metadata that you apply to your images will be identical from photo to photo. Your by-line will always be the same; your copyright notice will only change once a year; you may use a common set of keywords across several images because you specialise in one particular area or type of photography.

Rather than having to type all of these details anew each time you import a fresh set of photos, therefore, Aperture lets you define them just once as sets and then add them by picking the appropriate set from the pop-up Metadata menu. You can define as many sets as you need, which allows you to duplicate a great deal of common information in all of your presets, and adjust only those parts that vary between clients or shoots. In this way you can precisely tailor the data you pass on to each client, providing them with just what they need, without either overburdening them, or leaving any blanks.

Unfortunately these sets cannot be set up from the Import dialog, and you must set up your first preset after importing your first images. This will let you create a preset based on existing data and append any changes you want to make.

With any image selected, switch to the Metadata Inspector. Click the Shortcut button and create a new view, giving it a meaningful name, which will later appear on the Import dialog's pop-up Metadata menu. This will open up the Tag Selector, a window that slides up from the bottom of the Metadata Inspector. This is split into five sections for Keywords, Exif data, IPTC, Other and Archive, which only includes information about the last time each image was backed up in a Vault. This last detail cannot be user defined, but checking the Include in Summary box will add it to the attached Metadata view nonetheless.

Progress through the various sets, checking the boxes of the variables you want to include, remembering to only ever include those that will be common to every image you import using that set. You can clear out individual fields at the point of import, but it saves a lot of work in the long term to define accurate Metadata sets at this point that you know you can rely on in the future.

Once you have selected your tags, use the text boxes that appear beside each one to enter their variables, following any conventions specified by your clients.

Obviously not all metadata variables can be edited in this way, as any that already exist will have been set by the camera, and so are immutable facts, rather than judgement calls on your part. These can be included in a Metadata view so that you can call them up at a later point to examine a specific range of data in one place, but including them in a preset is unnecessary as they will already be imported with your images anyway. In the interests of speed, therefore, they should be excluded at this point (Figs 3.11 and 3.12).

Although you have entered data in your chosen fields, this set remains nothing more than a view. To apply it automatically to imported photos, you must save it as a preset. Return to the Shortcut menu and choose Save as Preset …, then give it a name and open the Import dialog again. It will now appear on the Add Metadata from … pop-up menu. Selecting it will add the pre-defined data to the import workflow and attach it to your photos when you finally import them (Fig. 3.13).

You will see that there are two Radio buttons between the pop-up menu and the fields themselves to either append or replace the data that already apply to your photos. Their functions speak for themselves, but you should be careful when choosing between them. Appending data can lead to bloat, where a lot of insignificant information is attached to your files. However, replacing existing data can lead to key facts being lost.

Importing Your Pictures

By now you have reached the end of the import workflow, and all that remains is to bring your images into your Library by clicking the Import button at the bottom of the Import dialog.

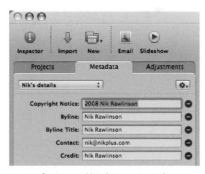

Fig. 3.11 Setting up a Metadata preset cuts the amount of time you'll spend tweaking photos with similar themes when you come to import them into Aperture.

Fig. 3.12 Once you have defined a view and entered your commonly used metadata, use the Save as Preset . . . option and it will appear in the Import dialog the next time you come to import images.

Fig. 3.13 Both your saved views and your presets will appear in the Add Metadata from drop-down in the Import dialog, allowing you to quickly append commonly used information to every image you add to your Library. Alternatively, you can opt to replace any data that are already in place with those stored in your presets.

Aperture will either copy your pictures into the Library package that it stores in your Pictures folder or reference them within the Library.

Importing from Other Sources

Images can also be imported from a folder, stored either locally on your hard drive, or on any networked drive. The principle is the same as importing from a memory card, except that it requires a little more manual intervention.

Opening the Import dialog and clicking any available volume will open up the Import screen which, as when you import from a camera or card, slides out from the drive and links it to the top of your Library.

Aperture can handle a wide range of image formats, including Gif, Jpeg, Jpeg2000, PNG, Photoshop PSD, Digital Negative (DNG) files, TIFF and Raw. This latter option will not be available for all cameras, since each manufacturer maintains its own Raw format, but Aperture keeps up with the leading manufacturers, including Canon, Nikon and Pentax. Apple maintains a list of supported cameras at apple.com/aperture, and there's a chance that even if your camera is not supported right now, it would be in the near future, as it frequently adds to the range when it updates the operating system. Bear in mind that some manufacturers give their cameras different names in different territories. This is usually an internal marketing convention derived through research that shows which name would perform best in different territories. A prime example is the Canon EOS 350D, which took this numeric name in Europe, was the Digital Rebel XT in the USA, and in Japan masqueraded under the title EOS Kiss Digital N. Each has – ostensibly – the same specification, but because the naming convention is included in the files used to decode the Raw data, using mis-matched Raw definitions will not work. As such, you should only ever assume that your camera will work flawlessly when the title of your specific model of the camera is included in the range of Raw-parsing updates delivered by Mac OS X's Software Update.

Assuming your camera is supported, then any Raw files you have saved onto a drive can be imported as quickly and easily from here as they can from a memory card.

Importing Without the Dialog

If your images already exist on your system – whether internally or on an attached external drive – then it is possible to bypass the Import dialog altogether when adding images to the Library, by selecting an existing Project (or creating a new one with **⌘ N**) and dragging the images to it from a Mac OS X Finder window. Aperture will then run through the regular import routine itself, saving you the time of working through the process step by step.

By default it will copy them to the Library, where they will become Managed images. If you would rather leave them where they are and use them as Referenced images, then hold down **⌘** and **⌥** while dragging them into Aperture.

This is a speedy shortcut, but it carries with it one very significant disadvantage: bypassing the Import dialog means you won't have applied any user-defined metadata to your images, and so they will only carry with them information about your camera, settings and shooting conditions. They will not have any keywords attached, any captions, copyright notices, rights information or credits, and so these must be added manually at a later point. For a single folder of images, therefore, using drag and drop to import them into your Library can actually be a false economy.

If you are importing several folders, though, it can pay significant dividends – particularly if you are setting up Aperture for the very first time. Over several years of use, you may have built up a significant collection of images elsewhere on your Mac – say, for example, your Pictures folder. Importing these using the Import dialog would be a time-consuming affair, which by necessity would have to be done in stages, with a new Project created for each group, and Albums created within these for individual subsections. In an instance such as this, you may want to import existing folders as Projects in their own right (Fig. 3.14).

Aperture will recognize each folder's name and use this as a Project name, with sub-folders used as Albums inside the Projects. You can then select the contents en masse and apply a pre-defined Metadata set to them before moving onto the next Project. You can do this using the Batch Change command on the Metadata menu (*Shift* **⌘ B**) to call up a subset of the Metadata Inspector (Fig. 3.15).

Fig. 3.14 If you need to import multiple images already stored on your hard drive, you can bypass the Import dialog by dragging them into the projects pane from a Finder window. They can be dropped into an existing Project, but dragging a folder will create a new Project, with all sub-folders used as the basis of Albums inside the Project.

When importing images in this way, Aperture will take the name of the folder from which you are importing as the name of the Project into which it should drop the pictures once it gets them inside its Library, with any sub-folders used as Albums within the Project.

Renaming Files

Your images' names, as they appear in the Library, will be determined at the point of import. If you would rather that they don't just use the name specified by your camera, which will be a prefix followed by an incremental counter that marks the number of shots taken since it was new, you can specify a more appropriate name based on various internal metadata or criteria that you specify yourself. This is selected through the Import dialog, using the settings at Aperture > Presets > File Naming…

Fig. 3.15 After importing photos by dragging them from a Finder window into the Aperture Projects Inspector, you can apply metadata changes to them as a group using the Batch Change dialog.

You can likewise change the names of your images when they are exported, again by specifying a pattern derived from metadata and an optional custom field of your choice, using the presets at Aperture > Presets > Image Export … The settings defined here will appear in the Export dialog.

However, there are times when you will want to change the names of your files as you work with them in the Library. This is done by switching to the List view by using the shortcut **ctrl** **L** and then double-clicking on the name of the file you want to change, typing your replacement and hitting **Return**. Note that while you will see a new name in the Library, only the Version would have been changed, as under the surface Aperture sticks to its promise not to interfere with your Digital Masters and leaves their names intact.

Backing Up Raw Files

Your Raw files are the most valuable assets in your photography workflow. More important, even, than your Mac, your Aperture installation, or your camera. Each of those can be replaced with a little expenditure, but your Raw images are irreplaceable originals. Even if you were to spend time recreating each scene and re-shooting them individually, they would never be exact replicas of the originals.

Further, any adjustments you have made would apply to those originals, which would now have been lost, leaving you to repeat your time-consuming work on new photos, with no guarantee of achieving the same end result.

As such, it is vital that you implement a regimented backup procedure that safeguards your Raw Digital Masters and any Versions derived from these. The recommended process would be to implement this within Aperture itself using the Vaults system (see Managing Vaults, p. 99). However, there are issues here surrounding Raw images that are not stored within your Aperture Library, as Vaults can only contain images found within the Library itself. With referenced files, only adjusted Versions and associated metadata will be saved.

To ensure you have adequately protected your originals, then, you should either relocate your images within the Library itself or, if you've already set up your Library with your images stored

externally, implement a third-party backup tool, or the tools within Mac OS X itself to properly protect your assets.

Backup and Time Machine

Apple ships the appropriately named Backup application as part of its MobileMe online service. This simplifies the process of backing up files and folders to archive media, including external hard drives and optical media such as CDs and DVDs. It will also let you back up your files off-site to your MobileMe iDisk, which gives you access to 10 GB of storage in the default configuration, and up to 20 or 40 GB for an additional £30 or £59 annually, respectively.

Backup can be downloaded by accessing your iDisk using the entry in your Mac OS X Finder sidebar and navigating to the Software folder. Here you'll find two Backup sub-folders; one for Mac OS X 10.3.9, and one for 10.4.2 or later, and 10.5.

In Mac OS X 10.5 Leopard, Backup is supplemented by Time Machine, Apple's automated backup tool, which saves incremental copies of your file system to an external, attached hard drive or Time Capsule, the company's integrated router and network-attached storage drive (Figs 3.16–3.19).

However, while Time Machine will make a good job of backing up all of your files at regular intervals, irrespective of their location, and Backup can be set to run at specified intervals, combining them with tools like Mac OS X's Smart Folders,

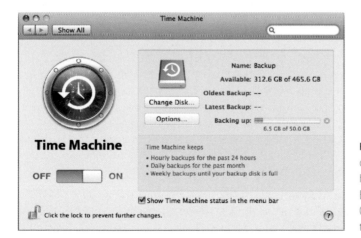

Fig. 3.16 Time Machine automates the process of creating incremental system backups on an external hard drive or network-based Time Capsule device. Ensure you are running the most recent Version of Mac OS X 10.5 to have your Vaults and Libraries included in the Time Machine archive set.

Fig. 3.17 Time Machine makes backup both friendly and easy, by presenting a history of your files in a graphical, easily understood interface that lets you 'roll back' your system state through time.

Fig. 3.18 Backup is a free utility for all MobileMe subscribers. Download it from your iDisk by clicking its entry in your Finder sidebar and navigating to the Software folder.

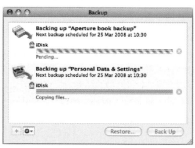

Fig. 3.19 Backup can be set to create backups at set intervals by defining a data set to store and specifying a schedule to which it should conform.

Automator and Folder Actions can further secure your backup procedure and place more of the burden for safeguarding your files on the file system itself.

Managing Vaults

Aperture has its own Backup tool in the form of Vaults. These are virtual copies of your Library that are stored, like Time Machine archives, on an attached external hard drive. However, unlike Time Machine backups, these are managed directly from within Aperture, and they are dedicated specifically to rebuilding a corrupted Library, not scrolling backwards through time and extracting individual changes. So important are the Vaults maintained by Aperture, that they even have an entry on the application splash screen, showing how many images and projects are not yet backed up.

If you are running Leopard and plan to use Time Machine to secure your Library, ensure you have updated your system with the most recent patches, as early releases were incapable of handling Aperture Vaults properly, and these had to be specifically excluded from backup sets.

For more information on backing up your Library, see the section on Moving Libraries (p. 106) and apply the same principles to your primary image store.

Creating Your First Vault

Vaults are managed through their own panel at the bottom of the Aperture Inspector. Expand it by clicking the Show or Hide Vaults button at the bottom of the interface (**Shift** **R**). This opens a blank pane where your Vaults will be organized.

Connect an external drive to any one of your Mac's available ports and then click the Shortcuts button (the cog beside the show Vaults button) and choose Add Vault, then navigate to the newly attached drive (Figs 3.20 and 3.21).

Once added, the drive will show as a new, empty Vault. Its capacity will be reported, and a capacity bar will show how it is currently being used and what space remains. The portion colored light gray is free and available for use. The darker gray section is already occupied, but not by Aperture files, and the

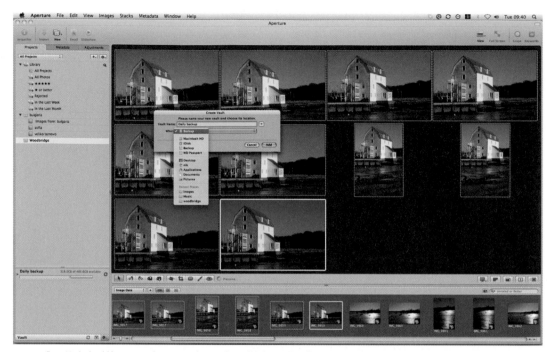

Fig. 3.20 Every Vault should have an easily recognized name that will help you identify it every time it is connected to your Mac. You should also ensure that you never store more than one Vault on a single physical drive.

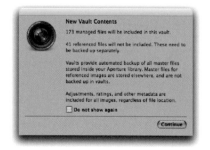

Fig. 3.21 When you create a new Vault, Aperture tells you what will be included and what excluded from the backup set it contains. Only images stored within the Aperture Library package can be backed up using Vaults. All referenced files must be backed up using external tools, such as Time Machine or Backup.

green-colored progress meter shows how much of the free space is used to store your Aperture backup.

As we'll explain below, you can manage several Vaults through Aperture, which can be connected either simultaneously or in sequence as you perform different types of backup at different times. You should therefore give each one a meaningful name, which for ease of identification would ideally match a physical name attached to the casing of the drive itself. You can do this at the time of creation, but if you later find you want to change it, then click on the progress bar to open up the existing name for editing. You are now ready to create your first backup (Fig. 3.22).

You'll see that the circular synchronization arrows to the right of the Vault are red. This indicates that there are Digital Masters in your Library that have never been stored in any Vault. It is a serious warning that can only be remedied by synchronizing the whole Library to the Vault, which you'll do by clicking either

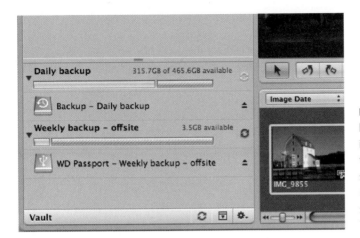

Fig. 3.22 Aperture color codes the Synchronization buttons in the Vaults pane. Red circular arrows indicate that there are Digital Masters in your Library that have never been backed up in a Vault. Yellow shows that all Digital Masters have been backed up, but not all Versions are saved in the Vault. A black icon shows that everything has been backed up and your Vault is up to date.

these arrows, or their duplicates at the bottom of the Inspector. Why two sets of arrows and warnings? Because the Vaults panel eats into valuable Inspector space, yet most of the time is unnecessary. As such, you'll spend most of your working time inside Aperture with the panel minimized so that you can devote as much space as possible to navigating your Projects. In this way you can perform backups by clicking the button at the bottom of the panel without first opening it up and save breaking your creative flow.

Should the arrows show amber, rather than red, Aperture is giving you a less serious warning. In this instance, all of your Digital Masters are backed up, but you have unsecured data in your Library, such as Versions or changes made to the metadata attached to an image. Again, manual synchronization will remedy this.

The only time you don't need to pay your Vaults any attention is when the icon is black, indicating that all Digital Masters and Versions are backed up. Even this can be deceiving, however, as there are two exceptions that could lull you into a false sense of security.

The first is that you may have no Vaults set up at all. In this instance, the icon would remain black, despite the fact that your images exist in only one location. It would be hard to imagine a situation when you might think that this meant you had no cause for concern. However, the latter reason – that your images reside outside of your Aperture Library – is more obscure.

Aperture will only store managed images in your Vault. If you choose, when importing originals into your Library, to leave them in their original folders or store them anywhere else on your Mac and instead simply refer to them in Aperture, it will be unable to store them in a Vault. Instead, it will back up only derivative Versions. Adjustments made to the originals will cause the icon to glow amber, but on no occasion will it show red, as your Digital Masters don't actually exist within the Aperture environment. As such, deleting them from the Finder or through any other application will make them inaccessible to Aperture, and you will be unable to restore them from a Vault. A secondary backup procedure to secure the folder in which they reside must be implemented as a matter of course.

You can connect several Vaults at once and run an incremental backup procedure, with daily backups to be kept onsite and weekly or monthly backups to be stored in a separate building, to keep them safe in case of fire or flood.

Of course, size quickly becomes a consideration when working with Raw files, which are larger than the relatively conservative JPEG images written by consumer cameras. Combine these with all of the adjustments, Versions and keywords that you'll add, and a single Vault can quickly consume a small drive. For this reason, you should always buy the most capacious drive you can afford after considering the average size of each Raw file that you shoot, and how many you expect to take in a single year.

Maintaining Your Vaults

Each Vault assigned to your Aperture Library should be a living, constantly developing resource. It's no good performing a backup at the end of January and then not doing another until mid-June, by which point you could have added 1000 or more Digital Masters and 5000 Versions to your Library. The chances of you losing them are – admittedly – slim, as hard drives are generally reliable units, but the cost if you did could be considerable if they pertain to possible work and contracts. Even if they don't, your originals will still be difficult to recover without the assistance of expensive data recovery specialists, and impossible to recreate, as each one will be a record of a unique moment in time.

For these reasons, it is essential that you are assiduous in your backup routine, and you update your daily Vaults every time you import new images to your Library, at the end of every working

session when the synchronization icon glows amber, and on a weekly or monthly basis – as appropriate – for your off-site copies.

You should never store more than one Vault on a single drive in separate partitions, as this will do nothing to reduce your chances of losing your backups. When creating more than one backup at a time, then, you should either connect all relevant external drives at one time, and click the Synchronize button on the bottom of the Vaults panel, to update them simultaneously, or connect them one after the other and perform the updates in sequence. There is no option to have a Vault update automatically when you have finished each session of working with Aperture.

As a Unix-based operating system, Mac OS X doesn't take kindly to drives being removed without warning, as it likes to close things off neatly. Not giving it the chance to do this could corrupt your data, and expose you to the risk of losing your valuable backups, making the images stored on your Mac's internal hard drive your only copies.

To reduce the risk of this happening, always eject any drive holding a Vault by clicking the Eject icon beside its name within the Vaults panel (click the Disclosure triangle to show this if it isn't visible), or use the same Eject function in the Mac OS X Finder. When it disappears from the Finder or Vaults panel, it can be safely removed. The next time it is connected it will automatically remount and reappear.

Restoring Your Library from a Vault

With any luck, you will never need to restore your Library from a Vault. If you do, it usually means you have suffered a serious internal hard drive failure. Fortunately, if you have been keeping your Vaults up to date, you should be able to recover all of your work, except that which you have done since your last backup (which really should be no more than a day). If you ensure that you do not delete your photos from your memory card before they are stored in a Vault, you should be able to recover any new images imported since the last backup by returning to your original media (Figs 3.23 and 3.24).

Following a fresh format and install of the operating system, the creation of a new Mac OS X user, or the replacement of a faulty drive, open Aperture and press ⌘ R to open the Vaults panel. Ensure your most recent backup is attached to the system and

Fig. 3.23 You can restore your Library from a Vault following a hardware failure. If your Vaults are kept up to date this should mean that you never risk losing more than a few hours' work following any disruption.

Fig. 3.24 Aperture keeps you updated on the progress of any restoration options when you rebuild your Library from a previously stored Vault.

pick Restore Library from the Shortcuts menu (the button with the cog icon). Aperture will explain what it is going to do, and let you choose a source Vault and a destination location. By default the destination will be your current Aperture Library, but by opening the drop-down menu you can pick a new location, such as a separate folder. This is more than just good disk-keeping niceties; by picking a folder separate from the one that contains your current Library you can import the photos in the Vault into an entirely separate location, and thus run the Libraries side by side, switching between them using the Preferences dialog (⌘ ,) or by holding ⌥ while launching the application.

Once you have finished restoring your Library from a Vault, Aperture will restart and run through a recovery procedure to rebuild and validate your Projects.

Transferring Your Library to a New Mac

You can also resort to your Vaults to transfer your Library to a new Mac. This is a fine solution if, when importing your photos into your Library, you transfer them wholesale into Aperture's directory structure. If you instead leave them in referenced locations, such as a folder elsewhere on your drive, or a different drive entirely, however, they will not be stored in the Vault. In this case, restoring from a Vault would leave you with an incomplete Library, featuring any Versions you have created but lacking the Digital Masters from which they are derived.

On this occasion, you could manually copy your entire Pictures folder, including your Aperture Library and referenced originals. This is a common solution, but in itself it can introduce further problems if the relevant permissions applied to the files prevent the user account on your new Mac from manipulating them.

A smarter solution is to copy your existing user folder from the old Mac to your new machine. Do it the right way and it will also transfer your existing applications and settings, so you are up and running right away. As an added bonus, when the files and settings are written to the new machine they can be defragmented and optimized, allowing your new machine to run more efficiently than your old one.

To do this, switch off your old machine, and on the new one launch Applications > Utilities > Migration Assistant. Click through the dialogs until asked to connect your two Macs by

FireWire cable and switch on the old Mac. This will mount it as a drive on your new system and Migration Assistant will start to copy across all of the relevant data from your old drive. By the time it is finished, the drive on your new system will exactly match that on your old machine. Your folder structure will be identical, your email client will be pre-populated with your messages and your Mac OS X Desktop will still show the same files as it did before. More importantly, though, your Aperture Library will also be imported with the correct permissions, allowing you to step right back in where you left off (Figs 3.25 and 3.26).

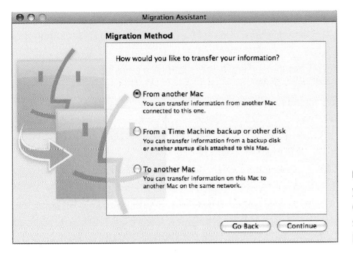

Fig. 3.25 Migration Assistant makes it easy to transfer your data and settings from your old Mac to a new one when you come to replace your hardware. If you stored your Aperture Library in your user folder, it will be transferred along with the rest of your data.

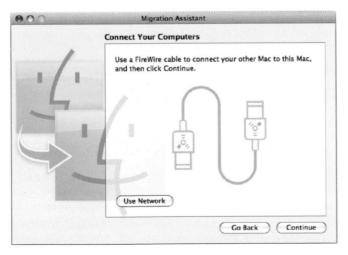

Fig. 3.26 Files are transferred by connecting your two Macs together using a FireWire cable. Your old Mac will then be used as a mounted drive by the new host machine.

If you stored your original assets as referenced images on an external drive, you can now attach this to your new Mac, and give Aperture access to the Digital Masters from which the Versions in the newly imported Library were created.

We'll cover moving Libraries in more detail in the next section.

Moving Libraries

By default, your Aperture Library is stored in the Pictures folder of your user account. It is a package called Aperture Library, the contents of which can be viewed by right-clicking and picking Show Package Contents. You should never mess with this Package's contents, but you can safely move it wholesale to another location on your Mac, or to an external drive connected by FireWire or USB.

This is particularly important when you have been using Aperture for some time and your Managed Library starts to grow. Even a fairly conservative Library containing a little over 1000 photos can total more than 4 GB. Several years of work, then, can swamp a notebook hard drive for those running Aperture on a MacBook, MacBook Pro or PowerBook, and start to feel somewhat cramped on even a desktop machine.

When this starts to happen, you should consider a more capacious location, such as an external hard drive, in which to store it. Prices for these are falling all the time, and so it is well worth buying a well-known brand such as LaCie or Western Digital rather than a cheap no-name device.

Research your drive before buying it, paying particular attention to Mean Time Between Failures (MTBF) statistics, which give an indication of the life of the drive. The longer the mean time, the better.

Other factors to consider include seek time and transfer rates, which measure how quickly a drive can move its read and write head to a specific point on the platters where a required piece of data can be found, and how quickly that data can then be passed from the drive to your Mac. Both of these factors will affect how responsive Aperture feels, particularly when scrolling through extensive Libraries. Fortunately, switching to Quick Preview mode when scrolling through your Library helps greatly here, and once you have found your required image, you can switch back to the regular Management mode.

Whichever drive you choose, don't be tempted to store any externally hosted Library on the same drive as your Vault. The Vault is designed to be a safe backup of the Versions and Digital Masters stored in your Library, and can be used to rebuild it should your master Library be lost due to disk corruption or any other hardware, software or user malfunction. To store your Library and Vault on the same drive would open you up to the risk of losing both your Master File store and your backup resource, and should be avoided at all costs.

Fortunately, almost all well-specified external drives allow for daisy chaining of further drives, saving you from using up all of the ports on your system that would otherwise be used for peripherals. This would enable you to store your Library on a connected drive, and your Vaults on a separate connected drive, connected via the first, should you choose.

To move your Library from your Pictures folder to an external drive, quit Aperture, and copy the Library package to its new location.

Now re-launch Aperture while holding down 🔣, and you will be asked to select the Library you want to use, at which point you will select your new location.

Don't be tempted to delete your old Library right away. Although you will know immediately whether the transfer has been successful, it is good practise to work with it for a few days before deleting what you know for sure is a good original copy on your local drive.

Splitting Up Your Library

There are real benefits to dividing your Library into smaller parts, particularly if you can confine the contents of each to specific, highly differentiated subjects or clients. You might, for example, have a Library for wedding shoots, another for personal projects and a third for portraits. All are very different subject areas, and one is purely personal, rather than commercial. As such there will be little in the way of overlap, and so grouping them into discrete Libraries makes sense in terms of both convenience and performance.

The simplest way to do this is to quit Aperture and rename your existing Library (to, say, weddings.aplibrary) before restarting. Given the option of creating or choosing a Library, create a new one using the default name (Aperture.aplibrary), and then repeat

Fig. 3.27 You can easily split your Library into distinct parts along subject lines and then choose between them by holding the ⌥ key while launching Aperture. The result will be several Libraries existing side by side.

the above action, quitting and renaming it (as personal.aplibrary) and repeat the process for a third time, this time creating a Library using the name portraits.aplibrary.

You'll now find yourself in an empty portraits Library. Should you want to change to one of your other two Libraries, switch them using Aperture Preferences (⌘ ,) and then quit and restart.

From now on, hold down the ⌥ key whenever you launch Aperture and you'll be asked to choose the Library you want to use. As Aperture will always restart with the Library active in the Preferences the last time you quit, this will save you from having to quit and restart again should you find that it's not launching with the one you need (Fig. 3.27).

Moving Referenced Images

There are many reasons why you may want to move referenced images on your system. If they are stored on an external drive that is approaching its maximum capacity you will probably want to transfer them to a larger drive. If you have upgraded a server on which they were always held you will certainly need to move them. Perhaps you're just having a spring clean of your file system, or you are working simultaneously on both a laptop and desktop. In any of these scenarios, Aperture may lose contact with your original files, because they won't be stored in the locations you originally specified. In this case, you need to show it where they can now be found. You do this by managing your referenced images.

At the same time, however, you may want to import a series of external, referenced files into your Aperture Library so that you can take advantage of the Vaults system to back them up with your other Digital Masters, any metadata you have applied and any Versions you have created. This is called Consolidating Masters.

Managing Your Referenced Images

Ordinarily, when you move some referenced Digital Masters in the file system, Aperture will keep track of them itself. It works hand in hand with the operating system to ensure that changes made in one don't have an undesirable impact on the other. You can also check that it has been recognized that they have moved by right-clicking on any referenced file in the set you have moved and picking Manage Referenced Files. This will show you where it is reading the files from and, if you have only renamed the folder holding them, it should show that its records have been updated. Any listed in red pose a problem. Those in black are properly located.

However, if the badge in the lower-right corner of each thumbnail in the Browser shows a yellow warning triangle, this indicates that Aperture knows where the image should be, and can find the folder where it should be found, but that it is not there. You will still be able to view the previews of each one, which are stored in the Library itself, but all of the editing options in the Adjustments Inspector will be grayed out and inaccessible. This most often happens when you have copied your images to an alternative location and then deleted the originals. In this instance you need to give Aperture a helping hand by pointing to the new location for the files it is using.

To do this, select all of the images in the moved collection, right click and pick Manage Referenced Files. The dialog that appears will show which images are posing problems. Select all of these and then navigate to their new home using the folder structure in the lower half of the dialog, and then click Reconnect All. This will reassociate your referenced images with those found in the target directory, with a bar monitoring the progress of the operation (Fig. 3.28).

To avoid having to manage your Masters in this way in the future, you should use Aperture's own Relocate Masters tool, found on the File menu whenever you want to move referenced files on your hard drive. Select all of the images you want to move before

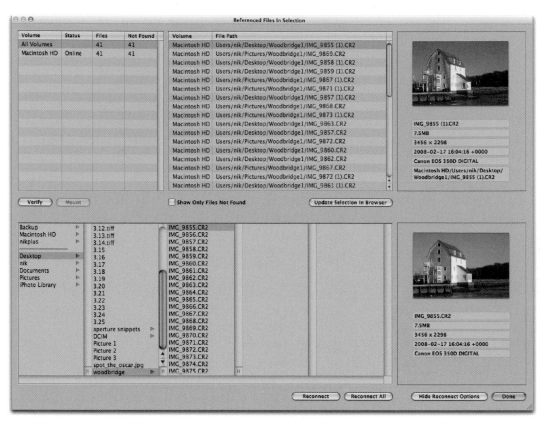

Fig. 3.28 Using Aperture's Manage Referenced Images dialog allows you to reconnect your Library with referenced images that have been moved since they were added to Projects in the Library.

picking the tool, and then use the dialog that appears, to point to a new location on your system (Fig. 3.29).

Use the pop-up menus for sub-folder and name formats, following the guidelines in the importing section for defining these variables (p. 84). Once you click the Relocate Masters button, the new folder structure will be built, and populated with your images. At the same time, Aperture will update its database to take account of the change.

Consolidating Your Masters

When you consolidate your referenced Digital Masters, you place them in the directory structure maintained by Aperture inside its Library package. You can either do this wholesale – by moving

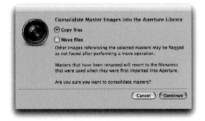

Fig. 3.29 Rather than moving your referenced images using the Mac OS X Finder, you should relocate those files using the Relocate Master command within Aperture. This will allow you to define a folder structure and naming convention in line with that used in other parts of the Aperture working environment.

them – or you can copy them so that a Version of the originals will remain in their current location. Obviously if you move them rather than copying they will be inaccessible to the file system without navigating through the Library package's folders, and so shouldn't be touched by any application other than Aperture.

Aperture already knows where the images can be found, as this was defined when they were originally added to the Library, or when you relocated your Masters following a folder move, and so once you have chosen whether you want to copy or move them it will go about the task of bringing them into the Library itself without any further intervention from yourself (Fig. 3.30).

Aperture will remove the referenced image badge from the lower-right corner of each thumbnail to indicate that they are now stored internally, rather than referred to in an external folder.

Image Migration

One of the improvements Apple delivered with the move from Aperture 1 to Aperture 2 was a set of enhanced Raw processing

Fig. 3.30 Aperture's Consolidate Master function moves referenced images from external folders into the Aperture Library package, allowing you to back them up using the Vaults system. Aperture already knows where your referenced images are stored, so this is a one-step procedure.

algorithms, which the company claims will produce better end results. Images imported into the Library after upgrading will use this new routine to ensure the best output.

However, as the company recognizes that all of its upgrading users will already have an extensive Library in place it respects your existing settings, and will let the two formats exist quite happily side by side, and give you access to the same editing and adjustment tools on each, regardless of the underlying settings for your various images.

As such, you might not immediately see the benefits of a wholesale upgrade of your existing images from one architecture to another, particularly as this can be a time-consuming business, and so there are two different ways of performing this automated process. One is quicker, and one is more flexible; which you choose will depend very much on how much time you have, and whether or not you want to experiment as you go along.

Migrating Images the Quick Way

The quickest way to migrate your images is to select a group – a Project, Album, Smart Album or your whole Library – in the Projects Inspector and pick Migrate Album, Migrate Smart Album or Migrate Project from the File menu. If you have just one image selected, you'll be given the opportunity to do a single photo from there too. You can also migrate images on a case-by-case basis by right-clicking their thumbnails in the Browser.

When you do this, you'll be given the option of upgrading your images as they are so that you see only one edition in your Library – the new Digital Master – or creating upgraded Versions of your Raw images, in which case, the photo's existing state will be treated as a Digital Master, and a new edition with updated Raw processing will be created as a Version. The two will then be stacked in the usual way. You can also choose whether all images should be migrated, or just those either with or without adjustments.

Whatever option you choose, the selected files will all be migrated to use the Version 2 Raw decoder (Figs 3.31 and 3.32).

Fig. 3.31 The quickest way to upgrade the Raw decoding of your images is to right click a Project and pick 'Migrate Project...'. This will convert all of your images en masse, although you can opt to restrict the conversion to only those pictures either with or without adjustments, and to make copies of your originals.

Migrating Images the More Flexible Way

You can also migrate images from the Adjustments Inspector in the same way that you would apply, say, a color temperature change or levels tweak. So long as you have a Raw image selected, a Raw fine tuning section will appear on the Inspector immediately below the Histogram. This lets you select the Version of the Raw processor that you want to use, with options for Versions 1, 1.1 and 2 (Fig. 3.33).

Version 2 is of course the most flexible and Version 1 the most rigid (it tells you only the model of camera used, and doesn't allow you to make any changes).

Version 1.1 opens up basic exposure adjustments (Boost), overall or edge sharpening, and chroma blur correction. Version 2

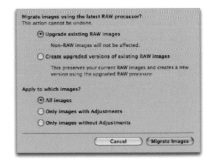

Fig. 3.32 The quickest way to upgrade the Raw decoding of your images is to right click a Project and pick 'Migrate Project...'. This will convert all of your images en masse, although you can opt to restrict the conversion to only those pictures either with or without adjustments, and to make copies of your originals.

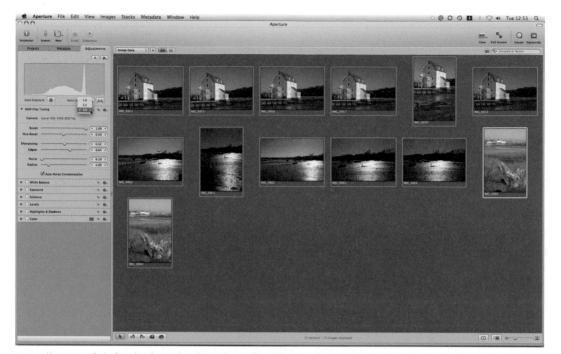

Fig. 3.33 You can specify the Raw decoding tool used to render your files within Aperture using a pop-up menu in the Adjustments Inspector.

Fig. 3.34 The three Raw decoding options – Versions 1, 1.1 and 2.0 – progressively add more features and flexibility to the Raw fine tuning tools at your disposal. The most basic, Version 1, offers no options at all.

dispenses with chroma blur, but retains boost and sharpening with a supplemental hue boost option, and adds in controls for Moiré correction (Figs 3.34–3.36).

Whichever method you choose when migrating your images, the option is only available if you are actually working with Raw files. Picking an image of any other format in the Browser will still give you the migration option in the File menu, but when you come to the end of the process you'll be told that no Raw images were found to migrate.

Hard Disk Management

If you have chosen to store all of your images in your Aperture Library rather than referencing them from elsewhere on your hard drive, then it will take care of the management of your photos for you, and you need to follow only basic advice for keeping your hard disk in good shape. The most important is to

back up regularly, which we cover elsewhere. Next is to always make sure that you leave at least 10% of the total capacity of your drive unused, so that Mac OS X can effectively shuffle and optimize your files. With less than 10% free you will notice a considerable performance hit.

However, if you have chosen to leave your photos in existing locations, or store them in a series of folders outside of the Aperture Library, you will have the option to access them directly from the file system itself. It also means you can use the operating system's built-in search tools to find them.

Smart Folders

Smart Folders are special directories that intelligently update their contents by examining the attributes of files on your system and change their listings to reflect these. Whenever you add files to your system that match the search attributes set for the Smart Folder, they will be listed in the folder without being moved out of their original location, allowing you to see all matched files across your system regardless of their actual location.

Opening a Smart Folder and then executing or opening one of its contents will open it from the original location, saving you from having to search through your system to find it. The files themselves will never be moved, as the Smart Folder contains only links to each source.

You can therefore set a Smart Folder to list all of your Raw images, regardless of where they are stored, and you can use this as the basis of a backup routine, without having to set multiple source locations within your backup software.

To create a new Smart Folder, open any Finder window (or make the Desktop visible) and press ⌘ ⌥ Ⓝ. This opens a Mac OS X search folder. Use this to search for files sporting the extension used by your camera (say .CR2, or .DNG). Leave 'This Mac' selected on the search bar, but change 'Contents' to 'File Name' so that the specified extension only applies if found in the name of a file, rather than within it. Leaving it set to Contents would include word processed files in which you have typed those characters. Mac OS X will show a live preview of your search results. Once you have applied whatever refinements you need to hone your results, clicking Save will write the search terms

Fig. 3.35 The three Raw decoding options – Versions 1, 1.1 and 2.0 – progressively add more features and flexibility to the Raw fine tuning tools at your disposal. The most basic, Version 1, offers no options at all.

Fig. 3.36 Switching to the version 2 Raw decoder gives you far finer grained control over the rendering of your images.

Fig. 3.37 Smart Folders are shortcuts to live search results, showing files that match user-defined variables. By using the file extension written by your camera as a search term, and searching on File Name, rather than Contents, you can easily isolate all Raw files on your system.

to a new Smart Folder and give it a name. Every time you add new images to your system and reopen the folder, its contents will reflect current state of play, with the new images included alongside those that existed when the folder was defined (Fig. 3.37).

You can refine it further by using the ' + ' button before saving it to define several tiers of conditions that must all be met before an image qualifies for inclusion. Say you want an easy way to monitor which Raw photos you have added to your system each day; in that case you would want to restrict the contents of the Smart Folder to just those files created in the last 24 hours. As far as Mac OS X is concerned, a file was 'created' when it first appeared in its catalog, not when a scene was captured by the camera, and so changing the first pop-up menu on the second tier of search terms from Kind to 'Created date', and the second to 'today', will trim down the list of results to something more relevant to your own particular needs (Figs 3.38 and 3.39).

The results shown in your Smart Folder are just that: results. They are not files in themselves, but links to the originals elsewhere on your system. Copying or backing up the Smart Folder, therefore, will save only a notional file of around 4 KB in size telling your system how to find the originals, not the several-hundred gigabytes of Raw files you want to preserve. Smart Folders are not intended, therefore, to be used as the first step in a manual backup process. For this you should use them as a pick list for dragging files to a separate, perhaps online location.

Fig. 3.38 By further refining your Smart Folder search terms you can restrict the results to show only those files added to your system in the last working day, making it easy to see which files still need to be backed up.

Fig. 3.39 Save your Smart Folder in an easy-to-find location. By default, Mac OS X suggests a Saved Searches directory and the option to pin it to the Sidebar so that it can be found quickly.

Alternatively, you can create a Burn Folder, which you'll use in conjunction with this Smart Folder.

Burn Folders

Burn Folders are manually updated collections of files you want to copy to CD or DVD which, despite questions over their long-term durability, remain an easy short- to medium-term backup and a convenient way to transport large collections of sizeable files between computers or users.

You can use Burn Folders in conjunction with a date-based Smart Folder by using the Smart Folder to identify recently created files, which can then be dragged from there to an appropriately named Burn Folder elsewhere on your system (Fig. 3.40).

Fig. 3.40 By combining Smart Folders with Burn Folders, you can set up a simple manual backup workflow by dragging the contents of the Smart Folder to the empty Burn Folder and then writing the results to optical disk.

As you are creating aliases within the Burn Folder to the original files referenced in the Smart Folder, these references will show up in the Smart Folder, as they will carry the same file extension – assuming that is the criterion you have used to identify them. As such, you should delete the contents of the Burn Folder after creating your disk to avoid bloating the Smart Folder with irrelevant files.

If you regularly find yourself working beyond midnight and want to use Smart and Burn Folders in this way to run a manual, ad hoc backup system, you should change the date criterion in the Smart Folder set up to identify no files created 'today', but those that first appeared on the file system within the last day by specifying 'Created date' is 'within last' 1 'day', with the sections in quote marks picked from the pop-up menus.

You can adjust an existing Smart Folder in this way by opening it to view its contents and picking 'Show search criteria' from the Shortcuts menu button.

Folder Actions

Apple introduced Automator in Mac OS X 10.4 Tiger and updated it for Version 10.5 Leopard. It is a simple programming environment that allows you to construct fairly complex routines by dragging and dropping elements into a workflow. The workflow can then be saved as an application, an AppleScript to be called from within an application, an iCal event to run at a specified time or, of most interest to Aperture users manually managing their images, a Folder action.

Folder actions are routines attached to folders on your system that monitor the contents of the folder and perform a range of tasks when they spot any changes. These can be as simple as copying the files from one place to another, launching an application to execute them, or changing their filenames and dropping old Versions in the Trash.

Each workflow routine is built using so-called Automator actions. Mac OS X ships with a wide range of these already installed, which can be expanded either by downloading new ones from apple.com/downloads/macosx/automator or installing applications accompanied by specific actions that expose their internal functions for exploitation inside Automator. Aperture is one such application (Fig. 3.41).

Fig. 3.41 Automator is a highly extensible application. Additional actions can be downloaded for free from Apple's website.

Fig. 3.42 The Automotor workspace is split into three sections showing actions and categories, alongside a large workflow creation space. A Help panel explains in more detail what each action can do.

Launching Automator and Accessing Aperture's Actions

Automator is found in your Applications folder. Opening it up you will see three distinct panes. The two on the left organize your Actions (column 2) into categories (column 1), below which a descriptive window explains what each Action does when you click on it. The larger window to the right is where you build your workflow by dragging and dropping individual Actions into it, in the order in which you want them to run. As you can pass the output of one Action into the input of another, laying out your Actions in the correct order will let you build surprisingly complex routines (Fig. 3.42).

Aperture's actions aren't shown by default, but typing Aperture into the search box at the top of the second column, while you have Library selected in the first, will bring up those Actions that it adds to the list. These Actions range from adding keywords and choosing Albums to extracting metadata and filtering images for use as Picks in Stacks.

Building an Aperture Workflow

We are going to build a workflow that will automatically rate and import into Aperture only our very best images. This lets us

Fig. 3.43 Workflows are created by dragging elements from the actions list into the workflow area to the right of the application window. Here we are building a workflow that will first take the contents of a folder and then pass them on through the workflow for manipulation.

drag and drop individual images from a folder or media card into the system and have them appear in the Library with a certain number of metadata already applied, to cut processing time once they are there. It also means that we aren't having to import a whole raft of pictures and then sort them in situ.

As we will be adding images to our Mac while doing this, it makes sense to attach this workflow to a folder, as that will also provide a space in which the images can be stored once transferred to our machine.

We want our Automator workflow to grab any new images dropped into this folder and use them as the basis of what it does next. To do this, click on Files & Folders in the first column, and then drag Get Folder Contents from the second into the main window on the right (Fig. 3.43).

Click on Library and type Aperture into the search box to call up the Aperture Actions, and then drag Import Photos into the workflow window beneath Get Folder Contents. You will see that the border surrounding the Get Folder Contents box changes to include an arrow at the bottom, which points into a tab at the top of the Import Photos box. This indicates that Automator will take whatever it finds in the specified folder (which we'll define

Fig. 3.44 Automator's Aperture actions are written to work in partnership with Aperture itself. This gives it access to the list of Projects maintained by the application. By dragging a second element into the workflow space, we have told Automator to pass the results of our first action to the second as a selection to work upon.

in the very last step) and pass it to the next step in the process: importing it into Aperture (Fig. 3.44).

The various elements of Aperture's Import dialog have been split up among several different Actions, and the only options available to you, even if you click the Options lozenge at the bottom of this section of our workflow, are where the images should be saved, whether they should be imported wholesale or used as reference files, and whether they should be deleted after they have been imported.

We have created a new Project in Aperture called Latest Import and are using this as the dumping ground for our imported photos. We will largely be importing batches of similar image types from a single shoot, so we should be able to select them as a group and move them en masse. As such, we will return to Aperture before we start importing photos of a different subject each time we use this routine and reorganize the images into their final Projects and folders.

So, we've selected Latest Import as the destination folder, chosen from the drop-down menu of Projects which is automatically populated by Automator after examining your Aperture Library. If you don't already have a Project sporting the name you want,

you'll have to create one inside Aperture: Automator can't create one itself unless you use the New Project option to create a new Project on every import.

Because we want the images to appear in our Aperture Library rather than being referenced from the folder into which we're dropping them, we have left the Import by Reference box unchecked. We also don't want the images deleted after import, as in this case we want a separate copy of the originals kept in the Mac OS X file system for use in other applications.

We'll now set some relevant metadata. Unfortunately you don't have access to pre-defined metadata sets here, but drag the Set IPTC Tags action into the workflow area and you'll see a range of attributes with which you'll already be familiar. Fill in only those sections that will be relevant to all of the images you'll import by this method at any time. Don't specify anything that is specific to just your next import session, or else you'll have to go back and change it every time you use the workflow, which defeats the object of setting it up just once as a timesaving measure (Fig. 3.45).

You should be quite safe entering a by-line, credit, contact details and copyright notice, but avoid filling in headlines, captions and keywords at this stage; they are better handled within Aperture itself.

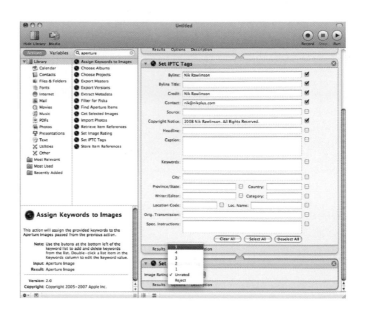

Fig. 3.46 The final step in our workflow is to rate our images with five stars. This rating is passed to Aperture and can be used as a search element. However, it will not be accessible to Spotlight searches.

These data will only apply to the images inside your Aperture Library, not the copies stored on your hard drive in the file system. As such they can't be used as Spotlight search terms to point to the originals.

Finally, as we are going to use this workflow to import only the best images into our Aperture Library as we come across them, we can safely assume that everything we import is the best of the best. So, we'll drag Set Image Rating into the workflow beneath the Set IPTC Tags section and set the Image Rating drop-down to '5' (Fig. 3.46).

Our workflow is now complete and we need to save and test it. Pick Save As Plug-in … from the File menu or use the shortcut ⌘ ⌥ S and give it a name. You then need to assign it to a folder, so click the 'Plug-in for' drop-down and pick Folder Actions, then choose Other … from the Attached to Folder drop-down.

Navigate to the parent folder you want to use and create a new folder to which you will attach your workflow. We would recommend placing it somewhere easy to find, such as your Pictures folder or the Desktop. We have called ours 5 stars and saved it on the Desktop. Using a logical name like this means we

Fig. 3.47 Save your workflow as a Folder action and attach it to a folder on your system. Whenever Mac OS X spots a change to the contents of that folder, such as images being dragged into it, it will run through the workflow and, in this case, import the additional files to Aperture, set the metadata and rate them.

can set up additional folders for images rated with four, three, two or one star if we also want to import those in the same way.

Ensure Enable Folder Actions is checked and then click Save (Fig. 3.47).

You can now close Automator and import your first photos. Choose one or more of your best images and drag them onto the new folder. You should see the Automator workflow icon – a smaller Version of the Automator application icon – briefly appear in the Dock, and an explanatory line appear in the Menu bar, telling you what it is doing. If Aperture isn't already open, it will launch, and the images will be imported into the application, have metadata attached and be rated as appropriate.

You can check that it worked by clicking in the Latest Import folder to see that they have arrived safely, and then on the 5-star smart album at the top of the Library to check that the rating was correctly applied.

Working with Metadata

Introduction

Computers aren't yet very good at understanding and interpreting images. Presented with two images, one of a horse and another of a tree, in the absence of any other information, a computer would not be able to tell you the difference, or very much else useful about them.

And so we have metadata – literally data about data; textual information that tells us everything we need to know about our images and helps us find them. Metadata allow us to say 'show me all the pictures of horses, but not the ones with trees in' and to ask other questions that go well beyond the equine and arboreal.

Broadly speaking, metadata fall into one of two camps. Either they're added by the camera at the time the image is shot or they're added afterwards. The first kind are sometimes referred to as Exif metadata are easy to deal with because, for the most part, they're added automatically and you can't edit them, but you can use them as the basis for searching for photos.

The second kind, usually known as IPTC metadata, are added and edited manually, after the event. Consisting, among other things, of caption and credit information, location data and keywords, which

describe the image content, they are the stuff that helps to differentiate between foals and foliage.

Aperture provides powerful tools for adding, editing and searching metadata. Using them to organize and identify the content in your image Library will help you locate it when you need it without wasting time. This chapter will show you how to do that.

Rating Images

Arranging the Workspace

Apart from assigning keywords, rating images is the best way to organize your image library and place a relative 'value' on individual shots. Aperture's rating system goes from zero to five stars. Images in the five star category are denoted as 'Picks' and there is also a Reject category.

Initially, at least, you'll want to skim very quickly through a Project, attaching star ratings to images, tagging obvious rejects and short-listing definite Picks. There are a number of ways to do this and you'll develop your own preferred method; here are some suggestions that you might like to use as a start.

First, select Quick Preview mode by clicking the Quick Preview button on the Control Bar. Quick Preview displays the JPEG preview, rather than the high resolution image data. Especially if you're working with Raw images, this will speed things up considerably. You don't need high resolution detail to make ratings assessments at this stage – the JPEG preview is easily good enough.

If you're working on a single screen, choose Browser and Viewer mode from the View pop-up menu on the Toolbar, selecting View > Browser & Viewer or pressing the **V** key to cycle the View modes. If Filmstrip mode isn't already set, select it by clicking the Filmstrip View button on the Browser.

If you've already stacked your images, press **⌥** **I**, or select Stacks > Open All Stacks so that you can see them all. As you're unlikely to need it while rating, you can make more space for the Browser by getting rid of the Inspectors panel: press **I** or click the Inspector button on the Toolbar. Unless you're using it to apply ratings, do the same for the Control Bar by pressing **D** (Fig. 4.1).

Fig. 4.1 This is a good single-screen setup for rating images, providing large enough thumbnails and maximizing available screen space for the Browser. Quick Preview provides good enough quality at this size to make ratings judgements. If you're working with a dual-screen setup, the selection will preview on your second monitor if View > Secondary Viewer is set to Alternate. But in this case, you're better off setting your primary screen to Browser Only view.

Using the Keyboard

The quickest and simplest way to apply ratings is using the keyboard. The keyboard commands for applying ratings are as follows:

1 to **5**: Apply one to five stars to the current selection.
9: Reject the current selection.
****: Apply five stars to the current selection (select).
0: Unrate the current selection.

When you've rated an image, use the ➡ key to advance to the next image. If you change your mind, navigate back to the previous image using the keyboard and apply a new rating. Applying a new rating automatically overwrites any existing rating.

Fig. 4.2 The Control Bar ratings buttons. From the left: Reject, Decrease Rating, Increase Rating, Select, Move Selection Left and Move Selection Right.

Using the Mouse

If you prefer to use your mouse rather than the keyboard to apply ratings, you have two options. You can apply ratings from the Metadata menu or you can use the Control Bar. To display the Control Bar, press **D**. The Control Bar has six buttons (Fig. 4.2), which are used to apply ratings; from left to right they are:

Reject
Decrease rating
Increase Rating
Select
Previous image
Next image

One of the problems with using the Control Bar is that it doesn't have buttons so that you can apply, for example, a three star rating with a single click. On an image with no rating, you have to press the increase rating button three times, which can get a bit tedious. One thing the Control Bar is very useful for is adding keywords, which we'll deal with in the following sections.

When you've gone through and rated an entire Project or folder or when you return to re-evaluate a batch of images, you'll need to adopt a slightly different approach. For one thing, you'll probably want to make a more careful comparison of similar images; for another, Aperture is more flexible when it comes to editing ratings and there are some keyboard modifiers that will help speed the process even more.

Comparing Images

Use the Browser to select the first image you want to rate and press the **Return** key to set it as the Compare item. The Compare item appears on the left of the Viewer surrounded with a green border and the subsequent image – we'll call it the Alternate – is displayed alongside on the right with a yellow border. If you're not working in Quick Preview mode the Alternate border is white.

To change the Alternate, just select a new thumbnail in the Browser – you can do this using the keyboard arrows. Any time

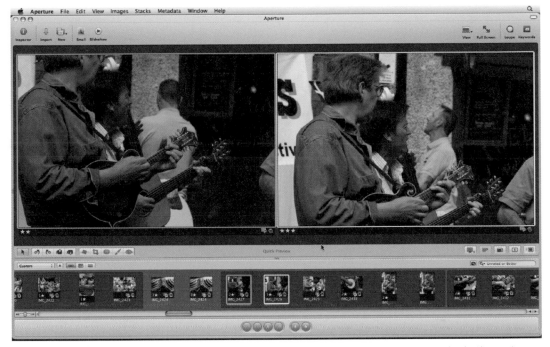

Fig. 4.3 Press **Return** to designate a selected image as the 'Compare' image – the image to its right is automatically selected as the Alternate, but you can select any other image(s) in the Browser using either the keyboard or mouse.

you want to select a new Compare item press the **Return** key. Whenever you set a Compare item in this way, the image to the right of it is automatically selected as the Alternate (Fig. 4.3).

Use the following keys to change the rating of the compare image:

⌥ **–**: decrease rating
⌥ **=**: increase rating

And to edit the rating of the Alternate:

–: decrease rating
=: increase rating

To select more than one Alternate, **Shift** or **⌘** select them in the Browser. If you have Primary only on, ratings edits will apply only to the selected Alternate which is displayed with a thick yellow (white if Quick Preview is off) border. If Primary Only is off, subsequent Alternates are displayed with a thin yellow border and ratings edits apply to all of them (Fig. 4.4).

Fig. 4.4 The Compare image (top left) is shown surrounded by a green border; Alternates have a white, or, in Quick Preview mode, a yellow border. This is the one to which your ratings changes will apply if you have Primary Only turned on. Otherwise, the change will apply to all of the Alternates – probably not what you'd want in most circumstances.

Adding IPTC Metadata

Adding metadata to images can be a time-consuming chore; but by adopting a systematic approach, you can minimize the effort involved considerably. As a general rule, try to add metadata at the earliest opportunity; this will avoid additional work down the line – adding missing information to versions or spending time searching for images that lack it.

Work from the general to the specific. Some metadata, for example photographer credits, copyright notices, location information, generic keywords and, in some cases, captions, can be batch added to all images in a shoot as soon as you've imported them or even on import. You can then go through adding specific information such as individual captions and keywords once you've rated images and chosen Picks.

Fig. 4.5 Three of the Metadata views available from the Metadata pane: L to R – General, IPTC – Expanded and Exif Expanded.

To add metadata to your images, you can use either the Metadata Inspector or the Metadata HUD. To display the Metadata Inspector, click its tab in the Inspector pane and select a view using the pop-up menu. The General view displays a combination of Camera and IPTC metadata as well as other information including rating, badges, the file name and the Project to which it belongs (Fig. 4.5).

Take a look at some of the other metadata views available. Generally, metadata fit into one of two categories: they are generated by the camera or added afterwards. Camera-generated metadata include the image date and time, information about the camera model and lens, exposure information and other technical information such as the ISO setting, image resolution and so on. These kinds of data are often referred to as Exif data in reference to the file structure (Exchangeable Image File format) used to contain them. Exif data aren't editable in Aperture or most other applications so you can't, for example, change the indicated ISO speed setting or lens focal length. These and the other Exif fields are grayed out in Aperture.

The second kind of metadata, that is added and edited in software after the image file is created, is referred to as IPTC metadata. The International Press and Telecommunications

Fig. 4.6 The IPTC – Expanded Metadata view includes Caption, Credit and Copyright Notice fields as well as Keywords.

Council is a consortium of news agencies that developed the standard for added image metadata of this kind.

IPTC metadata fields include Caption, Copyright Notice and Credit. The list is quite lengthy and, as well as fields for general press and publicity use, includes specialized fields such as standard location identification codes and audio specifications. For the full list of available IPTC fields, click the IPTC button at the bottom of the Metadata Inspector.

Using the Metadata Inspector

To add IPTC metadata to a single image, select IPTC – Expanded from the pop-up menu on the Metadata Inspector. Select the first image and enter your Copyright Notice into the Copyright Notice field (press **⌥** **G** for the © copyright symbol).

Continue to enter as much metadata as you want for the selected image. In this instance, The Caption, Credit, Copyright Notice, Province/State and Country Name categories have been completed (Fig. 4.6).

Using the Lift and Stamp HUD

To apply the same metadata to all of the images in the project, choose Lift Metadata from the Metadata menu, the Lift and Stamp HUD will appear showing the completed metadata fields and their contents in two columns. Press **⌘** **A** to select all of the images in the project (or select just those you want to stamp), then click the Stamp Selected Images button to add the metadata to all of the selected images (Figs 4.7 and 4.8).

Fig. 4.7 Use Lift and Stamp to copy metadata and apply them to multiple images.

Fig. 4.8 Use Lift and Stamp to copy metadata and apply it to multiple images.

Don't worry about captioning all of your images with a 'generic' caption. Even if you intend to add specific captions at a later stage, adding a generic caption to all the images now will ensure that every image is captioned and none falls through the cracks (Fig. 4.9).

Using Metadata Views

There are two views that display IPTC data exclusively – IPTC Expanded, which we've seen and IPTC Basic, which displays a small subset of the IPTC Expanded view. In all likelihood neither of these will provide the exact IPTC fields you need. It's also likely that you'll want to display and edit different views for different jobs or clients. For example, you may supply images to both sports and news agencies and require different IPTC metadata for each (Figs 4.10 and 4.11).

You're not restricted to adding metadata from a single category. You can combine fields from the Exif, IPTC and Other metadata panes to create whatever combination of information you find useful. You can also edit the existing Metadata views in this way.

Creating Metadata Presets

Much of the metadata you need to add to images is the same for every job – Copyright Notices, Credits, Bylines and so on are unlikely to vary. You don't want to be keying in this information every time you add a new project to your Aperture Library; metadata presets provide a way for you to add everything in one go.

By creating several presets for different clients, you can automate the process of metadata editing. This is useful if you only have one metadata set; if you include different metadata on images for different clients, it's an even bigger time saver.

In the example in Fig. 4.12, the Caption & Credits Metadata view has been used to apply Byline, Credit and Copyright Notice information to the selected images.

To create a Metadata preset using this information, select Save as Preset from the Action pop-up menu on the Metadata Inspector, enter a preset name and click OK (Fig. 4.12).

To add the preset to other images, first select them, then choose either Append with Preset or Replace with Preset from the

Fig. 4.9 You can use the Metadata pane of the Inspectors HUD to add metadata to images in exactly the same way as with the Metadata Inspector.

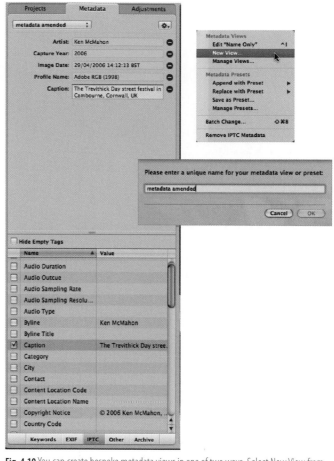

Fig. 4.10 You can create bespoke metadata views in one of two ways. Select New View from the Metadata Action pop-up menu, enter a name for the view and click OK. This creates an empty metadata view which you can populate by clicking the buttons at the bottom of the Inspector pane and checking the boxes next to the fields you want to include.

Metadata Action pop-up menu and select the saved preset from the list. Append and Replace affect only fields in which there is existing metadata in both the preset and the image to which you are applying them and do exactly what they say.

If, for example, you have added captions to all of your images, it's safe to subsequently apply a Metadata preset that does not

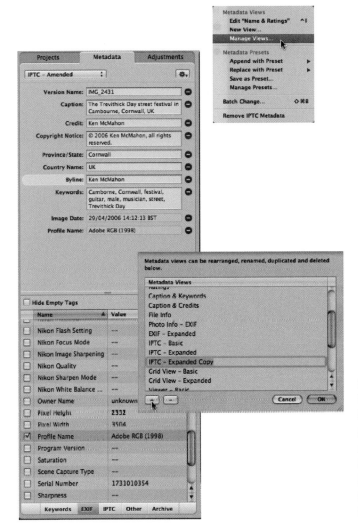

Fig. 4.11 Alternatively, choose Manage Views from the Metadata Action pop-up menu and select IPTC Expanded or any other view that has at least some of the fields you want. Click the plus sign to create a copy of the view, rename it IPTC – Amended and click OK. Now select the IPTC – Amended view from the Metadata Views pop-up menu, click the IPTC button at the bottom of the Inspector pane and add and remove fields as required.

include caption data using Replace with Preset; the existing caption data will not be replaced by a blank caption field. Having said that, it's best from a workflow standpoint to first add metadata using any presets you have defined, and then progress to captioning and other metadata tasks that require an image-by-image approach. If you accidentally overwrite

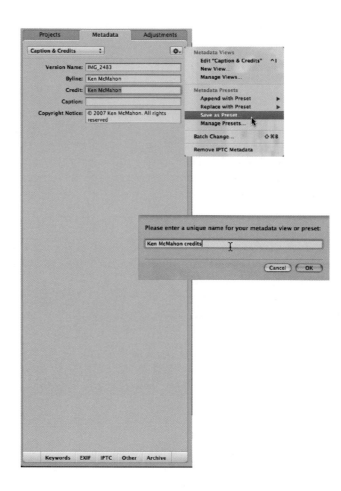

Fig. 4.12 Select Save as Preset from the Action pop-up menu on the Metadata Inspector to create a Metadata preset that you can easily apply to other images.

existing metadata fields, press ⌘ Z to undo the operation (Fig. 4.13).

Use Append with Preset to add metadata to fields in which there is already existing information: for example, if you have Metadata presets that add keywords to images that already contain keywords.

Batch Operations

Another way to apply metadata changes to multiple images is to use Batch Change, one of the options on the Metadata Action pop-up menu. If all you want to do is add or append metadata to images, Batch change doesn't really offer any special advantages

and you're better off simply applying a Metadata preset directly. Batch Change does offer some other options that you might find useful in special circumstances though.

Changing the Time

If you require accurate time metadata in your images and your camera's clock was incorrectly set you can adjust the time stamp in the Image Date Exif field (this is one of the few Exif fields that are editable). This problem most commonly occurs if you've travelled to a location in a different time zone and omitted to adjust the camera clock setting.

Fig. 4.13 Replace with Preset overwrites existing metadata for completed fields only.

Check the Adjust Time Zone radio button at the top of the Batch Change dialog box and select the time zone that was set on camera from the Camera's Time Zone pop-up menu. Then select the actual time zone of the shoot location using the Actual Time Zone pop-up menu. For example, if you travelled from London to New York select Europe/London from the first menu and America/New York from the second. In this case, 5 hours would be subtracted from the original time stamp.

Adjust Time Zone adds or subtracts time in hour increments. If you know the time difference between you camera setting and the shoot location you can enter it manually using the options on the GMT submenu. Selecting UTC sets the time to UTC (Coordinated Universal Time), which is essentially the same thing as GMT (Greenwich Mean Time). One other thing to be aware of is that these changes only apply to Versions. If you want to change the Time metadata on your Masters you need to use the Adjust Date and Time option on the Metadata menu.

The bottom panel in the Batch Change dialog box contains an 'Add Metadata From' pop-up menu which allows you to add Metadata subsets contained in some of the Metadata views. This is useful if, for example, you only want to add caption and keyword metadata. You can also add any of your Metadata presets which appear at the bottom of the pop-up menu. As with the other metadata editing methods, you can choose to either replace the existing metadata or append to them.

Fig. 4.14 Batch Change provides time adjustment as well as comprehensive tools for renaming files. You can append an index number, the date and time, a sequence number (e.g. one of four) to the existing version name or a new custom name.

Adding Metadata on Import

Once you've defined Metadata presets, you can further automate the process and save yourself extra work by adding metadata

during the import process. The Import dialog box provides the same options for adding metadata from a Metadata view or preset as those discussed earlier. See Chapter 3 for more details.

Keywords Overview

More than any other kind of metadata, keywords define the content of your images and help you locate them. Effective keywording of your images can make the difference between finding the perfect shot for a job or page upon page of also-rans. More importantly, it can mean finding the shot you know you have within a couple of seconds, as opposed to spending hours in a tedious trawl through folder upon folder of the wrong stuff.

Keyword Strategy

You might think that applying keywords to images is something that requires an individual approach and, to a degree, you'd be right. Regardless of the nature of a shoot, there will inevitably be some images that require unique keywords. The average soccer match doesn't have an abundance of goals, not many wedding shots include the priest (hopefully) and not all product shots are cutouts.

These are the exceptions, though in many situations, you'll find that most of the keywords you apply to images can be applied to all of them. Location, main subject, client, orientation – these and other generic keywords can be applied to an entire shoot. So adopt a top–down approach with keywording, first applying generic keywords to all, or most of, your shoot, and then making selections of images to which common keywords can be applied and finally adding unique keywords to individual images.

Don't be under any illusions – keywording your image library is a major undertaking. It requires a well-thought-through approach and systematic application. Adding a few hastily thought-up keywords every time, you import a shoot which is better than nothing, but will take longer than applying them from a prepared list and won't yield the full search potential of applying them in an organized fashion.

Fortunately, Aperture provides some excellent tools that make keywording less of a chore that it might otherwise be. There are three ways to add keywords to images in Aperture; which of these you choose to use will depend on the nature of the task in hand as well as personal preference (Fig. 4.15).

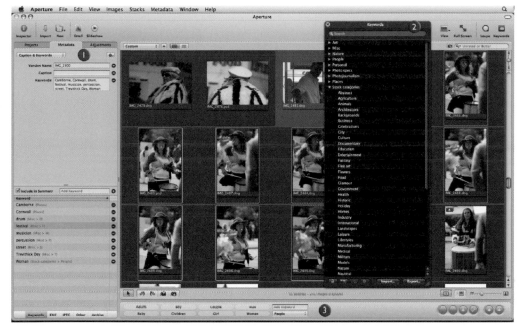

Fig. 4.15 Aperture's three Keyword tools: The Metadata Inspector (1), Keywords HUD (2) and Control Bar (3).

The Metadata Inspector shows a keywords field in certain Metadata views, for example, General, Caption and Keywords, IPTC Basic and Expanded and List Basic and Expanded. You can add keywords to selected images simply by typing them in here, separating individual keywords with a comma.

The Keywords HUD displays all of the available keywords organized into keyword groups. You can apply keywords by dragging and dropping them from the HUD onto selected images. You can also add keywords to the list and search for keywords to apply (but not search for images containing those keywords – for that you use the Query HUD).

The Control Bar has 14 keyword buttons which can be applied to selected images with a single click. The Default buttons display keywords from the predefined Aperture keyword – sets but can be configured to display your own keywords.

Adding Keywords Using the Metadata Inspector

As we've seen, you can add keywords to selected images by typing them into the Keywords field in the Metadata Inspector. Separate

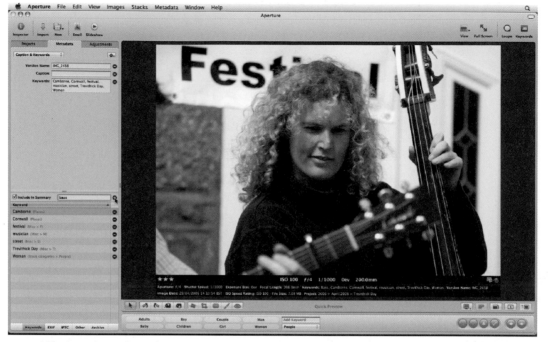

Fig. 4.16 Adding keywords using the Metadata Inspector.

individual keywords with a comma. Click the Keywords button at the bottom of the Metadata Inspector to see the keywords for a selected image. You can also add keywords by typing them into the Add Keyword field and clicking the '+' button or pressing *Return*. To remove a keyword from the selected image, press the '–' button that appears to the right of it in the keyword list.

Adding Keywords Using the Keywords HUD

To display the Keywords HUD, select Window > Show Keywords HUD or press *Shift* *H*. Unless you've previously added keywords to images, or imported images containing keywords, the HUD will list only the predefined Aperture keywords organized into keyword groups.

If you haven't yet added any keywords of your own, take a look at these; they will help you avoid duplication and provide some useful ideas on how to organize your own keywords. There are comprehensive keyword groups for wedding photography and photojournalism – even if these don't contain exactly what you need, they may provide a useful starting point.

To add a new keyword to the list, click the Add Keyword button at the bottom of the HUD and overwrite the Untitled entry that appears. To add a keyword to a keyword group, first select the keyword group, then click the Add Subordinate Keyword button and overwrite the Untitled entry that appears below the keyword group and is indented.

A keyword becomes a keyword group when subordinate keywords are added to it, but the keyword group still behaves like an individual keyword. For example, the Wedding keyword group contains many subordinates, some of which are themselves keyword groups. Nonetheless, you can still drag the 'Wedding' keyword onto an image. Doing this adds the keyword 'Wedding' to the image not, as you might expect, all of the subordinate keywords within the Wedding keyword group.

If you want to add more than one keyword to selected images either **Shift** click or **⌘** click to select them in the Keywords HUD then drag and drop them onto the selected images in the Browser.

Adding Keywords Using the Control Bar

The Control Bar provides a very efficient way of adding keywords to images in the Browser. To display the Control Bar press **D** and to display the Control Bar's keyword buttons press **Shift D**.

You can add a keyword to selected images simply by typing it into the Control Bar's Add Keyword field. The AutoFill editor helps you by producing a pop-up list with previously entered keywords. To edit the AutoFill list, select Edit AutoFill List from the Metadata menu (Fig. 4.19).

One advantage of using the Control bar over the Metadata Inspector is that you can apply keywords to multiple selected images. Unless you have Primary Only turned on, a keyword typed into the Keywords field of the Metadata Inspector will be applied to all of the selected images.

The Control Bar also contains a selection of Keyword buttons, which can be applied to either a single image or a selection of images. The displayed buttons form a preset group which you can select from the Keyword Preset group pop-up menu just below the Keyword field. Select Stock categories from the Preset group pop-up menu to see the buttons from that group. These keywords on the Control Bar buttons also appear in the Add Keyword and Remove Keyword submenus of the Metadata menu.

Fig. 4.17 The Keywords HUD. To add a new keyword, click the Add Keyword button at the bottom of the HUD and overwrite the Untitled entry.

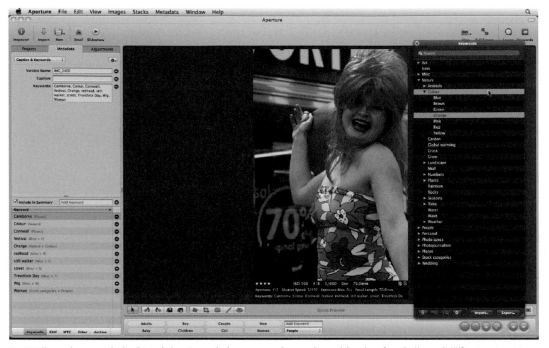

Fig. 4.18 Keyword groups and subordinates behave in exactly the same way when you drag and drop them from the Keywords HUD onto an image in the Viewer or Browser. Both the Keyword group Color and its subordinate Orange have been added to this image.

While Stock Categories are useful, they are not the most useful group of keywords to have on the Control Bar because it's unlikely that you'd be adding keywords to a group of photos with such wide ranging subjects (unless you're keywording submissions to a stock Photo Library that is). But it does demonstrate one thing, and that is that the Control Bar can accommodate up to 20 keyword buttons in a preset group.

Select the Wedding preset group from the Preset groups pop-up menu. This provides a better example of what the Control Bar is best at. With this group of related buttons under your mouse, you can quickly skim through a Project adding appropriate keywords to groups of photos or individual shots. A two-pass approach works well – first select groups of images to which you can apply common keywords and then go through them individually.

You can speed the process by using the keyboard to select images sequentially and you can also add keywords from the Control Bar using the keyboard. The first eight buttons are

AutoFill Editor

Guitarists play at the Trevithick Day street festival in Cambourne, Cornwall, UK
Liverpool Street station.
yarg!
boscundle Manor
Coombe Creek
▼ IPTC Category
▼ IPTC City
 Cornubia
▼ IPTC Contact
▼ IPTC Content Location Code
▼ IPTC Content Location Name
▼ IPTC Copyright Notice
 ©isser
 © Isabelle Risner 2007
 © 2007 Ken McMahon. All rights reserved
 © 2007 Ken McMahon
▼ IPTC Country Code
▼ IPTC Country Name
 UK
▼ IPTC Credit
 isabelle risner
 Ken McMahon
▼ IPTC Date Created
▼ IPTC Digital Creation Date
▼ IPTC Digital Creation Time
▼ IPTC Edit Status
▼ IPTC Editorial Update
▼ IPTC Expiration Date
▼ IPTC Expiration Time
▼ IPTC Fixture Identifier
▼ IPTC Headline
▼ IPTC Image Orientation
▼ IPTC ImageType
▼ IPTC Keywords
 Bass
 Chris Sharma
 Man
 sp
 Beach
 Newquay
 Cornwall
 Acoustic
 Guitar

+ −　　　　　　　　　　　　　　Cancel　Save

Fig. 4.19 AutoFill completes text fields in the Metadata Inspector, Control Bar and other places based on previously entered words. You can ignore and overwrite these, but they can save time and help you avoid entering keyword variations for the same thing (e.g. Bird and bird). Select Metadata >> Edit AutoFill List to edit the list.

Fig. 4.20 The Control Bar can contain up to 20 keywords in a preset group – in this case from the Stock Categories preset.

assigned keystroke ⌥ **1** through ⌥ **8**, the top left being 1, the bottom left 2, and so forth (Fig. 4.21).

Removing Keywords

Adding keywords is easy; removing them isn't always so straightforward. Removing keywords from individual images is

Fig. 4.21 Keyword buttons on the Control Bar can also be applied using the keyboard. Hover over the button with your mouse to reveal the tooltip with the keyboard shortcut (make sure you have 'Show tooltips on controls' enabled in Preferences).

easy enough, but removing them from a selection of images can be more problematic. The Control Bar provides some of the best options for doing this.

Given that the subject matter in an image isn't all that liable to change; the most likely reason for wanting to remove a keyword is that it was applied in error. If you realize your mistake immediately ⌘ Z or Edit > Undo Change Keywords is the simplest remedy.

As we've seen, to apply a Control Bar keyword button using the keyboard you press ⌥ and one of the number keys 1 to 8 to apply the Keyword button at that position. To remove a keyword, press *Shift* ⌥ and the appropriate number key.

You can also remove keywords by *Shift* ⌥ clicking the buttons. This doesn't restrict you to the first eight keyword buttons; you can remove any keyword that appears on the Control Bar by *Shift* ⌥ Clicking it. If the keyword you want to remove doesn't appear in group preset, just add it to one. All of these options are also available from the Remove Keyword submenu of the Metadata menu.

Creating and Editing Preset Groups

As you'd expect, you can edit the existing Preset Groups and create new ones. The final item on the Preset Groups pop-up menu, Edit Buttons, opens the Edit Button Sets dialog box. This dialog box is divided into three vertical panels. The available Button Sets are listed on the left, the contents of the selected Button Set are listed in the middle and your Keywords Library is shown on the right. A check box next to each preset determines whether it appears on the Preset pop-up menu or not.

Select the Stock Categories Preset Group from the list on the left and click the disclosure triangle to expand the Stock Categories Keyword Group in the list on the right. The Contents list in the middle tells you what buttons will appear on the Control Bar for this Preset group. There are exactly 20 of them, the maximum that the Control Bar can display (Fig. 4.22).

Fig. 4.22 Select Edit buttons from the Preset groups pop-up menu to edit the Keyword button sets that appear on the Control Bar. To add keywords to a Button set, first select the Button set in the left column, then drag the keywords from the right column and drop them in the middle one.

Scroll down the list and add the Nostalgia subordinate keyword to the Stock Categories Preset Group by dragging and dropping it onto the middle column. Because the group already had 20 buttons, Nostalgia replaces the 20th item on the list. You can reorder contents by dragging and dropping items; to remove a keyword from the list, click the minus button underneath it. List order is important because only the first eight items can be applied using the keyboard. Even if you don't plan to use the keyboard, it's helpful if you place the most often used keywords at the top of the list.

The contents of a Preset Group aren't confined to the equivalent Keyword Group in the Keyword Library; you can add any keyword to any preset group within the maximum limit of 20.

To create a new Keyword Group, click the plus sign underneath the Button Sets list and rename the untitled group, and then drag the keywords you want to add from the Keywords Library to the empty contents list. The check boxes in the Button Sets list determine whether or not Button Sets appear on the Control Bar's Preset Groups pop-up menu.

Displaying Metadata on Images

Viewer and Browser Sets

We've already seen how you can display metadata in the Metadata Inspector and HUD; metadata are also displayed on image previews in the Browser and Viewer. What you see and how they are displayed is determined by settings in the Metadata tab of the Preferences dialog box. To open it, select Preferences from the Aperture menu or press ⌘ ; and click the Metadata button at the top of the Preferences dialog box.

The panel is divided into three sections which determine how metadata are displayed in the Viewer and Light Tables, in the

Browser in Grid and List modes and in the tooltips that are displayed when you mouse over an image. Changes made in the Preferences dialog box take effect immediately, so you can see what you get when you experiment with different views.

The Viewer check box determines whether metadata are displayed in the Viewer. Below this are two Radio buttons – Set 1 and Set 2. Check the Set 1 Radio button and if it isn't already selected choose the Viewer – Basic Metadata set from the pop-up menu. If the Viewer isn't visible, display it by selecting Viewer Only from the View menu or cycle views using the **V** key – you can do this with the Preferences dialog box open.

From the Viewer Set 2 pop-up menu, select Viewer – Expanded; don't check the Set 2 Radio button just yet. Now take a look at the image. The default Viewer Basic metadata set displays the Badges and rating.

Now check the Set 2 Radio button to display the Viewer – Expanded Metadata set. This displays a lot more information including exposure information, the Version name and the lens focal length as well as the rating, badges and keywords.

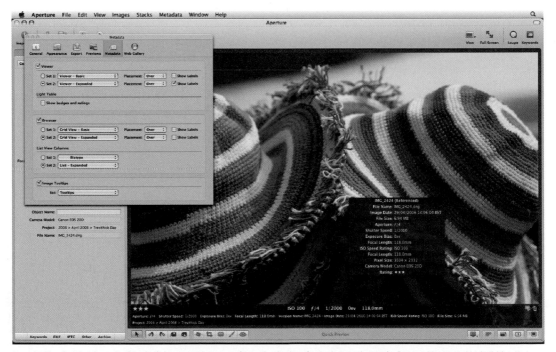

Fig. 4.23 Use the Metadata tab of the Preferences window to configure the display of metadata overlays in the Browser, Viewer and Light Tables. Here, Viewer Set 2 has been configured to display the Viewer – Expanded Metadata set.

The Placement pop-up menu controls positioning of the metadata, and Show Labels toggles the display of the metadata label, for example, 'Aperture, Shutter Speed, etc.' that accompanies the metadata (Fig. 4.23).

Now switch to Browser Only view; if it isn't already selected choose Grid View – Expanded from the Browser Set 2 pop-up menu and check the Browser Set 2 radio button. Grid View – Expanded displays Rating and Version name on the Browser thumbnails. You can select any of the Metadata views for the Browser overlay, but it's best to avoid those that include lots of fields or caption, keyword and other text – the information will be truncated if there isn't room to display it. If you need to see this information on an overlay assign it to the Image Tooltips set so that it appears when you hover over a thumbnail in either the Viewer or Browser. To turn off any of the Metadata overlays uncheck the Viewer, Browser or Image Tooltips check box (Fig. 4.24).

You can't display a lot of metadata on a Browser overlay – there isn't room and anything too long will be truncated. More detailed information can be added to the Image Tooltips set which appears when you hover over a thumbnail with your mouse.

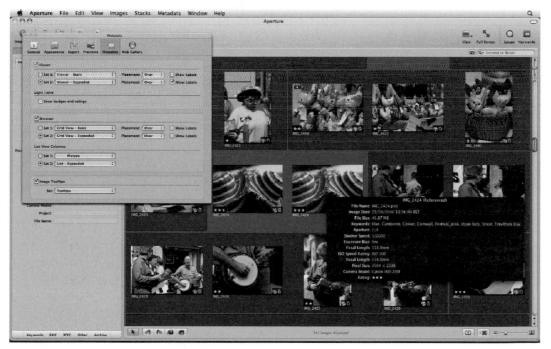

Fig. 4.24 You can't display a lot of metadata on a Browser overlay – there isn't room and anything too long will be truncated. More detailed information can be added to the Image Tooltips set which appears when you hover over a thumbnail with your mouse.

All of the Metadata views that appear in the pop-up menu on the Metadata Inspector, including custom and edited views, are available in the set pop-up menus on the Metadata tab of the Preferences window.

It would be more than a little inconvenient if you had to open Preferences every time you wanted to switch Metadata overlay sets. You can toggle between the two Metadata sets by selecting View > Metadata > Change Viewer set and View > Metadata Change Browser set or by using the keyboard shortcuts **Shift** **Y** for the Viewer and **Shift** **U** for the Browser.

Sorting and Searching

The location and retrieval of images can, without doubt, be one of the most time consuming and frustrating of all photo management tasks. Whether you need to locate an image that was shot on a specific date, for a particular client, by an individual photographer, or containing specific subject matter, Aperture can help you find what you're looking for quickly and almost effortlessly.

The success of your image searching depends to some degree on how rigorous you are in your application of metadata. Many of Aperture's search filters work on the basis of ratings and IPTC metadata fields including keywords, caption and copyright. The inclusion of these data in all of your images will make subsequent search and retrieval operations that much simpler.

Even if your images lack appended metadata, Aperture still provides you with plenty of options. Exif metadata recorded by the camera at the time of shooting can provide the basis for locating images shot on a particular date or time of day, or pictures shot with a certain lens. If you connect a GPS receiver to your camera, you can even track down images to a specific location.

Aperture's search filters can be put to work on an individual project containing only a few images or your entire Library. Either way, Aperture 2's newly rewritten database engine will return results swiftly, even on very large Libraries containing many thousands of images.

Search Tools

Although you may not be aware of it, the image thumbnails displayed in the Browser are constantly filtered. By default, Aperture

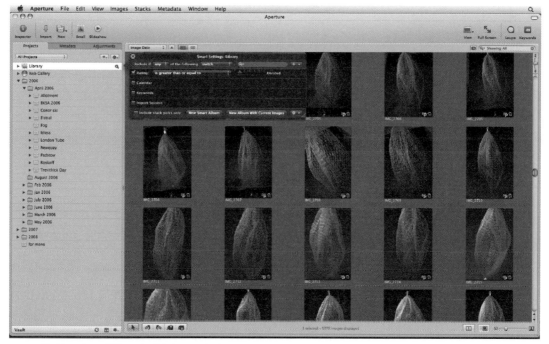

Fig. 4.25 The Library Query HUD is set by default not to display rejects.

filters out and does not display any image that had a Reject rating applied to it. This is the default setting for viewing the entire Library and individual Projects, Albums and folders (Fig. 4.25).

Click the Library at the top of the Projects panel, then click the Query HUD button that appears to the right. Any search criteria you set in the Library Query HUD applies to the entire Library as displayed in the Browser when you select Library at the top of the Projects Inspector.

In its default setting, the Rating box is checked and the Rating slider is set to the second of six tick marks on a slider. The ticks correspond to the following ratings:

Reject
Unrated

1 star
2 star
3 star
4 star
5 star

The Rating pop-up menu is set to greater than or equal to, so the Library is configured to display all images with a rating of unrated or higher. Rejected images are not displayed. If you drag the slider as far to the right as it will go, you will see only the five star images in your Library. To display all the images, including reject, drag the slider to the extreme left under the first tick mark; and to display only the rejects, select 'is' from the Rating pop-up menu.

Search criteria that you apply using The Library Query HUD only affect what's displayed in the Browser when Library is selected in the Project Inspector. This HUD allows you to carry out library-wide searches using all kinds of criteria, but there's another HUD – the Query HUD that is used for more general purpose searching and which has almost identical controls.

For now, return the Rating slider and pop-up menus to their default settings and close the Library Query HUD.

The Query HUD

The Query HUD is situated at the top left corner of the Browser. Alongside the Query HUD button is the Query search field. You can use the Query HUD to search within individual Projects, Albums or folders, and you can also use it to search the entire Library (Fig. 4.26).

For quick searching, the Query search field provides a pop-up menu with some useful search filter presets. As with the Library Query HUD, the default is set to display 'Unrated or Better' images – so you won't see rejects in this view (Fig. 4.27).

Search options on the pop-up menu include showing all images of a specific star rating or better, Show All, Unrated and Rejected. To return to the default Unrated or Better view, click the Reset button on the right of the search field.

Searching by Rating

To activate the Query HUD, click the Query HUD button to the left of the Query search field, select Edit > Find or press ⌘ F. As with the Library HUD, the default setting for filtering rated images is greater than or equal to unrated, which is displayed in

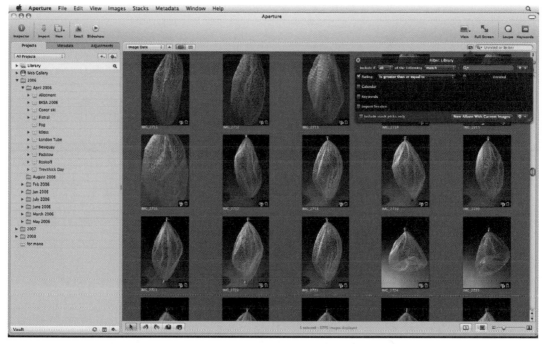

Fig. 4.26 The Query HUD.

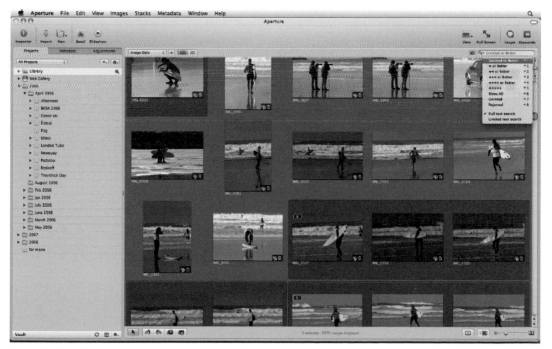

Fig. 4.27 The Query HUD Search pop-up menu provides some useful preset ratings-based searches.

Unrated or Better	^ `
★ or Better	^1
★★ or Better	^2
★★★ or Better	^3
★★★★ or Better	^4
★★★★★	^5
Show All	^6
Unrated	^7
Rejected	^8
✓ Full text search	
Limited text search	

Fig. 4.28 The Query HUD Search pop-up menu provides some useful preset ratings-based searches.

the search field as 'Unrated or Better'. You can use the Rating pop-up menu and slider as already described to search for images with a rating equal to, greater than or equal to or less less than or equal to the slider value. A more immediate way to search for images of a given rating or higher is to use the keyboard:

ctrl 1: 1 star or Better
ctrl 2: 2 star or Better
ctrl 3: 3 star or Better
ctrl 4: 4 star or Better
ctrl 5: 5 star
ctrl 6: Show all
ctrl 7: Unrated
ctrl 8: Rejected

As we've seen, all of these options are also available on the Query HUD pop-up menu, so you don't need to open the Query HUD at all to perform a ratings search. The Rating search criteria is included in the HUD so that you can search multiple criteria including ratings. We'll cover using multiple search criteria a little later.

Text Searching

You can, of course, do a text-based search by entering the text you want to search for into the search field. Aperture offers two kinds of text search, Full and Limited, which appear at the bottom of the Search field pop-up menu. Full text search includes everything – all IPTC and Exif metadata, file name, version name, anything associated with the file (Fig. 4.29).

Limited text search omits a lot of the stuff you are unlikely to need including most of the metadata other than keywords, aspect ratio, orientation, pixel size, processed pixel size, Master location and Import group. Unless you have quite specialized text search requirements, limited text search is good for general use and it's faster than full text searching. We'll look at searching for multiple text entries in a while.

Keyword Searching

Probably the majority of searching that you'll do in Aperture will be keyword searching. Provided you are methodical in your approach to adding keyword metadata to imported images,

Fig. 4.29 Type in the Query HUD search field to locate all images that contain the text in metadata. Full text search looks deeper, but for general use, limited text search is more than adequate.

keyword searching provides one of the fastest and most direct ways to find what you're looking for.

To search by keyword, first make sure that all other search criteria are unchecked and check the Keyword box in the Query HUD. This displays all of the keywords attached to images displayed in the Browser in alphabetical order. If none of the images contains keywords, the Keywords section of the Query HUD is grayed out.

Sometimes, you'll find it simpler to use a text search rather than a keyword search. This is particularly true when searching large Projects or the entire Library. The Keywords section of the HUD lists every keyword in the selection in alphabetical order in two columns. The HUD can't be resized to include more, or longer columns, so you might have to hunt through a very long list to find what you're looking for.

To display images containing a keyword, simply check the box next to it in the list. The Keywords pop-up menu provides several

Fig. 4.30 Searching for images that contain either 'Agriculture' or 'Pig', or both keywords using 'Include any of the following'.

search options. 'Are applied' simply shows images that have keywords and 'Are not applied' those that don't. The remaining options are fairly self-explanatory. For anyone not familiar with Boolean search operators, the following explanation may prove helpful.

All or Any

The Query HUD can operate using multiple search criteria. At its simplest, this might involve searching for images that contain two or more keywords. When this is the case you have two options: to search for images that contain ANY of the keywords or to search for images that contain ALL of the keywords (Fig. 4.30).

In this example, the keywords Agriculture and Pig are checked and 'include any of the following' has been selected from the Keywords pop-up menu. The result is that the Browser displays images that contain only the keyword Agriculture, images that

Fig. 4.31 Searching for images that contain both 'Agriculture' and 'Pig' keywords using 'Include all of the following'.

contain only the keyword Pig and also images that contain both keywords, a total of 371 images (the number is displayed in the center of the tool strip at the bottom of the Browser) (Fig. 4.31).

Selecting 'Include all of the following' results in only the 27 images that contain both keywords being displayed.

The Keywords pop-up menu also allows you to search for images that don't contain all or any of the selected keywords.

Searching by Date

Check the Calendar search criterion to search for images taken on a particular date or within a given period. The calendar display shows a 3-month period with dates on which images were taken highlighted white. Dates for which there are no images are grayed out. If you are viewing an individual Project, it's likely that all the images will have been shot on the same day. The Calendar

Fig. 4.32 Use the Calendar to display images taken on a specific date or within a date range. Note that, for any search, you can elect to include Stack Picks only using the check box at the bottom of the Query HUD.

is most effective when used to search either Projects containing images shot over a long period or the entire Library.

The VCR buttons above the calendar display control the displayed months and allow you to skip back and forth through the months. Click the center diamond to display 1 month either side of today's date. To display all of the images taken on a specific day, click the date on the calendar display. **Shift** click to select a continuous calendar period or **⌘** click to select multiple non-continuous dates.

For most date-based searches the pop-up menu setting 'is' will give you exactly what you need. The alternative, 'is not empty and is not', shows all the images that were not taken on the specified dates (Fig. 4.32).

Searching by Other Criteria

The Query HUD is not limited to the displayed search criteria. The Add Filter pop-up menu shows the other options that are

available including Adjustments, Exif, IPTC, File Status and Other metadata. You can explore what's available by selecting any of the options from the pop-up menu. This adds a new search section to the HUD. A text search can work equally well for some of these categories, but they can help to narrow the focus of the search (Fig. 4.33).

For example, a full text search for '300 Spartans' will find images with that text in any metadata field including the caption, file name and Exif metadata including the shutter speed and lens focal length, and it's unlikely that you're going to want included all the images numbered 30000–30099 plus 300, 3000, 1300 and all the others. But if you are looking only for images with 300 Spartans in the caption, an IPTC search is a better option. Alternatively, if you want to find all the shots using a 300 mm lens, use an Exif Search (Fig. 4.34).

The Adjustments search criteria is a new addition to Aperture 2 and allows you to search for images that have had adjustments applied using the Adjustments Inspector. It could usefully be used to search for all vignetted images, monochrome Versions produced using the Monochrome mixer, cropped images or various other adjustment criteria. You can also use the Adjustments search to locate images produced using different Versions of the Raw Decoder (Fig. 4.35).

Using Multiple Search Criteria

While quick searching using a single text entry, a keyword or a rating can often get you what you want, using multiple search criteria can really help you narrow the focus to find the handful of images or the single shot that exactly fits your needs.

A multiple search often begins with a ratings selection, though it doesn't have to. It can include any of the existing default search

Fig. 4.34 This Exif search displays all images in the St Ives project shot with a telephoto lens of 200 mm or longer.

Fig. 4.35 Aperture's new Adjustments filter lets you search for images that have had any adjustment applied – here, black and white Versions produced using the Monochrome Mixer.

Fig. 4.36 A multiple search to locate all three star images in the Library shot by Ken McMahon during April 2006.

criteria plus any that you want to add from the Add Filter pop-up menu. For example, you might want to search for all three-star-and-above images shot in a particular calendar month by a certain photographer (Fig. 4.36).

To do this, first check the Rating criteria, select 'is greater than or equal to' from the match criteria pop-up menu and drag the slider to the three star position. Next, check the Calendar search criteria, navigate to the required month, click the first date on the calendar and *Shift* click the last date. Finally, select IPTC from the Add Filter pop-up menu, check the IPTC search criteria, select Credit includes from the match criteria pop-up menus and enter the photographer name in the IPTC text field.

Multiple Text Searching

To search for multiple text fields, Select Text from the Add Filter pop-up menu. Check the Text search criteria and enter the first search term in the text field. Add second and subsequent text fields as required.

Note that the match criteria for multiple text searching are determined by the pop-up menus at the top of the Query HUD, which apply to all of the selected search criteria. Generally, you'll want these set to the default 'include if all of the following match'. But it's also possible using the available menu combinations to search for a match with any of the criteria and to search for exclusions, for example, 'do not match'.

Unlike Keyword searches, you cannot use 'all or any' options exclusively for multiple text searching within a wider multiple criteria search. For example, you can search for images that are rated three stars and above that contain the text Agriculture and Pig, by selecting the relevant rating and text criteria and choosing 'include if all of the following match'. But you can't find three star images that contain either word. Selecting 'include if any of the following match' will find those images but will also display three-star images that contain neither word. In this instance, you're better off with a Keyword search (Figs 4.37 and 4.38).

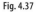

Fig. 4.37

Fig. 4.37 & 4.38 Be careful what you search for. Using 'include if any of the following match' can widen the catch to include images you probably don't want. Use a Keyword search instead.

Fig. 4.39 Click the New Smart Album button on the Query HUD to create a Smart Album using the selected search criteria.

Fig. 4.40 Troubleshooting. If at any time you don't see what you expect to see in the Browser, (e.g. fewer images than you were expecting, or none at all) one possibility is that a search filter has been inadvertently applied in the Query HUD, or applied and not removed. Aperture retains search filters applied using the Query HUD, so if you navigate away from a Project that you've searched, when you return to it, the search filters will be applied as you left them. A quick check of the Query HUD Search field will tell you if this is the case. It will show the text or icons for rating, Calendar, Keyword or Import Session searches that have been applied. To clear the search filters, click the Reset button on the right of the search field.

Saving Search Results

You can save search results to an Album or Smart Album using the buttons at the bottom of the Query HUD. The New Smart Album button doesn't appear when the Library is selected in the Projects Inspector. By saving search results as a Smart Album, you can ensure that any images added in future that fit the search criteria will also appear (Fig. 4.39).

For example, if you create a Smart Album from a search for all three star or better images and re-rate your images later, the Smart Album will update to reflect the new ratings. See Chapter 2 for more about how Smart Albums work. Don't forget that, unless you reset the Query HUD to its default 'Unrated or Better' position, it will continue to filter the contents of the selected Project or folder according to the last used search criteria (see troubleshooting; Fig. 4.40).

651 UXA

Adjusting Images

Introduction

Very few images require the array of adjustments and creative tools available in an image editing application like Photoshop. Some images are fine just the way they are and require little or no adjustment beyond what the Raw decoder produces from the data as they were shot. The vast majority require only minor tweaks, maybe small White Balance and Levels adjustments and sharpening. A few, with exposure problems or color casts, may require more intensive care.

Aperture provides all the tools you need to carry out these everyday darkroom tasks as well as features that allow you to produce more creative results. All of Aperture's Adjustment tools can be found on the Adjustments Inspector or Head Up Display (HUD). This chapter provides an explanation of how each of them works and shows how you can use them to fix commonly occurring problems and to produce black and white (B&W) and tinted monochrome versions.

The Adjustments Inspector

Everything needed for analyzing and editing images can be found on the Adjustments Inspector. With a few exceptions, such as the Red Eye, Retouch, Spot and Patch tools and Aperture 2's new edit plug-ins,

Fig. 5.1 The Adjustments Inspector.

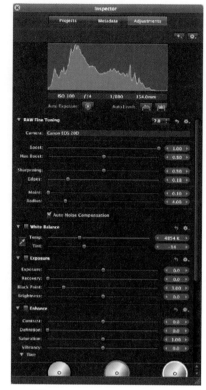

Fig. 5.2 The Adjustments HUD.

these adjustments are global – they affect the entire image. Aperture doesn't have selection tools, masks, adjustment layers or any other method for selectively applying these changes.

Each section in the Adjustments Inspector is called a 'brick'. The Inspector is organized so that the most frequently used bricks – Raw Fine Tuning, White Balance and Exposure, appear near the top of the Inspector. Bricks are also organized to provide a logical workflow progressing from top to bottom. At the very top is the Histogram, the key analytical tool which should inform most of the decisions you make about how to edit and enhance images.

Immediately below the Histogram, Auto Exposure, Auto Levels Combined and Auto Levels Separate buttons are provided for single-click automatic tonal optimization. Sometimes they produce excellent first-time results, but treat them with caution

Retouch
Red Eye Correction
Spot & Patch
Devignette
Straighten
Crop
White Balance
Exposure
Enhance
Levels
Highlights & Shadows ^H
Color ^C
Monochrome Mixer ^M
Color Monochrome
Sepia Tone
Noise Reduction ^N
Sharpen
Edge Sharpen ^S
Vignette ^V

Fig. 5.3 The Add Adjustments pop-up menu.

Remove Selected
Remove All Adjustments

Hide Camera/Color Info
Hide Histogram
Hide Auto Adjust Buttons

Color Value Options
 Don't Show Color Values
 RGB (%)
✓ RGB (0–255)
 Lab
 CMYK
 HSB
 HSL
Color Value Sample Size
 1×1 px
✓ 3×3 px
 5×5 px
 7×7 px

Histogram Options
✓ Luminance
 RGB
 Red Channel
 Green Channel
 Blue Channel

Fig. 5.4 The Adjustments Action pop-up menu.

and think of them more as a place to start or as an indication of the direction to take with your manual corrections.

The Adjustments Inspector (Fig. 5.3) has an Add Adjustments pop-up menu and an Adjustment Action pop-up menu. The first of these contains additional adjustments that don't appear on the Adjustments Inspector by default. These include Vignette and Devignette, Straighten, Crop, Monochrome Mixer, Noise Reduction and Edge Sharpen. The Adjustments Action pop-up menu also includes Histogram display options, color value sample and display options and an option to remove all adjustments from the current selection (Fig. 5.4).

The Adjustments HUD

The Adjustments HUD replicates the adjustments and controls on the Adjustments Inspector and works in almost exactly the same way. In this chapter, the terms Adjustments HUD and Adjustments

Fig. 5.5 Press the 🅕 and 🅗 keys to activate full screen view and display the Adjustments HUD. Position your mouse at on the top edge of the screen to display the toolbar and at the bottom edge of the screen to display the Filmstrip.

Inspector are used interchangeably. HUDs are free-floating; their purpose is to provide a more flexible workspace and to allow you to make edits in Full Screen mode without unnecessary screen clutter.

Making image adjustments requires continual visual assessment of the changes you make using the controls on the Adjustments HUD. The best way to do this is in Full Screen mode, often at 100% view magnification and with nothing to distract from as objective an assessment as possible of the image color, tonal values and other qualitative factors and how they are changing in response to your inputs.

You can display the Adjustments HUD and enter Full Screen view by selecting Window > Show Inspector HUD followed by View > Full Screen, then clicking the Adjustments button on the Inspectors HUD. But it's much simpler using the keyboard shortcuts 🅗 and 🅕 in any order. Press 🅕 again to exit Full Screen view (Fig. 5.5).

In Full Screen view, position the cursor on the top edge of the screen to display the Toolbar and at the bottom edge of the screen to display the Filmstrip. When making adjustments it's often helpful to display the Master alongside the adjusted Version to provide a before-and-after comparison.

The Adjustment HUD Brick by Brick

The Histogram

Aside from the image itself, the Histogram provides more information about digital image tonal and color quality than

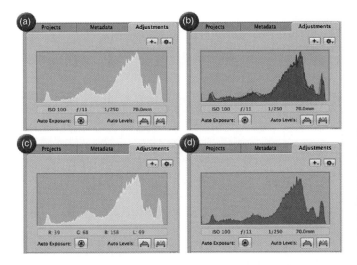

Fig. 5.6 The Histogram can be configured from the Adjustments Action pop-up menu to display luminance (a); overlayed red, green and blue channels (b); or individual (red here) color channels (c). When the cursor is positioned over the image the RGB values of the underlying pixels are displayed, otherwise camera Exif data is shown (d).

any other single analytical tool. It can tell you if there is clipping of the highlight or shadow detail; if an image lacks contrast; even if there is a color cast.

Aperture's Histogram works in much the same way as those on digital SLR (dSLR) cameras and in other image editing applications such as Photoshop. If you're not sure how the Histogram works, see the detailed description on page 196. The Histogram Options section of the Adjustments Action pop-up menu provides five view options: luminance, RGB, and individual red, green and blue channels (Fig. 5.6).

Show Camera/Color Info displays the red, green, blue and luminance values of pixels immediately below the cursor. Use the Loupe to position the cursor more accurately. The Color Value Sample Size determines the sample size used to produce the color value and can be set at the individual pixel level, or taken from an averaged sample up to 7 × 7 pixels square. When the cursor isn't over image pixels the ISO, aperture, shutter speed and focal length data is displayed. You can hide this information as well as the Auto Adjust buttons and the Histogram itself.

Raw Fine Tuning Brick

For the most part, the process of converting Raw data into an RGB file in Aperture happens automatically. See Chapter 1 for a

detailed explanation of what this involves. The Raw Fine Tuning brick appears only when a Raw file is selected. The Decode Version pop-up menu provides four decoder options. Version 2.0 is the most recent and best Raw decoder. It's the default option and the one you should use in nearly all circumstances. The 2.0 DNG decoder is for decoding RAW files for which Aperture has no native support that have been converted to Adobe DNG format. For more detailed information about using these decode options, migrating files from earlier decoder versions and the other controls in the Raw Fine Tuning brick, see Chapter 1.

White Balance

White Balance is the process of evaluating the color of ambient light in a scene. This determines which surfaces should appear neutral in color and from this all other color values are derived. Incorrect White Balance results in an unnatural color cast.

White Balance is initially determined in-camera using a preset, such as Daylight or Tungsten, or an automatic White Balance setting. If you shoot Raw, the camera White Balance setting becomes largely irrelevant, because you can set White Balance retrospectively using Aperture's White Balance controls. Shooting with auto White Balance set on the camera is a good general policy, alternatively if your normal policy is to determine White Balance by shooting a gray reference card this remains a valid option.

The White Balance brick has three controls: an eyedropper, used to set White Balance from a neutral area in the image; a Temp slider which initially indicates the camera White Balance, color temperature and a Tint slider.

Using the eyedropper, click on a neutral area in the image – a gray card if you use one, a white wall or other neutral area. When you do this you'll see the Temp and Tint sliders take up new positions based on the sample area.

The Temp slider indicates the assessed color temperature in Kelvin of the ambient light conditions in the scene. Dragging it to the right and increasing the color temperature value therefore makes the scene warmer. By dragging the slider to the right you are telling Aperture that the light in the scene was bluer than the White Balance setting indicated by the camera, and therefore the image becomes warmer (Fig. 5.8).

Fig. 5.7 Use the eyedropper to set the White Balance by clicking on a neutral white, gray or black area of the image. The Loupe allows you to make a more accurate selection. The pixel value of the sample (defined in the Adjustments HUD Action pop-up menu) is shown. The closer together the red, green and blue values are, the closer to neutral the sample is and, therefore, the less shift will be applied.

Fig. 5.8 With the eyedropper adjustment made, use the Temp slider to fine tune the White Balance adjustment.

Fig. 5.9 This image has been overexposed by a full stop. Dragging the Exposure slider to the left to a value of −1.13 restores all of the highlight detail producing a textbook Histogram with a full tonal range.

Once the White Balance is set to your satisfaction, use the Tint slider to remove any green or magenta color cast. Moving the slider right adds magenta; moving it to the left adds green.

Exposure

The Exposure brick provides tools for improving overall image tonality and correcting common problems like over and underexposure. It has four sliders: Exposure, Recovery, Black Point and Brightness. Don't think of the Exposure brick as something to be used only for problem images. Even correctly exposed well-balanced images can be improved with minor Exposure adjustments (Fig. 5.9).

Use the Exposure slider to correct over- and underexposed images. Dragging to the right increases 'exposure'; dragging to the left decreases it. The Exposure slider range is −2 to +2; the value slider (drag in the exposure value field) extends this to −9.99 to +9.99. Exposure is very effective at restoring highlight and shadow detail in images that are up to two stops either side of the correct exposure setting; beyond that, even with Raw images, good quality results are hard to achieve.

The Recovery slider is a new addition in Aperture 2 designed to rescue 'blown' or clipped highlights in images that are overexposed or where the camera sensor has been unable to record the highlight detail in a subject with high dynamic range (HDR). The difference made by using the Recovery slider can be quite subtle, but it is effective when used in conjunction

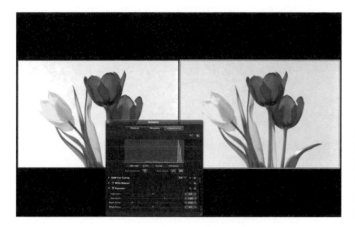

Fig. 5.10 The Recovery slider is used to recover blown highlight detail – here it has done a first-rate job of recovering the detail in the yellow tulip on the left. In most circumstances, you'll need to use the Recovery slider in combination with other tonal adjustments to achieve a good result.

with Exposure and other tonal controls such as Highlights and Shadows. See the section on correcting exposure problems later in this chapter (Fig. 5.10).

Black Point controls shadow detail and can be used to add contrast to the shadow regions or to restore detail to crushed shadows. A check of the Histogram will reveal whether an image requires Black Point adjustment. If the left side is clipped, drag the Black Point slider to the left to restore shadow detail. If the Histogram stops short of the left side, drag the Black Point slider to the right to increase contrast in the shadows.

Brightness adjusts luminance values of image pixels across the entire tonal range whilst maintaining the Histogram end points – in other words it won't clip shadow or highlight detail.

Enhance

The Enhance brick consists of five controls: Contrast, Definition, Saturation, Vibrancy and Tint. Contrast and Saturation are image editing standards. Contrast increases or decreases image contrast by 'stretching the Histogram', i.e. extending B&W points and evenly redistributing the values in between.

Saturation increases or reduces color saturation of all the hues in the image by the same amount. In-camera processing of JPEG files usually applies a preset saturation boost and Raw files can appear desaturated by comparison. Small increases in saturation produce a marked visual effect and few images will need more than 1.20 to add punch to the colors. Keep an eye on the

Fig. 5.11 Contrast vs. Definition. The contrast slider in the Enhance brick increases or decreases overall contrast in an image by stretching the Histogram, moving pixels out towards the edges, whitening light tones and making dark grays blacker. Note the difference in the Histogram for the original (left) and contrast adjusted version (center). Aperture 2's new Definition slider adds punch to images by increasing contrast in local areas without affecting the overall image contrast. The Histogram of the definition adjusted image (right) is almost identical to that of the original.

Histogram to avoid color clipping. Dragging the Saturation slider to the extreme left desaturates images to monochrome, but provides no tonal control. Use the Monochrome Mixer to produce B&W images. See the Color to B&W example on page 219 for a detailed explanation of how to use the Monochrome Mixer.

Definition is a new tool which increases local contrast without affecting overall image contrast. It can help to reduce haze and to improve images that, despite having a full tonal range, appear flat or muddy. The default position for the definition slider is on the far left at 0 and the maximum is 1.0.

Drag the slider to the right to increase definition. Note that, as you do this, overall tonality is unaffected and the Histogram display remains unchanged. Definition produces a similar effect to applying Photoshop's Unsharp Mask filter with a low amount and high radius value, a technique commonly used to make images 'pop' (Fig. 5.11).

Vibrancy is another tool that's new to Aperture 2. Like Saturation, it changes the saturation of colors, but not all hues are equally affected and the results are more subtle than with the Saturation slider. Colors that are already well saturated are affected less by increasing Vibrancy than those that are muted. Likewise, when reducing Vibrancy, the most saturated colors are more affected.

Fig. 5.12 Saturation vs. Vibrancy. The center image shows the original (left) with a saturation adjustment of +2.0, which is the maximum that can be applied using the slider. Saturation increases uniformly regardless of the existing pixel color values. Note from the center Histogram that the saturation increase has resulted in color clipping of the blue channel. The Vibrancy adjustment (right) has a maximum limit of one and it doesn't affect pixels which are already close to full saturation, producing a more balanced, natural-looking result.

Vibrancy is configured to ignore skin tones so you can safely use it to change color saturation in portraits and model shots (Fig. 5.12).

The Tint controls allow for selective color correction in the shadow, midtone and highlight tonal ranges. To correct a color cast in the highlights click the White eyedropper and sample a highlight region of the image in which the cast is most prominent, then make fine tuning adjustments using the color wheel.

The Tint controls are effectively selective White Balance controls. As such, changes to White Balance will affect Tint adjustments and vice versa. Though you don't need to adhere rigidly to it, the layout of the Adjustments HUD provides a good guide for adjustment workflow. Tint adjustments are best made after overall White Balance has been set.

Levels

Another standard image editing tool, Levels, provides control over tonal distribution via three sliders which remap shadow, mid-tone and highlight regions of the Histogram. Check the Levels box to activate the adjustment and display the Histogram.

The Black, Gray (midtone) and White Levels sliders below the Histogram provide three adjustment points. Click the Quarter

Fig. 5.13 Use Levels to improve image tonality. The most commonly applied Levels adjustment involves dragging the White and Black Levels sliders to touch either end of the Histogram, improving image contrast. Dragging the Gray Levels slider to the left increases brightness in the midtones.

tone controls button to display two additional adjusters for the shadow and highlight quarter tones. Use Levels to increase contrast in images where the Histogram display falls short of either end of the graph and to increase (or decrease) brightness in the midtones. Generally speaking, the way to do this is to drag the B&W Levels sliders until they touch either end of the Histogram – this is more or less what the Auto Levels button under the Histogram does. Use the Channel pop-up menu to adjust the red green and blue channels individually, for example, to neutralise color casts.

Highlights and Shadows

Highlights and Shadows is another tool designed for recovering detail at the extremes of the tonal range. The Shadows slider works well on images with a full tonal range that are lacking shadow detail due to a subject with a high dynamic range having been exposed to retain highlight detail, e.g. silhouettes. With underexposed images that have already undergone Exposure and Levels adjustments; however, there is a significant risk of introducing unacceptable levels of noise into the shadow areas. Keep an eye out for this by viewing images at 100% (press **Z**) or using the Loupe to examine shadow areas while using the Shadows slider.

Click the disclosure triangle to display the Highlights and Shadows advanced controls. Generally speaking, you won't need to bother with these advanced controls, which is why they are normally tucked away under a disclosure triangle. However, with

Fig. 5.14 The Shadows slider of the Highlights and Shadows brick acts like a fill flash, restoring detail in dense shadow areas.

Fig. 5.15 The Highlights slider of the Highlights and Shadows adjustment is one of several tools that help restore detail to blown highlights. It works well on its own, better if used in conjunction with other highlight rescue adjustments like Exposure and Recovery.

some images, for example, those with specular highlights such as reflections on water or metal, you may be able to improve on the results achieved using the basic controls.

Mostly with these controls it's a case of suck it and see; knowing what they do is often not nearly as helpful as seeing the results, so experiment. The Radius slider defines the size of the clump of pixels that Aperture analyzes to determine what constitutes a highlight. The default position for Radius is 200. Increasing it effectively reduces the overall effect of the Highlights slider and can be helpful if large amounts of Highlights adjustment result in unnatural looking flattened highlights.

Color correction controls the saturation increase in shadow detail uncovered using the Shadows slider; the default position

is 0. Recovered shadow detail often doesn't match surrounding areas for color, increasing saturation using the Color Correction slider can help remedy this.

The High Tonal Width slider determines the tonal range that the Highlights slider affects. If you increase the High Tonal Width by dragging the slider to the right, more of the highlights – extending into the light three-quarter tones – will be affected by the Highlights adjustment. The Low Tonal Width slider does the same thing for the Shadows adjustment.

Mid Contrast adjusts contrast in the midtones. Like contrast, it stretches the Histogram, but in a non-linear fashion, pushing the midtones out to the quarter and three-quarter tones. You'd use this to compensate for compression of midtone values caused by Highlights and Shadows adjustments; if this is necessary, you might first want to experiment with reducing the High and Low Tonal Width settings.

Color

The Color brick provides controls for selective Color adjustment and can be used to subtly modify, for example, skin tones, skies, or foliage or for more radical color replacement tasks such as changing the color of clothing. Even in the absence of selection and masking tools these controls can do a very effective job.

The range of the color adjustment is initially set by selecting a base color from one of the six color swatches at the top of the brick. To more accurately define the base color use the eyedropper to sample pixels from the image. The Range slider expands or contracts the range of colors either side of the base color that is affected by the Color adjustments. If you want to make adjustments to more than one hue range, click the Expanded View button at the top of the Color brick to display separate controls for each color (Fig. 5.16).

The Hue slider shifts the color value of pixels within range of the base color. The extent and direction of the shift is controlled by the Hue slider. It helps if you picture the color values you are attempting to adjust positioned on the visible spectrum, or a color wheel, much in the way that the base color swatches at the top of the Color brick run from red through yellow, green, cyan and blue, to magenta.

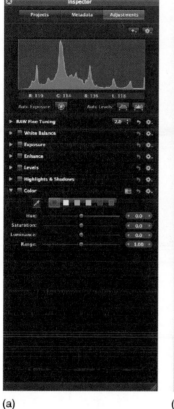

(a)

(b)

Fig. 5.16 (a) The Color brick in default view showing the six base color swatches (b) and in expanded view displaying individual Hue, Saturation, Luminance and Range sliders for each color. Use the color eyedropper to select a custom base color from within the image.

When you select, for example, the blue swatch, note the color on the hue slider, which extends from blue in the center to cyan at one end and magenta at the other. Drag the slider to the right to shift blue pixels in the image towards magenta and to the left to shift them towards cyan.

The initial value of the hue control when the slider is in the center position is zero. The values at either end of the slider are 60 and −60, which result in a shift of one color position, i.e. blue to cyan or magenta. Using the value slider extends the shift range to 180 and −180. As you might expect, this shifts hues 180 degrees on the color wheel to produce their complementary color. In other words a hue value of 180 turns blues to yellows and produces the same effect as dragging the value slider in the opposite direction to −180.

Fig. 5.17 When colors in an image are well isolated, like the red in this vintage car, changing them is relatively straightforward. Select the Red swatch, or use the eyedropper to sample from the image and drag the Hue slider until you get the color you want. Dragging the slider to its limit shifts the hue one swatch along, 60 degrees around the color wheel, in this instance from red to magenta. You can use the Value slider to go all the way to 180 degrees — the complementary of the original color.

Fig. 5.18 It isn't always so easy to isolate individual colors. In this case shifting the hue value of the reds in the image affects the skin tones as well as the kite. In the absence of more sophisticated color sampling or masking tools the options here are to use a color adjustment plug-in, or round trip the image to Photoshop.

Fig. 5.19 Use a Color adjustment to boost saturation of specific colors. Here, sampling the sand with the color eyedropper allows us to boost the saturation of the beach, making it look warmer and more inviting, without affecting the sea and sky.

The Saturation slider is used to increase or decrease color saturation of pixels within the selected color range and luminance changes the brightness of those pixels. Used on its own, you can use the Saturation slider to selectively boost saturation. For example, by selecting only yellows you can boost the saturation of sand in beach shots without affecting blue skies (Fig. 5.19).

With subtle color changes it can often be difficult to gauge the extent of the selected color range and, therefore, to know what parts of the image are being affected. The best way to proceed in such circumstances is to make your selection using either the eyedropper or color swatches and then increase the saturation to its maximum of 100. It will now be obvious which pixels are affected by any hue changes – drag the Hue Value slider to 180 to make the selection even more obvious. Next, use the Range slider to extend or limit the range of selected pixels until only those colors you want to change are affected. Finally, return the Saturation and hue sliders to their original positions and make the desired color adjustments.

When attempting extreme color changes, the chances of a successful outcome will be increased if you choose hue shifts that are appropriate given the tonal qualities of the original color. It's unrealistic to expect to turn bright yellow flowers into dark blue ones, but if you settle for pale blue, you'll probably succeed.

Other Adjustments

The Adjustment tools covered in the next section of this chapter don't appear on the default Adjustments Inspector/HUD; you add them as required from the Add Adjustment pop-up menu.

Spot and Patch and Retouch

Aperture's retouching tools consist of the Spot and Patch tool and the Retouch tool. Both are essentially clone tool variants and can be used to retouch blemishes such as sensor dust spots and skin blemishes and for basic cloning operations. Spot and Patch was introduced in Aperture 1.0 and superseded by the more capable Retouch tool in Aperture 2. The Spot and Patch tool has been retained for reasons of backward compatibility.

Aperture 2 allows you to work with images that were previously edited with the Spot and Patch tool, but for all other retouching jobs the Retouch tool provides more options and produces better results. For the sake of completeness, a brief description of the functioning of the Spot and Patch tool is given below.

The Spot and Patch tool has two modes – Spot and Patch. The former is used to retouch textureless areas of flat color, for example, to remove dust spots from sky areas. A resizeable target disk is positioned over the spot, and color detail from surrounding pixels is used to automatically retouch it (Fig. 5.20).

In Patch mode, a source area is also specified and the tool works like a more conventional cloner. In both modes the Adjustments

Fig. 5.20 Aperture's Spot and Patch tool has been superseded in Version 2 by the more able Retouch. Use it to edit images that have been spotted and patched in earlier Versions or better still, remove the Spot and Patch adjustments and redo them using Retouch.

Inspector provides controls for the radius (the size of the spot or patch), (edge) softness, opacity, detail (blur) and angle.

The retouch tool works more like a brush – retouching is applied using brush strokes, rather than by defining a circular target area. Like its predecessor, the retouch brush has two operating modes – repair and clone. Repair is used to retouch spots, blemishes and other unwanted detail and to cover the offending pixels using both color and texture detail from other parts of the image, usually closely matching pixels from the surrounding area.

To use the Retouch tool either select it from the Toolbar or choose Retouch from the Add Adjustments pop-up menu on the Adjustments HUD. The Retouch HUD displays the tool's controls and a Retouch brick, with a Stroke Indicator, and Delete and Reset buttons, is added to the Adjustments HUD (Fig. 5.21).

The default mode for the tool is repair. Use the Radius slider or, if it has one, the central scroll wheel on your mouse to change the brush size to suit the area to be retouched and if necessary adjust the edge softness and opacity of the brush using the other two sliders.

'Automatically choose source' selects an area matching in texture and color for you. It works well in most circumstances and you should leave the box checked at least for your initial attempts. Detect edges is a useful feature which masks edge detail from the effects of the Clone tool so that you can, for example, repair a dust spot in the sky without cloning out the branches of a tree.

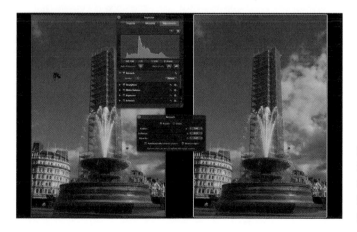

Fig. 5.21 Repairing with the Retouch tool. The Retouch tool automatically retouches out blemishes or, in this case a bird, using pixels from the surrounding area, or source pixels chosen by ▨ clicking. It's quick and produces seamless results with very little effort.

Fig. 5.22 In Clone mode the Retouch brush works like a conventional non-aligned clone brush. ⌥ click to define the source point from which pixels are copied to the destination. The brush has no 'aligned' mode; each stroke is cloned from the original source point. Strokes can be deleted in reverse order to which they were applied using the Delete button on the Retouch brick of the Adjustments HUD.

If your initial attempts using these settings don't produce successful results uncheck the Automatically choose source button, hold down the ⌥ key and click using the crosshair target on a suitable source area.

If you click the Clone button in the Clone tool HUD the Clone tool behaves like a conventional clone brush – copying pixels from a specified source area to the destination. ⌥ click to define the source then paint over the target area having first defined the brush size, softness and opacity (Fig. 5.22).

If you make a mistake while repairing or cloning, press ⌘ Z to undo the last brush stroke. Continue pressing ⌘ Z to undo your brush strokes in reverse order. You can also remove strokes in the reverse order to which they were applied at any time by pressing the Delete button on the Retouch brick in the Adjustments HUD. To remove all retouching click the Reset button.

Its improved ability to deal with texture and the excellent edge detection feature mean that you can now deal with most minor retouching jobs within Aperture. For more involved cloning, however, you'll still need to round trip images to Photoshop.

Vignette and Devignette

A vignette is an image that fades or darkens at the edges. The term is widely used to describe any image with a soft-edged border, but Aperture's Vignette adjustment produces a more subtle effect that fades from the center becoming darker at the edges. This simulates an effect common in early photography

Fig. 5.23 Aperture's new Vignette adjustment is a subtle affair. The Gamma Version shown here produces a more pronounced effect than the alternative, Exposure, which reproduces the kind of light falloff typical with older wide-angle lenses.

caused by light falloff at the periphery of images due to lens limitations. It was also simulated in the darkroom using oval-shaped templates to burn image edges on an enlarger. Vignetting isn't entirely an historical artifact; it's still common with super-wide angle and fisheye lenses and Aperture's Devignette adjustment can be used to rectify the problem.

To add a Vignette adjustment, select Vignette from the Add Adjustment pop-up menu. There are two basic vignette types – Gamma and Exposure – selected from the Type pop-up menu. Gamma vignettes are intended for artistic effect and are more pronounced than Exposure vignettes, which are designed to simulate a lens-produced vignette (Fig. 5.23).

There are only two controls for both types of vignette. Amount controls the degree of edge darkening and size specifies the distance from the center of the image at which the effect begins. Vignettes are applied after cropping so, if you crop an image after applying a vignette, the vignette is freshly applied to the cropped image to maintain the visual effect.

Devignette does the opposite of Vignette: it lightens image edges restoring brightness in image areas that have been darkened due to light falloff at the periphery of the image circle produced by the lens. In modern super-wide angle and fisheye lenses vignetting, if it exists at all, is likely to be marginal and restricted to the very edges. You'll need to experiment with the amount and size parameters to find the right settings for specific lenses, which you can then save as a preset using the Action pop-up menu (Fig. 5.24).

Fig. 5.24 Devignette is used to compensate for light falloff at the periphery of images, a problem these days mostly confined to ultra-wide angle and fisheye lenses. If you crop an image to which Devignette has been applied, the vignette is applied first to maintain the correct parameters for the lens.

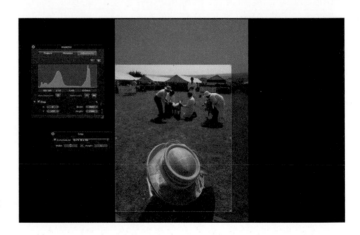

Fig. 5.25 Drag with the Crop tool to define the Crop area. Use the Crop HUD to constrain the aspect ratio to the formats available from the pop-up menu. Like all other adjustments in Aperture, Crop is reversible and the original image dimensions can be restored at any time.

Crop and Straighten

Crop and straighten adjustments can be applied either by selecting them from the Add Adjustment pop-up menu or by selecting the Crop or Straighten tools from the tool strip. If you do the latter the appropriate brick is automatically added to the Adjustments Inspector and to subsequently access the controls you need to select the appropriate tool.

To crop an image drag with the Crop tool to define the crop area and drag inside the crop area to reposition it. A selection of size

Fig. 5.26 The Straighten tool provides a grid to help you align horizontal and vertical edges. Edges are automatically cropped.

presets is available from the Crop HUD. To remove a crop, or any other 'additional' adjustment from an image, select the brick and choose Remove selected from the Adjustment Action pop-up menu.

The Straighten tool is actually a Crop and Straighten tool in one. To use it, select it from the tool strip and drag inside the image to simultaneously rotate and crop it to maintain straight edges. A grid overlay appears so that you can align horizontal or vertical edges. Note that when the Crop tool is selected you can use the slider in the Adjustments Inspector to rotate the image. Likewise, you can enter specific x and y, width and height values when cropping.

Monochrome Mixer, Color Monochrome and Sepia Tone

The Monochrome Mixer is a channel mixer control that converts color images to monochrome with a high degree of control over tonal reproduction. It can be used to simulate the effects of colored filters with B&W film. In film photography, colored filters are used to lighten same color tones and darken complementary colors. Typically, yellow, orange or red filters are used in landscape photography to darken blue skies and emphasize cloud detail.

The Monochrome Mixer default preset combines 30% of the red channel, 59% green and 11% blue. This takes most of its

Fig. 5.27 The Monochrome Mixer presets simulate colored filters for B&W photography. Clockwise from top left: Original, Monochrome (30% red, 59% green, 11% blue), red, orange, yellow, green, blue and custom (68% red, 36% green, 0% blue).

information from the green channel, which, due to the make-up of the Bayer mosaic used by most dSLRs, contains most of the image data and is a good all-round solution.

The preset pop-up menu contains five color filter options and a custom filter which you can define yourself. Additionally, as with all of the Adjustments you can create presets. To find out more about creating presets, see page 201.

Color Monochrome produces a color tinted image. The name is in fact a little misleading as a monochrome image is produced only when the effect is applied at its maximum setting of 1.0 – the default position of the adjustment's Intensity slider. Between 0 and 1 the image is progressively desaturated and tinted. Only at the higher settings of around 0.8 and above is most of the color removed from the image. This can be used to produce a quite pleasing effect which combines a desaturated, almost hand-colored look with tinting. The default sepia tint color can be changed using the Colors Palette.

Sepia Tone is effectively the same as the Color Monochrome adjustment without the option of changing the tint color. For more detailed information on using the Monochrome mixer and tinting images, see the section on creative techniques starting on page 209.

Noise Reduction

Digital noise becomes apparent in images made at high ISO settings and using long exposure times. It can also become an

Fig. 5.28 Drag the Noise Reduction Radius slider to reduce the noise apparent in images shot at high ISO ratings, with long exposures, or those that have undergone tonal re-adjustment of the shadows. Restore blurred image detail using the Edge Detail slider.

issue where underexposed images are corrected to produce an acceptable result. Aperture's Noise Reduction filter is designed to reduce digital noise.

There are two controls: radius and edge detail. Noise Reduction attempts to isolate noisy pixels by comparing them with neighboring pixels. The radius control determines the size of the area analyzed. In practical terms the higher the radius value, the more aggressively the noise reduction is applied. High radius values, however, lead to overall softening of the image. The Edge Detail slider can be used to restore sharpness to image detail affected in this way. Inevitably, noise reduction involves a compromise; at some point, you will find radius and edge detail settings which result in acceptable noise reduction without unacceptable loss of image detail (Fig. 5.28).

Sharpening Tools

Possibly because Aperture and other tools provide more than one way of doing it, sharpening is a process which is often not very well understood. Though it's not a common misconception among photographers, it's worth clarifying that sharpening is not intended to fix images that are out of focus. Digital image editors, Aperture included, provide a wealth of tools for fixing exposure problems but, if your images are out of focus, you're out of luck and those shots are destined for the reject pile.

All Sharpening tools work on the same principle – that image sharpness can be enhanced by increasing contrast in local areas of

existing high contrast. To put it another way, if neighboring pixels in an image vary widely in luminance, that's probably an edge, and the edge can be sharpened by further increasing the contrast.

The difficulty for sharpening algorithms lies in differentiating true edges from other image detail. Over-zealous sharpening can exaggerate noise, make skin, skies and areas of flat color look granular, exacerbate fringing caused by chromatic aberration and cause 'haloing' (light fringing) in very high contrast edges.

But don't let that put you off. Nearly all digital images, and certainly all Raw images, require some level of sharpening and, used judiciously, sharpening can radically improve overall image definition.

Aperture provides three sharpening tools designed for two different purposes. The first of these is the Sharpening slider in the Raw Fine Tuning brick. This Sharpening filter is designed to overcome the softness that results as a consequence of the demosaicing stage of the Raw conversion process. For a more detailed explanation of this, see Chapter 1.

Some people prefer to deactivate Sharpening by dragging the Sharpening slider all the way to the left and do all of their sharpening outside of the Raw decoding process. If there is a quality advantage to be gained from this approach, we've yet to see it demonstrated.

The default Sharpening applied in the Raw Fine Tuning brick is tailored to the characteristics of the specific camera model. The amount of sharpening applied is small and a better end result can be achieved by using the default Sharpening setting in the Raw Fine Tuning brick for all images and subsequently applying less aggressive sharpening than would otherwise be necessary using the other Sharpening tools (Fig. 5.29).

Another advantage of this approach is that you'll be working with sharper images that are closer to their final output appearance all the way through your adjustment workflow. This is particularly relevant while applying contrast-related adjustments such as Contrast and Definition, which are affected by sharpness adjustments.

Outside of the Raw decoder, Aperture has two sharpening adjustments: Sharpen and Edge Sharpen. Sharpen is a fairly basic

(a) (b)

Fig. 5.29 Sharpening applied during the Raw decoding process is based on camera characteristics and is so marginal, it's actually quite difficult to see the effect. (a) The image has had the default sharpening applied and (b) it has been removed. On balance, it's best to leave Sharpening at its default settings.

Sharpening filter which was introduced in Version 1 of Aperture. The superior and more sophisticated Sharpen Edges Adjustment was introduced in Aperture 1.5, but Sharpen was retained for the sake of backwards compatibility.

Aperture's Edge Sharpen is a sophisticated professional sharpening tool. It uses an edge mask so that only edges are sharpened and sharpens on the basis of luminance, rather than RGB data. This approach avoids many of the problems mentioned above.

Edge Sharpen does one other thing that helps produce excellent results while avoiding some of the drawbacks of conventional sharpening tools – it applies its sharpening algorithm in three passes. Multi-pass sharpening techniques are nothing new. It's long been argued that several applications of low levels of Unsharp Mask in Photoshop produce a better end result, with less risk of haloing than a single large application. Aperture's Edge Sharpen Adjustment simply automates this process.

If you're used to Unsharp masking in Photoshop, Edge Sharpen may seem a little underpowered at first, because it doesn't provide a range that extends beyond that needed for natural-looking results. Edge Sharpen has three sliders. The first, Intensity, controls the amount of sharpening applied to the image. Edges determines what's an edge and what isn't. At lower settings only fine detail is sharpened and as you drag the slider to the right, the number of pixels that qualify as edges increases. In practical terms, overall image sharpness increases as you drag

Fig. 5.30 Even at the maximum setting for Intensity and Edges it's difficult to go over the top with Edge Sharpen. Clearly this image (right) has been over-sharpened, but it's not possible to produce the kind of ultra high contrast effects you can get with Photoshop's Unsharp Mask.

the Edges slider to the right, but beyond a certain point you'll start to lose detail.

The final slider, Falloff, determines the degree of edge sharpening that is applied in subsequent passes. Edge sharpening is a three-pass process with each pass applied using a different pixel radius. The first pass is applied at a radius of 1 pixel, the second 2 pixels and the third pass is applied using a 4 pixel radius.

The Falloff slider determines the percentage of the total sharpening power applied during the second and third passes. At a setting of 0.7, the amount of sharpening applied during each pass is:

- 1st pass: 100%
- 2nd pass: 70%
- 3rd pass: 49%

Setting the Falloff slider to zero results in all the sharpening being applied in a single pass with a 1 pixel radius. At 1, all three passes receive the same amount of sharpening. The sum of the three sharpening passes is always equal to the value indicated on the intensity slider (Fig. 5.31).

The first thing to do when applying any kind of sharpening adjustment is press **Z**. It's impossible to gauge the effect of a Sharpening tool at anything other than the pixel level provided by 100% view. Hold down the **Spacebar** and drag in the Viewer so that you can see a representative part of the image that

Fig. 5.31 All of these images have had the default amount of Edge Sharpen applied – 0.81 Intensity, 0.22 Edges. The top image has had a Falloff setting of 0.69, whereas the Falloff for the center image was set to 1.00 and for the bottom image to 0. For many images the Falloff setting won't make a huge difference to the result, but it can help you obtain acceptable results with high contrast images where haloing might otherwise be a problem.

includes both fine detail and flat areas of color or out-of-focus regions.

Select the Edge Sharpen Adjustment from the Add Adjustment pop-up menu. Drag the Intensity slider all the way to the right until the value field reads 1.00. Next press 🖰 to activate the Loupe, right- or *ctrl* click inside it and select 800% view from the context menu and position the Loupe over a contrasting edge. Then, drag the Edges slider to the right until you can see evidence of haloing – a pronounced light or dark fringe that extends beyond the edge details – and drag the slider back towards the left until the halo disappears.

Press 🖰 to deactivate the Loupe and reduce the intensity until a natural looking, but sharp result is obtained and the image loses its harsh contrasty appearance. Apple recommends restricting intensity levels to 0.5 or lower but depending on the camera, lens, subject matter and intended output, higher levels of sharpening intensity may be required.

For most images, you can leave the Falloff slider at its default 0.69 setting. In images where it's difficult to attain a good overall level of edge sharpness without introducing haloing the Falloff slider can make the difference. Set the Intensity and Edges sliders as described, but accept a degree of haloing when setting the Edge parameter. Then use the Falloff control while examining the offending edges with the Loupe to reduce or remove the halo (Fig. 5.32a–c).

How to Use the Histogram

The importance of the Histogram in analyzing an image's tonal qualities and assessing the impact of changes you make using Aperture's Adjustment controls can't be over-emphasized. The Histogram confirms what you can see with your eyes (and, sometimes, things that aren't so apparent), but it also provides a diagnostic review of exactly what's happening with an images' tonal range.

The Histogram is a graph of the frequency of pixels, displayed on the y-axis, against their value, displayed along the x-axis. Assuming the luminance channel is displayed, for an 8-bit RGB image (for the sake of simplicity), the range of the x-axis extends from 0 on the left to 255 on the right (Fig. 5.33).

Fig. 5.32a To gauge the correct amount of Edge Sharpen to apply, activate the Loupe (press ⌒) and position it over some edge detail. Drag the Intensity slider to the maximum, then drag the Edges slider to the right until you see the edge start to halo – light and/or dark bands of color will appear either side of it.

Fig. 5.32b Next, drag the Edges slider back towards the left until the haloing disappears.

Fig. 5.32c Finally, reduce the intensity to produce a more subtle and natural-looking degree of sharpening.

R: 210 G: 210 B: 214 L: 210

Fig. 5.33 The Histogram shows pixel luminance along the x-axis and frequency on the y-axis. The taller the column, the more pixels of that value occur in the image. Moving from left to right, pixel values increase in value and tone from black (0) to white (255).

Pixels with a luminance value of 0 are black, those with a value of 255 are white. Everything else is in-between those two values, ranging from the deep shadows to bright highlights. For a well-exposed scene with a full range of tones the Histogram extends the full width of the chart with peaks and troughs (but, unless there's a serious problem, no gaps) corresponding to the number of pixels at each luminance level. All being well, the graph tails off close to either end where the incidence of pixels at the extremes of the tonal range declines to zero.

The most common problem identified by the Histogram is clipping – where the graph appears cut off at one end rather than declining gradually to zero. This indicates that the camera sensor has been unable to capture the full tonal range in the scene though, as we shall see, especially in the case of highlight clipping, much of this detail can be recovered.

At a glance, the Histogram can tell you if an image is over- or underexposed, if the highlights or shadows are clipped, or if it lacks contrast. Just as important, the Histogram can be your guide when making adjustments, providing vital feedback to ensure that you don't lose highlight detail when making exposure adjustments or introduce noise by stretching the tonal range in the shadows.

Figure 5.34 shows Histogram profiles for some common problems. Generally speaking, when making tonal adjustments you should use the Histogram's luminance view. This displays the tonal range clearly without cluttering the graph with color information that you probably don't need.

Aside from the obvious, like clipping values at either end of the range, when using adjustments you should maintain an awareness of what's happening to the tonal range in the Histogram. Although problems of image degradation common with 8-bit RGB files (e.g. posterisation – discontinuities in the Histogram caused by stretching tonal values across too wide a range) are unlikely when working with 12- or 16-bit Raw data, you should nonetheless be aware of the consequences of shifting tonal data around and the difference between using similar tools, e.g. Black Point and Shadows, to achieve the same end – Recovery of Shadow detail. While visual observation of the image can get you a long way to achieving your goal, if you keep one eye on the Histogram you can also ensure the integrity of your image data and, ultimately, the quality of the end result.

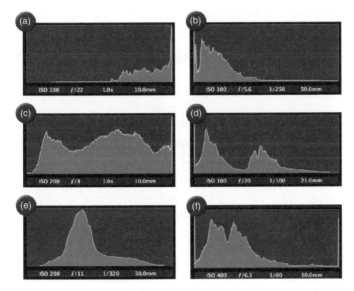

Fig. 5.34 (a) Overexposure, (b) underexposure, (c) clipped highlights, (d) clipped shadows, (e) low contrast and (e) high contrast (high dynamic range with clipped highlights and shadows).

Hot and Cold Spots and Clipping Overlays

Aperture 2's new clipping overlays provide useful visual feedback which can help you when making tonal adjustments using controls in the Exposure and Levels adjustments. To activate the overlay hold down the ⌘ key while dragging the sliders (Fig. 5.35).

The overlay color indicates which color channel the clipping occurs in. White indicates clipping in all channels, red in the red channel and so on. Yellow means clipping is occurring in both the red and green channels. The Aperture User manual contains a complete list of the clipping overlay colors and their corresponding channels.

You can change the color overlays to monochrome in the Appearance tab of the Preferences window. The lighter the gray, the more channels are being clipped. Generally speaking, you should aim to eliminate clipping in all channels.

The clipping overlays work for the following Exposure adjustment controls:

- The Exposure slider shows highlight clipping.
- The Recovery slider shows highlight clipping.
- The Black Point slider shows shadow clipping.

Fig. 5.35 Holding down the ⌘ key while moving the White Levels slider activates the highlight clipping overlay. Here clipping has started to occur in the blue and green channels and would eventually occur in all three channels indicated by a white color.

And these Levels controls:

- *Black Levels slider* shows shadow clipping.
- The *White Levels slider* shows highlight clipping.

Selecting View > Highlight Hot and Cold Areas, performs a similar function. The Hot and Cold areas are displayed permanently, rather than only when using certain adjustment sliders which makes them a little less convenient. Also, clipping for individual color channels is not shown; hot areas appear red, cold areas appear blue. They can be quickly toggled on and off by pressing ⌥ Shift H.

Copying Adjustments Using Lift and Stamp

Adjustments you have made to one image can quickly be applied to others using the Lift and Stamp tool. You can do this by clicking the Lift tool in the tool strip, but this will open the Lift and Stamp HUD with metadata as well as adjustments selected. To work only with the adjustments right click the image you want to copy the adjustments from and select Lift Adjustments from the contextual menu. Click the Adjustments disclosure triangle to see a list of adjustments and delete any that you don't want by selecting them and pressing ⌫.

Fig. 5.36 Right click an image and select Lift Adjustments to display the Lift and Stamp HUD showing only adjustments. Click the disclosure triangle and select and delete any you don't want, then select the images you want to apply the adjustment to and click the Stamp Selected Images button.

Select the images in the Browser that you want to apply the lifted adjustments to, and then click the Stamp Selected Images button on the Lift and Stamp HUD (Fig. 5.36).

Using Adjustment Presets

You'll frequently apply adjustments with the exact same settings to multiple images. As part of your workflow you might want to, for example, routinely apply Edge Sharpen to images, or apply the same noise reduction settings to all images shot at 800 ISO.

Presets make it easy for you to do this by saving commonly used settings so you can apply them from the Preset menu, rather than having to repeatedly adjust individual sliders by the same amount. To save an adjustment preset, select Save as preset from the Adjustments Action pop-up menu (Fig. 5.37).

Common Problems and How to Correct Them

Overexposure

With Raw images, there's a fine line between ensuring that you use the full range of available bits to capture as much of the tonal information in as scene as possible and overexposure. But even when you go a little too far, and end up with a Histogram that's clipped on the right hand side, Raw images seem to have something in reserve that Aperture is very good at recovering. Aperture's Exposure and highlight recovery tools can rescue highlight detail from images that, on an initial assessment, seem beyond the pale.

The tools you need for correcting overexposure and recovering highlights are located primarily in the Exposure brick. You can increase your chances of a successful result by careful tweaking of the Raw Fine Tuning controls and by employing a combination of adjustments including Highlights and Shadows and Levels.

Because they require different approaches, we'll deal separately with overexposure and high dynamic range problems. Overexposure occurs when you (or your camera, if you're shooting using an Auto Exposure mode) select the wrong aperture and shutter speed combination for the scene you are photographing which results in more light hitting the sensor than would result in a balanced exposure recording all the tones in the scene and producing a Histogram like that in Fig. 5.38.

A very overexposed image has a Histogram which looks like that in Fig. 5.39. There are no pixel values in the left half of the Histogram and everything is bunched up on the right side, resulting in loss of highlight detail (Fig. 5.39).

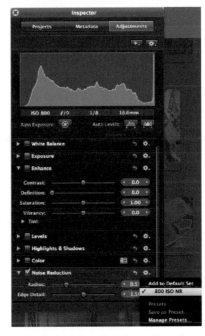

Fig. 5.37 Saved adjustment presets are added to the Adjustment Action pop-up menu.

Fig. 5.38 The Histogram from a correctly exposed image.

Fig. 5.39 The Histogram from an overexposed image.

In some ways, overexposure is easier to deal with than high dynamic range problems, because all of the tonal values need to be shifted leftwards on the Histogram, i.e. darkened. The primary adjustment for accomplishing this is the Exposure slider in the Exposure brick of the Adjustments HUD.

As a first step open the Exposure brick and drag the Exposure slider towards the left until you can see the right side of the Histogram. The slider is not linear, but is calibrated to provide more control at lower adjustment settings. The further you move the slider towards the end of the scale, the more effect incremental adjustments have. The first four-fifths of the slider's range change the Exposure value from 0 to −1 and the final fifth changes it from −1 to −2.

If an exposure value of −2 is insufficient to bring the right-hand edge of the Histogram within range you can add further Exposure adjustment by dragging the value slider. This can take you all the way to −9.99 but, if an image requires more than two stops of exposure correction it's unlikely you'll obtain a great quality result.

With the exposure adjustment made, all of the Histogram should now be within range, but the image may still be lacking highlight detail. You can use the recovery slider to regain some of this, but with very overexposed images combining it with the Highlight and Shadows Adjustments is often more effective.

First drag the Recovery slider all the way to the right, then use the Highlights slider to further bring overexposed regions into the highlight and three-quarter tone area of the Histogram. If at this stage of the process you discover that the right edge of the Histogram is well within the right boundary, but the image still lacks highlight detail, return to the Exposure slider and ease off the original setting by dragging the slider slightly back towards the center and compensate by adding more Highlight adjustment. By re-adjustment of these two controls – Exposure and Highlights – you should be able to reach a position which looks good visually and, from a Histogram standpoint, with reasonably good detail in the three-quarter tones and highlights.

The final problem you are likely to have with an overexposed image is that the Histogram falls short on the left-hand side, the shadows look washed out and the image lacks contrast. You can fix this either by dragging the Black Point slider in the Exposure Brick to the right or by using a Levels adjustment (Figs 5.40–5.46).

Fig. 5.40 Dealing with overexposed images. This image is quite badly overexposed, but not beyond rescuing.

Fig. 5.41 First, use the Exposure slider to bring the right side of the Histogram into view.

Fig. 5.42 Then use the recovery slider to try to get some detail back into the highlights.

Fig. 5.43 If you can't get sufficient detail into the highlights with Recovery, move on to Highlights and Shadows.

Fig. 5.44 Return to the Exposure adjustment and ease off to accommodate the recovery and Highlights changes.

Fig. 5.45 Finally, add some density to the shadows using the Black Levels slider.

Fig. 5.46 Before (top) and after (bottom).

Slight Overexposure and High Dynamic Range

In most situations the range of tones in a scene, from solid black to pure white, can adequately be captured by dSLR sensors which are capable of capturing around seven stops. In subjects that exceed this range something has to go and you'll lose detail in either the highlights, shadows or both.

High dynamic range is also a term applied to a technique which combines several bracketed exposures in order to capture tonal detail in scenes with a dynamic range that it would not be

possible to capture with a single exposure. HDR images use 32-bit floating point data which is usually tone mapped to a 16- or 8-bit integer format in order to print it or display it on a monitor.

Aperture doesn't provide such HDR compositing tools, but it is so good at recovering highlight detail that you can often get excellent results from a single image, provided it is well exposed.

The first place to start is the Raw decoder, which applies contrast to the image during the decoding process. In the 1.1 decoder this is controlled using a single Boost slider; the 2.0 decoder has two sliders, Boost and Hue Boost. Boost controls contrast and Hue Boost maintains the hues as the contrast is increased.

Reducing the Boost from its default setting of 1.0 can recover a significant amount of lost highlight detail. Don't try to fix everything in one hit. Boost controls the contrast over the entire tonal range, so keep an eye on the Histogram and watch out for compression of the midtones and loss of detail in the shadows.

Generally speaking, you shouldn't be reducing the boost beyond the mid-way 0.5 mark. You can always come back and re-adjust it if necessary when the other adjustments have been made.

Next open the Exposure Brick and drag the Recovery slider to the right. Recovery is a new tool specifically designed to recover blown highlights. Its effects can appear to be quite subtle, and recovery is more successful in images with clipping in only one- or two-color channels than where all three are blown. Hold down the ⌘ key to use the highlight clipping overlay and keep dragging the slider right until all of the clipping is eliminated or at least substantially reduced.

Although the highlights are no longer clipped, they still lack detail which can now be recovered using Highlights and Shadows. Drag the Highlights slider to the right to restore as much of the remaining highlight detail as you can.

Restoring highlight detail involves reducing the brightness of pixels in the highlights – effectively squeezing the right-hand

side of the Histogram to restore detail to clipped highlight areas. Sometimes, a consequence of this is that the midtones are compressed and images can begin to look dark and flat as a result.

Although it seems somewhat counter-intuitive to brighten an image that you've spent time and effort in restoring highlight detail to, adjust the brightness to lighten the midtone values. Finally, you may need to restore some contrast by moving the Black Point slider to the right until the left side of the Histogram approaches the edge. At all times during this process your eyes should be on the Histogram as well as on the image (Figs 5.47–5.52).

Fig. 5.47 The range of tones in this image is too wide to be captured by the camera sensor. An exposure has been made that captures the shadow detail without clipping, but the highlights are blown out. With high dynamic range subjects, this is the kind of Histogram you want to see. To reverse the old adage, Expose for the shadows, Develop for the highlights.

Fig. 5.48 Initiate highlight recovery by reducing Boost in the Raw Fine Tuning brick. Boost applies quite an aggressive contrast increase and reducing it to around half its default value can make a big difference, but don't try to do it all with the Boost slider.

Fig. 5.49 Next, drag the Recovery slider to the right while holding down the ⌘ key until none of the color channels is clipped.

Fig. 5.50 Restore additional highlight detail using a Highlights and Shadows adjustment. Drag the Highlights slider to the right.

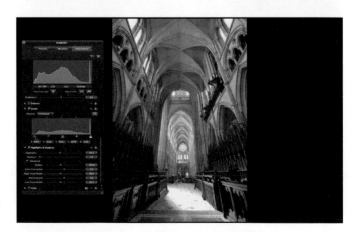

Fig. 5.51 Finally, restore contrast using a Levels adjustment. Drag the Black Levels slider slightly to the right to add density to the shadow detail.

Fig. 5.52 Before (left) and after (right).

Underexposure

Severe Underexposure

Underexposure is a more difficult problem to remedy than overexposure and therefore one which, if at all possible, should be avoided. The problem with adjusting underexposed images is that what tonal information there is, is recorded using only a fraction of the bits available to the camera sensor. See Chapter 1 for a more detailed explanation of why this is so.

A consequence of dealing with image data recorded using relatively few bits is that edits carry the risk of enhancing noise as well as genuine image data. While the Histogram can tell you how healthy an image is in terms of tonal distribution, the only way to tell if you've produced a noisy image is to take a close look at it. Very often when dealing with underexposed images, noise is simply something you have to live with.

Fig. 5.53 This is the kind of severely underexposed image you might get if a flash fails to fire. It can be rescued, but spreading the relatively small amount of data recorded in the shadow region of the Histogram will introduce severe noise.

First let's look at a case of severe underexposure. Figure 5.53 shows an indoor shot that's several stops underexposed and exhibits a typical underexposed Histogram – there's very little pixel data in the right half of the Histogram. Dragging the Exposure slider to the right side of the scale results in some improvement, but the shadows and midtones are still heavily compressed. Dragging the Exposure Value slider to around 2.60 results in further improvement but the Histogram indicates that any further increase in exposure risks clipping the highlights in the illuminated panel above the dance machine.

To recover the deep shadows, first drag the Black Point slider from its default value of 3 towards the left end of the scale. A Black Point value of 0 reintroduces some shadow detail without affecting the contrast too badly.

Next open the Highlights and Shadows brick. The Shadows adjustment is designed specifically to reintroduce detail into dense shadows, drag the slider to the right to further enhance the shadow detail. You might find it helpful while you're doing this to toggle the Shadows adjustment on and off using the Highlights and Shadows checkbox. Note when you drag the Shadows slider to the right the Histogram shifts in the same direction, but the Black Point – the left-most pixel values on the chart – remains fixed.

At this stage of the process noise will almost certainly start to become apparent even at less than actual size view. To get a proper look at just how bad the problem is, press the **Z** key to view the image's actual size or press **⌐** for the Loupe.

Fig. 5.54 Start with a hefty Exposure adjustment. Dragging the slider will only get you to 2.0; for larger adjustments like this one you need to drag the Value slider (position the cursor over the value field and drag) or enter the value in the field.

Fig. 5.55 Drag the Black Point slider to the left to get back yet more shadow detail. Reducing the Black Point value to 0 recovers some shadow without a big reduction in contrast.

Fig. 5.56 Now use a Highlights and Shadows adjustment to lighten the shadows up to the midtones. Drag the Shadows slider to the right.

Fig. 5.57 Finally, you may need to reintroduce some density to the blacks to restore contrast and reduce the impact of noise. Here we've done that with a Black Levels slider adjustment.

Fig. 5.58 Before (left) and after (right).

Fig. 5.59 This shot has tonal detail extending into the highlights, but the shadows have been clipped and the foreground detail is dark.

The only effective way to deal with it is to back off the Shadows and Black Point adjustments to reintroduce clipping of the shadows, or alternatively to clip the blacks with a Levels adjustment. The noise is inherent in the Shadow data and the two are, practically speaking, inseparable. You can also try reducing the impact of the noise using Noise reduction.

Mild Underexposure and Shadow Recovery

Much more common than the sort of severe underexposure just dealt with, is an image in which some degree of shadow clipping has occurred either as a result of slight underexposure or because of high dynamic range in a scene. In an attempt to hold the highlights, an exposure has been made which has lost some of the shadow detail.

The Histogram for this kind of image looks like that in Fig. 5.59. Unlike the underexposed image the pixel data extends well across the Histogram and is almost touching the right side, but the left side is clipped indicating that some shadow detail has been lost.

Depending on how close to the right side of the Histogram the highlights are, you may get away with a small amount of positive Exposure adjustment, but in an image with a full tonal range you're likely to lose highlights as you gain shadows, so it's probably best avoided.

The Shadow slider of the Highlights and Shadows adjustment is designed specifically for this task and is most likely the only thing you'll need. Drag the Shadows slider to the right until the spike

Fig. 5.60 The Highlights and Shadows adjustment was designed to address exactly this kind of problem. Dragging the Shadows slider to 33 provides a 'fill flash' effect.

disappears from the left side of the Histogram. Depending on the nature of the subject and the degree of Shadows adjustment necessary it may also help to boost the midtone contrast a little.

As always when making adjustments that stretch the shadow region of the Histogram, be on the lookout for noise. If this becomes apparent, rather than backing off the Shadows adjustment you may get more mileage (in other words, reduce the degree of visible noise with less of a compromise on shadow recovery) by increasing the radius value and/or decreasing the Low Tonal Width value. To access these controls check the Advanced disclosure triangle.

Low Contrast (flat) Images

Low contrast images can be identified by a Histogram that doesn't reach either end of the chart. There are no pixels with values in the shadow or highlight tonal ranges and, in the absence of rich blacks and pure whites or values close to them, images look flat and washed out.

Fixing poor contrast simply involves stretching the Histogram and evenly redistributing the tonal values so they extend to either end. The Auto Levels tool usually makes a pretty good job of this, but you can do the job almost as quickly using a manual Levels adjustment and, even if you do use Auto Levels you'll probably need to make a slight adjustment to it anyway.

Figure 5.61 shows a flat image that's lacking in contrast. Click the Auto Levels button and open the Levels brick to view the adjustment that has been made. Auto Levels had adjusted the

Fig. 5.61 To fix poor contrast start by clicking the Auto Levels button; this will adjust the B&W Levels sliders to the ends of the Histogram.

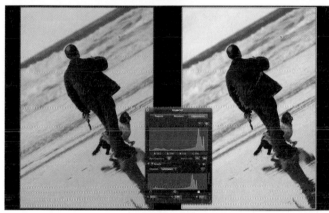

Fig. 5.62 Depending on the image, further adjustment may be necessary. Turn on Highlight Hot and Cold Areas (View > Highlight Hot and Cold Areas or ⌥ *Shift* *H*) to see any clipping that may have occurred.

White Levels slider to 0.86 and the Black Levels slider to 0.02. The mid-point Gamma Level has moved from its default position of 0.5 to 0.44 as a consequence of the overall tonal redistribution resulting from the White and Black Levels shifts.

The result isn't bad, but some highlight detail in the sky has been lost and the shadows still lack sufficient punch. Turn on Highlight Hot and Cold Areas (View > Highlight Hot and Cold Areas or ⌥ *Shift* *H*) to see any clipping that may have occurred. To restore the highlights drag the White Point slider back to the right until all of the red-colored hot pixels disappear.

Next, drag the Black Levels slider to the right to add density to the shadows. Shadow clipping is indicated by cold, blue-colored pixels. A little filling in of the jacket is acceptable in order to produce an image with improved overall contrast (Fig. 5.62).

Fig. 5.63 The first stage in your color correction workflow should be to set the White Balance. This early evening scene was determined by the camera's Auto White Balance to have a color temperature of 5693 K and has resulted in a cold image with a blue horse. Increasing the White Balance to 8030 K results in a warmer, more natural-looking image with a white horse.

Dealing with Color Casts

Using White Balance

Color casts are most often caused by incorrect White Balance and are therefore easily corrected using the White Balance adjustment. Incorrect White Balance leads to either a blue cast if the White Balance is set too low or a yellow cast if it is set too high. Setting White Balance for tungsten lighting with a color temperature of 3500 K and then shooting outdoors leads to a pronounced blue cast and doing the reverse – setting daylight White Balance of 5500 K and shooting indoors – leads to a pronounced orange/yellow caste. In between exists a range of problems most often caused by a camera's Automatic White Balance setting getting it wrong.

As mentioned earlier, if White Balance is critical, a neutral gray card can be photographed in the scene and subsequently used to set White Balance using the White Balance adjustment's eyedropper.

In the absence of a gray card use the White Balance eyedropper to click on any neutral area in the image, the Loupe automatically appears when the eyedropper is selected to help you make an accurate selection.

Further manual adjustment is likely to be necessary after you've used the eyedropper. Move the Temp slider to the right to increase the indicated source color temperature and make the image warmer (more yellow) and to the left to make it cooler (more blue).

The Tint slider is used to correct green/purple casts. Depending on the camera and the scene, its usual position is in the 0–10 range and, on the rare occasions you might need to adjust it

to eliminate a slight purple or green cast, only small variations should be necessary.

Using Tint

Uniform White Balance problems are easily dealt with using the White Balance adjustment, but sometimes color casts are not uniform. Scenes lit by a mixture of daylight and artificial light, e.g. interiors with room lighting switched on and daylight coming in through windows, are impossible to color balance using White Balance. If you adjust for the room lighting, areas lit by daylight appear blue and vice versa.

In these situations, the Tint controls on the Enhance brick provide a solution. First, set the overall White Balance as just described. You will need to have, at the outset, a clear idea of how you want the final image to look. It will probably not be possible, or even desirable, to completely neutralize all casts. Usually, in an interior short you'll want to maintain a degree of warmth in the image and eliminate the worst of the blue daylight cast, so start by using White Balance to achieve the desired color temperature of the interior lighting.

Next, click the Tint disclosure triangle on the Enhance brick to reveal the Tint color wheels. The three sliders control Tint adjustment in the shadow, midtone and highlight regions, respectively. Each has an eyedropper which you can use to sample from the image, but provided you can identify where the cast is, you're probably better off just dragging the White Point spot in the center of the relevant color wheel and visually assessing the result.

In Fig. 5.64, the offending blue cast is in the highlights and midtones outside the window. Dragging the Gray and White Tint controls to the yellow side of the color wheels considerably neutralizes the blue cast. If you find it hard to judge the degree of correction, temporarily increase the Saturation slider to exaggerate your changes.

Fortunately, most of the interior of this shot falls into the shadow regions and so is unaffected. Tonal ranges aren't always so accommodating and you may find it is impossible to correct the cast without adversely affecting acceptable parts of the image. If this happens the only resort is to round-trip the image to Photoshop and attempt to correct the cast using a mask layer (Fig. 5.64).

Fig. 5.64 Use the Tint controls of the Enhance brick to deal with color casts caused by mixed lighting. Here the blue cast on the sofa caused by the daylight entering through the window has been reduced by adjusting the Gray and White Tint color wheels.

Using Levels

You can correct a color cast using the individual red, green and blue channels of the Levels adjustment. Although you can visually gauge the effect of editing individual color channels while adjusting the sliders, some knowledge of color theory will help you make the right choices. A detailed explanation of color theory is outside the scope of this book; however, those not familiar with basic color theory might find it helpful to know that adding one of the three primary colors to an RGB image has the same effect as subtracting its complementary color (i.e. the opposite color on the color wheel). So:

- adding red is the same as removing cyan;
- adding green is the same as removing magenta;
- adding blue is the same as removing yellow.

Using a Levels adjustment to address color cast issues has the advantage that you can confine your adjustments to specific parts of the tonal range. To remove a blue cast from the midtones select the blue channel from the Channel pop-up menu in the Levels brick and drag the Gray Levels slider to the right. This removes blue (adds yellow) to the midtones.

To remove blue from the shadows drag the Black Levels slider to the right. If you want to remove blue from the highlights, you will need to drag the White Levels slider to the left on both the red and green channels. You can't drag the White Levels slider to the right and adding red and green is the same as removing blue.

Fig. 5.65 This image has a slight green cast in both the shadow and highlight regions. To remove the green cast from the shadows, select the green channel in the Levels brick and drag the Black Levels slider to the right to remove green.

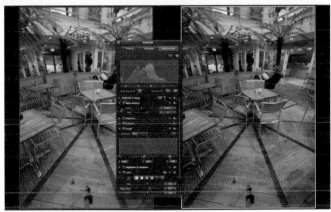

Fig. 5.66 You can't add green to the highlights using green channel, but adding green is the same as removing its complementary color, magenta, which is the same as removing blue and red. Select the blue channel from the Channel pop-up menu in the Levels brick and drag the White Levels slider to the left.

As a general rule, drag the Levels sliders at the bottom of the Histogram to the right to remove the selected channel color and to the left to add it. For more control over color casts in specific tonal regions click the Quarter Tone controls button and use the quarter and three-quarter Tone Levels sliders.

Creative Techniques

Color to B&W

Although it doesn't provide a wealth of creative options, Aperture has a good set of tools for converting color images to monochrome and applying tints. Whether for weddings and portraiture, fine art photography or just experimentation, you

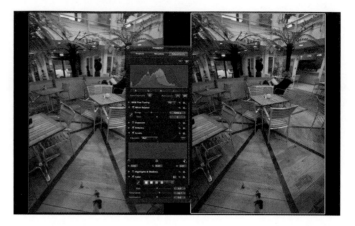

Fig. 5.67 Finally, select the red channel and drag the White Levels slider to the left.

can quickly and easily produce monochrome and tinted versions from color Masters.

If you've used Photoshop's Channel Mixer, or B&W filters, or if you've used colored filters in B&W film photography, you'll quickly feel at home with Aperture's Monochrome Mixer. To add the Monochrome Mixer to the Adjustments HUD, select it from the Add Adjustments pop-up menu.

The Monochrome Mixer mixes tonal data from the RGB images' three-color channels to produce a monochrome result. Initially the mix is set at 30% red, 59% green and 11% blue, which produces a well-balanced result.

By changing the mix you can emulate the results produced when using color filters with B&W film. For example, dragging the red slider to 100% and reducing blue and green to zero has the same effect as a red filter – lightening the tone of red elements in the image and darkening greens.

To reproduce the effect of a yellow filter use 50% red and 50% green. You can obviously reproduce any color filter you like in this way; the only general rule you need to follow is to ensure that the sum of the three channels equals 100% if you don't want to lighten or darken the image overall.

The Preset pop-up menu provides five preset colored filters and there's a custom setting which you can define. If you need a lot of filter variants you can add additional ones to the Presets section of the Action pop-up menu.

Fig. 5.68 This graphic shot is a good candidate for conversion to B&W using the Monochrome Mixer because the predominant colors are well spaced on the color wheel and will be easy to separate.

Fig. 5.69 Select the Monochrome Mixer from the Add Adjustment pop-up menu. The default result isn't bad with good tonal separation between the orange Austin lettering and wheel and the blue paintwork.

Fig. 5.70 Selecting the Monochrome with orange filter preset lightens the orange lettering and wheel and darkens the blue paintwork, providing a more dramatic contrast between the two.

You can usually get the effect you're looking for – whether it's roses with light flowers and dark foliage, or dark skies with billowing cumulus clouds – by following the general rule that a filter lightens the tones of same or similar colors and darkens those of complementary colors. Hence for the rose you'd choose a red filter or orange for a less dramatic effect. Start with a preset, then use the sliders – keeping in mind the 100% rule – to make minor tonal adjustments (Figs 5.68–5.70).

Tinting

Aperture has two tint adjustments – Sepia Tone and Color Monochrome. Sepia Tone is little more than a single tint version of Color Monochrome. You can do everything Sepia Tone does, and more using Color Monochrome so, other than including an example of what Sepia Tone does, we'll concentrate on Color Monochrome.

To add a Color Monochrome adjustment select it from the Add Adjustment pop-up menu. There are only two controls: a color swatch and an intensity slider. The default color is sepia and the intensity is the maximum 1.0. At this intensity all the colors in the image are replaced by the tint.

To change the color, click the color swatch and select a new tint color using the Colors Palette. The image updates in real time so you can see the effect immediately. Drag the Intensity slider to the right to reduce the tint intensity and reintroduce some of the original image color.

Fig. 5.71 Sepia Tone is a one-trick pony; use the more versatile Color Monochrome instead.

Fig. 5.72 At intensity settings below 1.00, Color Monochrome combines a desaturated version of the original with a monochrome tint. Click the Color Monochrome swatch to select the tint color using the Color Palette.

Reducing the tint intensity produces a pleasing effect. The reduced color saturation and tint combine to produce an effect that looks part tint, part hand colored. But it isn't a B&W tint in the conventional sense of a mono print which has had a chemical toner applied. To reproduce this effect, combine Monochrome Mixer and Color Monochrome adjustments.

First add the Monochrome Mixer adjustment as described earlier. One of the advantages of this method is that you have more control over tonal reproduction. Choose a color filter preset, and use the Red, Green and Blue sliders to achieve the desired tonal balance.

Next, apply the Color Monochrome adjustment. Select the desired color tint and adjust the intensity. Now, instead of a mix between the original image colors and the tint, the Intensity slider progressively replaces the tones in the B&W image, producing a conventional mono color tint.

You can continue to adjust the red, green and blue balance in the Monochrome Mixer to optimize the effect after the color tint has been applied. You may also want to make a Levels adjustment to lighten the midtones.

Fig. 5.73 For a true monochrome tint, with greater control over tonal reproduction, combine Monochrome Mixer and Color Monochrome adjustments.

By comparison with the transfer function-based Duo- tri- and quad-tone and mask-based split-toning effects possible in Photoshop, Aperture's Color Monochrome adjustment is relatively unsophisticated. Hopefully, Apple will improve on it in future releases (Figs 5.72 and 5.73).

Aperture Workflow

Using Projects, Albums and Folders

As explained in Chapter 2, Aperture subdivides your assets into various different groups. These groups can contain further subgroups, helping you to quickly navigate to the precise photos you need; they also help the software to perform searches on the basis of your specified criteria.

Sometimes this is done automatically, such as when you import a series of folders as a Project; sometimes it is done manually, as when you create a folder yourself and drag images into it. Occasionally it is done passively, such as when you create a Web page, which uses photos from an existing collection to create an entirely new one while you work on a related creative Project.

These groupings are set to cascade, so that each superior group – whether that be a Project, folder, Album or the whole Library, also gives you access to all of the contents of the inferior groups. As such, viewing the contents of a folder will also show you the contents of the Projects that go to make up that folder. If that folder contained four Projects, though, clicking on any one of them individually would show you only its own specific contents and not those of the other three Projects within the overall folder.

The easiest way to visualize this is as a top-down view of an open box, inside of which there are several smaller boxes. From your aerial vantage point you can see the large box – the folder, in our analogy – and the contents of all of the smaller boxes – the Projects, Albums and so on. However, if you were to lower yourself so that your face was close to one of the small boxes, you would no longer have an overview of all of the constituent parts, but only those of the smaller box directly in front of you.

The only anomaly comes in the fact that when you have a top level folder or a Project selected in the Projects Inspector, then the Browser – whether in grid, list or film strip mode – shows only the contents of the constituent subdivisions, and not the subdivisions themselves, so you will have no way of knowing whether all of the images you are looking at appear in the same Project or Album, or in different ones. There is good reason for this: the Browser and Viewer are focused entirely on the processes of sorting and editing your work, whereas the Projects Inspector is focused solely on organization (Figs 6.1 and 6.2).

However you look at them, these subdivisions remain the most powerful tools at your disposal when it comes to visualizing how your assets relate to one another, and they back up the metadata-based filtering carried out behind the scenes by Aperture itself.

Folders

Folders work on two levels. First, they sit above your projects, in the root of the Library, and act as a loose container into which you can throw everything with which you are working, including your Projects, sub-folders, Light Tables, Books and Web Projects. These top-level folders, and any folders they contain that are not also a part of a Project, are colored blue.

On the second level, you can create folders that act as subdivisions within a Project. These are colored brown and again they are used for organising assets, although at this level you cannot use them to store projects. Brown folders buck the trend for hierarchical viewing of your assets, as they expose their contents to blue folders, but not to Projects. So, you may have a Project called 2009, containing four folders for spring, summer, autumn and winter. This Project is itself contained in a blue folder

Fig. 6.1 The Projects Inspector is used purely for organizing your projects, folders and creative products. It works hand in hand with the Browser, which displays the contents of each item in the Inspector.

Fig. 6.2 The Projects Inspector is used purely for organizing your Projects, folders and creative products. It works hand in hand with the Browser, which displays the contents of each item in the Inspector.

called Events. Clicking the Events folder would show you the contents of every organizational element it contains – Projects, Albums and sub-folders.

The only thing you can't store in any folder, regardless of its color, is images themselves.

Projects

After the overarching Library, which contains every asset in your collection, Projects house the largest group of assets at your disposal. They are the first level in which you can store images, but they can also contain products such as Web Pages, Web Galleries, Journals and Books. They can only be created inside either the Library's root level or in blue folders: they can't be created within brown folders or inside existing Projects.

Projects will usually be organized along subject lines, and should be seen both as a collection of assets and of the output of those products right up until the point just before they become physical printed items. A Project can exist only within the Library and not inside any of the smaller divisions, such as a folder.

A Project will be the initial point of entry for items in your Library, however you bring them into the application. As such, they should be the most generalized collection of images at your disposal. Despite this, they can remain useful delimiters, allowing you to differentiate between, say, different clients, or the countries in which a series of travelog photos were taken.

Because you can only import images in Aperture into Projects (and a new Project will be created inside whichever other organizational entity you try to use), they are the ideal means of organizing related images, and so are the best defining block to use when you want to move pictures en masse from one installation to another.

Many professional photographers will work with two machines: one powerful desktop set-up in the studio, which they use for editing and output, and one smaller, lighter, less powerful portable machine that they use on the move. If you are importing your images into this mobile machine on location you will need to transfer them to the desktop machine when you return to the studio. Likewise, if you're half way through an editing job at the end of the day, you may want to transfer your work to the portable to continue at home, or during a commute.

In these instances, you would use Project Exports to move whole batches of images, including Versions and Digital Masters, from one computer to another. You would not use Image Exports, as these would include only individual photos, and not all of their supporting assets, or the directory structure you have put in place.

Exporting Projects is a simple case of choosing that option from the File menu and picking a name and destination folder. If your Project uses referenced Images stored elsewhere on your Mac, you should check the option to consolidate these so that they are exported along with the rest of your work. The exported file can then be copied to the new computer and integrated into that machine's existing Library by picking File > Import > Projects.

Projects are the key to quickly accessing your assets, in much the same way that motorway signs point to towns, and that only once you've finished with them you will start looking for individual road signs.

Projects are also important when it comes to organizing the Inspector, as they are the highest filing element that can be collapsed. In this respect there are benefits to producing highly generalized conceptual Projects that encompass enormous subject areas, as they allow you to quickly show and hide their contents using a disclosure triangle and so save you from a lot of dragging and scrolling.

In this way, you might like to create folders rather than Projects for every country you visited on a European tour, and drop these inside a single Project called Europe. You can still store individual

folders for cities inside each country folder, but by organizing your work in this way you can shrink the whole continent down to a single line in the Inspector when you want to work on something else.

Aperture organizes the Projects Inspector alphabetically, so you can easily order your folders (Projects and so on) by using prefixes. Punctuation, such as !, @ and — come first, followed by numbers and then characters. Using appropriate leading characters should therefore enable you to separate out your Projects and top-level folders if you don't want them mixed together (Fig. 6.3).

Favorite and Recent Projects

The All Projects drop-down menu at the top of the Projects Inspector conceals two further options: Favorite Projects and Recent Projects. The latter of those two is the ultimate smart folder, as you don't even have to define any attributes that qualifying items should satisfy. It is simply a list of the projects you have accessed most recently, allowing you to quickly skip back to them.

Favorite Projects are defined by the Add to Favorites option on the Shortcut menu, and they stay there until you select the Remove option from the same menu. This menu could be either somewhere to temporarily store ongoing Projects that you will access periodically over a certain amount of time or a space to permanently reference long-term works. Either way, it lets you skip straight to Projects that might otherwise be buried inside folders without cluttering the Projects Inspector by promoting them to root-level items for speedy access (Fig. 6.4).

Albums and Smart Albums

Albums are the purely organizational elements within Aperture's Library structure, since their only purpose is to keep a collection of images contained, allowing you to manually define the limits of that focused collection within a larger whole. So, you might have a Project containing 450 images from a wedding assignment, with Albums holding the various parts of the day, split into logical sections like arrival, ceremony, reception, speeches and party. Each of these would have an individual Album, allowing you to focus on just one aspect of the day at any time, or zoom back out to the event as a whole by clicking back to the umbrella Project or folder.

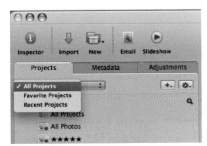

Fig. 6.3 By using intelligent leading punctuation, such as @ and ! in conjunction with regular names, you can manually sort the order of items in the Projects Inspector. Here, we have forced an item beginning with W to appear before another one beginning with E.

Fig. 6.4 The Projects Inspector can be quickly slimmed down by using the Recent and Favorite Projects selector on the drop-down. Favorite projects are added and removed manually.

Inside Aperture, an Album is a collection of references to images elsewhere in your Library. When you click on one you see the images referenced within it, but they don't actually exist there. You can see this when you delete an Album and get no warning that you're going to lose your pictures. This is true even if you've been working on an image while it was selected in an Album.

They generally sit inside Projects and reference the images in that Project, but they don't have to. They can call on pictures from anywhere in your Library, and you can add images to an Album by dragging them there. They can therefore contain images from several Projects and folders at once, which is useful when you're building a portfolio book or website and want to present a selection of work spanning several years.

Smart Albums share a common base principle with regular Albums, in that they are used as an organizational device for defining boundaries between different sets of images. However, rather than being defined manually as a result of the user dragging their images into them, they are constructed using variables, like search terms, entered using the Smart Settings dialog. This is called up from the menus (File > New Smart > Album) or using the shortcut **Shift** **⌘** **L**. Once the album has been given a name and its variables have been defined, its entry in the Projects Inspector will sport a magnifier. Clicking this will let you go back in and redefine the search criteria on which it is based (Fig. 6.5).

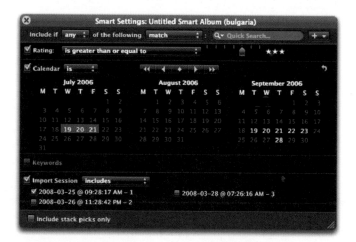

Fig. 6.5 Smart Albums are created using an intuitive search interface that draws on the metadata attached to the images in your Library.

In this respect, Smart Albums are similar to Smart Folders in Mac OS X, or Smart Playlists in iTunes. They are reference collections built by Aperture itself on the basis of parameters that match each image's metadata. So, if you were a frequent traveller and wanted to maintain an Album showing your best pictures from around Europe without having to spend 2 hours at the end of each trip dragging your best photos from your Europe folder into a 'Best of' folder, you'd create a new Smart Album inside your Europe folder and specify that it should contain only those pictures rated four stars and above.

Now, every time you import a new collection of images into a Project or an Album within your Europe folder you need only to navigate through them using the cursor keys and rate them with the numbers **1** to **5** on your keyboard. Anything marked four or five would then show up in your new Smart Album. A 60-minute job has just been cut down to **6**.

If you later change your mind about a picture and dock it two stars down to three or below, Aperture will remove it from the Smart Album without any further intervention from yourself, ensuring that it really does contain nothing but your best work.

Besides ratings, Smart Folders can be organized on the basis of import dates, keywords, search terms or the date on which each photo was taken.

We will explore setting up Smart folders later in this chapter.

Real Life Workflow from Camera to Export

Aperture has powerful editing tools that can really help you to get the best from your photos. However, Its emphasis is at least as much on organization and workflow as it is on editing. Its classic three-pane interface centralizes every task from import to output, keeping every tool within easy reach in an environment that changes very little, saving you from learning different set-ups for each task you want to perform.

However, getting the best out of it involves a certain amount of pre-planning, and although your workflow will evolve over time as you become more familiar with the application, establishing a set way of working in harmony with Aperture from the very start will pay dividends.

The first step, then, is to plan an import strategy.

Defining Your Metadata Presets

If you already know enough about the kind of images you'll be importing as you use Aperture, you can build an extensive general purpose Metadata set to apply to them at the point of import right now. The chances are, though, that over time your assets will be too varied to fit within a single defined Metadata set, and so at this point you will be able to specify only the barest basics that you know will be true of all of your work. These will be your credit and copyright notice.

Click the Metadata tab and use the Shortcut button at the top of the dialog to pick New view…. Give your view a meaningful name, and click OK. The Metadata area will switch to a blank view, and the Tag Selection dialogs will slide up from the bottom of the screen. Click IPTC and check the boxes beside Byline, Credit and Copyright Notice, which are the only variables we want to add to our view at the present time. They will appear in the order they were selected and can be rearranged by dragging their names (Fig. 6.6).

You have now defined your first Metadata view. Click the IPTC button again to close the Tags dialog and save the view. You now need to convert it to a preset for use when importing images.

Fill in the relevant details in the boxes that define your Byline, how you'd like to be credited and what copyright notice you want to see appended to your images. If you include a date in this copyright notice – as you should – you will obviously need to update it on an annual basis as you continue to add photos to your Library.

Now click the Shortcut button again and choose Save as Preset…. You'll be asked to give your preset a unique name so that you can pick it from a menu in the Import dialog at a later point (Fig. 6.7). Note that it really must be unique; if you pick a name that you've already saved at an earlier point the OK button will be deactivated until you change it. If you want to edit an existing preset, therefore, you should make your changes and then use Manage Presets (again, in the Shortcut menu) to delete the existing preset before returning to the Metadata Inspector's Shortcut menu and choosing Save as Preset…using the same name to save. This time around your changes will be written to disk.

You are now ready to import your first photos.

Fig. 6.6 Create your own Metadata Views and Presets to speed the application of metadata to your photos at the point of import, and to tailor what you see in the Metadata panel when you select them in your Library.

Fig. 6.7 Only ever enter generic details that you know can be safely applied to images imported as a batch, and save your metadata view as a preset.

Importing Your Photos

If you are importing your photos from a media card or camera, you should now attach them to your Mac. If Aperture is set to launch whenever a device is attached it should open the import dialog, but if it does not, or if you are Importing from a folder somewhere else on your system, click the Import button on the Toolbar and select the source of your photos in the Import Source area that appears above the Projects dialog.

Where you want to store your photos is perhaps the most important decision you have to make in the whole workflow. As we explain in detail elsewhere, the decisions you make here will have a profound impact on the way you will back them up later on. By storing them inside Aperture's Library file, you will be able to rely on the Vaults system for backing up your Versions and Digital Masters simultaneously. Recovery from a fatal hardware fault is then a simple matter of restoring from your intact backup by installing Aperture on a new or repaired machine, connecting the external drive containing your Vault and using the tools built into the Vaults panel to restore your last working state.

If you choose not to store your images in the Library, but elsewhere on your hard drive, you will enjoy the benefit of being able to manually navigate your assets through Mac OS X's Finder. You will also be able to share these files with other users on a network. However, you will have to formulate your own backup routines and ensure that you regularly safeguard your work. Further, as your Digital Masters will be kept separate from your edited Versions, which will be stored inside the Library, any

breakdown in this routine – whether through human error or otherwise – means you will lose not only the originals but also your edited products. This could impact not only on individual adjusted images but also books and Web products in which they are used. Recovering from this kind of failure would be difficult, and could be impossible.

There is no reason why you need to adopt the same strategy for every set of images you import. You could, for example, store all commercial work in your Aperture Library to take advantage of the Vaults system, and import personal work as referenced images on an external drive, allowing you to remove that drive when not in use, and to save space on the drive storing your Vaults by restricting this to 'business' use.

Whether you choose to save your photos in Aperture's Library or reference them from an external source, you still have to save them in a Project. If you haven't yet set any up and you were to just click the Import button at the bottom of the dialog, Aperture would create a new untitled Project for you to rename and drop the images there. This is fine, but a better way of working would be to create the Project first or, if you already have Projects set up, to click on them in the Projects Inspector to move the output of the Import workflow – indicated by the arrow pointing out of the dialog and into the Inspector – to that location.

You should consider here how you want to organize your working area. If you only envisage ever having a limited number of Projects, then there is no problem creating them in the root level of the Library using the shortcut ⌘ N and entering a project name. However, for the professional photographer this is an unlikely scenario, and so you should consider setting up folders to house Projects with similar attributes. These could be as specific as subject areas, such as weddings, sports and travel, or as general as years. You can embed folders several layers deep, and name them however you feel most appropriate, mixing subject-based and chronological descriptors in a chain. So, you may have a top-level folder called 2009, inside which you keep two folders for flora and fauna, within each of which you have 12 numeric sub-folders for the months and only inside these you would store your Projects, which could be given titles that reflect the plants or animals they contain. A study of the flowering and

fruiting progress of a quince tree would therefore be found in 10 Projects, each called 'Quince', in folders '03 March' to '10 October' in the folder flora, which itself would be embedded within 2009.

Would this be an appropriate structure? It is impossible to tell. The most appropriate arrangement of folders and Projects will vary from user to user, depending on their own specific needs.

Work your way through the right-most pane of the Import dialog, correcting any time offset to compensate for a mis-set camera clock that may still have been set to your home time when you travelled overseas, and then use the drop-down beside Add Metadata From to select the Preset that you set up in the first stage of this workflow. It can be found at the very bottom of the drop-down. Don't confuse it with the Metadata view that you have set up and will be found at the bottom of the Views section. This will be empty of any data.

If you have any other metadata to add to your images, use the same drop-down to pick alternative data sets and fill in their variables, ensuring that the Append radio button is selected so that this data is added to what is already in place, rather than replacing it.

The more often you add data in this way, the more Aperture will learn about the way that you work, and over time it will start to automatically complete the data that you are entering based on common values you have used before. You can pre empt this by adding your own values from the outset, or correcting inaccurate suggestions that appear as a result of you having mis-typed an entry in the past through the Edit Autofill List option on the Metadata menu. Here you can add and delete entries entirely using the + and − buttons at the bottom of the dialog, and edit those already in place by double-clicking them and making your amendments.

With your metadata set, use the Stacks slider to group together consecutive images taken in quick succession where appropriate. Most images taken within a few seconds of each other will be the result of attempts to capture a better view of the same scene, but not always. Sports photographers may find that they take several pictures of different horses or cars in quick succession as they pass by a finishing post. On occasions such as these it would be inappropriate to stack them all together as their subjects are

Fig. 6.8 The slider that appears on the bottom of the Import dialog lets you stack images at the point of import, on the basis of the interval between each one being taken. The sticky tape, razor blade and no entry buttons manually stack, split and unstack your images.

fundamentally different. As such, manually selecting matching images by clicking with the mouse while holding down the ⌘ key will let you manually stack them by clicking the sticky tape icon in the lower right of the Import dialog's Browser window.

If you have used the slider to stack your images automatically, you may find that what is right for one set of images is too verbose for another, and that while some stacks do indeed group together related images in one part of your Import group, in another they manage to snare completely separate pictures that you nonetheless took within a very short space of time. In these instances, click within the Stack at the point where the subject changes and use the Split Stack command (⌥ K or the razor blade button at the foot of the interface) to split them into two (Fig. 6.8).

You are now ready to import your images. If you want to take all of the pictures in the collection into your Library, ensure that none is selected, and use the Import All button or click the arrow that connects the dialog to the Project in which you want them to appear. If you want to import only a selection, then pick them using the mouse and use the same buttons to bring them into the Library.

Perform Your First Backup

Now that your images are in Aperture, and before deleting them from your memory card, you should perform a backup. If you chose to store your images in the Aperture Library, rather than referencing them from elsewhere on your hard drive, you should use the Vaults system by opening the Vaults panel at the foot of the Inspector and connecting an external hard drive by either FireWire or USB.

If you have already set up a Vault on this drive, Aperture will recognize it and mount it automatically. You can then perform a backup by clicking the Synchronize button beside its capacity gauge.

If you have not yet set up your first Vault, use the Shortcut button at the foot of the Inspector and pick Add Vault. Aperture will tell you how many images it is going to back up and, once you have clicked Continue, ask you for a name for the Vault. This will be used in the Vaults pane to help you identify multiple backup sets, if you use them. As such, this name should be both unique and descriptive. Perhaps this Vault will be used every day, in which case Daily Backup would be an appropriate name. If you also maintain a weekly backup cycle, with that drive being taken offsite to save your files from possible fire damage, you would call that copy Weekly Backup. Use the drop-down menu beside where to choose the attached drive as the destination for the backup and then click Add.

Aperture will never automatically back up your images – not even the first time you create a Vault, so as with the instruction above for backing up to an existing Vault, click the Synchronize button, which is two arrows in a circular formation chasing each others' tails. It will be red at this point to show that there are Digital Masters in your Library that have not yet been stored in a Vault. If all of your Masters had been backed up, but some of your Versions had not, it would be amber.

Aperture will show you a progress meter as the backup completes. Once it is done, you can disconnect the Vault – remembering to first unmount the drive by clicking the Eject button in the Finder or Vaults panel – and delete the original images from your memory card.

Sorting Your Images

With your photos successfully imported into your Library, your first management task is to break them down into a finer-grained series of collections and groups that will make them easier to manage. Select images that relate to one another and use ⌘ L to create a new Album for each set. These Albums can be named as you go along, and while clicking on each will show only its own contents, and none of those from the other Albums, you can still see all of the photos you have imported to that Project as a whole by clicking on the Project's name in the Inspector and exposing the contents of every Album (and any images not yet placed in Albums) at the same time in the Browser.

No photographer – not even the best – could hope for every image in a shoot to come out the way they wanted, and even the best photos often benefit from some minor adjustments. The trick is to identify those photos with the best potential to use as a starting point.

There are a number of ways to do this in Aperture. The first would be to step through each Album and apply ratings to the photos they contain. Another would be to physically delete photos from the collection, which while destructive does at least offer the benefit of slimming down your Library and avoiding bloat on either the drive holding your Library or the one you use to store your Vaults.

However, the most inspirational way, and the method that most closely matches the way in which we work in real life is to use a Light Table. This lets you scatter your images across the screen, and sort them into groups, helping you to get your head around the way in which they work together and relate to one another. This lets you create finer distinctions between your images rather than the broad-brush divisions created by Albums.

Select the images you want to use on your Light Table, either from a single Album or the Project as a whole and pick Light Table from the Toolbar's New menu. Note that if, in future, you create new Albums in a Project that use images not stored in that Project, you can still create a Light Table using those images, so long as the Album holding them is selected at the point of creation. If you instead have the Project selected, which doesn't hold the images themselves but is just a symbolic link to them in the Album, then even if you choose the option to include all images, only those that appear in the Project will be included and not those drawn into it by Albums referring to other Projects.

Drag your images from the Browser onto the Light Table and start to organize them however seems most logical. Use the resizing handles to change their dimensions, and stack those that go together, bringing the best of each group to the top of the pile (Fig. 6.9).

As you work with your Light Table, you will start discarding the shots that are not up to scratch, and keeping others in Stacks so that you can go back to them later on to make a second assessment. Slowly your collection should start to filter down

Fig. 6.9 Use Aperture's Light Tables to organize, sort and filter your images. Images can be stacked in the same way as in the Browser, dragged into logical groups and resized. This closely mimics the way photographers would traditionally scatter images on a table, or examine slides on a Light Table.

to just the best pictures in your collection, which you can then begin to rate.

Giving your images ratings is key to identifying your best and most saleable work. It also gives you another series of parameters that you can use when searching or setting up Smart Albums.

Select your photos and use the number keys **1** to **5** to rate them, using **0** to remove a rating you have already applied.

Rating and Picking Your Photos Using Comparisons

Light Tables are an excellent way to sort images, but there are occasions when a traditional side-by-side approach is more appropriate. In these instances, you will switch to using Aperture's compare view. This can't be done on a Light Table, so switch back to your Albums and use the shortcut **⌥ 0** or use the Viewer Mode button to select Compare.

In Compare mode the Viewer will always show two images – one that you have chosen as the reference image and the one against which you want to rate it. The reference image will be shown on the left, surrounded by a green border, whereas the comparisons, bordered in white, sit to the right. These same color indicators are used in the Browser below the Viewer.

Pick your reference image by selecting it in the browser and pressing *Return*. Now move through the other images in the Browser, using either the mouse or keyboard until you find one better or more appropriate than the reference image. At this point, tap *Return* again to make this the new reference image and then return to stepping through the remaining images in your collection to complete the comparison exercise (Fig. 6.10).

By the time you reach the last image, the green-bordered photo should be the best of all of your assets, and can now be safely

Fig. 6.10 These two images may look similar, but there are subtle differences. By comparing side by side we can pick the best. The green border denotes our reference image, whereas the white border surrounds the image with which we want to compare it. Notice how these colors are also used in the Browser frame.

given a five-star rating before you go on to start the editing process.

Gather all of the best photos from your shoot into an Album to make them easy to find without moving their physical location and then switch to the Adjustments Inspector.

Edit Your Photos

With only a tiny number of exceptions – red-eye correction, for example – edits are conducted on a whole-photo basis. This is in stark contract to traditional photo editing tools that focus more clearly on smaller areas of an image for correcting more specific problems.

As such, edits in Aperture are more about correction than creation, and you should not expect to get a perfect result from a poorly shot image with burnt-out highlights or underexposed shadows.

Nonetheless, Aperture's editing tools are both powerful and extensive, and explored in detail in Chapter 5 (Fig. 6.11).

Output Your Photos

You should perform your editing tasks with each image's eventual use in mind, bearing in mind that some color and exposure adjustments that may work well as a page background in a book would not work well on a Web page, or as part of a gallery. Judicious cropping, rotating and color correction should be used to maximise the impact of your results before you move on to the final stage of the workflow: output.

If you are using your images as part of a Web page or Journal, you will have to choose between publishing to your MobileMe web space – if you are a subscriber – or saving your output to your Mac's hard drive and transferring it manually to your own Web space. If you have chosen to produce a Gallery, you have no choice but to send it to MobileMe, as it uses several server-based technologies that are not included in third-party hosting packages.

The Mac is well served by FTP applications, but one of the best is the free Cyberduck (cyberduck.ch), which uses industry standards and lets you drag items directly from the Mac's file system to the remote server and back again.

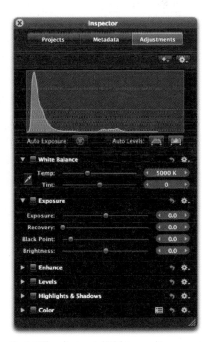

Fig. 6.11 The adjustments HUD lets you edit your photos in full-screen mode, or when you have hidden the Inspector to maximize your working space.

Books must ultimately be printed by Apple's partners by clicking the Buy Book button on the book creation interface and using your Apple ID. However, you can also print the pages of the book or save it as a PDF for proofing prior to paying any fees for a hard copy. In this way, you can seek sign-off from a client before taking the ultimate step.

If you are printing the proofs of your book, or any individual photos, it is essential that to get the most accurate representation of your photos in their final state you follow the color management guidelines in Chapter 8.

Not all photos need to be published or printed. There are many instances when you will want to save a photo to disk, either because you need to send it to a client or you want to use it in an external application, such as Adobe Photoshop.

In these instances, you would use the File > Export command to save the photo using one of your Export presets, which can be set up in advance or by picking Edit from the Preset drop-down on the Export Dialog.

Aperture ships with 18 existing presets catering for a wide range of needs, including Photoshop PSD export at both full and half-size resolutions, so there are few instances when you will need to create your own to supplement these. However, as none of these export settings includes watermarking as a default, you should seriously consider creating a logo that can be stamped onto your work when being exported for approval by a client. This would stop them from using the work without your authorization.

Aperture can use a range of image formats for watermarking, but the most versatile and highest quality are flat Photoshop files with transparency, which will give clean edges and allow you to maintain a high degree of detail. You should create your watermark in a range of sizes and create different presets for each one, as Aperture can scale overlarge watermarks down to fit but cannot scale up any that are too small to act as an effective deterrent.

Backup, Backup and Backup Again

At the end of your editing session, you will have added several new image Versions to your Library. Although they are based on the Digital Masters that you stored in a Vault at the start of the workflow, they have not themselves been safeguarded. As such, the Synchronization icon in the Vaults panel will be amber, warning you that you risk losing work if you suffer a hardware failure.

At this point, and before quitting Aperture for the day, you should re-attach your Vault and perform a backup. Only when the icon shows black will you know that your work is safe.

Light Tables

Once you have imported your images, you need to start thinning them out. A single photo shoot can stretch to several hundred frames, the vast majority of which will be unsuitable for one reason or another. You could sort them by stepping through your newly imported pictures in the Browser strip, assigning ratings and keywords to each one as you go, but this is cumbersome and unrealistic. Nobody who used to shoot with film would have taken their pictures out of their envelopes one at a time, rated and cataloged each one and then put it away again before moving on to the next.

Instead you would scatter them across a table and rearrange them by hand into collections and groups. Aperture's Light Table feature lets you do the same in the digital realm.

Create a Light Table by selecting a range of images in a folder in your Library and picking File > New from selection > Light Table. The Light Table will appear as a new entry in the Projects pane, and open up as a grid-based space above the Browser strip. You can scale it using the slider above and to the right of it.

Start by dragging all of your images onto the Table. They'll be arranged neatly so that each one has a full facing and none of them overlaps, giving you a good immediate overview of your pictures (Fig. 6.12).

You will already be able to see how the pictures relate to one another in terms of composition and color temperature if you've been shooting in a studio; subject and location if out and about. These factors should be the starting points of your sorting. At this point you'll probably want to close the Browser and maximize the Viewer window (press **V**).

To sort your images simply do what you would in the physical world: grab hold of them and drag them around using the mouse. As you move each one you'll see that yellow guidelines appear along its edges and center showing when it is aligned with the edge or center of other pictures on the Light Table, and as you move beyond the edge of the existing checked area in any direction, it grows to accommodate your image. You can, of

Fig. 6.12 As you move photos on the Light Table, Aperture uses dynamic guides to show when you have lined up the center or edge of each one with any other element on the Table.

course, ignore the guidelines should you choose, and you can stack images on top of one another if you need to save space on a smaller monitor.

As you do, it's easy to lose track of what has become obscured by other images that overlap or cover it up. In this instance, select any of the images covering up one of the others and press **Shift X** to have Aperture intelligently rearrange them to give each image in the group a full facing (Fig. 6.13). The rest of the Light Table will be dimmed, and although you can't directly manipulate any of the images you have uncovered, you can click on them. This will select the clicked image and drop them all back into their original locations, only this time with the selected image on top and ready to be worked on.

You can select and move several images at once by holding **⌘** while clicking them, and then dragging them as a group, or by dragging a selection box around adjacent images to select them as one entity. Right-clicking a selection of this type gives

Fig. 6.13 Once you have stacked a group of images, you may want to temporarily rearrange them to expose those that have been covered up. *Shift* **X** does this, allowing you to click one of the lower images to bring it to the top of the pile.

you the option to align any of their edges, and to space them out evenly on a horizontal or vertical plane (Fig. 6.14). This makes it very easy to stack similar images, most of which will have been taken in quick succession by dragging a selection box across them and then aligning both their top and right sides in sequence.

A right-click here also gives you the option to arrange your images. This is a handy as it shuffles the selected pictures so that none of them is overlapping, and then lets you drag them as one set to a new location, complete with yellow guidelines that appear in relation to the group as a whole.

As your collection consolidates you'll find that it quickly becomes easy to identify the duds, which can be removed by selecting them and using **⌘** **⇐** to delete them, in the same way that you would send a file to the Trash in the Finder. A less destructive option is to put images from the Light Table back into the Browser bar by selecting one or more and using the shortcut *Shift* **P**. As you'll see if you have the Browser visible (cycle through the View modes using **V**), this removes the image from the Light Table, but keeps it close at hand should you want to use it again in the future.

The more images you remove, the more space you will have, which gives you the opportunity to start enlarging the ones that remain to give you a better view and help you discern smaller differences between them. Every time you hover over an image,

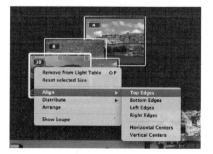

Fig. 6.14 Don't have time to neatly arrange your photos yourself? Right-click a collection of photos, and the context-sensitive menu offers to automatically align the pictures along specified dimensions.

therefore, you'll notice that eight grab handles appear around the edges. Pulling any of these out from the center enlarges the image, maintaining its proportions as it does, while pushing them in towards the center shrinks it down.

Because Light Tables will always be a work in progress to which you will return time and time again as you work on a particular Project, Aperture lets you keep as many as you need in your Library at any one time, and even use the same images more than once in several different Tables. Clicking away from them or closing Aperture saves their current state so you can come back to them in another session.

Performing Sorts and Edits from a Light Table

Images on a Light Table remain live at all times, meaning you can edit them here just as easily as you would an image in a Project or a folder. With the Inspector or Inspector HUD open, you can switch to the Adjustments tab and apply adjustments using the regular controls, remembering to zoom in or resize your images to give you a good view of the results. Depending on your Preference settings, any edit you make may create a new Version of the image, which will be placed on the Light Table alongside the original. Neither these Versions nor the Digital Master can be resized while unstacked, so to shrink or enlarge them click on the Version count on the Digital Master to collapse them back into a single Stack, resize the Digital Master and then click the number again to expand them back into an opened Stack with all Versions in view side by side.

As ever, tapping **F** gives you a full-screen view of any image selected on the Light Table so you can edit at the largest possible size. However, you can also apply edits by showing the image in the Viewer window. This is hidden when you're viewing the Light Table, but can be shown by clicking the Viewer button. Ensure you have the Browser and Light Table visible, by tapping **V** to cycle through the different View modes until you see the Light Table displayed above the Browser strip.

The control strip at the top of the Browser pane sports a number of buttons, a drop-down menu and a search box. The drop-down lets you sort the images by orientation, date, keyword, rating and so on, whereas the search box lets you trim them down by typing in a search term. Clicking the magnifier at the left-most end of the box gives you quick access to the preset star ratings. There is another magnifier to the left of this that calls up the filter HUD,

allowing you to perform more extensive searches. The button to activate the Viewer for more effectively performing edits sits to the right of the List View button. Clicking once opens the viewer; clicking a second time returns to the Light Table.

Stacking

Aperture is built to work like a professional photographer. As such, it can intelligently stack photos taken at a similar time, understanding that they are probably taken in a single burst, or at least in very quick succession, and thus are directly comparable.

Stacks are created automatically, either when you edit a Digital Master by creating a new Version or by examining the file creation time – something Aperture can do either at import or later, when you're browsing the Library.

You can preview how your images will stack at the point of import, by using the Auto-Stack slider at the bottom of the Import dialog. This appears directly below the image thumbnails, and is broken into second increments, with markers at 15, 30, 45 and 60 seconds. Moving the pointer to the right increases the window within which images can fall to be stacked. So, dragging it to the furthest right extremity would stack all images taken within a minute of each other. Taking it back again half-way would release those taken with a delay of more than 30 seconds between each one.

Stacks will be shown using the Digital Master, stamped with a number indicating the number of images within the Stack. This number, and the box surrounding it, is called the Stack button. You'll notice this number appearing every time you make an adjustment to a Digital Master within the Browser and Viewer environment (Fig. 6.15).

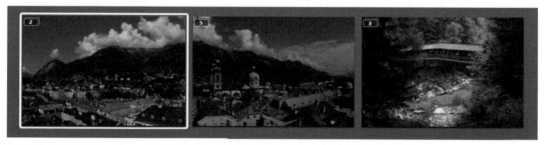

Fig. 6.15 The badge in the top left corner of a Pick image on a Stack indicates how many photos exist in each Stack.

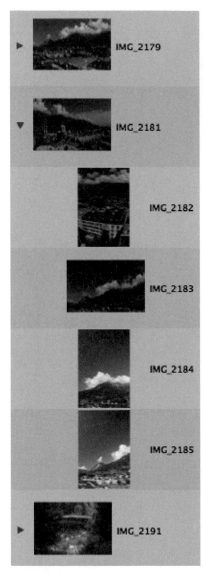

IMG_2179

IMG_2181

IMG_2182

IMG_2183

IMG_2184

IMG_2185

IMG_2191

Fig. 6.16 Stacks can contain images of any orientation or subject but are always indicated by a single image in the list view unless they are expanded, as shown here.

However, you can also create Stacks manually in the Browser, and once there manipulate them, using both the mouse and the keyboard. It's worth remembering that the button that controls Stacks, in almost every instance, is **K**, which is combined with the *Shift*, **⌘** and **⌥** modifiers to perform a wide range of functions. This lets you group images by whatever criteria you choose, and so is more versatile than being restricted to stacking purely on the basis of time (you might, for example, be importing images from several cameras or several photographers, all of whom have been taking photos of the same subjects and want to amalgamate the best photos into a single Stack. Alternatively, you may have thinned out the immediately unsuitable images from your latest import and want to stack those that remain to give yourself some more space to work on the rest of the import).

There is no reason why Stacks should be restricted to consecutive images; holding **⌘** while clicking on multiple photos scattered throughout a single Project or folder and then pressing **⌘** **K** will join them as a Stack. If your Browser is in the Filmstrip or Grid mode, they will be given a darker gray background. If you're using the List View, the first image in the Stack will be used as a folder containing the other images you selected. A small disclosure triangle will let you expand and close the folder within the Browser to show or hide its contents (Figs 6.16 and 6.17).

The image used to represent the Stack in the List View, or in the Grid or Film Strip Views when the Stack is collapsed, is called the Pick image. This can be changed at any time – to reflect the best image in the Stack, for example – by dragging an image from within the Stack onto the Pick image when in List View, or in front of it in the Grid and Film Strip Views. **⌘** **** achieves the same thing without using the mouse.

Pressing **Shift** **K** toggles a Stack open or closed, while pressing **⌘** **Shift** **K** when any image in a Stack is selected will unstack every image. You can also open and close Stacks by clicking on the small indicator on the Pick image that shows how many photos the Stack contains. The most powerful Stack shortcuts are those that open and close all Stacks at once: **⌥** **¬** and **⌥** **/** respectively.

The more time you spend working with your images and thinning them down to just the very best examples from any

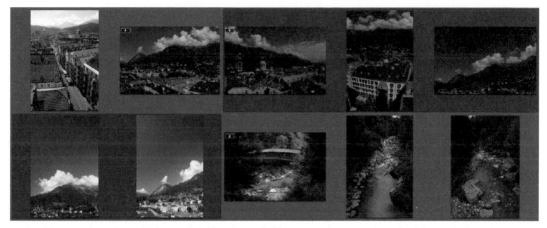

Fig. 6.17 When viewed in grid mode, Stacks are indicated by grouping all of the constituent images together with a darker gray background.

shoot, the better you will understand their relationship with one another. At this point you may find that your Stacks are no longer relevant as they don't represent groups of the best related photos. When this happens you'll need to start breaking up your Stacks. However, the chances are that you'll want to keep at least some of them stacked, perhaps because they need further sorting. As such, the shortcut to dismantle the Stack entirely (⌘ *Shift* **K**) is overkill.

At times like this you want to manually drag images out of the Stack. The principle is the same whatever view you're using, but the way it is represented on-screen differs slightly depending on whether you're using List, or either Film Strip or Grid Views.

Dragging an image from your stack to any other position within it when using List View will always highlight the whole of any other image in that Stack as you hover over it. In this way you know that you are still within the Stack, and won't drop your image in the Stack's last position, thinking you've dropped it just outside of it. Once you have moved outside of the Stack, the position indicator changes to a hairline divider, which sits between images, indicating where your photo will sit once you drop it.

When using the Grid or Film Strip views, your image position is always shown using a vertical green bar, whether you're moving inside or outside of the Stack. This means that when you drag an image to the very end of your Stack, you'll see that the green line

appears in two different positions with very small movements of the mouse: one position inside the Stack and one just outside, a few pixels away from each other (Fig. 6.18).

The same theory works in reverse, allowing you to quickly add images to a Stack by simply dragging them in from anywhere else in your Project. Alternatively, select any image in your Stack, and then any image you want to add, and tap ⌘ K. The new image will be added in the final position within the Stack. Shift ⌥ K will remove any selected image from a Stack.

You can move images within a Stack using the keyboard, as well as the mouse, and this is almost the only instance when the shortcut strays from using K. ⌘ I and ⌘ J moves an image to the left and the right respectively. If you are having trouble rating your images within a Stack, and deciding which should be used as the Pick image to represent the whole Stack, this is a good way to compare them side by side, one by one.

Fig. 6.18 When relocating an image inside a Stack in Grid mode, a narrow green line indicates its position. At the end of the Stack the line will appear either inside or outside of the bordered area to indicate its removal from or addition to the Stack.

This shortcut only works within a Stack; you can't use it to rearrange images within a general Library. Neither can you move your images beyond the boundaries of the Stack, so this is not a way to move images either into or out of an existing Stack.

Why is it important to choose a good Pick image? Not only does the Pick represent the Stack as a whole (and should therefore be representative of the style and content of the Stack as a whole) but the Pick is also used in various products created using the photos in your Library.

Versions and Version Sets

With Aperture's incremental versioning system, you can push your creativity further, always applying one more adjustment than you would usually be happy with, safe in the knowledge that you can always revert to an earlier safe state with which you were happy. The result should be more dynamic, eyecatching and – ultimately – saleable work.

Each Version, which can be created automatically or manually, acts as a safe milestone to which you can return if you take things a little too far. However, they also act as options, allowing you to give clients a range of choices, each derived from a single Digital Master.

Because a Version is just a list of metadata applied to the Master, each one takes up very little space on your hard drive, allowing you to create far more Versions using Aperture without increasing the capacity of your system than you would with an alternative, such as Photoshop.

Automatically Created Versions

Every original image in your Library is, as we have already shown, a Digital Master, which Aperture considers to be sacred and untouchable. It is the digital equivalent of a film negative, which would always exist in its original state, with only the derived products – your prints – edited by dodging, burning and changing the way in which the photosensitive paper is exposed.

As such, Aperture never lets you make any changes to your Masters, apart from editing their metadata, or changing the way they appear in products, like books, Light Tables and Web pages. When only one edition of any image is shown in your

Library it is, by default, the first Version, with the original stored safely, untouched, on your drive. You can, however, set Aperture to automatically create new Versions of the first instance of any image when you apply extensive edits to it at any point through Aperture's Preferences' General pane.

You can make as many further edits to this Version as you like without another Version ever being created.

Manually Created Versions

There are times when you will want to make alternative edits to either an existing Version or the Digital Master from which it was derived, to give you a choice of finished products or works in progress. This lets you experiment, and is particularly useful in the early stages of working with your photos, if you have not been given a clear brief by a client, or you are unsure how best to handle your material.

To create a new Version from the Digital Master, have the Master or any Version selected, and use the shortcut ⌥ G (modifying this by simultaneously holding the *Shift* key will open both Versions side by side so that you can compare them). This gives you a fresh, untouched copy of the original from which you can start working all over again. You can achieve the same thing by selecting the Digital Master again, and making fresh edits, but this shortcut saves you some mousing, and fits better with a keyboard-based workflow, in which the keys are used to perform commands, and the mouse to make edits.

To create a new Version from an existing Version, select the Version in question and use the shortcut ⌥ V. In effect, this creates a new edition from the Digital Master and applies to it any adjustments you have made to the Version from which you made the duplicate. The existing Version then becomes your safe-haven milestone to which you can return, whereas the duplicated Version is the one on which you will experiment by applying further, more extreme adjustments, or by cropping and rotating the image.

Working with Other Applications

Introduction

It's entirely possible that you might use your Mac and Aperture exclusively to organize and edit your image Library without ever launching another application. But not very likely. Images are usually just the beginning – only when they've been organized, categorized, sorted, rated, labelled and edited, are you ready to begin using them. And that's where Aperture's ability to integrate with other applications becomes critical.

To begin with, in this chapter we'll look at what to do if you're new to Aperture and want to migrate your existing image Library from iPhoto or Adobe Bridge. We'll also discuss the implications of this for your image metadata and look at some of the differences in the Raw image processing tools provided by Aperture and Adobe Camera Raw (ACR).

Then we'll take a look at how you can use Aperture in conjunction with a range of applications from Apple's own iLife and iWork suites to other applications such as Adobe InDesign. We'll tackle this from two opposing angles: round tripping images to other applications from Aperture and accessing your Aperture Library from within other applications.

The potential for enlisting the help of third party applications to edit your images in Aperture is about to grow exponentially with the introduction of Aperture 2.1's new edit plug-in architecture. We'll also take a look at some of the first new plug-ins to become available.

Importing Your iPhoto Library

When you first open Aperture, a dialog box appears that allows you to import your iPhoto Library. If you decide to import your iPhoto Library after you've been using Aperture for a while, select File > Import > iPhoto Library (Fig. 7.1).

Use the Store Files pop-up menu to tell Aperture where you want to store the imported image files. 'In the Aperture Library' will copy the files from the iPhoto Library to the Aperture Library. If you have a large iPhoto Library you'll need to consider the storage implications of this, and make sure you have sufficient disk space for the duplicates (Fig. 7.2).

'In their current location' treats the images in the iPhoto Library as referenced files; they are not imported into the Aperture Library, Aperture maintains a link to them in their current location. For more details about the difference between working with managed and referenced files see Chapter 2. Alternatively, you can choose a location where you want the image files copied or moved to.

Fig. 7.1 Select File > Import > iPhoto Library to import your entire iPhoto Library into Aperture.

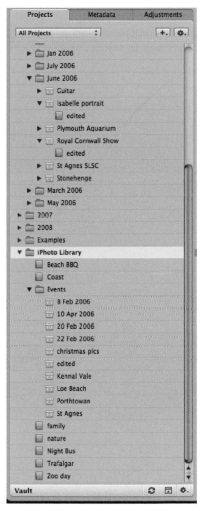

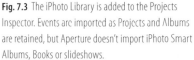

Fig. 7.2 In the dialog box, tell Aperture where you want to store the iPhoto images, how to deal with sub-folders and whether to rename the original files.

Leave the Version Name pop-up menu on its default of Master Filename to import images with their current filenames, or select one of the options if you want to rename the files on Import. Finally, click the Import button to import your iPhoto Library.

Aperture maintains the organisation of your iPhoto Library as Projects within an iPhoto Library folder. Albums are imported, but Aperture doesn't import iPhoto Smart Albums, books or slideshows. The Exif information is included as are any keywords, ratings and image adjustments that you applied in iPhoto (Fig. 7.3).

Importing Individual Images or Albums

You don't have to import your entire iPhoto Library into Aperture. The iPhoto Browser allows you to select individual images or Albums. To open the iPhoto Browser select File > Show iPhoto Browser or press ⌘ ⌥ **I** (Figs 7.4 and 7.5).

The top panel of the iPhoto Browser shows Events, Photos, Recent Events and Imports and Albums. Selecting any item in the top pane displays its contents in the pane below. To display the contents of an individual Event, click the Events button to display all of the Events in the bottom pane then double-click the Event you want. Selecting Photos displays all images in your iPhoto Library.

Fig. 7.3 The iPhoto Library is added to the Projects Inspector. Events are imported as Projects and Albums are retained, but Aperture doesn't import iPhoto Smart Albums, Books or slideshows.

New	▶
New from Selection	▶
New Smart	▶
New Project	⌘N
New Folder	⇧⌘N
Close Tab	⌘W
Duplicate Album	
Delete Version	⌘⌫
Delete Master Image and All Versions	
Import	▶
Tether	▶
Export	▶
Show iPhoto Browser...	⌥⌘I
Relocate Master...	
Consolidate Master...	
Show in Finder	
Manage Referenced Files...	
Email...	⌥E
Slideshow...	⇧S
Order Prints...	
Vault	▶
Migrate Image...	
Print Image...	⌘P
Print...	⌥⌘P

Fig. 7.4

Fig. 7.4 & 7.5 You don't have to import your entire iPhoto Library. Select File > Show iPhoto Browser to select individual Events, Albums and images and drag and drop them onto the Projects Inspector.

The Browser includes tools to help you sort and locate images within your iPhoto Library. Use the Sort pop-up menu to arrange images by name, rating, date created or other criteria. Click the Search button in the top right of the iPhoto Browser to do a text search for images.

Previews

You can adjust the size of the thumbnail previews in the bottom pane by dragging the slider in the bottom right corner. Alternatively, double-click an image to display a larger preview including Exif and rating information. Use the navigation controls at the bottom of the preview window to move back and forth through the image selection.

When you've located and selected the Events, Albums, or images you want to import, drag them onto a Project in the Projects Inspector or HUD. If you drag images or Albums onto the Library in the Projects Inspector a new Project is created for them. If you don't want to import the images into your Aperture Library, hold down the ⌘ and ⌥ keys while dragging and dropping to reference the iPhoto files in Aperture.

Moving from Adobe Bridge and Adobe Camera Raw

For many photographers not yet utilizing a digital image workflow application such as Aperture, Adobe Bridge and Adobe Camera Raw (ACR) provide the means by which they organize their image collections and convert Raw files to RGB images.

Aperture and Adobe Bridge

The advantages of using Aperture over a Bridge/ACR workflow are numerous. Aperture's organizational tools and versioning system make it easier to keep track of your images and edited Versions, take up much less disk space and, ultimately, help you work faster than a system which relies on producing multiple RGB files for each edited Version of an image. You'll also find locating images within a large Library much faster using Aperture.

Suppose you want to produce two Versions of the same Raw file, one color and another black and white. Using ACR you would set the required conversion options for the color image and output an RGB file. Then you'd need to go back to the Raw file and output a second image using ACR's grayscale conversion parameters. If you then decided you want a cropped version of the mono image a third file would need to be produced. You can do all of this in Aperture without creating a single additional file (Fig. 7.6).

Aperture and Adobe Camera Raw

If you're used to using ACR to convert your Raw files to RGB images you should find working with Aperture's Raw Fine Tuning and other Adjustments easy to adjust to. The controls on ACR's Basic panel – White Balance, Exposure, Recovery, Fill Light, Blacks, Brightness, Contrast, Clarity, Vibrance and Saturation – all have Aperture equivalents and even share the same or similar names.

ACR provides some correction tools that Aperture lacks, or doesn't implement in the same way. For example, Aperture doesn't have an equivalent of ACR's chromatic aberration lens corrections, but the Moiré adjustment in the Raw Fine Tuning brick is an effective tool for the removal of color fringing. Aperture also lacks the equivalent of ACR's Tone Curve, but again, you can utilize the quarter-tone controls in the Levels brick to effectively change the shape of the tonal curve in much the same way.

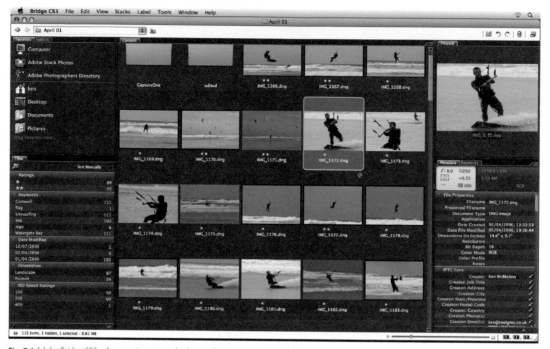

Fig. 7.6 Adobe Bridge CS3 references images and other media types on your hard drive and allows you to organize and display them in a Browser and edit metadata.

And ACR's Split toning is different in effect to Aperture's Color Monochrome Adjustment, though, arguably, no more useful.

In its favor, Aperture puts a much broader range of adjustments and editing controls at your disposal. Chapter 5 will tell you everything you need to know about these, but the list of Aperture adjustments that Raw convertors like ACR lack includes selective color replacement, additional sharpening (outside of demosaic compensatory sharpening) and red eye correction. Aperture's 2.1's new plug-in architecture adds a whole new range of editing tools to these core features.

Moving from Bridge

The process of migrating your image Library from Bridge to Aperture is, in most respects, relatively straightforward. Bridge references image files in their existing location; it doesn't store the actual image files. To make a comparison with Aperture's way of doing things, it works with referenced rather than managed files.

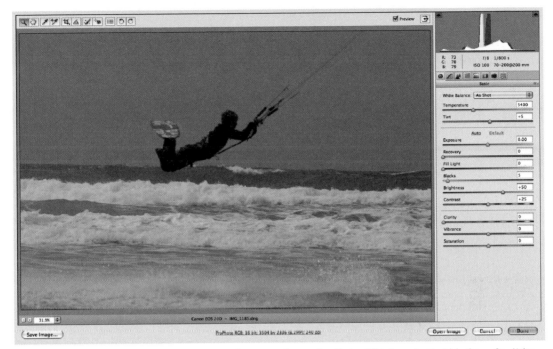

Fig. 7.7 Bridge doesn't provide Raw decoding. Interpretation and conversion of camera Raw files into RGB is done using the Adobe Camera Raw Utility. ACR can store adjustments to raw images in a sidecar XMP file (or embedded within an Adobe DNG file) and these are used by Bridge to display the adjusted thumbnail. However, you can only have one set of adjustments per Raw file. For more than one Version, it's necessary to output multiple RGB files.

Because of this, you don't actually need Bridge to import images that you've managed using Bridge into Aperture. In fact, if you're used to working with Bridge as part of the CS3 suite there's no reason you can't continue to do so, provided you configure Aperture to work with referenced rather than managed image files. See Chapter 2 for more details on how to do this.

As we'll discover shortly, though, if you have added metadata to your images in Bridge, and want to import it with the images into Aperture, things aren't quite so straightforward.

To import a folder of images that you've previously worked with in Adobe Bridge, first you will need to locate them in the Finder. This shouldn't be too difficult as all you have to do is look in the Folders panel. You can also right-click a folder in Bridge and select Reveal in Finder from the Context menu (Fig. 7.8).

Fig. 7.8 Locating folders of photos using Bridge is straightforward because the Folders pane displays the file structure on your hard disk. Alternatively you can right-click an image or folder and select Reveal in Finder from the Context menu.

Now all you have to do is import the folder into Aperture in the normal way. Either drag and drop it from the Finder into a folder in the Projects Inspector, selecting File > Import > Folders as Projects, or click the Import button. For more detailed information on importing folders of images see Chapter 3.

Metadata

If you've used Bridge to add IPTC metadata and keywords to your photos you may be in for an unpleasant surprise when you view their metadata in Aperture – it may not be there. Depending on the image format, metadata is either embedded in the image file itself or it is written to a separate 'sidecar' file. Usually, metadata is embedded in TIFF, JPEG and PSD files and Raw file formats have their metadata written to a separate sidecar file (Fig. 7.9).

The sidecar files that Bridge, ACR and many other applications use to exchange metadata are in XMP format. XMP stands

Fig. 7.9 When you add or edit metadata in a camera Raw file in Bridge, it stores it in an XMP 'Sidecar' file. These CR2 Raw files from a Canon dSLR were shot on 1 April 2008. On 4 April they were rated, which is when Bridge created the XMP file for each one.

for eXtensible Metadata Platform and is a widely used Adobe standard for the storage and exchange of metadata.

So, if you add IPTC metadata to your camera Raw files in Bridge, it will be stored in a separate file along with the Raw file. For example, if the Raw file is called IMG_6341.CR2 the sidecar file will be called IMG_6341.xmp.

It's not just Adobe applications that use sidecar XMP files. XMP is supported by other image management and Raw processing applications including iView Media Pro, Extensis Portfolio and Capture One 4. Aperture itself supports the export of XMP sidecar files but, and here's the bad news, Aperture 2 doesn't support the import of XMP sidecar files.

This leaves you in a difficult position if you've spent many hours adding metadata to your Raw image files in Bridge or any other application that exports that data in an XMP sidecar file.

DNG Conversion

There is currently no way to import the data in XMP sidecar files into Aperture. There is a work-around that will enable you to import the files into Aperture complete with IPTC metadata and keywords intact, though not ratings. This involves converting your camera Raw files to Adobe DNG format.

DNG is Adobe's Digital Negative format, an open and published alternative to proprietary camera Raw formats. For more detailed information about the DNG format see Chapter 1. To convert your camera Raw files to DNG you'll need Adobe's DNG Converter application which you can download free from the Adobe

Fig. 7.10 This is what you'll find if you open an XMP file in a text editor. This section of the file contains the Exif information, further down is the IPTC metadata and the list of adjustments made in ACR.

website. Here's a brief explanation of how to convert your camera Raw files to DNG so that you can import them to Aperture with most of their metadata intact (Fig. 7.11).

Launch DNG Converter and make sure the preferences in panel 4 are set to

JPEG Preview: Medium Size
Compressed (lossless)
Preserve Raw Image
Don't embed original.

If not, click the Change Preferences button and change them. In panel 1, click the Select Folder button and navigate to the folder

Fig. 7.11 Adobe's DNG Converter is a utility that converts proprietary camera Raw files into Adobe's 'Open' DNG format. This has future-proofing advantages for your digital archive, and also provides a migration route for your image Library from Bridge to Aperture with metadata intact.

containing the images to be converted. Make sure the .xmp files are in the same folder as the Raw files. Check the box to include images contained within sub-folders. In panel 2, select Save in New location from the pop-up menu and choose a folder in which to save the converted Images. Check the Preserve sub-folders box. In panel 3 leave everything as it is, so that your files keep their name but are appended with the .dng file extension.

When you click the Convert button, DNG converter will begin the conversion process. You can convert your entire image Library to DNG this way, but it may take a while. Before you embark on a large scale conversion you may want to try a test with a single folder of images. As long as you have a safe backup of the original Raw files and you save the converted files to a new location with a .dng suffix, you've got nothing to lose and can always revert to your camera Raw files if you decide against using DNG in future.

When the conversion process is complete, you'll have a duplicate of your image Library with the same file and folder structure containing .dng rather than camera Raw and .xmp sidecar files.

Fig. 7.12 Use DNG converter to convert your camera Raw files to DNG format with the metadata embedded. The Preferences should be set as shown here, though you don't have to compress your DNG files and you can select a different preview size if you prefer.

Fig. 7.13 When you click the Convert button, DNG converter will begin the conversion process. For a large Library this could take some time. Do a test run on a small folder of images to ensure everything works as expected.

DNG converter automatically embeds the metadata that was in the sidecar file into the .dng file (Figs 7.12–7.14).

Now you're ready to import the .dng files into Aperture. Select File > Import > Folders Into a Project and navigate to one of the converted folders. Aperture imports all of the images into a single Project and creates Albums for sub-folders, so you might first want to decide how you want your Projects organized in the Projects Inspector and set up a suitable folder structure.

When Aperture imports the .dng files it also imports the IPTC metadata and keywords. It's not possible to import image adjustments made to Raw files in ACR, even DNGs into Aperture. Although ACR saves the adjustments to the XMP sidecar file or, if possible, the file itself, and they are imported into Aperture, they

Fig. 7.14 Import the converted images into Aperture. Keywords and other metadata added in Bridge are preserved, but not ratings or adjustments made using ACR.

are immediately overwritten by the Aperture Raw decoder and default adjustment settings.

Aperture and Adobe Photoshop

Although Aperture has everything you'll need for processing the majority of your images, there will be occasions when you need to turn to an external image editor. For most people that's going to be Photoshop, but you can use any imaging editing application in conjunction with Aperture.

You define the external image editor you want to use in the Export tab of the Preferences window. Click the Choose button to navigate to the application, then click Select. Choose the file format that you want to use from the External Editor File Format pop-up menu. The range of file formats you can work with has been extended in Version 2.1 of Aperture and now includes 8-bit as well as 16-bit PSD and TIFF files (Fig. 7.15).

Fig. 7.15 Choose the application that you want to use for external editing in the Export panel of the Preferences window. Aperture 2.1 has extended the range of round trip file formats to 8 and 16, PSD and TIFF files.

The default resolution for opening files in your external image editor is 72dpi. Note that this doesn't affect the number of pixels in the image, only the resolution. If the Raw Master has pixel dimensions of 3504 × 2332 that remains unchanged whether the resolution of the opened file is 72dpi or 300dpi. In other words images are not resampled.

To open an image in Photoshop (or your chosen external editor) select it in the Browser and choose Images > Edit with > Photoshop. Alternatively, right-click the image thumbnail and choose Edit with > Photoshop, or press *Shift* ⌘ *O* (Fig. 7.16).

There's a short delay and the message 'Preparing IMG_1234 for editing' appears. What's happening during this time is that Aperture is producing a file of the format specified in Preferences, e.g. a 16-bit PSD file. All of the adjustments you made to the selected Version using the Raw Fine Tuning controls and other adjustments are applied to the image and then it's opened for you in Photoshop (Fig. 7.17).

New Masters

Whether you make any changes to the image in Photoshop or not, the new file is added to your Aperture Library and appears stacked alongside the Version from which it was created. With the image still open in Photoshop, press ⌘ → to switch back to Aperture and you'll see its thumbnail. If you have a metadata display enabled that shows badges, on the new thumbnail you'll see a badge – a circle with a dot in the middle – that indicates this is a Master created by an external editor.

Fig. 7.16 Select Images > Edit with [application], right-click and select Edit with [application] or press **Shift** **⌘** **O** to open an image in your chosen external editor – in this case Photoshop CS3.

Fig. 7.17 Here the image has opened in Photoshop as a 16-bit PSD file, as defined in the Aperture Preferences. Behind it, you can see the new Master Version that Aperture has added to the Library, stacked with the original Master and denoted with a target badge to indicate it has been created with an external editor.

Fig. 7.18 If the original image was referenced, the Master produced by round tripping to an external editor is now stored in the same location, rather than in the Aperture Library.

If the new Master was produced from a managed Master then the PSD file will be stored in the Aperture Library. In Aperture 2, round tripped Masters created from referenced Masters are stored in the same location as the original referenced Master. In earlier Versions of Aperture this was not the case and all new Masters produced as a result of external editing, regardless of whether the original was managed or referenced, were stored in the Aperture Library.

This caused much consternation among Aperture users who wanted to access these images outside of Aperture. The new Master either had to be manually dug out from the Library package or exported from Aperture to the original location and then re-imported to the Aperture Project. Thankfully, Apple has now addressed this issue.

In any case, access of managed Masters from other applications is no longer the issue it used to be as; using MacOs 10.5 Leopard, it is now possible to access your Aperture Library from other applications such as iLife and iWork. This is covered later in this chapter.

Workflow Considerations

One very important consequence of external editing is that the new PSD and TIFF Masters are not editable in the same way

Fig. 7.19 A round-tripped image is no longer a Raw image, so you obviously won't see the Raw Fine Tuning brick in the Adjustments Inspector. All other adjustments are also set to their defaults — you're starting afresh with a new image.

as the original Raw Masters or Versions from which they were created. Obviously the Raw Fine Tuning brick will not be available and any other adjustments you made prior to editing the image in Photoshop will have been applied and effectively 'fixed'.

For example, if you applied edge sharpening to the original you won't find the Edge Sharpening brick when you select the new externally edited Master. And if you add more edge sharpening the controls will be set at their defaults – not the sharpening settings you originally applied; those are now undoable (Fig. 7.19).

Think carefully about at what stage in the workflow you are going to incorporate external editing. Usually you'll want to leave it as late as possible, but not always. In the case of sharpening, for instance, you probably wouldn't want to apply edge sharpening to an image prior to carrying out retouching in Photoshop as this kind of work is best done prior to sharpening.

Transparent Problem

If you do editing work on a Photoshop file, or import into Aperture an existing PSD file that contains Alpha channels, it won't display properly in either the Viewer or Browser. This problem isn't confined to Aperture; if you view the image in Preview or iPhoto it will look exactly the same because all of these applications (but not Photoshop) rely on operating system routines to display Photoshop images.

Usually, the Alpha channel causes parts of the image to render as black or white. Note that you don't get this problem with layer masks, though if you've produced a layer mask from a selection that you've saved as an Alpha channel you will have the same problem (Figs 7.20 and 7.21).

Fig. 7.20 & 7.21 The Master on the left has been externally edited with Photoshop to produce the new PSD Master on the right. A selection has been made around the windbreak which has been saved to an Alpha channel. This displays incorrectly in Aperture previews. In this case, it's not a huge problem, because you have the original to refer to. If the PSD is the only image you have, if you want to see it properly in Aperture, you'll have to produce a duplicate with the Alpha channel removed. This problem doesn't occur with Layer Masks.

Fig. 7.21

The only way around it, until Apple revises the operating system routine that causes it, is to select the offending PSD file, choose Images > Edit with Adobe Photoshop and delete the Alpha channel in the Photoshop Channels palette. As has been mentioned, there's no need to delete layer masks; though, given this will just be a reference to correctly display the thumbnail and preview, you may as well take all the steps you can, such as flattening the image, to make the file as small as possible.

Close the image in Photoshop and you'll find it displays properly in Aperture's Browser and Viewer. You might find it helpful to rename it something like original file name_no_alpha.

Apple Plug-ins

Shortly after Apple released Aperture 2.0 in February 2008, it announced Aperture 2.1, an upgrade that included support for edit plug-ins from third party developers. The idea is that plug-in

developers can produce image editing tools that Aperture lacks and users can choose those tools that are useful in their workflow. In this way users get the tools they want without Aperture becoming overburdened with image editing tools that most users don't require.

Dodge & Burn

The first of these new plug-ins, Dodge & Burn, developed by Apple itself, is included in the Aperture 2.1 update. To access the Dodge & Burn plug-in select Images > Edit with > Dodge & Burn. There's a short delay while Aperture prepares the selected image for the plug-in; then it opens in a separate window with its own controls (Fig. 7.22).

Dodge & Burn is a brush tool that works in a similar fashion to Photoshop's Dodge and Burn tools. Areas of the image to which the brush is applied can be selectively lightened or darkened.

Aperture's Dodge & Burn brush supports pressure-sensitive tablets – applying more pressure with the stylus increases the amount of dodge or burn applied. Brush strokes are applied on an overlay which can be edited separately during the current session.

Fig. 7.22 To work with the new Dodge & Burn plug-in in Aperture 2.1, select Images > Edit With > Dodge & Burn.

Fig. 7.23 The Dodge & Burn tools open in their own window. There are three brushes – one to apply the effect, an Eraser and a Feather brush for softening edges. Three sliders control brush size, softness and the strength of the effect applied with each brush stroke.

To apply the Dodge brush and selectively lighten parts of an image, first select the brush size using the slider at the top of the screen, and adjust the edge softness and strength. The default setting of 10 is a good place to start. Too strong, and you'll create tell-tale brush strokes.

You can only undo the last stroke, but if you get carried away and don't realize you've overdone things until it's too late, all is not lost. You can edit the brush strokes already applied. Select the Erase tool and brush over the dodged area. On the default strength setting of 1 the eraser removes all of the dodging as you brush. Reduce the strength to reduce the dodging without erasing it altogether. If the dodging itself looks OK, but there's a definable edge, you can soften it using the Feather tool.

After a while it can become tricky to tell what's been dodged and what hasn't. Select Show Dodge as Overlay from the Action pop-up menu to display the dodging as a red overlay. You can continue to use the Dodge, Erase and Feather brushes with the overlay turned on. You can also variably adjust the zoom – a feature that's not generally available in the Aperture workspace – by dragging the Zoom slider in the bottom left corner. Click the button next to it to toggle between 100% view and fit to window (Fig. 7.24).

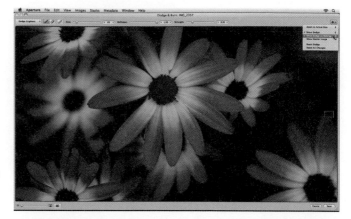

Fig. 7.24 Dodge & Burn effects are applied on an overlay, so you can toggle them on and off and display a mask overlay which clearly shows which parts of the image have had the brush applied. You can continue to edit in this view, using the Brush, Eraser and Feather tools to finesse the retouching.

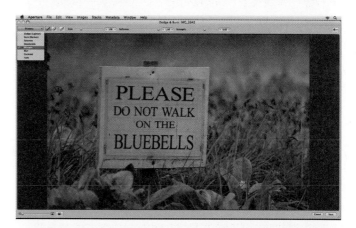

Fig. 7.25 The Dodge & Burn plug-in can also be used to selectively apply Sharpen (shown here), Saturate, Desaturate, Blur, Contrast and Fade.

Fig. 7.26 Click the Save button to apply the edits to a newly created Master. The new file will be in the format specified in Aperture's Export Preferences and the end result is the same as if you had round-tripped the file with an external image editor. For this reason it's best, in most instances, to save working with plug-ins until the final stages of your workflow.

Other options on the Action pop-up menu include Show Dodge, which toggles the dodging on and off, Show Master image, Reset Dodge and Reset All changes.

While Dodge lightens pixels, the Burn brush darkens them. But Dodge & Burn goes beyond the limited tonal transformations that its name implies. A pop-up menu in the top left corner of the window also provides Saturate, Desaturate, Sharpen, Blur, Contrast and Fade options (Fig. 7.25).

When you're all done, click the Save button to save the editing. Aperture creates a new Master file with the edits applied.

How Edit Plug-ins Work

Ordinarily, Aperture's adjustments aren't applied to Master images or Versions until you export them. They exist in Aperture as lists of edit instructions which are applied to images on the fly as you view them. Image editing plug-ins work differently.

Dodge & Burn, and all of the other image editing plug-ins announced so far, work by first creating an RGB file using the Raw decoder and applying any adjustment, then passing this to the plug-in. When your edits using the plug-in are complete and you press Save, a new PSD or TIFF file is saved to disk and loaded into your Aperture Library. This is a similar process to what happens when you round-trip a version to Photoshop, or another external image editor.

The new Master appears in the Browser with the target badge to indicate that it is a Master created using an external editor. The kind of file produced by the plug-in round-trip process is the same as that produced when you use an external image editor, i.e. an 8- or 16-bit TIFF or PSD, and is set in the Export pane of the Preferences window.

A significant consequence of this approach is that any edits you make using an image editing plug-in are irreversible. Furthermore, as a new TIFF or PSD Master is created you will no longer be able to edit previously applied adjustments.

This has important consequences for your workflow. If possible, it makes sense to leave editing that involves plug-ins to the final stage of your workflow. For one thing, as you're by now aware, Raw files contain more data and are more robust from an editing standpoint than RGB PSDs and TIFFs.

Aperture, Plug-ins and External Editing

Imagine the following scenario. You have a landscape shot that has some dense foreground detail that would benefit from application of the Dodge brush. You first go through your normal adjustment workflow, creating a new Version of the Master file and applying Raw Fine Tuning settings, adjusting White Balance, and sharpening the image. Finally, you sort out the dense foreground using Dodge & Burn which produces a new master PSD or TIFF file. There are now three thumbnails of the image in your Browser, the original Master, an adjusted Version and the new edited Master.

Now let's suppose you decide that the images require cropping. So you select the new dodged Master file and crop it using Aperture's Crop tool, so far, so good. Now you want to open the image in Photoshop to do some cloning that's too demanding for Aperture's Retouch tool, so you select Images > Edit with > Adobe Photoshop.

The file opens in Photoshop, but the cropping hasn't been applied. Why is this? The reason is that in order to apply crop, Aperture would have to create another Master PSD file. It doesn't want to do this unless it's absolutely necessary, so you have to tell it to. You do this by holding down the ⌥ key when you select Edit with > Adobe Photoshop from the Images menu. Notice that the Edit with menu choice has changed to Edit a Copy with. Select Images > Edit a Copy with > Adobe Photoshop and the image will open in Photoshop with the latest Aperture adjustments. When you save your Photoshop changes, a further Master PSD file is added to your Aperture Library (Fig. 7.27).

The Aperture plug-in architecture is written in such a way that not all plug-ins need to create Master PSD or TIFF files, but can work on the Raw data, producing Versions in the same way that Aperture does. These should lead to some interesting future developments which, as well as broadening what you can do with Aperture, may also change the way you work with images and Versions.

In the meantime there are already a number of edit plug-ins on the verge of being released for Aperture. A good place to find details on the Web is Apple's Aperture resources page at http://www.apple.com/aperture/resources/, the downloads page at http://www.apple.com/downloads/macosx/aperture/ and at Aperture plugged in – http://www.aperturepluggedin.com.

Fig. 7.27

1. This Aperture Master file is in need of some work to prepare it for use in a book.
2. A new Version is adjusted for White Balance, straightened and tonally adjusted using Exposure, Black Point and Highlight and Shadows, but this isn't enough to bring out the detail in the foreground foliage.
3. The Dodge & Burn plug-in is used to selectively lighten the foliage and when the adjustments are saved a new PSD Master is created and added to the Library.
4. It's then decided to crop the image, so the Crop tool is used to remove the top section from the PSD Master. The Aperture Browser shows the three files from left to right – the Master, the Adjusted Version and the Dodged PSD with the crop subsequently applied.
5. If you open this Cropped Version using Image > Edit With > Photoshop the crop isn't applied. Aperture can't crop the PSD file without creating another new Master and it avoids doing this until you tell it to. (It will, however, apply the crop to exported images.)
6. To create and open a new PSD Master file with the crop (and any other Aperture Adjustments applied after the plug-in was used) hold down ⌥ and select Images > Edit a Copy With > Photoshop.

New Plug-ins

In the following sections you'll find a brief run-through of the first Aperture edit plug-ins to make it onto the market.

Nik Software – Viveza

https://www.niksoftware.com/viveza/en/entry.php

Viveza is a color correction and editing plug-in for Photoshop that uses a system of color control points called U Point. Nikon dSLR owners may already be familiar with U point from Nikon's proprietary Raw capture application, Nikon Capture NX. U Point

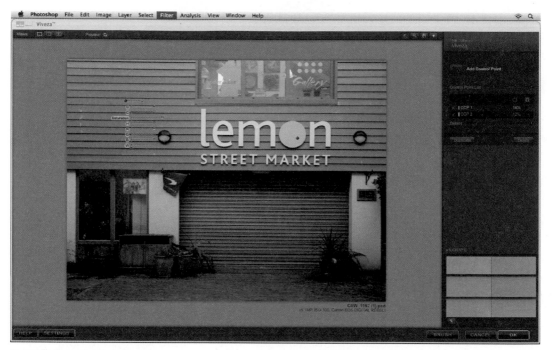

Fig. 7.28 The Viveza Photoshop plug-in.

control points are placed directly on color critical image areas – e.g. on sky areas, skin tones (Fig. 7.28).

The Photoshop Version of the plug-in features a selective tool which allows you to brush light and color changes onto an image. It will be interesting to see how the Aperture version implements this feature. If you already own the Photoshop version of Viveza you can get a free copy of the Aperture plug-in.

PictureCode – Noise Ninja

http://www.picturecode.com/

Picture Code's Noise Ninja is another Photoshop plug-in that's now also available for Aperture 2.1. Noise Ninja has a well-deserved reputation as one of the most effective noise reduction tools around. Its noise reducing capabilities are without doubt in a different class to Aperture's own Noise Reduction adjustment. If you shoot a lot of images at high ISO ratings this is one Aperture plug-in you won't want to be without (Fig. 7.29).

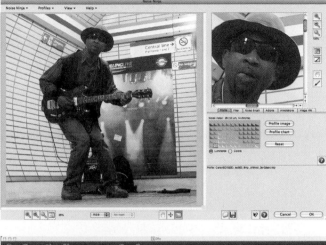

Fig. 7.29 Noise Ninja Photoshop plug-in.

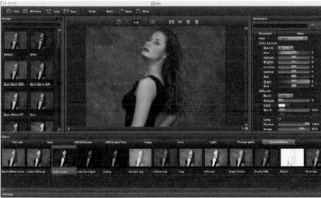

Fig. 7.30 Tiffen Dfx for Aperture 2.1.

Noise Ninja's success at reducing noise in digital images is down to a two-pronged approach. First, it uses camera profiles to identify the 'noise signature' of specific dSLR sensors at given ISO settings. Second, it uses advanced algorithms based on wavelet theory to eliminate noisy pixels while minimizing image softening.

Tiffen – Tiffen Dfx

Tiffen is probably best known as a manufacturer of photographic filters – the glass kind. Dfx is a suite of digital filter effects that's available as a standalone application as well as plug-in Versions for Photoshop and a wide range of video editing applications.

The Aperture plug-in contains hundreds of filter effects including digital equivalents of Kodak Wratten filters, graduated ND, Faux Film, Split tone and Cross Processing (Fig. 7.30).

Fig. 7.31 Dft Power Stroke Photoshop plug-in.

Digital Film Tools – Power Stroke

http://www.digitalfilmtools.com/powerstroke/

Power Stroke is a plug-in for Photoshop, after Effects, and now, Aperture that provides simple to use selection tools that are used as the basis for selective color correction and other image edits (Fig. 7.31).

dvGarage – dpmatte and HDR Toner

http://www.dvgarage.com/prod/prod_dpmatte.php

dvGarage has announced dpmatte, a chromakey style compositing plug-in which makes cut-outs from subjects shot against a plain color background and composites them onto another background image. The company has also announced a high dynamic range (HDR) plug-in called HDR Toner.

Image Trends – Fisheye-Hemi, ShineOff and PearlyWhites

http://www.imagetrendsinc.com/products/index.asp

Image Trends is making three of its Photoshop plug-ins available for Aperture 2.1 Fisheye-Hemi is actually a collection of three plug-ins that correct the distortion produced by fisheye lenses to produce a more natural looking image. Fisheye-hemi doesn't produce a rectilinear image, but one in which curved lines are straightened without the edge distortion and severe cropping normally associated with rectilinear conversion.

ShineOff automatically removes shiny highlights from skin tones, a sort of post processing digital makeup artist. And PearlyWhites, if you haven't already guessed, is a teeth whitener plug-in.

Using Aperture from Other Applications

Up to now, we've looked at how other applications work with Aperture. Whether talking about importing images from other applications or round tripping to external editors, the starting and finishing point for these processes is Aperture.

New features of the MacOs 10.5 Leopard operating system make it possible to access your Aperture Library from within other applications. Being able to access your Aperture Library in this way means that you can quickly find images to include in page layouts, presentations, email messages and other documents without having to leave the application you're working in.

Mostly, sharing your Aperture Library with other applications involves using the preview JPEGs generated by Aperture from Masters and Versions. This makes sense because if, for example, you want to attach a photo to an email, or include one in a presentation, the adjusted JPEG preview will be more appropriate than a full-resolution TIFF.

Preview Preferences

Before you can access your Aperture Library from iLife and other applications you first need to turn on preview sharing in Aperture preferences. Choose Aperture > Preferences, or press ⌘ ⁏ select the Previews pane and check the 'Share previews with iLife and iWork' box (Fig. 7.32).

While you're here you might also want to have a think about what sort of previews you want Aperture to generate from your image

Fig. 7.32 Check the Share previews with iLife and iWork to share Aperture previews with those and other applications. You can also set the size and quality of the previews that Aperture generates here. Bigger, better quality previews will increase the size of your Aperture Library and take a little longer to display.

Rotate Clockwise]
Rotate Counterclockwise	[
Remove Adjustments	
Edit a Copy With	▶
Remove from Album	⌫
Duplicate Version	⌥V
New Version from Master	⌥G
New Version from Master JPEG	⌥J
Create and Add to Selection	▶
Make Key Photo	
Generate Thumbnails	
Generate Previews	
Delete Previews	

Fig. 7.33 If you change the preview settings you'll need to force previews to regenerate. Hold down the 🔑 key and select Generate Previews from the Images menu.

files. The Preview Quality slider sets the amount of compression that is applied to the JPEG previews; the Limit Preview Size pop-up menu determines the pixel size of your previews. Don't limit makes the preview the same size as the original, so if your camera shoots images 2332 × 3504 pixels, the previews will be that size too. Other options include half-size and a variety of 'fit within' options down to a minimum of 1280 × 1280.

If you change the preview quality or size settings in Aperture Preferences, existing previews will not be updated until you either make an adjustment or force the preview to update. To do this, select the images you want to update, hold down 🔑 and choose Generate Previews from the Images menu. You'll need to quit and relaunch Aperture for the Sharing Preferences changes to take effect (Fig. 7.33).

iPhoto

Just as you can import parts of your iPhoto Library into Aperture using the iPhoto Browser, you can access your Aperture Library from within iPhoto. When you configure Aperture to share previews with iLife and iWork applications, a new item appears on the iPhoto File menu called Show Aperture Library. Select this to open the Aperture Photos Browser.

To add items from your Aperture Library to iPhoto, drag and drop them from the Browser into the iPhoto Source List. You can drag entire Projects, Albums, Smart Albums or individual images into iPhoto. Whatever the original format of what you import into iPhoto using the Aperture Photos Browser, a new Untitled Album is created for it. You can't, for example, copy an Aperture Smart Album as an iPhoto Smart Album, only the images it contains.

It's also worth a reminder that these aren't the original Masters you're bringing into iPhoto, but the JPEG preview files created by Aperture at the size and compression settings you specified in Aperture Previews Preferences (Fig. 7.34).

iTunes

To sync photos from your Aperture Library with your iPod or iPhone, plug in the device to launch iTunes, select your iPod or iPhone and click the Photos tab. Check the Sync photos from box. An alert box appears warning that syncing will replace all

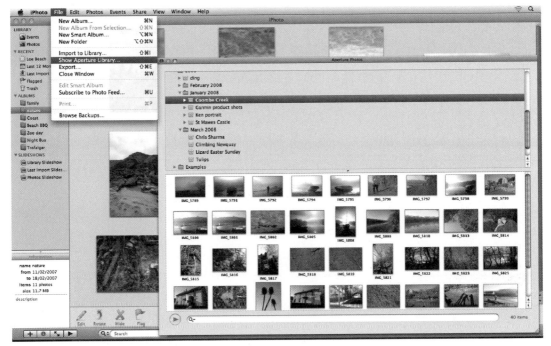

Fig. 7.34 Select Show Aperture Library from the iPhoto File menu to display a Browser from which you can drag and drop items from the Projects Inspector, or individual images into iPhoto.

existing photos on your device; if you want to proceed, click the Sync Photos button and, unless you want to download your entire Aperture Library, check the Selected Albums radio button.

iTunes provides a more limited Browser than is available in iPhoto and some of the other iLife applications. There are no thumbnail displays and only Albums are listed along with the number of images they contain. Select the Albums you want to sync with the device and click the Sync button (Fig. 7.35).

iWork Applications

Using Aperture with other iLife and iWork applications, such as iMovie, Pages and Keynote, works in much the same way as described for iPhoto. For example, to add an image from your Aperture Library to a Keynote presentation click the Media button on the Toolbar and you'll see a similar Leopard dialog box to the one that appears in the other iLife and iWork 08 applications (Fig. 7.36).

Fig. 7.35 You can sync Projects with your iPod from iTunes, but the Browser is limited to displaying the contents of the Projects Inspector – there's no thumbnail Browser.

Though they occasional vary in detail they all (except iTunes) share the common layout that allows you to access your Aperture Library in a Project Inspector-style layout in the top panel and display thumbnail images in the lower panel. Double-clicking or pressing the `Spacebar` displays a Quick Look preview of the selected image.

Mail

You can add selected images to an email attachment from within Aperture by selecting File > Email, or pressing ⌥ E This launches Mail and attaches the selected photos to a new message. As we've seen, however, most people want things to work the other way around. It's more likely that you'll want to access your photos while emailing, than that you'll want to access your email while organizing and editing your photos.

Open Mail and Click the New Message button on the Toolbar. In the New Message window there's now a Photo Browser button on the Toolbar, click it to open the Photo Browser.

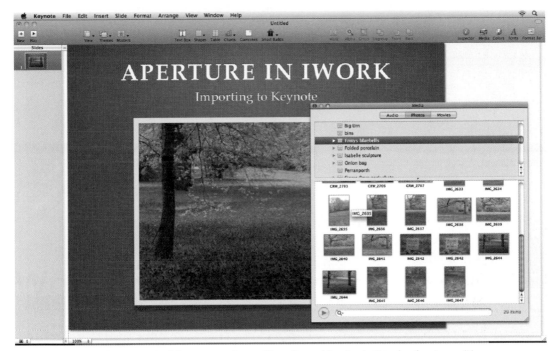

Fig. 7.36 Keynote's media browser provides full access to your Aperture Library. Drag and drop thumbnails to place them in your slides.

The Photo Browser works in a similar way to the other iLife and iWork applications discussed earlier. In the top panel you'll see Aperture and iPhoto if you have both installed. Click the disclosure triangle next to Aperture and you'll see all of your Projects, Albums, Smart Albums and folders as they appear in your Aperture Projects Inspector. You can track down individual images using the Search field at the bottom of the Browser, but this is of limited use as it doesn't search keywords and other metadata.

Navigate to the Project containing the photos you want to attach to the message and drag the thumbnails from the lower panel into the message window. The photos are automatically resized by Mail and appear actual size in the message window. To resize them select one of the size presets from the pop-up menu in the bottom right corner. The message size is indicated at the bottom left of the message window (Fig. 7.37).

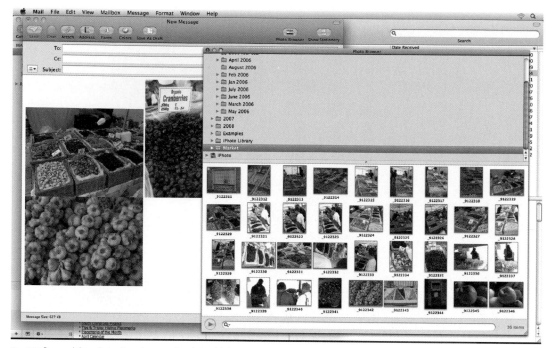

Fig. 7.37 Drag and drop photos from Aperture directly into Mail messages.

Photoshop

To open an Aperture preview from within Photoshop select
File > Open in the usual way. The Leopard Open dialog appears;
you no longer get the option to choose the Adobe open dialog
box as you did with earlier versions of MacOs. Click the Photos
button and select Aperture from the list in the top panel. Click
the disclosure triangle to display the contents of the Projects
Inspector.

As with all applications, what this does is open the Aperture JPEG
preview file in Photoshop and there isn't really much point in
doing this. If you need to do Photoshop editing on an image it
makes much more sense to work on a full quality, full-resolution
Version, which you can do by selecting Image > Edit with
external Editor from within Aperture. This method also has the
advantage that it will add the edited .psd or .tiff file created to
your Aperture Library (Fig. 7.38).

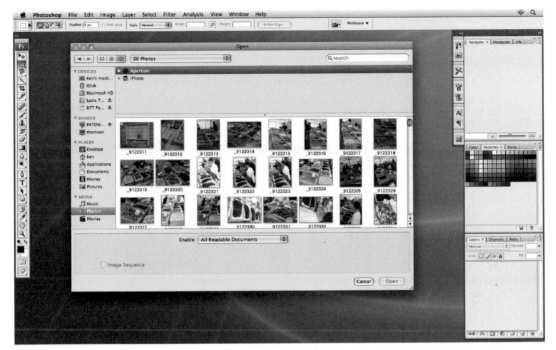

Fig. 7.38 You can open Aperture previews directly into Photoshop, but there's little point. Either use Image > Edit With > Photoshop, or if you want to open an existing PSD without creating a new Version, right-click it, select Show in Finder, and open it from there. That way, you'll be working on the full-resolution file, rather than the preview JPEG.

InDesign and Applescript

All of the previews generated in Aperture are referenced to their Versions and the original Raw Masters by a unique 'fingerprint' code that is stored in the Special Instructions IPTC metadata field of the preview JPEG. This code helps Aperture keep track of the relationship between Masters and Versions and it can also be used in a desktop publishing workflow to enable the use of Aperture's JPEG previews as positionals which can be updated with full-resolution Versions prior to output.

You can place Aperture previews into InDesign Documents in much the same way as we've already seen with the iLife applications, using the new Open Dialog box in MacOs Leopard. Click File > Place in InDesign, or press ⌘ D to place an image and select Photos from the Media pane on the left-hand side of the dialog box. Select the required Project, Album, Smart Album

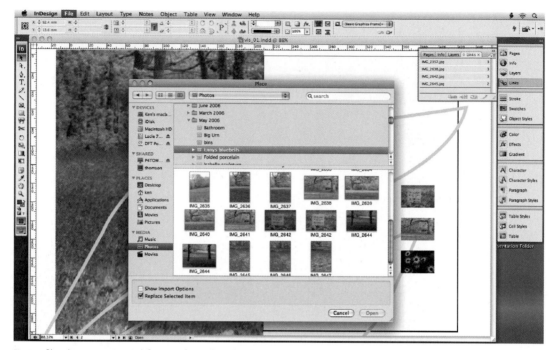

Fig. 7.39 Place Aperture previews in InDesign in the usual way, by selecting File > Place, then use the Browser to locate the image in your Aperture Library. These placeholder previews maintain a link to the Master, so you can automatically replace them prior to output.

or folder from the Aperture Library and the thumbnails are displayed in the lower panel (Fig. 7.39).

If you need to see a thumbnail image at a larger size, select it and press the *Spacebar*. You can then scroll through, previewing all of the images using the *←* and *→* arrow keys. Press *Spacebar* to return to the thumbnail panel. Click the Open button to place the chosen image.

Thanks to enhanced Applescript support in Aperture 2, management of placed images in InDesign is made a great deal more manageable than it used to be using the Finder. To demonstrate the potential for Aperture/InDesign integration, Apple has published a small collection of scripts on its website at http://www.apple.com/applescript/aperture/indesign/.

These scripts allow you to create Aperture Albums containing images placed in InDesign, compile InDesign Libraries containing images chosen from Aperture, easily locate and edit Aperture

Fig. 7.40

Fig. 7.40 & 7.41 You can create an Aperture Album or Project to hold all the images in an InDesign Spread or document. Select either New Album with Selected Images or New Project with Selected Images from the Aperture group on the Script menu.

Versions from their InDesign placeholders and automatically export high resolution press-ready Versions of placeholder images from Aperture and replace them in the InDesign document.

To create an Aperture Album from placed images in your InDesign document, select the placed images and choose New Album with Selected Images from the Aperture group on the Script menu at the top right of the InDesign menu bar. Enter a name for the Album in the dialog box and click OK (Figs 7.40 and 7.41).

To create an InDesign Library from images in your Aperture Library, select Aperture > Create Library using Aperture Images from the Script menu. This opens a Choose dialog that works in the same way as the one you use to place images. Navigate to the Project, Album or folder in your Aperture Library and select the images you want to add to the InDesign Library in the lower panel, then click the Choose button.

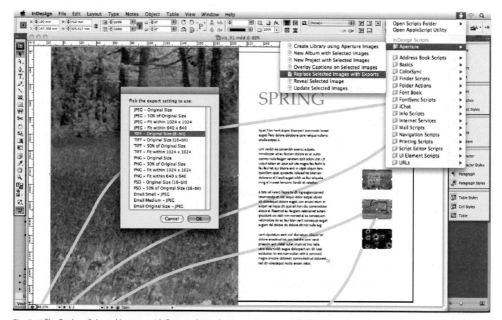

Fig. 7.42 The Replace Selected Images with Exports does what it says. It exports a high resolution version from Aperture and replaces the preview image with it. You can choose from a variety of export sizes and file formats.

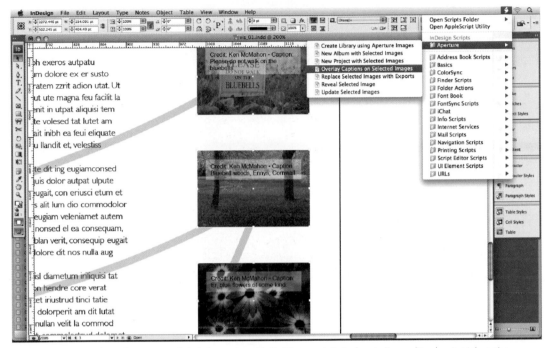

Fig. 7.43 Applescript can be used to automatically include metadata added in Aperture to InDesign layouts. Here credit and caption information has been overlayed in a text box on selected images.

To prepare an InDesign document for prepress by replacing the Aperture preview placeholders with high resolution TIFFs, first save the document then choose Replace Selected Images with Exports. Choose an Export option from the list (Fig. 7.42).

There's one other interesting script in the suite which overlays captions on selected images. The caption information is pulled from the IPTC metadata fields and can include the image name, Credit, Copyright Notice, Byline and Caption, among other things. The caption appears in a text box with a semi-transparent fill above the image (Fig. 7.43).

These scripts are not only useful in themselves but also demonstrate the potential for Aperture integration with other applications as part of an end-to-end digital imaging workflow.

Output

Exporting

The ultimate conclusion of taking a picture is bringing it to the public's attention. Whether that 'public' extends to a million people in a newspaper or just the members of your family, the goal is the same and so are the tools at your disposal.

Fortunately Aperture caters well here, as besides allowing you to export your images in the traditional sense – effectively saving them out as digital files – it also allows for a full range of printing and online publishing. It works in tandem with Kodak printing services to output prints, ties in with Apple's own MobileMe online service for publishing Web galleries, gives you the option of producing impressive books for personal or portfolio use and lets you create slideshows and contact sheets for reviewing and showing off your work.

There are, unfortunately, some obvious omissions from Aperture's output options, including the cards and calendars available in iPhoto 08. The easiest way to plug this gap is to view your Aperture Library in iPhoto and create cards and calendars from there, but this will require a copy of the iLife suite (of which iPhoto is a part) at a cost of £55 (Fig. 8.1).

Fig. 8.1 Viewing your Aperture Library within iPhoto will let you create calendars and other products using your images that are not available within Aperture itself.

Fig. 8.2 Use Aperture's Preferences dialog to choose which application should be used for external photo editing.

Unless you want to use all of your images in the products built into Aperture – Books, Galleries, Journals and so on – you'll spend a lot of time exporting your work to use it in different ways. Aperture works exceptionally well with other applications and can even read and write native Photoshop PSD files, which opens up access to a wide range of Photoshop filters.

It includes a range of preset export settings from which you can choose when outputting your images and you can choose a default external image editor by opening Preferences (⌘ ,) and clicking the Export tab (Fig. 8.2).

From here, you can choose between TIFF and PSD export formats and select their resolution, specify your email client for sending and to which level images should be compressed when emailed,

Fig. 8.3 The Export Presets tool lets you specify how your images should be optimized when exported from Aperture and includes three specific settings for images that will be distributed by email.

as well as specifying a default copyright notice for Web pages and Journals.

Clicking the Edit… button beside the Email Export Preset gives you finer-grained control over the level of compression by opening the Image Export Preset dialog (Aperture > Presets > Image Export) (Fig. 8.3).

Defining Your Own Export Settings

Presets defined here apply system wide and are available when exporting Web Pages, Journals and so on. They do not apply to Digital Masters exported as Projects to be reincorporated into another Library, as these are not compressed. You can create as many presets as you like, and they will then be presented in a drop-down when you export images in the future.

The range of available image types is impressive, including JPEG, Png, regular and 16-bit TIFF and 8- and 16-bit Photoshop PSD. Which one you choose will determine which other options are available to you when making up your specific export profile. While you can specify the dimensions and resolution of all image formats, for example, only JPEG gives you access to the quality slider, which specifies the level of compression and hence the resulting file size.

299

When exporting as a Png, TIFF or Photoshop PSD, you can only reduce the bulk of your images by specifying a physical or pixel-based size for the resulting file. Since images are usually exported in batches, rather than one by one, these sizes are specified either as a percentage of the original or to fit within a certain size, measured in pixels, inches or centimeters. Choose any one of these from the Size To: dropdown menu and fill in the width and height boxes to constrain them (Fig. 8.4).

The simplest, if your exported images will be emailed or published online, is to specify a common dimension, such as 800 × 600 or 1024 × 768. However, if you are using the inches or centimeters measurements, it is worth keeping an eye on the resolution (DPI) setting to give you an idea of the size of the resulting file.

An uncompressed TIFF with a resolution of 300 dpi to be printed at 10 × 8 in. would be a 7.2 megapixel image (3000 × 2400 pixel resolution). If you were to increase this to fill a spread in an A4 magazine (420 × 297 mm) it would leap to 4960 × 3508 pixels or 17 megapixels. Lump in all of the supplementary information

Fig. 8.4 Not all Export options are available for all file types. However, you can specify the dimensions of all exported images to fit within specified limits.

contained with a TIFF and leave it uncompressed, and your exports could easily touch 50 MB. Clearly this is no good for attaching to an email.

Diligent use of intelligent compression settings is therefore a must, and saving presets here – with logical, descriptive names – will save a lot of time in the future.

Protecting Your Exported Images

In many instances, your images will be both your livelihood and the public assets you use to drum up business. However, putting your images online in an effort to attract new customers can leave those images open to abuse by less scrupulous visitors, who may pay scant attention to copyright notices posted on the bottom of the page.

In this instance, you need to brand your images, rather than your pages, which is done with the Watermark setting in both the Image Export and Web Export dialogs.

Unlike some photo editors that let you watermark to images using plain text, Aperture overlays another image with an opacity level of your choice. If the image you choose – which should ideally be a Photoshop file with a transparent background – is larger than the photo you are exporting, Aperture will scale it down, but it cannot scale images up. This is logical, as you may only want your watermark to sit discretely in the corner of an exported image rather than obscure it entirely. If you want to have watermarks of various sizes for different export sizes – say one for 10 × 8 in. photos at 300 dpi and another for small Web editions – you should create multiple watermarks at the appropriate dimensions and save them to different Export presets.

In the same way, you can also create different watermarks for different clients and save them in presets dedicated to specific jobs (Fig. 8.5).

Your watermark can be as plain or elaborate as you like, but it should achieve two primary goals. First, it should clearly identify the work as your own without being easy to remove, meaning that it should not be easy to clone out, or that it should be positioned in such a way that the part of the image that it overlays can be cropped with no loss of meaning in the resulting picture. Second, it should not obscure the image to such a

Fig. 8.5 Protect your images by using a watermark. This is a Photoshop-format file that is overlaid on top of your files at the point of export. By specifying a custom opacity, you will ensure that clients can still see your work through the branding.

degree that it makes it a commercial disincentive. While nobody would ever think to misappropriate a photojournalist's image of riots at a G8 summit on which a watermark had been stamped square and center, few publications would be tempted to buy it if that same watermark obscured the main focus of the image and made it difficult to quickly see if it met their needs. There will be 1000 alternatives available to the busy picture editor, and it will be both quicker and easier for them to turn elsewhere.

Color Management

Mac OS X has excellent color management features. Its integrated ColorSync utility sits between the various parts of your system – applications, monitor, printer, scanner and so on – and translates the colors used by each one so that they can be accurately reproduced by each of the others. It does this because every piece of hardware is built in a slightly different way, and so none will be able to capture or display precisely the same range of tones as any other.

The range of colors any device can handle is called its gamut and is described in terms of being wide (a device with a wide gamut can handle more colors) or narrow (fewer colors). A consumer

Fig. 8.6 The CMYK color gamut is very narrow and doesn't come close to matching that of your RGB display. As such, Mac OS X will have to translate the tones used in your images between the two color spaces to achieve accurate matching between screen and printed output.

inkjet printer, therefore, will have a comparatively narrow gamut when compared with a professional photo printer, and a cheap all-in-one device with an integrated scanner will have a narrower gamut than a high-end digital camera.

In some cases, the differences are very small, such as that between Generic RGB and sRGB, but in others they differ by a wide margin, such as is the case when comparing Generic RGB with the much wider gamut of Adobe RGB. You can see for yourself by opening ColorSync Utility (Applications > Utilities > ColorSync Utility) and clicking through the installed profiles. The narrowest of the most commonly used color spaces, as you'll see, is CMYK. This has a particular relevance to digital photography, as images are captured with RGB sensors (traditionally sporting two green photosites for every one red and blue site) and edited on RGB monitors, before being output in the CMYK colorspace, on inkjet or laser printers or as professional photo prints (Fig. 8.6).

The problem, therefore, is in working out how each color relates to any other and how a pink blush captured by a camera should be recreated on an LCD screen, a conventional display, a photographic print, an Aperture book, a website or a PAL-based television.

It is little surprise, then, that Aperture builds color management right into the export dialog, by gathering together all of the

information it already knows about devices attached to your Mac and combining them with industry standards like Secam, NTSC, generic RGB and 'Black & White'.

If you are exporting photos for use on your own devices, such as a printer, or for import into a video editing application like Final Cut, you should choose the appropriate setting to ensure that what you created on screen while editing matches what you see on the output device, noting that for many printers the profile will vary between output media as much as it will for the hardware itself.

If you are exporting for client use and they have been unable to provide you with a specific profile, however, the general advice would be to leave the image as it is by selecting Use Source Profile and allow the client to apply their color management settings when they place the photo.

Defining Export Names and Destinations

All of the options set in the presets described above will be available when exporting Versions of an image from your Library (shortcut *Shift* ⌘ *E*). When you choose to export a Master (shortcut *Shift* ⌘ *S*) it will be output using the same name as that which it has inside your Library, complete with the original extension and in the original format. So a Raw file produced by a Canon DSLR and saved with the extension .CR2 will remain as such and be inaccessible to anyone without the necessary Raw converter or another Mac with an up-to-date Version of the operating system, which handles these files as a native format.

If you need to ensure maximum compatibility, then, you should export your images as a Version, even if you are outputting an untouched Digital Master. Doing so will include an Export Preset drop-down on the Export Dialog box that will be missing if you export a Master. This will show all of your saved presets and the defaults ones that shipped with Aperture (assuming you haven't deleted them) (Fig. 8.7).

Regardless of whether you are exporting a Master or a Version, though, you will always have the option to specify where your images should be saved and under which name. By default, Aperture will suggest the picture's existing name, which was probably set by the camera at the point you pressed the shutter

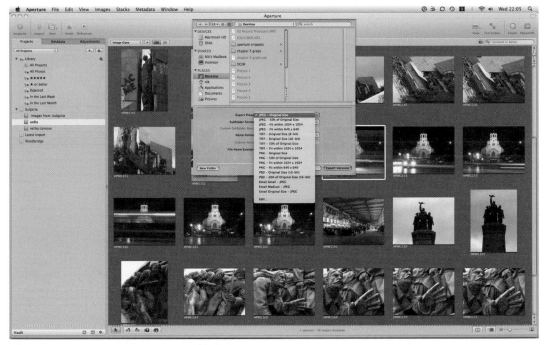

Fig. 8.7 Exporting a Version of your Digital Masters gives you access to the Export presets that shipped with Aperture and any new presets you may have created yourself.

release. However, you can specify your own or choose a logical encoded name that gives a more useful description of the file, based on its assets, than an arbitrary serial number.

These are found under the drop-downs beside Sub-folder format and Name format, and while they can be set by picking the Edit… option from each of those menus, their control panels are also found in the Presets section through which we set the compression levels above (Figs 8.8 and 8.9).

Why the Presets section? Because each one can make use of the metadata tracked by Aperture as it organizes and edits your files, and because as with the Export and Gallery presets, you can save a range of standard configurations for use with different clients and jobs.

We covered these in depth at the very start of our Aperture workflow, when we imported our images into the Library, as the

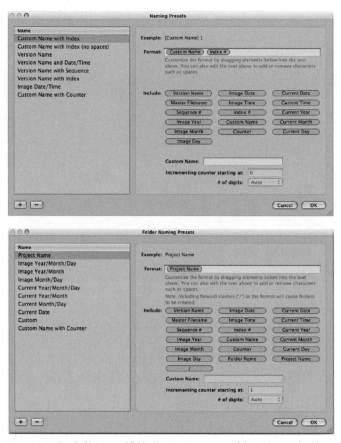

Fig. 8.8 & 8.9 Use the Naming and Folder Naming presets to specify how Aperture should title your images when it exports them, and where they should be written to disk.

same Preset tools used for specifying where your imports should be stored and what they should be called are used for directing the output of your exports.

The presets are accessed in one of two ways: either through Aperture > Presets > File Naming…/Folder Naming… or by picking Edit at the bottom of the File Name and Folder Name pop-up menus in the Export dialogs.

See p.84 for a more detailed explanation of each dialog, but in general remember the rule that you should adopt is a top–down approach to specify your folders and image names, with the largest, most general classifications coming first and

more specific, tightly focused attributes coming last. As such, if you were to create your own preset that would generate folders using Project names and dates, you should examine whether any of your Projects span multiple years. If they do, start with the year first; if not, start with the Project. Apply the same test to months. If your project all took place in the course of a single month, specify that the month delimiter should come immediately after the year; if not, break the two by inserting the Project first and so on down the line. As an example, using a Project called France:

For a collection of photos taken between the 21 and 23 September 2008, use the structure Year/Project/Month/Dates to give: 2008/France/09/21… 22… 23… or Year/Month/Project/Dates to give: 2008/09/France/21… 22… 23….

If the photos were taken between 29 September and 2 October, the project name must come first to avoid having two redundant project folders inside separate months. The structure would therefore be Year/Project/Month/Dates to give: 2008/France/09/29… 30… and /10/01… 02….

If they were taken between 30 December 2008 and 2 January 2009, move the Project name to the very front of the folder structure as Project/Year/Month/Date to give: France/2008/12/30… 31… and /2009/01/01… 02….

Using this last shooting schedule as an example, if you were to adopt the folder structure we specified first time around – Year/Project/Month/Date, and were using the Finder to browse pictures taken on 2 January 2009, you would need to navigate up three levels and back down three levels of the file system to see the photos taken on 30 December. Adopting our final recommended structure would require that you move up and down only two levels in each instance, and all of the images taken in France would be kept in a single parent folder on your disk.

Exporting Metadata

In an increasingly connected society where we spend almost as much time sharing photos with each other as we do taking them, metadata become more and more important. Attaching relevant filing and categorization information to our photos increases their value exponentially. Not only does it allow photo editors to quickly identify images they would like to buy and use – thus providing a

Fig. 8.10 Services such as Flickr can take advantage of metadata tags embedded in your photos to help you manage your collection.

financial incentive for the professional photographer – but it also greatly simplifies your own task of keeping your images in order and finding them more easily at a later date.

Some image formats, including JPEG and TIFF, can embed the data in IPTC format directly inside the headers of the file itself. In other instances, you can export a so-called IPTC4XML sidecar. IPTC is the International Press Telecommunications Council, an organization based in Windsor, west of London, which developed a protocol for interchanging information about images as early as 1979. This protocol carries captions, keywords, copyright information, bylines and so on and can be exploited directly by many online photo management sites, including Flickr. The fields are flexible and range widely in length, right up to a generous 2000 character field for captions. From a professional point of view, it is used by news agencies to help them maintain their Libraries, choose images to use in their media and manage rights (Fig. 8.10).

You can export the metadata for a chosen image or range of images, separately from the images themselves by picking File > Export > Metadata, in which case, it will be saved as a tab-delimited table in plain text format, which can be imported into a database or spreadsheet for sorting.

```
                              IMG_9855
 Styles    ▼  ≡ ≡ ≡ ≡   Spacing  ▼  Lists   ▼          ▶ ◆ ◀ ❀
  0      2      4      6      8      10     12    14    16    18    20
<?xpacket begin='' id=''?>
<x:xmpmeta xmlns:x='adobe:ns:meta/' x:xmptk='XMP toolkit 2.9-9, framework 1.6'>
<rdf:RDF xmlns:rdf='http://www.w3.org/1999/02/22-rdf-syntax-ns#' xmlns:iX='http://
ns.adobe.com/iX/1.0/'>
<rdf:Description rdf:about='' xmlns:Iptc4xmpCore='http://iptc.org/std/Iptc4xmpCore/1.0/
xmlns/'>
     <Iptc4xmpCore:CreatorContactInfo>nik#nikplus.com</Iptc4xmpCore:CreatorContactInfo>
</rdf:Description>
<rdf:Description rdf:about='' xmlns:photoshop='http://ns.adobe.com/photoshop/1.0/'>
     <photoshop:AuthorsPosition>Nik Rawlinson</photoshop:AuthorsPosition>
     <photoshop:Credit>Nik Rawlinson</photoshop:Credit>
</rdf:Description>
<rdf:Description rdf:about='' xmlns:dc='http://purl.org/dc/elements/1.1/'>
     <dc:creator><rdf:Seq><rdf:li>Nik Rawlinson</rdf:li></rdf:Seq></dc:creator>
     <dc:description><rdf:Alt><rdf:li xml:lang='x-default'>Woodbridge sits close to the
Ipswich, the county town of Suffolk</rdf:li></rdf:Alt></dc:description>
     <dc:rights><rdf:Alt><rdf:li xml:lang='x-default'>2008 Nik Rawlinson</rdf:li></
rdf:Alt></dc:rights>
     <dc:subject><rdf:Bag>
          <rdf:li>woodbridge suffolk river mill marsh</rdf:li>
     </rdf:Bag></dc:subject>
</rdf:Description>
<rdf:Description rdf:about='' xmlns:photomechanic='http://ns.camerabits.com/
photomechanic/1.0/'>
</rdf:Description>
<rdf:Description rdf:about='' xmlns:xap='http://ns.adobe.com/xap/1.0/'>
     <xap:Rating>0</xap:Rating>
</rdf:Description>
</rdf:RDF>
</x:xmpmeta>
<?xpacket end='w'?>
```

Fig. 8.11 Metadata exported in a Sidecar file is rendered as XML data. This can be parsed by third-party tools and used to catalog images in a database.

However, exporting metadata at the same time as your images is a simple matter of picking whether you want to export it embedded ('Include IPTC' from the Metadata pop-up in the Export Master dialog) or as a Sidecar file that is separated from the image itself, but given the same name, and the extension XMP. The format of this file remains plain text, but every attribute is surrounded by descriptive tags to make it more useful for sorting, parsing and including in third-party tools (Fig. 8.11).

Export Plug-ins

As a professional photographer, your work will be split into three distinct parts. One part will be for yourself, which you'll use for personal reference or recreation. Another will be for private clients looking for portraits and professional photos of personal subjects, and the third will probably be for professional clients who will use your shots in a photo library or publication.

For each, the treatment of your photos – and in particular your exports – will differ. Your personal Projects will be treated to meet your own specific requirements; private clients' work will be tailored to their specific tastes, and commercial work for professional clients will be adjusted to meet the house style of a particular publication.

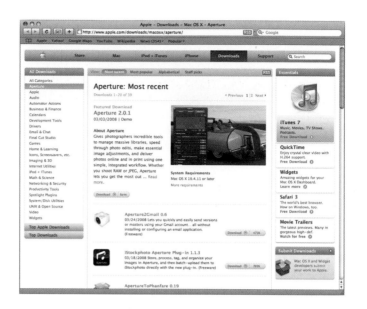

Fig. 8.12 Apple maintains an extensive collection of downloadable plug-ins for Aperture on its website.

In every instance, though, you will eventually want to export your work in some form or other, and while the guidance above will meet most requirements, you may be able to cut some corners through the use of plug-ins. These are add-ons to Aperture that automate the process of changing file sizes, formats and naming conventions to meet specific requirements and of posting your photos online, perhaps because a newspaper can only accept them in a particular manner, or because it's simply easier to cut out the tedious logging in and individual uploads to an online photo service such as Flickr or Picasa.

Apple maintains a catalog of available plug-ins for Aperture, including a wide range of Export plug-ins at apple.com/downloads/macosx/aperture. The list is extensive but by no means exhaustive, and an Internet search will turn up others. It's also worth talking to professional clients to see whether they have plug-ins of their own that they are willing to send out to freelance contributor (Fig. 8.12).

You can create your own plug-ins using the Aperture software development kit (SDK). However, this is only available to developers with an Apple Developer Connection membership, which starts at £329.

Working with Two Macs and Two Libraries

With the release of Version 2, Aperture gained the ability to play host to a tethered camera and write images direct to its Library. This affords the professional photographer great benefits as they can see far larger previews on a Mac than the camera-back LCD would allow. It also means they can make small adjustments to the results as they go along to see whether digital manipulation or physical adjustment of lighting, props and exposure settings would be beneficial.

It, too, means that they can take a notebook out into the field, cutting down on the range of kit they must carry, giving them an immediate backup and letting them start work on the filtering and editing before they even get back to the studio.

However, each of these benefits falls foul to a common downfall. Namely, unless the photographer is working with their primary Mac and their Master Library, the newly shot images will be stored in a Library separate from the rest of their assets. The simplest solution is to travel and work with your primary Mac, but this is inherently insecure and risky.

As such, it will be necessary at the end of every expedition to import any new photos into your Master Library. Clearly you shouldn't simply copy across your Aperture.aplibrary package, or you will overwrite any Versions and Digital Masters already stored at the destination.

To perform the copying accurately and safely without risking your existing assets, then, you must perform an export and import out of the mobile Library and into the one used at home base respectively. In this instance, select the Project you want to export in the Projects Inspector and pick File > Export > Project. You'll be given the opportunity to assign it a name and create a new folder to hold it and to 'Consolidate images into exported project'. What does this mean? It's simply offering to include any referenced Digital Masters in the export file if they are stored in folders outside of the mobile computer's Library package (Fig. 8.13).

Publishing Your Photos Online

There are three ways to get your images out of Aperture and onto the Web: Web Galleries, Web pages and Web journals. Each one gives you a little bit more control over the results than its

311

Fig. 8.13 Images stored in one Aperture Library can be safely transferred to another by exporting their parent Project and choosing to consolidate the images into that Project. This lets you shoot using a notebook and tethered camera when away from the studio and then incorporate your new work into your existing Library when you return to base.

predecessor, with Web Galleries simultaneously the most visually impressive and the least flexible of all three. We'll cover each in turn below.

Web Galleries

Aperture's Web Galleries feature lets you put your images online without any knowledge of HTML, PHP or other Internet technologies. It requires a MobileMe account, which costs £59 per year, as many of the features of Aperture Web Galleries use server-based code that is not written out by Aperture itself and isn't found in conventional hosting packages. You can sign up to MobileMe at www.me.com (Fig. 8.14).

These features include password protection, visitor-customizable layouts and slideshow transitions, as well as the ability for visitors to upload their own pictures to the Gallery, should you permit them (Fig. 8.15).

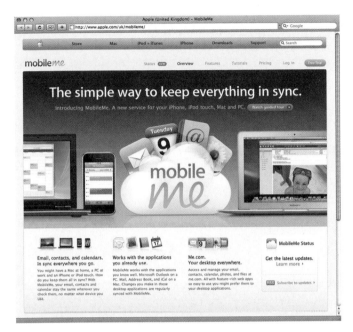

Fig. 8.14 Apple's online service, MobileMe adds synchronication, email, shared calendaring and – of most interest to Aperture users – online publishing tools to the operating system and several of Apple's core applications.

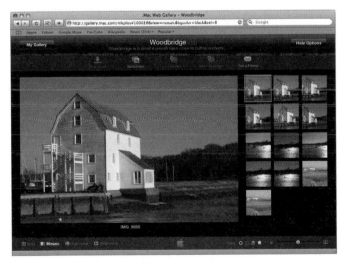

Fig. 8.15 Web Galleries are impressive Web 2.0 sites that give your visitors a great deal of interactivity and even allow them to your site to upload their own images.

To create your first Web Gallery, select a Project or a collection of images and click New > Web Gallery on the Toolbar. You'll be asked to give it a name and description and choose who should be allowed to view the images it contains. This is done through the 'Album viewable by' drop-down, which by default is set to allow everyone to see your images. The other options are to

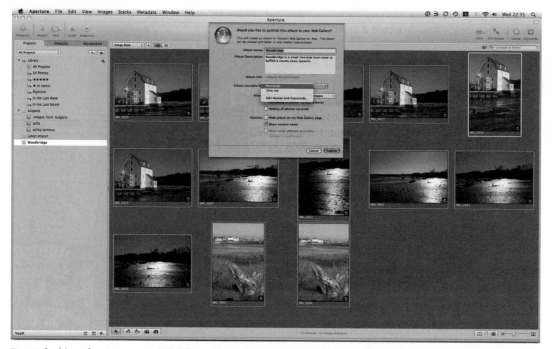

Fig. 8.16 Careful use of restrictions on your Web Gallery will let you keep it protected from unauthorized viewing. This makes Galleries of this sort an effective means of showing your work to a client but retaining a degree of confidentiality.

restrict it to yourself, in which case its title will be removed from the links in your MobileMe pages, or to people to whom you give a password (Fig. 8.16).

This latter option will let you individually control who has access to every Album you publish, as by allocating each user a different password you can give them access to some, but not to others. It is set by picking Edit Names and Passwords from the viewable drop-down and using the '+' button to add new users to the list. Aperture keeps track of who has been authorized to view each Album and so will automatically populate the third column of the table – Albums – on that basis. In this way, you can use Aperture as a tool for allowing clients to preview images before signing them off by posting them to a Web Gallery that only they can access (Fig. 8.17).

In this situation, you might want to prevent them from downloading the images themselves, in which case clearing the

Name	Password	Albums
nik	apple	
ken	pear	
rich	orange	
oscar	tomato	

Name may consist of a-z, 0-9, underscores and a single dot (.)
Password should be four characters or more, capitalization matters.

Cancel · OK

Fig. 8.17 User names and passwords let you restrict who can see your Smart Galleries on an Album-by-Album basis.

checkbox that allows that, or tailoring what can be downloaded is a sensible move. The Allow section also lets you tailor users' ability to add their own photos, either by email or through the Browser. There are simple controls to stop this being abused in the form of a Captcha device requiring users to enter the text version of a series of letters and numbers displayed in a graphic to prove that they are a real person, but it is still advisable to use the Browser upload feature with care. The email feature, however, is a boon for iPhone users, who can use it to upload images direct from their phones when away from home. Each Gallery is given a unique email address in the form of username-serial@post.me.com, where username is the membership name you chose when signing up to MobileMe, and serial is a unique identifier appended by Apple to differentiate your Galleries from one another.

Once published, you can add new images to your Web Gallery from Aperture itself by dragging them from Projects in your Library onto the Gallery's entry in the Projects pane. You can specify whether Aperture automatically updates the online edition of the Gallery and if so, how often. Open Preferences (⌘ ,) and click Web Gallery, then change the Check for New Photos option to Every Hour, Every Day or Every Week, as appropriate (Fig. 8.18).

If you would rather maintain full control of the uploading of new photos, leave it set to Manual. You then need to update the published Gallery by clicking on the Check Now button or on the Gallery's entry in the Projects pane, followed by Web Gallery on the divider between the Browser and Viewer windows and then Settings…. This will call up the dialog used to create the Gallery in the first place, which sports a Publish button that, when clicked, uploads your newly imported image to your MobileMe space.

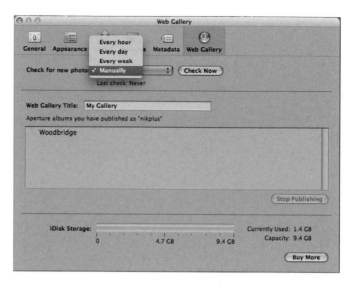

Fig. 8.18 Use Aperture's Preferences to specify how often it should update published Web Galleries. Leave it set at the default 'manually' if you want to retain control over updates.

You can stop publishing a Gallery at any time and remove any published images from your MobileMe web space by selecting the Gallery in the Web Gallery entry in the Preferences pane. Click on the name of the Gallery you want to remove and confirm your action.

Web Pages

Web Galleries are very attractive and full of impressive effects that will wow your visitors, but they are not very flexible. There is only one style of Gallery, and you have to publish them on Apple's charged-for MobileMe service. Not only does this mean you could end up paying twice – once for your personal Web space and once for MobileMe space; it also means that your Gallery's address will include the MobileMe branding. This doesn't look very professional.

The solution to both of these problems is to switch to the less ambitious, but no less attractive Web page option, which creates static pages for your photos that can be hosted on your own Web space under your own domain name. Don't be confused by the title, 'Web page'; this doesn't create a single page for all of your images, but a mini site with index pages showing thumbnails of every image you choose to include,

Fig. 8.19 Web pages created by Aperture have fewer features than Web Galleries, but they offer greater flexibility when it comes to layout and design.

which link through to individual pages for a full-size version of each one (Fig. 8.19).

The process starts off in a similar way to creating Web Galleries. Pick a Project or Album in your Library, select the images you want to include and choose Web Page from the New drop-down on the Toolbar. Aperture will create a series of index pages to hold thumbnails of all of the pictures in your selection and an individual page for each image, at a larger size.

By default, it will choose the Stock theme, but there are six to choose from, which you can access by clicking the Theme button on the Web page Toolbar that appears above the Web page thumbnails. Each theme contains only two types of page: the index thumbnails and the full image display pages. As such, any change that you make to one of these pages will be reflected on every page of the same type (Fig. 8.20).

So, for example, scrolling to the bottom of any page and changing the copyright data to protect your images will apply the same change to every page. The same goes for the site title.

Fig. 8.20 Aperture ships with six different themes for creating Web Galleries, each with two page styles – one for the index page and one for the detail pages that show each image at a larger size.

Fig. 8.21 Use the Web page Toolbar to change the number of rows and columns into which your images are organized. From this same bar, you can also specify the area into which each image must fit.

However, some aspects, such as image sizes and metadata, differ depending on whether you are working on the index pages or the detail pages.

Click on Page 1 in the Web Page panel and you can change the number of columns and rows displayed on the page. As you do, you'll see the thumbnail of the page update in real time and, if you have more than one index page, that change will also be reflected on the other pages in the panel. Switching to the Detail pages in the pane below, you can't adjust the number of images on the page (there's only ever a single image), but you can change the size of each one by constraining the size of the box in which it must fit. You have three options: rectangle, square and width, which are also available when sizing up the thumbnails on the index pages (Fig. 8.21).

The rectangle option lets you specify a maximum height and width for each image. Whichever is reached first will truncate the other. So, if we have a portrait image with a 3:4 aspect ratio (narrower than it is tall) and we have set up our Web page so that detail shots should fit within a 500 by 400 rectangle, and thumbnails within a 100 by 80 rectangle, the image will appear at 500 \times 375 pixels on the detail pages and 100 \times 75 pixels on an index page. You can change the dimension limits by either typing in a new value or clicking and holding on the value in each box and then dragging to the right or left to increase or decrease it.

The 'square' option will keep both width and height in line, while the 'width' option will concern itself only with the width of each image and let your pictures take as much vertical space as they require. This is logical, as Web pages are designed to work in a top–down mode rather than left-to-right, which is why it's more common to end up scrolling vertically than horizontally online. By using the width setting, you can therefore set your images to fit within a common Browser window size, such as 1024 pixels wide, and let them extend below the bottom of the screen if required.

The options for adding metadata are the same on both the index and detail pages, although the settings for one don't apply to the other, allowing you to pick a short data set, such as 'Caption only' or 'Name & Ratings' on the index page, and a more extensive set, such as 'IPTC-Expanded', which lists dates, times, photographer details, aperture, exposure, keywords and so on, on the detail pages (Fig. 8.22).

Fig. 8.22 The metadata options on the Web Gallery details pages draw extensively from the metadata attached to the images in your Library, and can be tailored to include views already defined in your Metadata presets.

Fig. 8.23 Move any picture on an index page to reposition it, and all other photos in the Gallery will shuffle themselves to accommodate its new location.

Fig. 8.24 If you want to publish your Web pages anywhere other than a MobileMe homepage, you will have to use your own FTP software. The free Cyberduck application (which invites donations) is an excellent client, and can be downloaded from www.cyberduck.ch

Your pictures remain editable, even after you've placed them on the page. Hovering over each one overlays it with two icons – a curled arrow that will take you to the detail page and a negative bar in a circle that will delete it entirely. Clicking on and dragging an image will move it to a new position on the page, with the other pictures shuffling to accommodate it in the new layout (Fig. 8.23).

You can upload your completed pages to your MobileMe space directly by clicking Publish to MobileMe…, but if you want to host them on your own website then you'll have to first save them to your local hard drive and upload them from there, as Aperture has no in-built FTP software (Fig. 8.24).

Whichever option you choose, the final step is deciding on the compression and color settings of your images. These are set individually for thumbnails and detail shots, with both defaulting to high-quality JPEGs. By picking from the drop-down menus beside each one, you can vary the compression or switch to PNG

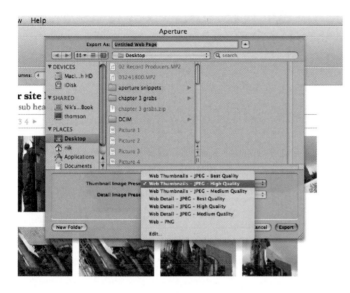

Fig. 8.25 When you come to export your Web pages you can specify individual compression levels for both the thumbnails on your index page and the full-size images on the detail pages.

format files, but selecting Edit… from the bottom of each one lets you define your own preset that will appear in the menus every time you save a future Web page. The Edit… option opens the Web Export Presets dialog, giving you access to 12 levels of compression (under the title Image Quality), gamma control and the ability to apply a ColorSync profile. This gives access to all profiles installed on your Mac, including those assigned to installed printers, and two gray profiles – 'Black & White' and 'Generic Gray Profile' – which let you apply changes to every image in your pages at export without having first gone through and edited them by hand within the Aperture environment (Fig. 8.25).

You can also protect your images by applying a watermark.

In switching from Web Galleries to Web pages, you lose features like the ability to upload new images by email or through a Web Browser, but you will find the end results to be less fussy and, perhaps, more professional than the glitzy alternative.

Web Journals

Web journals are by far the most versatile of all of the online products you can make with your photos in Aperture. They come closer to proper Web design than is offered by any of the other options the application can offer.

Its goal is less to show off your photos in isolation – as a portfolio – but to let you tell stories using a mixture of words and pictures. As such, it's the online equivalent of the Photo books (see later).

That said, it shares many features with the Web page. Again, you start by gathering together the images you want to use, in a Project, Album or folder, and use them to create a new Web journal from File > New > Web Journal. Once you've given it a name, you can start populating the pages with images, either manually by dragging them out of the Browser bar and onto the page or by asking Aperture to do the hard work for you.

Every image you add to your Journal's index page will link to a new detail page showing a larger edition of the same. There is no reason, then, why you can't put all of your thumbnails on one page, as you would in a Web page. However, this would miss the point of a Journal, which can take advantage of metadata attached to your images to split them into more logical sub-groups.

The Shortcut button between the page thumbnails and Browser pane (with a cog icon) conceals a drop-down menu that lets you automatically place all of the images in the Browser bar onto index pages defined by day, keyword, rating, byline, city or category. You will end up with one index page for each day, category and so on and one detail page for every image in the Browser bar. It's quick and simple, but, as we'll discover in a moment, lacks some flexibility (Fig. 8.26).

Once your images are in place, whether they were added manually or automatically, you can start adding your text. The same metadata features are available here as in the Web Page feature and is added using the same Toolbar button sporting the tag icon. On the index pages you can also add your own text boxes and captions.

The trouble is you can't drop a text box in the middle of an image box. So, if you want a paragraph of words between two strips of pictures, you'll need a total of three boxes: one each for the picture strips and another for the text. If you took the easy option and had Aperture split your images onto pages defined by metadata, it will have lumped them all into a single large container on each page, relegating any words you add to the very bottom of the page. Obviously this is more of an issue if your groups are particularly large, such as 100 images taken at one event and then sorted by date (Fig. 8.27).

Fig. 8.26 The Web Journal feature's Shortcut button lets you automatically place images within your Journal on the basis of their attached metadata. This is a quick and easy way of kick-starting your Journal, but it lacks flexibility and can have drawbacks later in the creation process.

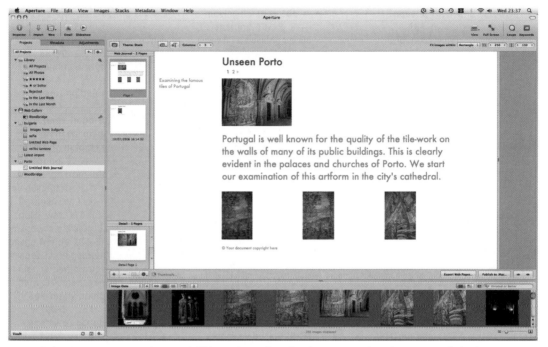

Fig. 8.27 By dragging your images onto the pages of a Web journal manually you have far greater control over the positioning of other elements on your page, including text and captions.

In all other respects, Web journals and Web pages work in precisely the same way. Journals' styles are defined by themes: you can set the number of columns on an index page and you can constrain both the thumbnails and the detail shots to fit within a square or rectangle of your own choosing. You can set boilerplate text, such as the copyright notice, and you can also access any of the export presets you set up when creating a Web page to downsample your images, change their color profiles or apply watermarks, before uploading them to your MobileMe Web space or saving them to your Mac's hard drive and then publishing them elsewhere using FTP.

Producing Books

Books are the most impressive products you can make with your pictures. If you've never seen one in real life, you'll be impressed by the range of choices on offer and the quality once they arrive. Apple offers a range of sizes and layouts and the choice of either

Fig. 8.28 Aperture ships with a range of book styles, most of which are skewed to the professional user and are not found in iPhoto, Apple's consumer image management application.

Fig. 8.29 If none of the default book sizes suits your needs, they are supplemented by a custom option, which lets you specify your page dimensions and margins. This is particularly useful if you intend to print the results yourself or send them to a professional bureau.

softback or bound hardback volumes. The choice is similar to that found in iPhoto, with a couple of extras thrown in to appeal to the professional photographer, in place of which it drops more 'family'-oriented options like the 'crayon' book found in its consumer offering (Fig. 8.28).

Books come in a choice of three preset sizes: large, medium and small and are now supplemented by a custom option, through which you can set page sizes, image spacing and margins on each page. There are eight styles on offer, encompassing formal occasions, art collections and stock books (Fig. 8.29).

Considering these are just templates into which you drop your pictures and text – the photo editing version of low-end desktop publishing, in effect – the range of customization options is impressive. And if you find your chosen style doesn't work for the pictures in your Library, you can even change the theme half way through, although with the caveat that custom layouts obviously won't be transferred to the new theme.

New books are created from the File menu, or the New drop-down above the Projects panel. Click on any Project, Album or Light Table and then pick Book from the New menu. As the first image in any of these collections will already be selected, you'll be given the option of creating your book using just that image or all images in the collection. Even if you pick All Images, there is no obligation to place them all in your completed book, so while you can go back and filter out just the pictures that you want to print, there is no harm in clicking Create With All Images at this stage.

Once you have specified which images should be available to the book, you need to pick its style. All of the books offered by Aperture have a sober and professional slant. The eight on offer should meet most needs, but if they don't they can be tailored extensively after selection. At this initial stage, then, you need only to select the one that comes closest to what you want and pick Choose Theme.

Obviously your choice of book will determine what it costs to have it printed. Prices will change over time, but at the time of writing (early 2008) softcover books ranged from £7.39 to £14.09 in the default page counts, with an additional charge of between 22p and 53p for each additional page. Hardback books cost £19.96 with their default page counts, with each additional page costing between 76p and £1.05, depending on whether they are double- or single-sided. All books have 10 pages (20 sides), and no book can have more than 50 extra pages (100 sides) added in.

At 6.7 × 8.9 cm, the 'small' book format isn't much larger than a credit card, and as such your choice of layouts is limited to the Picture book in which each image fills a complete page. Anything smaller would be fiddly. As the price is around £1.50 higher than for the medium-sized book, however, each order will comprise three identical books.

We'll walk through the creation of a Special Occasion book here, so select that from the theme options if you want to follow along.

Once you have chosen your book style, a new untitled book will be added to the Projects panel. Give it a name before examining the rest of the interface. You'll see that the main part of the display has been split into three sections: a Browser showing the images in your collection, above which two areas show thumbnails of the pages in your book and each individual page as you're working on it.

The pages are template driven, with boxes for images and text already in place. The Book Creation dialog opens with the cover page open showing a gray box where you can position an image. Dragging a picture from the Browser to the box drops it in place. Notice how its thumbnail in the Browser pane now has the number 1 stamped on its top-right corner to indicate that it has so far been used once in the book (Fig. 8.30).

Fig. 8.30 Books are constructed by dragging images into pre-defined holders on the pages or cover.

By default, it fills the box entirely, but if you want to focus on just one part then double-clicking it in place in the box will call up the Image Scale dialog. Sliding to the right will enlarge the image without increasing the size of the box. Sliding back to the left will reduce it again. Once you have resized your image, it may well be off-center with the focus on the least interesting aspect of the picture. It should therefore be repositioned by clicking and dragging on it within the box (Fig. 8.31).

Right-clicking on the image calls up a context-sensitive menu, giving you fast access to common layout defaults: scale to fill, scale to fit centerd, scale to fit left-aligned and scale to fit right-aligned. From here you can also cut, copy or delete the image (Fig. 8.32).

The same principle applies for placing photos on other pages within the book. However, internal pages are more versatile than cover designs. Notice how there is a small black arrow to the right of the cover in the Pages thumbnail window. Clicking this

Fig. 8.31 Resize and reposition placed images by double-clicking them on the page and then using the Image Scale slider to change their dimensions. Once the dimensions are correct, hold down on them with the mouse and drag to re-center them.

Fig. 8.32 A context-sensitive menu lets you easily resize your source material to suit particular frame shapes in your book.

will drop down alternative designs for the cover. There will be only two: the default style we have just been using and a second style in which the cover image spreads across the front and back of the book. Click on any internal page – other than the dust jacket's internal flap – and you will see that you have a far wider choice of layouts from which to pick. In the unlikely event that none of them meets your needs, pick the one that comes closest, and then set about customizing it.

When you create books in Aperture, you'll split your time between two working modes, in which you edit either the content or the layout of your pages. You can't work on both at the same time. To switch between them, use the two buttons to the right of the Theme description just above the page thumbnails. When you switch from the default of Edit Content to Edit Layout, clicking on an image or text box will apply grab handles to each side, with which you can resize it. While in this mode you can still drag in images from the Browser strip at the bottom of the screen. However, you cannot reposition them with the container frames, as grabbing onto them to do so instead moves the frames themselves. As you do this, Aperture will flash up yellow guidelines to show when any side or the vertical or horizontal centers of your frames line up with any other edge or central position on another frame (Fig. 8.33).

OK



Fig. 8.33 Switch from Edit Content to Edit Layout to change the dimensions of the image frames on your pages. As you drag the grab handles on each one, yellow guidelines will show you when you have lined them up with matching elements on the same or facing page.

(If you find it difficult to position elements using the guides, you can do it manually by opening the Layout Options dialog, which is found in the Shortcut menu indicated by the cog button below the pages' thumbnails. This lets you nudge frames in any direction and adjust images' border thickness; Fig. 8.34.)

While you can happily drop images from the Browser strip into frames in your book while you are editing the layout, you cannot drag images out of one frame and into another. The usage tally on the corner of each image thumbnail will be adjusted to reflect this, so that images that have been replaced by others have one deducted from their total (Fig. 8.35).

The remaining tools on the Book Toolbar work in the same way as their desktop publishing equivalents. The Type drop-down gives you quick access to the preset type styles that accompany your chosen Book theme. The range of styles will be determined

Fig. 8.34 The Layout Options dialog lets you control the size and position of your photo boxes more precisely by entering numerical dimensions. From here, you can also specify the thickness of the border on each one.

328

Fig. 8.35 The numeric badges on the upper right corner of each thumbnail in the Browser indicate how many times each one has been used in your book, making it easy to spot which have yet to be exploited.

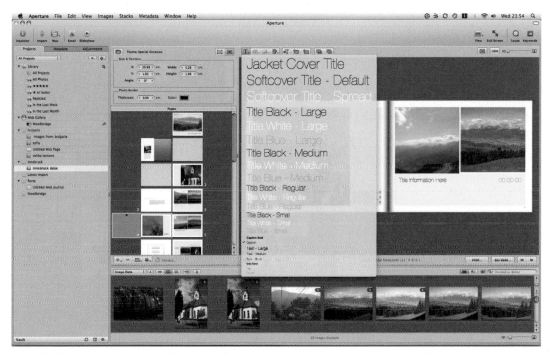

Fig. 8.36 The Type drop-down lets you select from the pre-defined styles that make up part of your chosen Book theme. You cannot add your own styles to the list.

by the theme, with some such as Special Occasion boasting 20 options, and others – the Small book, for example – having just one. These are all given logical names that pertain to a specific copy type, such as Cover Title, Date and Event Details-Smaller (Fig. 8.36).

Two along from the Text Styling button is the Photo Filter tool, which applies variations on three different styles to placed

Fig. 8.37 A small selection of image filters lets you change the look of each image in your book. By applying a wash, you can knock back the colors of images used as background files behind text.

images. The two most obvious are black and white and sepia filters, but these are supplemented by the option of a light or strong wash, which can also be applied to images in their original colors. These washes are particularly useful if you are placing text over the top of your images or image boxes on the top of picture-based backgrounds, as it allows you to reduce the contrast in the underlying material and so help the front-most items to sit forward (Fig. 8.37).

If, after washing your background images in this way, you still find that they are distracting, the next button – Set Background – gives you a quick way to disable it altogether. This drop-down has just two options: No Background and Photo – whose functions are self-explanatory.

Not all functions are available at all times, as this Toolbar is context sensitive. When you have focus on an image frame, for example, the text styling tool will be grayed out, and when you are in Layout mode, all of the positioning tools for adding new text and image boxes and layering them on screen will be inaccessible.

Switching to Edit Layout gives you access to Add Text Box, Add Metadata Box and Add Photo Box. The second of these deserves further explanation, as it hooks into Aperture's extensive database of information about every image in your Library.

To use it, select any positioned image in your book and then click the button. A text box will appear immediately below it, with a tab peeling off to the left stating Plate Number & Caption. This describes the content of the Metadata frame, which will most likely be empty at this point. Move four buttons to the left, to the Set Metadata Format button that we skipped over beside the Text Style button and click it to drop down a list of options. This gives you access to everything Aperture knows about your image, including keywords and copyright information you have applied to it yourself and shutter speed and focal length details written to its Exif data by your camera at the time of creation. Selecting any one of these places the relevant details in the associated Metadata box, which can then be formatted using the Text Styles drop-down (Fig. 8.38).

You can considerably speed up the process of laying out a book by allowing Aperture to do most of the hard work for you.

Fig. 8.38 By attaching Metadata boxes to your images, you can use the data you have already entered with respect to your images to add text to the page.

The Shortcut menu found below the Pages thumbnails (the button with the cog on it) duplicates many of the functions of the Book Creation Toolbars, such as adding photo and text boxes. However, it also contains several more powerful features, such as the ability to split text boxes into multiple columns, to show or hide page numbers and to save out individual pages to new documents should you wish to experiment on them elsewhere.

The four tools at the top of the menu, though, are the quickest way to build a book with the least amount of effort. Used to automatically flow all unplaced images, or all selected images or to rebuild the book from scratch with unplaced or selected images, they give Aperture free rein to fill as many of the photo frames as it can with the photos in your Browser bar. Of course, you can then go through the book yourself and rearrange them, but it is a quick and easy way to get a head start on what could otherwise be a lengthy process. The one thing it can't do, of course, is write your descriptive comments.

Fig. 8.39 Before you can buy your completed book, you must sign up for an Apple ID and turn on 1-Click ordering. If you have ever bought from the iTunes Store or signed up for MobileMe you will already have an Apple ID. If not, you can sign up through the book purchasing dialog.

Once you have completed your book, you have the option of buying it (the 'Buy Book…' button) or printing it yourself. To buy a book, you need an Apple account, with 1-Click ordering enabled. If you have ever bought from the iTunes Store, then you can use the same account details here, but if not, you can set one up through the Purchase dialog (Fig. 8.39).

If you would rather sort out your own professional printing or you want to send a completed book to a client for approval, then you can save your pages as PDFs by instead clicking Print and select Save as PDF… from the bottom of the Print dialog.

Printing

If pressing the shutter is one half of the photography equation, outputting your edited, perfected images is the balance. We've already discussed making Web Galleries, pages and Journals, and sending your photos to Apple's printing partners to produce professional-looking books. However, the most common form of output remains the standard studio, home or office-based print, on an inkjet, laser printer, dedicated 6×4 in. photo printer or large format device.

Fortunately, Aperture is well equipped to handle any kind of DIY printing job you care to throw at it, so you have an end-to-end photo production suite in one application, without having to resort to Photoshop for the final stage of the process.

As you might expect, they are controlled by presets, and while Aperture ships with two set of default printing presets already installed, you can add your own, and either edit or delete those already in place.

As with almost any application, the Aperture Print command is found both on the File menu and hiding behind the ⌘ P keyboard shortcut. However, unlike most other applications, it is a fully color-managed part of the application, just like any other part of the suite.

It is split into two halves, for printing single images or contact sheets showing several images from a particular collection. Each has a similar set of controls, and they differ only in terms of layout options. We'll start by looking at the common controls in both sets, before looking at the layout options for each individually below.

Before you step straight in and start changing the defaults shipped with Aperture, though, be sure to create new copies of each one. The settings in place are optimized for your particular set up, and while you may be able to improve on them for a particular output job, you should try to preserve these wherever possible.

As such, use the Shortcut button at the bottom of the dialog (sporting the cog icon) to create new single image or contact sheet presets from scratch, or to duplicate whichever preset is selected at any time. From here, you can also lock the existing presets, or indeed any others that you create, to prevent them being changed and overwritten. Once you have done so, the only changes that can be made to any preset without going back and unlocking it from the same menu is the choice of printer, the number of copies, and the range of pages that should be output (Fig. 8.40).

Note that presets remain works in progress, just like half-written documents in a word processor or semi-edited images in Photoshop. As such, you should save your changes as you go along, using the Save button at the bottom of the Print dialog.

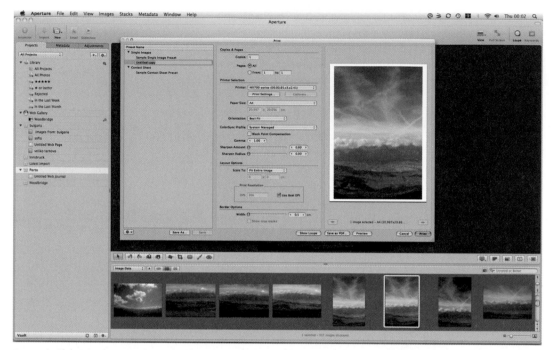

Fig. 8.40 Avoid changing the printing presets that ship with Aperture by creating new presets based on those already in place.

To set milestones, saving later amendments so that they do not interfere with existing settings; use Save As…, which effectively copies the Duplicate command from the Shortcut menu.

Common Features in The Printing Dialogs

The Copies & Pages section at the top of the Aperture Print dialog should already be familiar to any Mac OS X user. It specifies merely how many copies of your printout should be made and which pages you want to produce. Of course, this latter option will only be of relevance if you are printing more images that can fit on a single page, so More Than One in Single Image mode and More Than would fill the number of columns and rows set in the Contact Sheet preset (Fig. 8.41).

This should help clarify Aperture's use of the term Single Image. This preset does not relate to images printed on their own, one at a time, but batches of images in which each one occupies its own page.

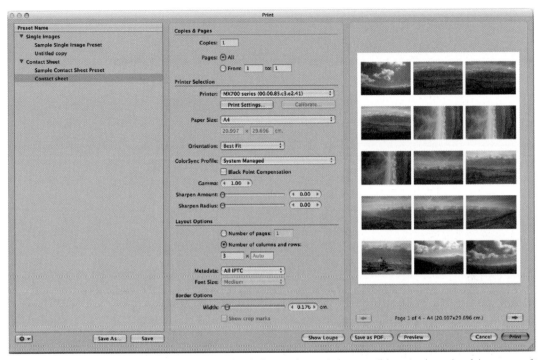

Fig. 8.41 When printing contact sheets, you can specify the number of columns and rows, which in turn will determine the number of photos you can fit on each page. Below this, the Border Options slider increases and decreases the margin between each image.

Your choice of printer is defined in the Printer Selection section and is saved as part of the preset. In this way, if you use one printer for low-grade proofing and another with more expensive inks and media for final output, you can define multiple presets, with one devoted to each output device, but which are functionally identical in every other way.

Why would you do this? Because your choice of printer, even in many cases the media you feed it, will have an impact on the colors achieved in the final output. All colors, inks and media have different color profiles, and so if they are to function as part of a fully color-managed system they must be treated as distinct and different entities.

Managing Color… or Not

Set the choice of paper using the Print Settings… button, which opens the standard Printer Options dialog for your printer. This

will differ between manufacturers and models but in general will include an option for Quality & Media, where you can specify the media type, a paper source on devices with more than one input hopper and print mode, which could include photos, tables, composite documents or grayscale images.

You should also be able to set color options here to specify how colors are managed. You should avoid making changes to any Color, Tone or Intensity sliders and instead disable Color Management from the Color Correction drop-down. This will leave Aperture in full control of color management and avoid the situation where you may find you have your printer driver correcting adjustments made by Aperture that it perceives to be less than perfect.

Laying Out Your Page

There is a Calibration button beside the one for Print Settings. Whatever its name may suggest, this doesn't give you access to further color management features but to a positional tool, which lets you tweak the position of your images on the page.

For some printers, it will be grayed out, but if it works on yours, it initiates a simple process of printing elongated L-shaped characters all around the border of an otherwise blank page. Each is assigned a number, and they run in groups along each edge, with each member of the group being slightly closer to the border than the one in the same position in the previous group. As such, a group that contains positions 27, 19, 11, 3 will be followed by a group labelled 26, 18, 10, 2.

Examine these closely and look for the one whose longest, narrowest end, running parallel to the edge of the page, is closest to the border without being cut off.

Aperture is set to assume that this will be the one labelled 0, but if that's not the case on any of the four edges, correct the Margins section of the Print Calibration dialog. Aperture will now position your images on the page more accurately.

Your choice of printer will have a bearing on the paper sizes available to you, and you will notice that some may even define standard sizes, such as A4, slightly differently, with hundredth of a millimeter variations between different manufacturers (the commonly accepted standard being, of course, $210 \times 279\,mm$).

The range of papers your printer can handle is found in the Paper Size drop-down and their corresponding sizes are shown below in the dimension boxes. By default, these will be purely informational, but if you are using a non-standard paper size then selecting Custom from the Size drop-down will let you enter your own specifications, measured in centimeters and decimals thereof.

This is used in conjunction with the orientation setting below, which skips between landscape and portrait, and a best fit option, which will rotate the image on the page as appropriate. This is useful when you are printing a series of images in both landscape and portrait format. When working with single image presets, choosing Best Fit, or an appropriate orientation for each image will let you maximise the portion of each page given over to your work, allowing for the border specified at the foot of the dialog. When working with the Contact Sheet preset, however, the effect of changing the orientation can be a marked variation in the number of images you can fit onto a single page, as we will see when we come to the Layout Options section.

Managing Printed Color

We can group the rest of the Printer Selection area in the Print dialog together, as each option deals with color management and the way in which the image you see on screen is translated for use on the page.

Screens and printers are fundamentally different technologies with one, the screen, emanating light of different colors, and the other, the printer, producing paper-based images that reflect selected tones in different areas. They also work with totally different colorsets. Screens make up their colors using red, green and blue pixels. Printers, on the whole, use cyan, magenta, yellow and black, often with half-strength variations of each thrown in to improve reproduction accuracy and smooth the transitions between similar tones. A small number even include pure reds, greens and blues used on monitors, but this still doesn't get around the problem of translating one color technology into another.

The ColorSync menu contains a list of installed profiles on your system from which you should choose the one relevant to your printer, before tweaking the output using the Gamma and Black Point Compensation options (Fig. 8.42).

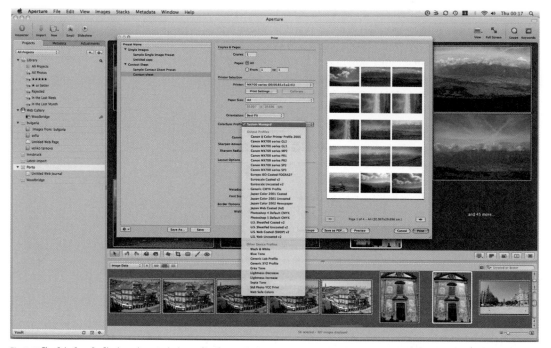

Fig. 8.42 The ColorSync Profile drop-down includes profiles for standard system settings and any hardware devices you have attached to your Mac.

Gamma handles the exposure of your image on the page, although only in one direction. It is impossible to darken an image at this stage, but you can lighten it by up to 30%, in 5% steps. This should help to counter the fact that, as discussed above, while your monitor can illuminate your photos from behind, the best your printer can hope to achieve is output that fairly accurately reflects the available light under which it is viewed. Inevitably some light will be absorbed by the paper, and some papers are worse offenders here than others, which can make your printed output look appreciably darker than what you have been viewing on screen. As such, the Gamma variable lets you lighten your printed output slightly to compensate.

The Black Point Compensation checkbox works hand in hand with Gamma. The chances are that if your images are printing too dark, subtle shadows are being lost and everything below a certain level of luminance is being lumped together. The result is muddy, or entirely missing detail at the darker end of the spectrum, which dramatically reduces the dynamic range of your printed work.

Checking the Black Point Compensation box uses the ColorSync profile for your selected output device as the benchmark against which your photos are adjusted. This is best understood in relation to the Histogram on the Adjustments panel. Using Auto Levels expands the range of tones visible in the image across the full luminance spectrum, so that the very darkest tones appear black, the lightest appear white, and everything in between is proportionally distributed across the rest of the scale.

However, the range of levels that your printer can reproduce may be far more restricted than those your Mac can display – particularly if your output device doesn't have half-strength inks in its lineup. Checking Black Point Compensation will therefore perform an equivalent task to the Adjustments Inspector's Auto Exposure button, but in relation only to printed output, by rescaling the luminance of your image so that the lightest and darkest tones do not exceed the extremes of the gamut defined by your printer profile.

On-Screen Proofing

Ink and paper – in particular specialist media – don't come cheap, and so while printing a photo several times is often the easiest way to ensure that the results look the way you want, it has three major drawbacks: cost, environmental impact and the amount of time it takes to run off several proofs with only minor variations as you apply sequential adjustments to your photos.

Fortunately, thanks to its excellent color management system, Aperture lets you proof your images on screen with a fair degree of confidence. Choose the profile of your output device by picking View > Proofing Profile and then use the shortcut *Shift* ⌥ *P* to toggle on-screen proofing on and off. Aperture will cross-refer the profile of your display with that of your output device to adjust the on-screen colors and luminance to approximate the equivalent printed results.

A line warning you that you are proofing in this way will appear below the Viewer window whenever it is toggled on (Fig. 8.43).

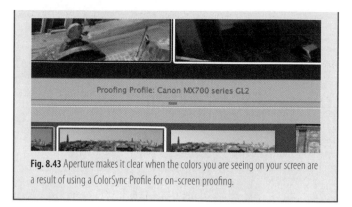

Fig. 8.43 Aperture makes it clear when the colors you are seeing on your screen are a result of using a ColorSync Profile for on-screen proofing.

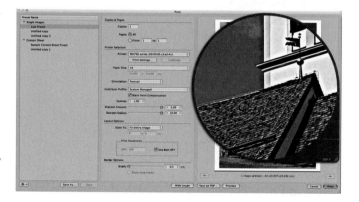

Fig. 8.44 Excessive use of the Sharpen sliders in the Print dialog will lead to undesirable, unrealistic results, as can be seen if you use the Loupe to examine the output at 100% magnification.

Sharpening Your Output

Particular care should be taken when using the Sharpen sliders, which control the amount of sharpening applied and how far from any contrasting edge – say between the roof of a dark building and the light sky against which it sits – the sharpening effect should extend.

It is easy to be heavy handed here, but judicious use of the Loupe, available in the Single Images Preset dialog, will show more accurately how damaging it can be. Excessive sharpening can create a halo effect around sharp contrasts, which looks unnatural and can actually make the results less – rather than more – clear. Fortunately, printed results can be better than the on-screen preview, so a little bit of trial and error can pay dividends (Fig. 8.44).

If you feel that your image would benefit from some crisper edges, a good starting point is to move the Sharpen Amount slider to around 0.70 – about a third of the way along its run – and then apply a very small radius value, by clicking the ⬅ and ➡ arrows surrounding the value to the right of the slider. Use the Loupe set to at least 100% magnification to examine your image for any halo effect, and only if you are certain both that you have not degraded the image in any way, and that you need to add more, should you then increase either the Amount or Radius values.

If you find you have already introduced problems, reduce the values accordingly, remembering always that you should aim to output your work with the smallest number of changes possible. Any edit or enhancement that is easy to see, unless that was your intention, is a bad edit.

Settings Specific to Single Image and Contact Sheet Printing

The Border setting at the foot of the Print dialog is the same, regardless of whether you are printing a series of single images or a contact sheet. However, the Layout Options differ considerably due to the more complex nature of a contact sheet.

When printing a single image, you need concern yourself only with its dimensions. Aperture comes set up with three commonly used sizes already specified: 4×6 in., 5×7 in. and 8×10 in. Note that none of these matches the 4:3 aspect ratios commonly used by digital cameras, and only 4×6 in. matches the 3:2 ratio used by some models.

So, if your images haven't been cropped to these proportions, choosing one of these common formats will introduce extra margins along at least two of the edges as Aperture scales the image to fill as much of the page as it can without losing anything over the edge. Choosing Fit Entire Image will do the same but this time in respect of the paper size chosen in the Paper Size drop-down. Fill Entire Page, however, will print right up to the defined margins, set at the bottom of the dialog, in all directions always taking the poorest-fitting dimension to extremes and cropping the adjacent sides.

So, if you have a 3:2 aspect picture that you want to print at 8×10 in., you will lose a little from each end of the picture in Landscape orientation or the top and bottom in Portrait. Printing

Fig. 8.45 Use the Scale setting to shrink or grow your images to common output sizes with less effort.

Fig. 8.46 The best compromise between output size and print quality can be maintained by checking the Use Best DPI box.

the same image on 5 × 7 in. paper would see the top and bottom cropped off in Landscape orientation and the sides trimmed down when set to Portrait.

Note that there is a very clear distinction between paper size and image size. The paper size chosen in the Printer Selection area of the Print dialog talks only about the media. The layout options talk only about the size of the finished image. If you have specified a paper size larger than your print size – say A4 paper – on which you're printing 5 × 7 in. images, the finished product will also sport crop marks, showing the dimensions of the picture itself.

The most versatile option, of course, is the Custom Scale setting, which unlocks the grayed-out dimensions boxes below the presets so you can enter your own.

When printing single images – but not contact sheets – you can specify the resolution at which they should be outputted. Resolution and maximum print sizes enjoy something of a symbiotic relationship: the higher the resolution, the smaller your images will have to be; the larger the images, the more visible dots you'll have to accept. To ensure the best balance of output size and quality, leave the Use Best DPI resolution box checked (Figs 8.45 and 8.46).

Contact sheets are used more for reference than display. They are an easy and effective way to get an overview of a collection of images and are the printed equivalent of a full-screen Browser view of the pictures in your Library. By default, you'd want to print all of the images in a collection across as many pages as you need, but if you want to first print a test page to see how they fit, restrict the Number of Pages setting to '1'.

Once you are sure it looks fine, having adjusted the margins at the foot of the dialog to suit your needs (which now applies to every image, rather than just the page as a whole), switch to 'Number of columns and rows' and specify how many columns of images you want to feature on each page and, optionally, the number of rows, too. By default, the rows will be set to Auto and will revert to this every time you remove any number e ntered in this box.

In order to help choose and filter images from a printout, you have the option of appending metadata to each photo. These are drawn from your Aperture Library and can be chosen using the

pop-up menu below the number of images, and the font used to display them using the font size. By default it opts to include All IPTC metadata.

Slideshows

You could be forgiven for thinking that a slideshow was just… well, a slideshow, in which the pictures follow one another in sequence.

To a degree that's true and as if to prove it, there's a Slideshow button on the main Aperture Toolbar. Clicking it, or pressing `Shift` `S` will launch a slideshow using your Slideshow presets and whichever view of images is open in the Browser, whether that be a folder, a Project, or even your entire Library. You have only two options: how you want each slide to transition into the next and whether you want Aperture to show the status of each image. A file's status tracks whether an image is stored locally, remotely or offline.

As such, default slideshows are a great way to get a quick fix on how a collection looks without having to manually click through every image in a folder. However, by tweaking the Slideshow presets, you can produce a far more compelling production, which will be suitable for public display, perhaps at the end of an event where you have been hired to provide your services.

Adjusting Slideshow Settings

Open Aperture > Presets > Slideshow… to access the Slideshow Settings dialog. As with the export presets for image and Web, this gives you access to the presets shipped as part of Aperture, which can be amended or deleted, and also lets you add your own from scratch (Figs 8.47 and 8.48).

Clicking through the six options already in place will give you a good idea of how each one works and how you can best take advantage of the various options on offer. To really understand them, though, it's always best to create a new one of your own.

We'll create a slideshow that shows nine images on every screen and transitions by fading the screen to black before bringing up the next page. Our first step is to add it to the list by clicking the '+' button at the bottom of the dialog and give it a name. We'll call it Dissolving Thumbnails.

Fig. 8.47 The Slideshow Presets dialog lets you define the way in which images should be displayed in an on-screen presentation.

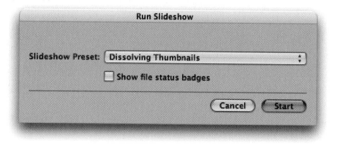

Fig. 8.48 Once you have defined the presets for your slideshows, you can use them by selecting a range of photos and clicking the Slideshow button on the toolbar.

You'll notice that as you do this, Aperture makes a copy of whichever preset was selected when you created the new one. This gives you a starting point, so if you are creating anything similar to one of the pre-existing presets, you'll save a lot of time by having that one selected when you add your own.

Unfortunately, there is no Preview option for slideshows, so if you don't have a clear image in your mind of what difference each setting will make to the completed product, you may find that working your way through the Slideshow Presets dialog requires a certain amount of trial and error. However, it is logical, starting out with the amount of time each image should be displayed. You have three options: manual, automatic, or fit to music. This last option is perhaps the most interesting as it leaves each image on the screen for the whole duration of each track that it plays.

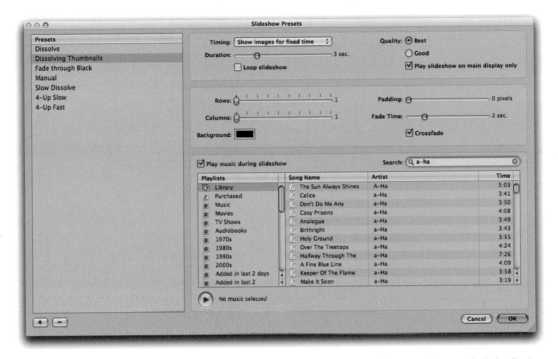

Fig. 8.49 You can use music from your iTunes Library to accompany your slideshow. Bear in mind that if you have set each image to be displayed in time with the music, each one will be shown for the full duration of each track.

Music is taken from your iTunes Library, and you can pick either single tracks or complete playlists. This opens up interesting possibilities for creating stills-based guides (see box 'Creating a stills-based guide; p. 349).

For the moment, we will select the option to Show images for a fixed time and specify this using the Duration slider below the drop-down, setting it to one second per photo. This is cumulative, though, so with nine images on the screen at any one time, appearing one at a time and displayed without interruption for a second each, it would take nine seconds for each image to be replaced in turn. Add into this any fade times you have set (see below) and you can see why a single second for each photo is more than enough. Nonetheless, we'll check the box to loop the slideshow so that it repeats indefinitely until someone stops playback.

Even if you don't choose to fit your slides to music, you can still play the contents of your iTunes Library while the images are being displayed, by checking the 'Play music during slideshow' box at the bottom of the dialog, picking the tracks or playlists you want and previewing them if necessary using the Play button. Aperture will tell you how long the selected playlist will run for, assuming it's not set to loop (Fig. 8.49).

If you use Aperture on a multi-monitor setup, the option to Play slideshow on main display only will obviously restrict it to just the screen on which you view the actual Aperture application with all of its toolbars and dialogs (the secondary display being the one on which you view your images full screen, if attached).

We now need to look at the layout of our slides. We have already decided that we want nine thumbnails on each screen, and the only way to do this is in three rows of three images. Aperture isn't flexible enough to allow you to design bespoke layouts that vary from page to page, as it only allows you to specify the number of rows and columns. You can get around this easily, however, by designing your slides in an external layout application, such as InDesign or Photoshop. Take advantage of whatever filters and layers you want, overlapping images and adding captions as appropriate, and then save your work as an image file which you then import into the Aperture Library and organize into a dedicated Slideshow folder. You would then create a Preset that displays these images in full screen, one at a time.

For now, then, we will drag both the Row and Column sliders to the right until they reach 3 out of a possible 10, and add 25 pixels of padding between each one. If we ignored the padding, each image would butt up against the others. With 25 pixels of breathing space, they will be more clearly differentiated and easier to read in the limited time our viewers will be shown each one. The Fade time slider controls how long it takes to transition between each page of the slideshow and is used in conjunction with the Crossfade checkbox below. Regardless of whether Crossfade is ticked or not, the point at which one image starts to disappear and the next appears will match what you have chosen on the Fade time slider. However, if you leave Crossfade checked the overall effect will appear slightly slower, as each

image – the old one and the new one – can equally share the allotted time (Fig. 8.50).

By clearing the Crossfade checkbox, you are asking Aperture to introduce a short period when only the background color (set using the Background color picker to the left) will be on display. This is a third element, for which the disappearing and appearing images have to leave time. To have your images appear instantly or swap out one for another, you would set the Fade timer to 0.

By default, the background color is always set to black, and unless you have good and specific reasons to change this, it's worth leaving it as it is. Black backgrounds focus the eye on the image, as they almost become invisible. Introducing red, green or white would be distracting and if they're brighter than the images themselves they will detract from the photos' impact.

The best argument for leaving this set to black, though, is the fact that it is neutral, and so compatible with any tone in your photos. Without being able to sample background colors from the images themselves or select different background colors for each slide without designing them one by one outside of Aperture, you can't guarantee that what works on your first will work on the last.

Controlling Playback

Slideshows are designed to be self-running: set them going and they'll cycle through your photos until either they come to the end of the run, or if you've set them to loop, you intervene.

As such, tapping **Spacebar** pauses and resumes a running slideshow, the ⬅ and ➡ arrow keys let you skip backwards and forwards through the slides as they would in Keynote or PowerPoint, and the **esc** key brings it to an end and gracefully fades it out.

Managing Slideshow Quality

Aperture builds your slideshow using preview images, rather than the Raw files that make up your Library. Each preview is stored alongside the Digital Master or Version to which it relates, and as it saves the application from parsing the Raw Master and then applying adjustments to create each Version every time you click onto a new image, they make the application feel more responsive. They also keep slideshows snappy.

However, if you have not set Aperture to create high-quality previews, you will find that the results of your slideshow could be softer or more compressed than you would like.

Preview quality is controlled through the Previews tab of Aperture's Preferences pane (⌘ ,). Here, you can set the preview quality on a scale running from 0 (low) to 12 (high) that matches the JPEG export options in Photoshop. You can also opt to limit the size of each preview within certain dimensions, supplemented by a 1/2 size option to reduce each image preview by 50%, or 'Don't limit' to keep them at full size (Fig. 8.51).

While reducing quality and image dimensions will both improve responsiveness and save on disk space, each degrades the quality of your slideshows. Limiting the preview size will mean that each one has to be scaled up further when displayed on screen, and so choosing a smaller setting, such as 1440 × 1440, can lead to softer

Fig. 8.51 Preview images are primarily used to help you navigate your Aperture Library more quickly. However, they are also the basis of the images shown in a slideshow. As such, you should be careful about the level of compression you choose to employ.

results or blockiness, depending on size, as it is scaled back up. Knocking down the quality, meanwhile, can introduce compression artefacts at areas of sharp contrast or where the underlying texture is complex, for example where the branches of a bare tree in a photo overlay the sky.

You must judge carefully, then, whether speed or quality are of greatest importance, and should make that decision as early on as you can, as previews will be created from the point of your very first import.

Creating A Stills-Based Guide

The Fit To Music option in the Slideshow Presets dialog tells Aperture that it should swap the image on display at the end of every track it has been instructed to play. These tracks are drawn from the iTunes Library which, with its Playlists feature, lets you specify a range of audio files and a specific order in which they should play. By combining a carefully ordered collection of photos and audio files through this dialog, it's easy to create a slideshow that goes beyond the usual transitions and music productions and becomes a truly useful resource.

The first step is to organize your photos into the most relevant order, remembering the movie-making convention of telling a building story, with each image moving on logically from the last. Once you have assembled your collection, you need to record a short narrative for each one. Apple's own GarageBand application, which ships as part of the £55 iLife suite, and the free Audacity recording and editing tool (audacity.sourceforge.net) are both excellent and easy-to-use options.

Rather than recording a single track to describe every image in the collection as a whole, you should produce a short clip for each one individually, and give them sequential numbers, with leading zeros to pad them out and make sure they are all the same length, so for a slideshow with fewer than 100 images each track would have a double-digit name, and for one with more than 99 but fewer than 1000 each track would have a three-digit name.

Each audio file name will match the position of the associated image in the slideshow, so that the track describing the seventh image would be 07, and the twelfth would be 12. Aperture can play back any audio format supported by iTunes, so saving as Wav or MP3 is safe, but Windows Media Files are inaccessible.

Import the tracks by opening iTunes and picking Add to Library… (shortcut ⌘ O) from the File menu and organize them into their own Playlist. This isolates them from the rest of the Library and lets you confine Aperture to use just those tracks as backing for the slideshow without straying into the rest of the Library.

Returning to Aperture, you would then create a Slideshow Preset with timing set to Fit To Music, and the newly created iTunes Playlist set as the audio source. Navigate to the folder within your Aperture Library containing the slideshow's images and then tap Shift S to start the slideshow, remembering to select your newly created Preset.

Unfortunately there is no way to export a narrated slideshow from Aperture. The easiest way to achieve this is by using the QuickTime export functions in Keynote (part of iWork) or a video editing application or to use the enhanced podcast tools in GarageBand.

INDEX